WE CREATE
ART
CREATES US

Brief edition of
Man Creates Art Creates Man

Duane Preble
University of Hawaii

 Canfield Press
San Francisco

A Department of Harper and Row, Publishers, Inc.
New York Hagerstown London

Cover photograph: FACSIMILE OF POLYCHROME
CATTLE Editions Arthaund, Paris.

WE CREATE ART CREATES US

Library of Congress Cataloging in Publication Data

Preble, Duane.
 We create art creates us.

 Abridgement of the author's Man creates art creates man.
 Bibliography: p. 260
 Includes index.
 1. Composition (Art) 2. Art—Psychology. 3. Art and so-
ciety. I. Title.
N7430.P692 701 75-31850
ISBN 0-06-386829-6

76 77 78 10 9 8 7 6 5 4 3 2 1

PREFACE

This brief edition of MAN CREATES ART CREATES MAN was designed to meet the need for a light weight, less expensive book which, like the first, would draw the reader into a new awareness of the visual arts by bringing together art theory, practice, and history in a single volume. The basic content and format remain unchanged, and all the color plates have been retained. Art history is presented in two chapters, one offering a world view of past traditions in a comparative style, the other devoted to the art of the twentieth century including additional examples. The final chapter on environmental arts is new material, easily accessible to the reader. It emphasizes the personal responsibility of each of us regarding the quality of our surroundings.

My thanks to the many people who have made this book possible—to the artists past and present whose works are represented here, to my colleagues who shared their ideas and knowledge, and especially to those closest to the actual production of the book: Sarah Preble, my wife and co-worker; Jeanne Wiig, researcher and long time friend; and Charlotte Speight, sculptor and editor for this edition. All of our work was brought to final form by the careful management, generous and creative spirit of the staff at Canfield Press.

To my students,
whose interest and ideas
helped create this book

Contents

Introduction 1

Chapter 1

Why Art? 5

The necessity for art 5

The concept "art" 5

Awareness 7

Creativity 10

Discovery and expression 18

Chapter 2

What Do We Respond To in a Work of Art? 30

Visual communication 30

Form and content 31

Visual elements 35

 light 35

 value 36

 color 39

 mass 43

 space 48

 time 57

 motion 58

 shape 58

 texture 61

 line 64

Design 66

Chapter 3

What Are the Visual Arts? 73

Drawing 74

Painting 81

 watercolor 83

 fresco 83

 tempera 84

 oil 85

 acrylic 85

Printmaking 86

 relief 87

 intaglio 87

 planographic 90

 stencils 91

Photography 91

Cinematography 96

Television 98

Design 99

 advertising design 100

 industrial design 101

Crafts 102

 ceramics 103

 fiber arts 103

 glass 106

 jewelry 106

 handmade furniture 107

Sculpture 108

Architecture 114

Environmental design 126

Chapter 4

What Was Art Like in the Past? 133

A world view 133

 expressive art 139

 social architecture 143

 human faces 149

 human figures 153

 landscape 157

 beyond the known world 158

 secular art 161

 the camera 166

 new ways of seeing 168

 Impressionism 170

 Postimpressionism 172

Chapter 5

What Is the Art of Our Time? 178

Twentieth-century art 178

Chapter 6

How Can Art Help Renew Our Hope for the Future? 233

List of Color Plates 243

Chronological Guide to Works of Art 244

Credits 252

Notes 258

Bibliography 260

Index 264

1 Saul Steinberg

Introduction

A technologically explosive society needs the integrating rewards of art experience. The arts and the sciences can work for man* in different ways. Science looks for and finds factual answers to questions related to our physical world. The arts help to meet our emotional and spiritual needs, and can help to shape our physical environment as well. Art is created by fusing skill, knowledge, intuition, and emotion with materials. Works of art are facts because of their physical existence; they must also possess inner life or spirit. Works of art have a unity of spirit and matter, and remain *alive* no

matter when or where created. For this reason, art may live in the present for anyone who becomes engaged in its appreciation.

The general ugliness pervading much of today's man-made environment seems to indicate that many of us have not realized the potential of our own visual capacity. Vulgarized versions of the work of today's artists enter the commercial world of buying, selling, and consuming almost overnight. Yet the general public, continuing to be limited in its concept of what art is, still feels it can comfortably enjoy "works of art" that were created generations and centuries ago for other times and other places. It takes considerable effort to close the gap that exists between art and life.

*All similar references to "man" are intended to apply to humanity as a whole, and not to the sex of any particular individual.

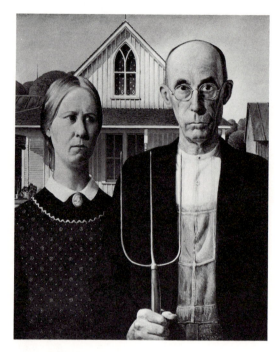

2 Grant Wood
AMERICAN GOTHIC
1930. Oil on beaver board.
29⅞ x 24⅞".

All of the visual arts are environmental: they exist in and help define human living spaces. Aesthetic awareness and design ability can help to deal with the expanding environmental crisis. Art can be a tool for understanding and averting potential disaster—and for making survival worthwhile.

In this book we have included many areas of artistic endeavor that fall under the following general definition:

A work of visual art may be anything man-made in which appearance is a primary consideration in its creation.

This book can only serve as an introduction to the visual arts. Ultimately the journey is your own.

3 Duane Preble
101 NORTH
San Francisco, 1971

Because art is sometimes vague, indefinite, and seemingly related to nonessential things, it is assumed by some that the creation of art is not significant work.

The necessity for hard labor and frugality that accompanied the settling of the continent of North America strengthened the puritan ideal of constant work and sacrifice as a way of life. Idleness was sinful. Nonutilitarian art forms were considered a frivolous commodity associated with the devil. Much of this attitude remains with us today. Calvin Coolidge summed it up when he said, "The chief business of America is business."[1]

Grant Wood's AMERICAN GOTHIC, painted in 1930, touches America's foundations. His strong visual comment has been modified to sell potato chips. Here is art borrowed and distorted, atop a pile of environmental chaos—as we continue business as usual.

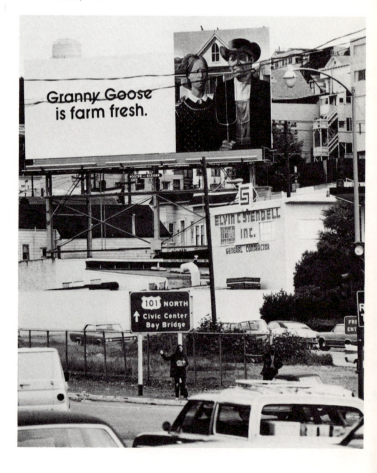

"I'd like to turn people
on to the fact
that the world is form,
not just function
and money."

Claes Oldenburg[1]

4 N. R. Farbman
Bechuanaland
1946

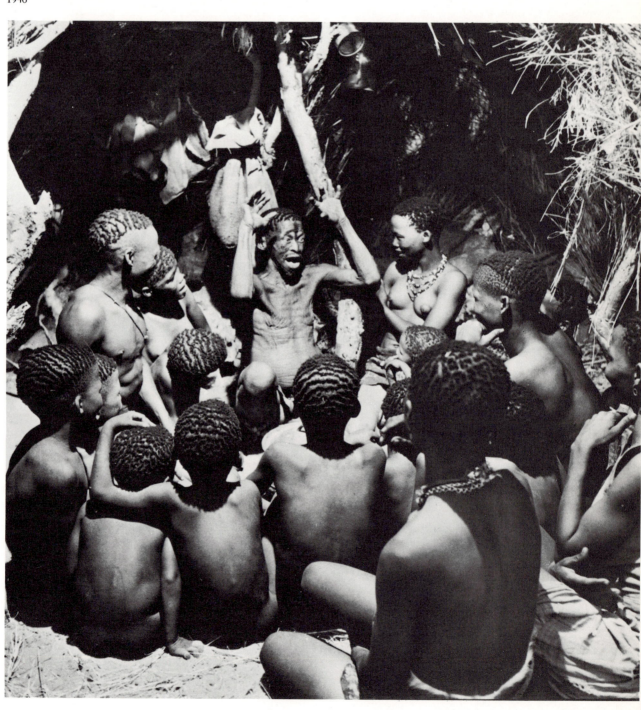

1

Why art?

To evoke in oneself a feeling one has experienced, and having evoked it in oneself, then by means of movement, line, color, sounds or forms expressed in words, so to transmit that feeling that others experience the same feeling—this is the activity of art.

Leo Tolstoy[1]

THE NECESSITY FOR ART

Art, like life itself, does not have to be defined or understood to be enjoyed. It must simply be received.

Art is not something out there. It grows from a capacity that we all possess. If you have ever experienced something intensely and have shared that experience with others, you have been where art begins.

Is it a necessity for us to give physical form to things we feel and imagine? Must we gesture, dance, draw, speak, sing, write, carve, paint, and build? I think we must.

Sharing experience is necessary for all of us. Studies have shown that an infant will not survive and develop as a healthy human being if denied interaction with another human being, even though provided with every other necessity of life. We know how important it is to communicate an idea to someone else. If the idea is important to us and we succeed in making it known to another person, we feel satisfied and strengthened by the success. If we fail to get the idea across, we are frustrated and diminished.

Much of our communication is verbal from the time we learn to speak. Yet any single means of communication has its limitations.

This is certainly true of visual communication. Still, many things can only be or are best "said" visually.

Art gives form to human experience. It can represent, interpret, clarify, and intensify those moments of life that are significant and complete in themselves. The entire range of human thought and feeling is the subject of art.

THE CONCEPT "ART"

A *work of art* is a physical manifestation of an idea, formed with human skill through the use of a medium. Any medium can either limit or expand experience, depending on the way it is used. When a medium is used so that it contributes to experience, that particular use of the medium becomes art.

To many people *art* means something done by an artist, and an *artist* is a painter or sculptor. This conception of art acts as a limitation. Almost anything that we do can be art. Art is something done so well that it takes on more than ordinary significance.

art (ärt), n. 1. the quality, production, or expression of what is beautiful, appealing, or of more than ordinary significance.[2]

The word "art" is being used here in a very general way. If we understand that no clear line needs to divide what is thought of as art from other human activities, we can then identify what are usually called "the arts" without erecting mental walls around them.

Creative works are produced by individuals, and they are enjoyed by the individual people who make personal contact with them.

5

No teacher or critic can tell you what to like.

There are no absolute standards for judging the quality of a work of art. If it contributes to *your* experience, then it is art for you. Each person must ultimately judge the quality of any work for himself. Likes and dislikes change with time, as we ourselves change. We may like something very much at one time, and find later that we have outgrown it. Works of art that continue to contribute to the experience of many people over a long period of time are considered masterpieces because of their lasting contribution to human life.

When people speak of "the arts" in our culture, they are usually referring to dance, drama, music, literature, and the visual arts. These arts are unique types of human activity, each producing forms perceived by our senses in different ways. Yet they grow from a common urge to give physical form to ideas, feelings, or experiences. It is an urge shared by all artists to go beyond functions, facts, and explanations. The arts could be thought of as attempts to fill or bridge the gap between the world we know and can measure, and that much larger universe whose presence we feel but cannot seem to comprehend consciously.

All living things are expressive. Art is an extension of the natural expressive quality of the human body.

5 A New Guinea tribesman admires the result of hours of preparation for a ceremony. Photograph: Jack Fields, 1969.

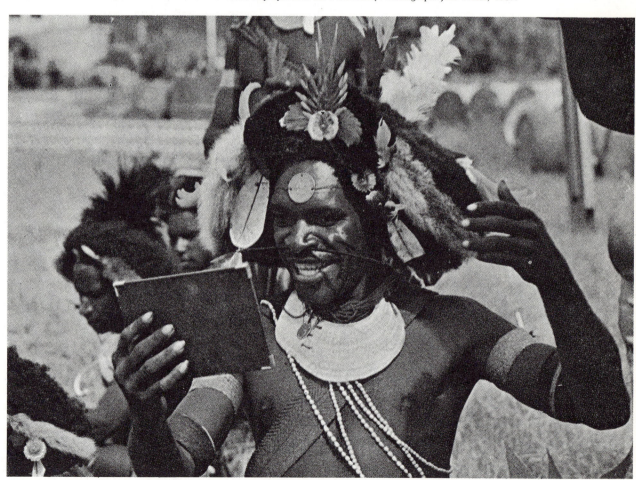

Above all art reflects us. As we look at ourselves in works of art, the experience can be either terrifying or inspiring, or both. Art experience may give the joy of discovery that is also found in scientific research, or the awe-inspiring feeling described as religious experience. Through contact with art we can discover dimensions of ourselves that we did not recognize before. Some of these dimensions may be very disturbing. In the ugliness and distortion of some of the images of man, we may recognize negative and destructive aspects of ourselves. Yet through the form of the works themselves, we can also realize the potential for positive growth and change.

Art gives sensible form to human values, giving them force and momentum of their own through aesthetic appeal.

Art intensifies our involvement with life, making experience more vivid by stimulating our capacity to feel and respond.

Art is magic. It can heal our doubts by merging the known and the unknown in beneficial harmony.

AWARENESS

Art helps us to see. It sharpens and rewards our senses. It is important for us to become conscious of what our senses tell us. We make choices based on sensory responses, yet we do not realize the basis of our choice.

Our awareness grows as we grow. As children we are taught what is good and bad—to reject some things and to accept others, thereby limiting our perception. We become prej-

udiced as we accept the standards and values of our culture and confuse them with objective experience.

We are guided in our perceptions by the people we emulate. We become aware to the degree that we are shown awareness by the awareness patterns of our relatives, teachers, and friends, and by the friendliness or hostility of our surroundings. We have to learn to use our senses. The eyes are blind to what the mind cannot see. As we mentally discover new possibilities of seeing, we increase our perception of the visual world.

In learning to cope with the world we have learned to conceptualize almost everything that we perceive. It is important to recognize that each of us has developed our own way of looking at the world. This perception is formed by the way our cultural group sees the world, and is often not the way the world actually is.

Every culture has a cognitive system that keeps it functioning. Yet major human problems are caused by the fact that almost every individual (and group) believes that his way of seeing things is the way things are.

"Looking" implies opening our eyes in a purely mechanical way, taking in what is before us in order to move about. "Seeing" is an extension of looking which leads to perceiving. In the world of process and function, a doorknob is something to be looked at in order to grasp and turn it, not something to be seen for itself. When we get excited about the bright clear quality of a winter day, the rich color of a sunset, or the shape and finish of a doorknob, we have gone beyond what we *need* to perceive and have enjoyed the perception itself.

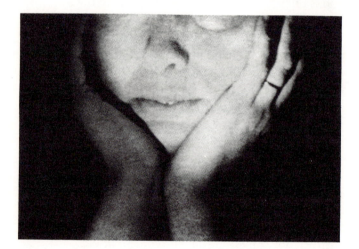

6

To see is itself a creative operation, requiring an effort. Everything that we see in our daily life is more or less distorted by acquired habits, and this is perhaps more evident in an age like ours when the cinema, posters, and magazines present us every day with a flood of ready-made images which are to the eye what prejudices are to the mind. The effort needed to see things without distortion takes something very like courage.

Henri Matisse[3]

The word "aesthetic" or "esthetic" was introduced into the English language to replace the phrase "sense of beauty" with a single word. As we become aware of common sensory-related decisions—aesthetic decisions—then we can begin to open up an entirely new world of sensory awareness. Ordinary things become extraordinary when seen in a new way. The opposite of aesthetic is anesthetic.

Most of us have limited ideas of what beauty is. Even so-called good taste is a limitation because it bypasses direct perception. We judge what is beautiful not so much by what we feel, but by what is commonly accepted as beautiful: flowers, sunsets, waterfalls, human form as defined by the fashion of the day, etc. We reject things that other cultures consider beautiful because they do not fit our mold.

We sometimes use the word "beauty" to refer to things that are simply pretty. Pretty means pleasant or attractive to the eye, whereas something beautiful has qualities of a high order capable of delighting the eye *and* the aesthetic, intellectual, or moral sense. "Beautiful doesn't necessarily mean good looking." (Louis Kahn.)[4]

Many people assume that the primary function of art is to please the senses. If this is true, then ugliness has no place in art.

Three artists from different times and places chose to push ugliness to its limits. Although the three works are similar in many ways, their similarities emphasize their differences. Each work is a unique expression, created from a particular point of view. They range in date from the eighth century to the twentieth.

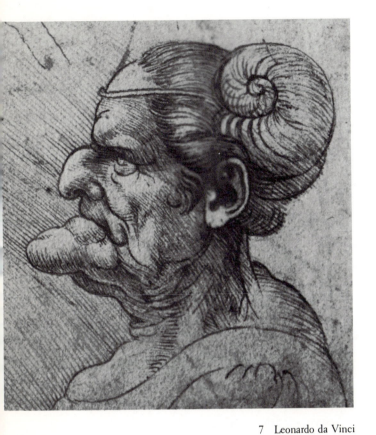

7 Leonardo da Vinci
CARICATURE
c. 1490. Detail. Pen and ink over red chalk.

8 CARICATURE FROM CEILING
OF HORYU-JI, NARA, JAPAN
8th century

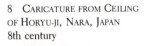

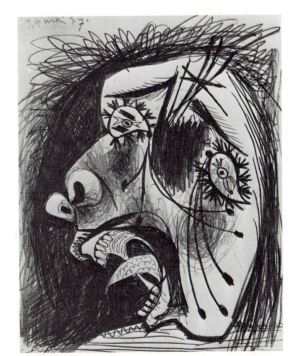

9 Pablo Picasso
HEAD (study for GUERNICA)
1937. Pencil and gouache.
11⅜ x 9¼". See illustration 280.

CREATIVITY

. . . a first-rate soup is more creative than a second-rate painting.

Abraham Maslow[5]

Imagination is more important than knowledge.

Albert Einstein[6]

Imagination is the source of creativity. It is impossible to think without mental images. The making of these mental images is called imagination. The process involves the ability to form images in one's mind that are not actually present to the senses and especially to combine images of former experiences, thus creating new images not known by experience.

Art is involved with the making of actual images or forms. In the visual arts these mental images are visual; in music they are audible.

We all possess the potential to be creative, but most of us have never been asked to be so. Yet creativity can be developed. We can deliberately seek new relationships between ourselves and our environment. To think of creativity as limited to those with "inborn talent" is a great mistake.

To be creative is to be able to put things together in original ways in order to produce new things of significance. Simply making things or doing is not enough. Nor is it enough to make something unique. Being creative is being able to bring into being new things of value.

There are as many ways to do this as there are creative people. The need or desire for a thing or condition not yet existing is certainly where the creative process begins. Formulation of the problem is probably as important as the solution.

An artist (or creative person) must be a dreamer, a realist, and a skilled workman. The creative process requires the ability to manipulate freely and consciously the elements of perceptual experience. This includes a dynamic process both of awareness and of action. Creative experience involves the open encounter of the person with the world.

What does it mean to be creative? Being creative includes the ability to:

- wonder, be curious
- be enthusiastic, spontaneous, and flexible
- be open to new experience, see the familiar from an unfamiliar point of view
- confront complexity and ambiguity with interest
- take advantage of accidental events in order to make desirable but unsought discoveries (called serendipity)
- make one thing out of another by shifting its functions
- generalize in order to see universal applications of ideas
- synthesize and integrate, find order in disorder
- be intensely conscious yet in touch with unconscious sources
- visualize or imagine new possibilities
- be analytical and critical
- know oneself, and have the courage to be oneself in the face of opposition
- be persistent, work hard for long periods in pursuit of a goal, without guaranteed results.

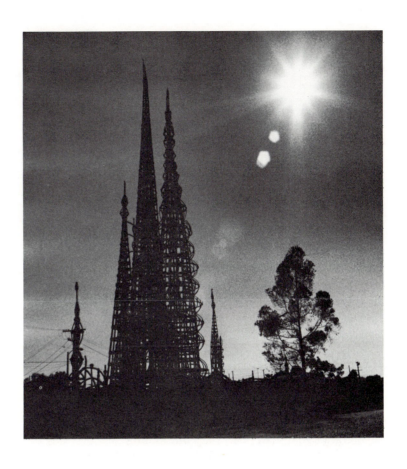

10 Simon Rodia
WATTS TOWERS

The ability to produce original ideas has little to do with measured intelligence. Although it is a fairly common ability in children, it is rare in adults. Sometimes it appears unexpectedly in adults who are able to either *stay in touch* with their imagination, or develop it.

The Watts Towers of California are the creative work of an Italian tile-setter named Simon Rodia. He worked for thirty-three years creating fantastic towers out of steel rods, mesh, and mortar. They grew from his tiny triangular backyard like Gothic spires. He lovingly covered their surfaces with bits and pieces of broken tile, melted bottle glass, and other colorful junk that he gathered from the vacant lots of the neighborhood where he lived.

I no have anybody help me out.
I was a poor man.
Had to do a little at a time.
Nobody helped me.
I think if I hire a man
he don't know what to do.
A million times
I don't know what to do myself.
I never had a single helper.
Some of the people say
what was he doing . . . some of the people
think I was crazy
and some people said
I was going to do something.
I wanted to do something
in the United States
because I was raised here you understand?
I wanted to do something for the United States
because there are nice people
in this country.

Simon Rodia[7]

Creative imagination is necessary not only to create things oneself, but also to fully enjoy the creations of others. What passes for complete education often promotes absorption and retention of information at the expense of creativity. Teachers often ignore and even attack evidence of creative imagination in their students because their own imaginations are underdeveloped and their classrooms are overcrowded.

Children's play often seems aimless and unproductive to adults, yet it is a most fertile activity for growth, particularly for the growth of imagination. As adults we seldom call our activity "play" even when our fooling around has no other goal than plain fun. But fooling around or "toying with possibilities" is a very important part of the creative process.

How we feel about all of this is important not only to our own lives, but also to the lives of our children. Is it too late for you to futher develop your own imagination? How can you help children who are influenced by you to develop their creative imaginations?

For all people, especially very young ones, mental and emotional growth depend on the ability to bring together experience of the world outside oneself with experience of the world felt within. Therefore, opportunities for creative expression are extremely important to us. Art helps a child (and a mature person) discover his world and relate himself to it. Until we are able to express our feelings and experiences, we do not really know what they are. By expressing them we objectify them. We take them out and look at them. This process provides for the integration of personal experience and the apprehension of reality. It allows us to meet the world with more self-assurance.

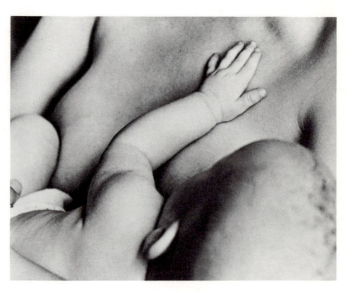

11 Wayne Miller. MOTHER AND BABY. 1948.

Most of the abilities listed as being characteristic of creative people are found in all children during the first few years of life. What happens to this extraordinary capacity? John Holt, author of HOW CHILDREN FAIL, answers:

. . . We destroy this capacity above all by making them afraid—afraid of not doing what other people want, of not pleasing, or of making mistakes, of failing, of being wrong. Thus we make them afraid to gamble, afraid to experiment, afraid to try the difficult and unknown.[8]

Children naturally reach out to the world around them from birth. They taste, touch, hear, see, and smell their environment, becoming part of it through their senses.

All forms of expressive communication are part of that reaching out. When a child is confronted with an experience that indicates to him that his experiment was of questionable value, he soon stops reaching so far.

12 This bird shows one
child's expression
before exposure
to coloring books.

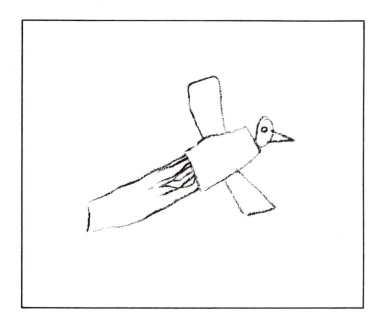

When our own limitations, prejudices, and fears are passed on to children through stereotyped projects such as workbooks and coloring books, the results can be disastrous, and we rarely notice. The accompanying sequence tells the story.

seven birds

Color seven birds blue.

Then the child had to color a workbook illustration.

After coloring the workbook birds,
the child lost creative
sensitivity and self-reliance.

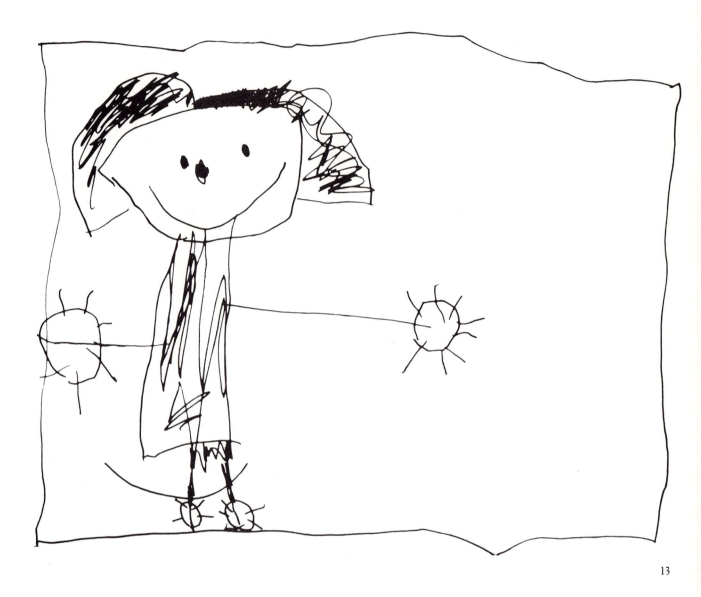

13

Children in the past had few toys. What toys they had were often simple. As the child played, the toy was able to fill almost any role invented for it. Can this be said of the machine-made replicas of stereotyped people and things that children are given to play with today? These toys, along with coloring books, regimented school "art projects," and uncontrolled television watching, act as a giant wet blanket on the developing imaginations of the young.

It is important to provide children with the opportunity to give their ideas and emotions an honest, tangible expression. Children, and adults even more, need a great deal of encouragement to be able to express themselves without fear or hesitation.

A four-year-old girl did this self-portrait. A line around the edge shows an awareness of the whole paper. One hand with radiating fingers reaches out, balancing the composition perfectly. This was accomplished spontaneously after much previous experience, but without any adult guidance or conscious knowledge of design.

14

At age four or five, children try to draw things they have experienced. This series of drawings shows a four-year-old's attempts to draw an elephant soon after seeing his first circus. He began with the most characteristic part of the elephant—the trunk. The child was dissatisfied with the results, but kept trying. Finally, he came pretty close to what he wanted to see. He then turned the drawing over, and drew a circus with an elephant, lion, juggler, and tightrope walker. This scene was so real for him that he asked his father to write down the story as he told about his picture.

There is an international language of expression formed by children's art. These pictures from many parts of the world have the same basic visual vocabulary.

15

Bali

Switzerland

India

Indonesia

Ceylon

United States

Typical motifs recur in children's art through-out the world, but their uses and variations are infinite. With bold colors this child gave us a sun, a tree, and much more.

We all were children once and as children many of us were discouraged by negative experiences with so-called art. These discouragements were felt before we reached an age when we could draw complex pictures from our personal experience.

It is important that the ten-year-old boy who did the drawing below was working with a subject that he knew well. It is also important that he had gained the self-confidence to draw what he knew.

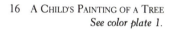

16 A Child's Painting of a Tree
See color plate 1.

17 Drawing by a
Ten-year-old Child

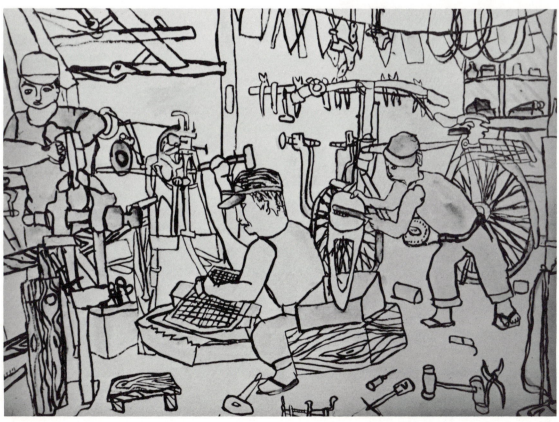

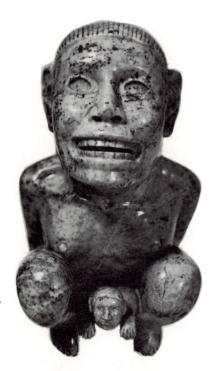

18 TLAZOLTÉOTL.
Aztec Goddess of
Childbirth.
c.1500. Aplite.
Height 8⅛".

DISCOVERY AND EXPRESSION

The artist's purpose is not merely to imitate nature, but to do what nature does, that is, to create "life"—to invent something that "works"—to express an inner reality discovered beneath the shifting impressions of everyday life. A work of art is a unique event fashioned out of the personal experience of the individual who creates it. This is true even when the style of art is strictly controlled by forces of the society within which the artist works, as in ancient Egypt.

To understand what art is and how it grows from and contributes to experience, it is revealing to examine a series of works with the same subject.

In this series, the universal relationship between mother and child is expressed by artists far apart in time and location. They show how varied images of the same subject can each be a valid symbolic expression of the ideals and the experiences of the artist and his culture.

It would seem that the most important event related to the mother and child theme is birth itself, yet our culture has long avoided depicting it.

The Aztec sculptor who carved this image of birth gave powerful form to essential aspects of the process of giving birth as it was practiced by that culture. The artist has simplified the image, exaggerating some parts and underplaying or omitting others. By so doing the artist has created a symbol of great impact based on a consistently bold abstraction of human anatomy.

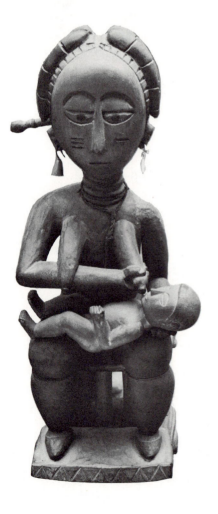

19 Detail of AFRICAN SCULPTURE. Ashanti, Ghana, c. 19th century. Height 31". Photograph: Eliott Elisofon.

The painted Byzantine Madonna and Child is at least as abstract as the Ashanti figure or the Aztec goddess, and perhaps more removed from natural appearances. As a depiction of mother and child, it feels much more remote than the preceding painting by a child. The Byzantine style is a successful compromise between the desire to avoid worshiping graven images and the need to educate the illiterate through pictures. The highly stylized figures of Mary and Christ emerge from a throne symbolizing the Roman Colosseum, where the early Christians met death for their beliefs. The entire image appears flat and richly decorative, emphasizing spiritual rather than physical concerns. The cloth covering the figures has been indicated by linear patterns, with scarcely a hint of three-dimensional form. This is certainly not the image of an ordinary mother and child. Christ appears as a wise little man, supported on the lap of a heavenly, supernatural mother.

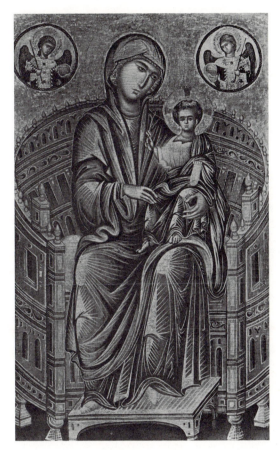

20 ENTHRONED MADONNA AND CHILD
1200. Byzantine School.
Tempera on wood. 32⅛ x 19⅜".

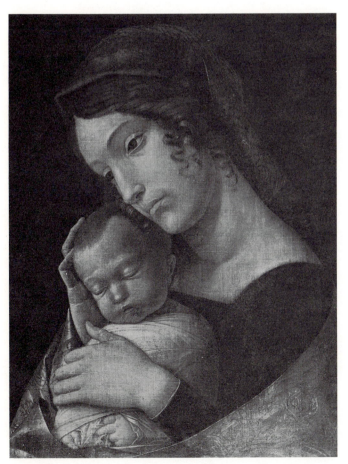

21 Andrea Mantegna. THE MADONNA AND CHILD. c. 1445. Tempera.

By the fifteenth century attitudes had changed. Even so, Mantegna painted a picture of the Madonna that must have been a real surprise to his contemporaries. Here is a quite natural image of a real mother and child. If it were not for the title, we would have no clue that this tender scene is meant to be Christ and his mother.

The Madonna is now a humble, accessible woman no longer enthroned. Christ is a sleeping infant with no suggestion of his future. Only Mary's introspective gaze suggests that there is more to come. The painting is a universal statement of the mother-child relationship, apart from its Christian subject matter.

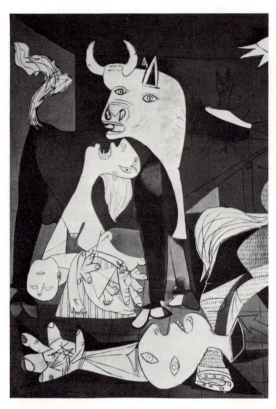

22 Pablo Picasso
Detail of GUERNICA
1937. Oil on canvas. See pages 210–211.

Picasso's drawing below has much in common with the tempera painting by Mantegna. The drawing is a study for a painting of a circus family. Picasso tried several times to capture exactly the right gesture of tenderness in the hands of the mother as she holds the baby. The relationship of love expressed between the figures is emphasized by the child's upreaching arm and by the mother's bent head and hanging hair bringing us back around to the child. Picasso modified anatomy in order to strengthen his idea.

Compare the elegant calm of this mother and child with the brutal anguish of the mother holding her dead child in Picasso's painting GUERNICA and you will see the breadth of his visual expression.

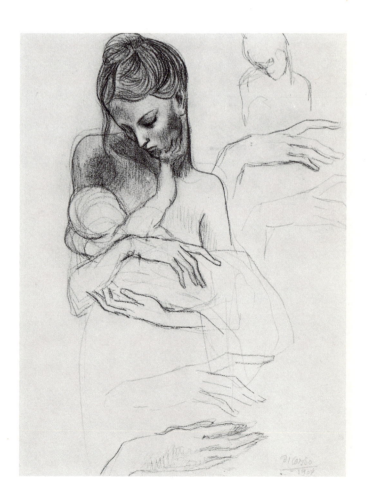

23 Pablo Picasso
A MOTHER HOLDING A CHILD AND
FOUR STUDIES OF HER RIGHT HAND.
1904. Crayon. 13½ x 10½".

Elliott Erwitt's photograph is taken by an artist who called upon all of his skill and intuition to capture this image from the flow of visual material around him. A mechanical device much more complex than the brush has made it possible to create a fully natural image defined by light, convincing us that we are there experiencing this intimate event, as he was.

We can see from the quality of the photograph that Erwitt had empathy with his subject. In art this is the rule rather than the exception. The creation of a work of art demands close contact with one's materials. Subject matter, media, and the language of visual form are the materials of the artist. A great deal can be learned by studying an artist's feeling for these interacting factors.

24 Elliott Erwitt. MOTHER AND CHILD. 1956.

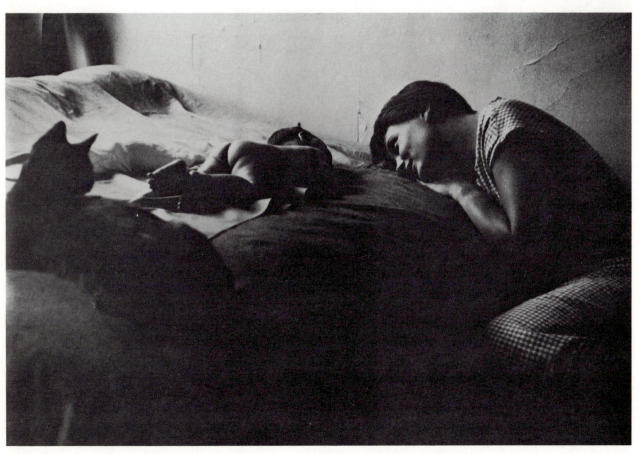

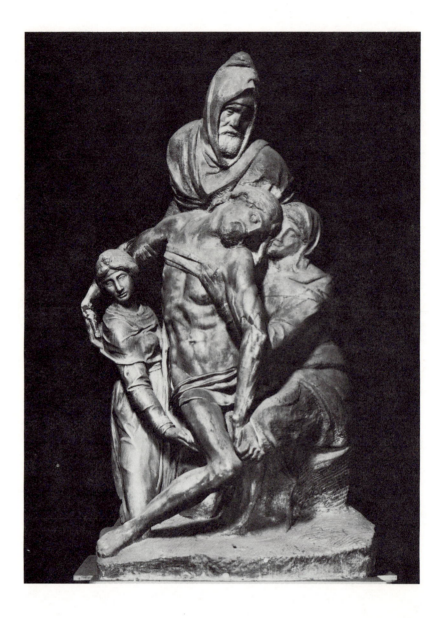

25 Michelangelo Buonarroti
DEPOSITION FROM THE CROSS
Left unfinished, 1555. Marble.
Height 7′5″.

One of Michelangelo's last works was his DE-POSITION FROM THE CROSS, left unfinished at his death. Christ's body has been taken down from the cross and is supported by Mary, Mary Magdalen, and Joseph of Arimathea, as they lay the body to rest in the tomb that Joseph of Arimathea had prepared for himself.

The axis of Christ's centrally located figure is a sagging vertical, barely held up by the smaller figures of the two Marys on either side. The group seems bound together by the hooded figure of Joseph of Arimathea appearing be-hind Christ. Not only is this the key supporting

figure in a dramatic sense, but it also reflects the father of the sculpture—Joseph's face is Michelangelo's. As a self-portrait this figure shows Michelangelo's intimate identity with his subject.

With this sculpture we begin a series of self-portraits. Only a few of them are self-portraits in which the artist puts primary emphasis on recording his own face. All of these works show clearly each artist's involvement with the rela-tionships between himself, his work, and the world at large.

Velázquez painted himself at work on the large canvas originally called THE ROYAL FAMILY, now known as THE MAIDS OF HONOR or LAS MENINAS. The Infanta Marguerita, the blond daughter of the king, is the center of interest. Velázquez emphasized her by making her figure the clearest, lightest shape and by placing her near the foreground close to the center. Around her Velázquez has created the appearance of his large studio, in which a complex group of figures interact with the princess and with the viewer. The interaction between ourselves and the subject could keep us interested indefinitely. As the king and queen viewed this work they saw themselves as painted reflections in the mirror on the far wall. As we view it today, we see it as if we were in the mirror ourselves. By masterfully controlling the light, color, and placement in space of everything in the room, Velázquez has led us through a very intricate composition. He has placed himself discreetly in semishadow. Showing himself brush in hand, his image acts as a kind of signature to the work.

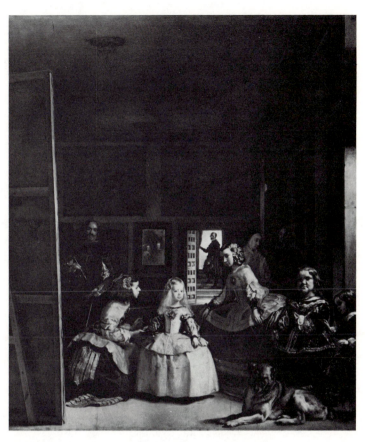

26 Diego Rodrigues de Silva Velázquez.
THE MAIDS OF HONOR. 1656. 18 x 15¾'.

27 Rembrandt van Rijn.
SELF-PORTRAIT IN A CAP, OPEN MOUTHED AND STARING.
1630. Etching. 2″ x 1⅞″.

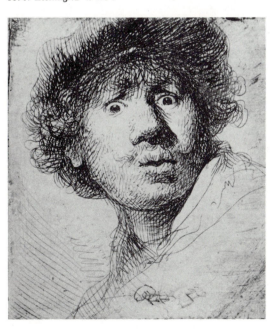

In contrast to Velázquez, Rembrandt's etching is simple and direct. It captures a fleeting expression of intense surprise. In this etching, Rembrandt faced his mirror directly, in order to study the expressive qualities of the human face.

Like his later countryman van Gogh, he produced many self-portraits. Most of the time Rembrandt seemed to look upon himself as a stranger or an actor, but with the same penetrating insight and depth of feeling that he brought to all his human subjects.

Another self-portrait that reveals great insight is Jan Vermeer's THE ARTIST IN HIS STUDIO. Like Velázquez, Vermeer painted himself at work, but here there is no royal portrait in progress. Our eyes move immediately past the heavy curtain to the strong black and white contrast on the back of Vermeer's shirt. We find ourselves looking with him at his painting on the easel and beyond that to the model. The model is posing as an allegorical figure who may represent fame. She is only mildly interesting; she seems like a prop and acts as a neutral pivotal point. The painting is a complete self-portrait, although we cannot see Vermeer's face. He is showing us himself in his studio. But much more important than the physical circumstances is the way in which they are presented. His way. Although it looks as though we came upon this situation by chance, every relationship in this painting was carefully selected by Vermeer. As in the work of Velázquez, light and placement play very important roles. For Vermeer, directional light was a major element defining exactly the character of each thing he observed.

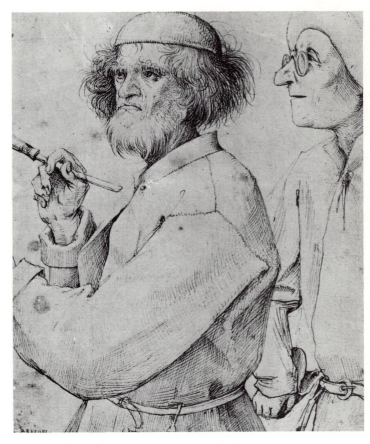

28 Pieter Brueghel
THE PAINTER AND THE CONNOISSEUR
c. 1568. Pen and bistre. 10 x 8⅜".

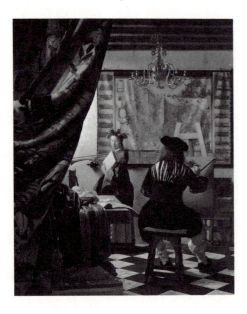

Again, we are looking over the artist's shoulder in Brueghel's drawing THE PAINTER AND THE CONNOISSEUR. Or are we? Maybe we do not wish to be identified with the connoisseur. Of course, since Brueghel and not the connoisseur did the drawing, he gives us the whole story from the artist's point of view. The drawing has been done in such a way that if we identify with anyone here, it is with Brueghel.

29 Jan Vermeer
THE ARTIST IN HIS STUDIO
c. 1665. Oil on canvas. 31⅜ x 26".
See color plate 2.

If we look at more than one work of a given artist, we soon begin to discover the point of view that is the basis of his personal expression. Of course this can change and often does. As point of view changes, style changes.

Each one of us has a particular point of view that we have developed from past experience. This point of view or attitude determines how we experience the world around us, and also what we experience.

In every work of art, the artist creates form out of his own experience. In doing this he is saying, "Here I am. I exist. This is what is important to me. This is how I see life." In this sense every work of art is a self-portrait. In another sense even a representational self-portrait is not merely a self-image, but is also an attempt to give a personal experience universal significance. As art contributes to the expanding consciousness of the artist and his audience, it creates man.

The works of the following three artists demonstrate this. Although they lived during approximately the same time, they come from different countries and hold very different attitudes. They are each primarily interested in human beings, and, therefore, the human figure is their most frequent subject.

In 1908, Henri Matisse wrote the following statement about his work:

The purpose of a painter must not be conceived as separate from his pictorial means, and these pictorial means must be the more complete (I do not mean complicated) the deeper is his thought. I am unable to distinguish between the feeling I have for life and my way of expressing it.[9]

Matisse wrote these words a few years before he painted NASTURTIUMS AND THE DANCE. The work illustrates his point. In the painting of a corner of his studio he shows a chair, a sculpture stand topped by a vase of flowers, and against the wall a section of his large painting called THE DANCE. Here Matisse expresses

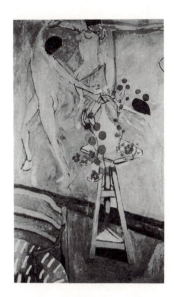

30 Henri Matisse
NASTURTIUMS AND THE DANCE
1912. Oil on canvas. 75¾ x 45".
See color plate 3.

what the French call *la joie de vivre* or "the joy of life." Every line, shape, and color radiates with it. And this is true of most of his work.

The human figure had a particular importance for Matisse. He said:

What interests me most is neither still life nor landscape but the human figure. It is through it that I best succeed in expressing the nearly religious feeling that I have towards life.[10]

Matisse was a great master of the first half of our century. Although during his lifetime (1869–1954) there was much human suffering in the world, he chose to emphasize happier themes.

In the article published Christmas Day 1908 quoted above, Matisse states his purpose as a painter:

What I dream of is an art of balance, of purity and serenity, devoid of troubling or depressing subject matter, an art which might be for every mental worker, be he businessman or writer, like an appeasing influence, like a mental soother, something like a good armchair in which to rest from physical fatigue.[11]

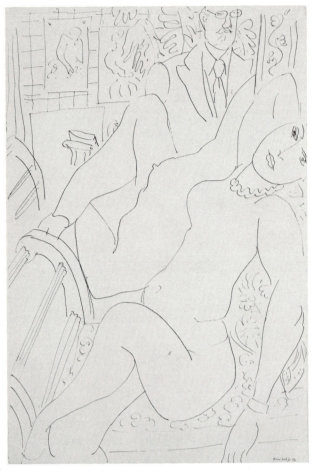

In this free and sensuous drawing, Matisse appears in a mirror along with the reflected back view of his model. His image acts as an effective point of contrast with the model, and appears, as in other works that we have seen, to remind us that the expressive lines exist because of him. There is no chance that we might confuse this with an anonymous reflection of reality. It is an extension of Matisse.

The third and fourth works by the master were cut from paper when Matisse was an invalid two years before his death. His feeling for life comes across as strongly as ever. These late works of Matisse are some of his most powerfully decorative and lifelike. Underlying Matisse's work is a profound and particular kind of expression. He would not let his works rest until they had achieved a balance of repose and personal intensity.

31 Henri Matisse
ARTIST AND MODEL REFLECTED IN A MIRROR
1937. Pen and ink. 24⅛ x 16¹/₆″.

32 Henri Hatisse
BLUE NUDE III
AND BLUE NUDE IV.
1952. Gouache cutout.
105 x 85 cm., 109 x 74 cm.

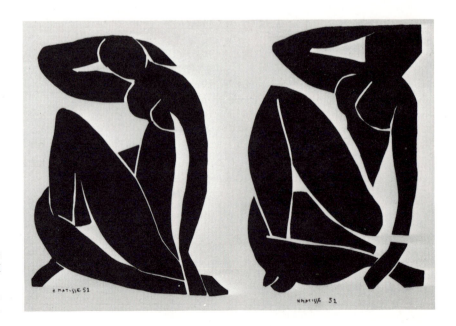

Color plate 1 A CHILD'S PAINTING OF A TREE. Gouache. 9¾ x 14⁵/₁₆″.

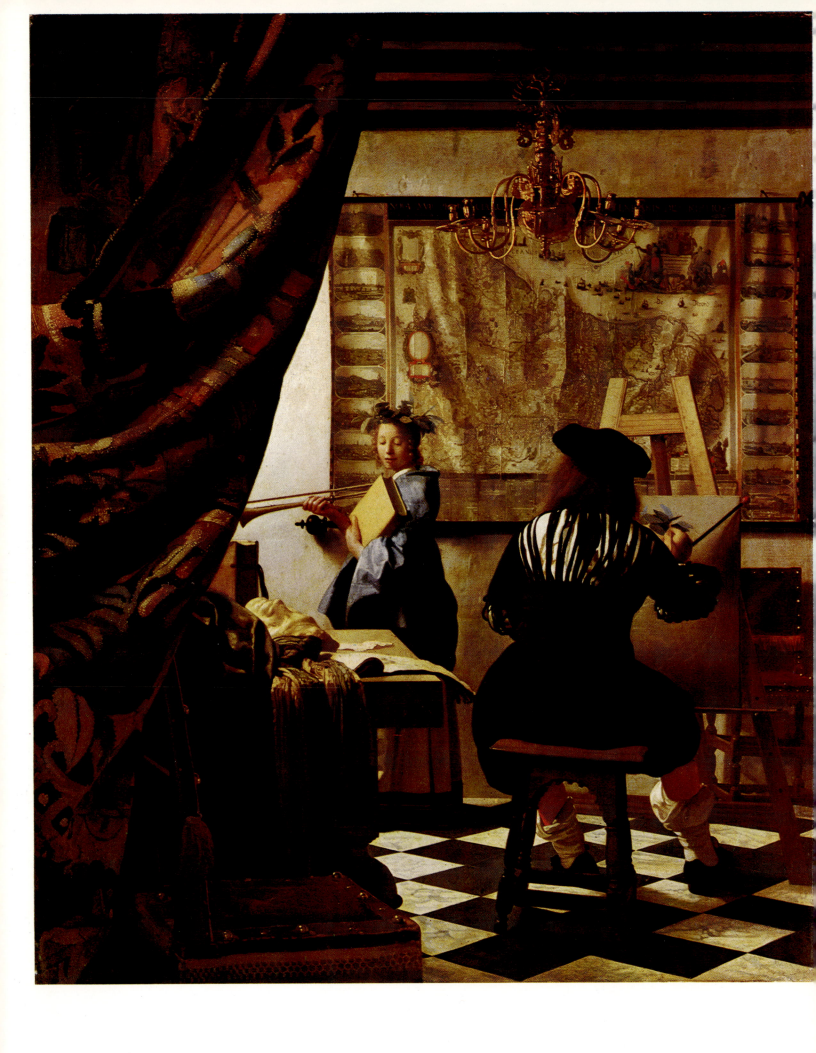

Color plate 2 Jan Vermeer. THE ARTIST IN HIS STUDIO. c. 1665. Oil on canvas. 31⅜ x 26″.

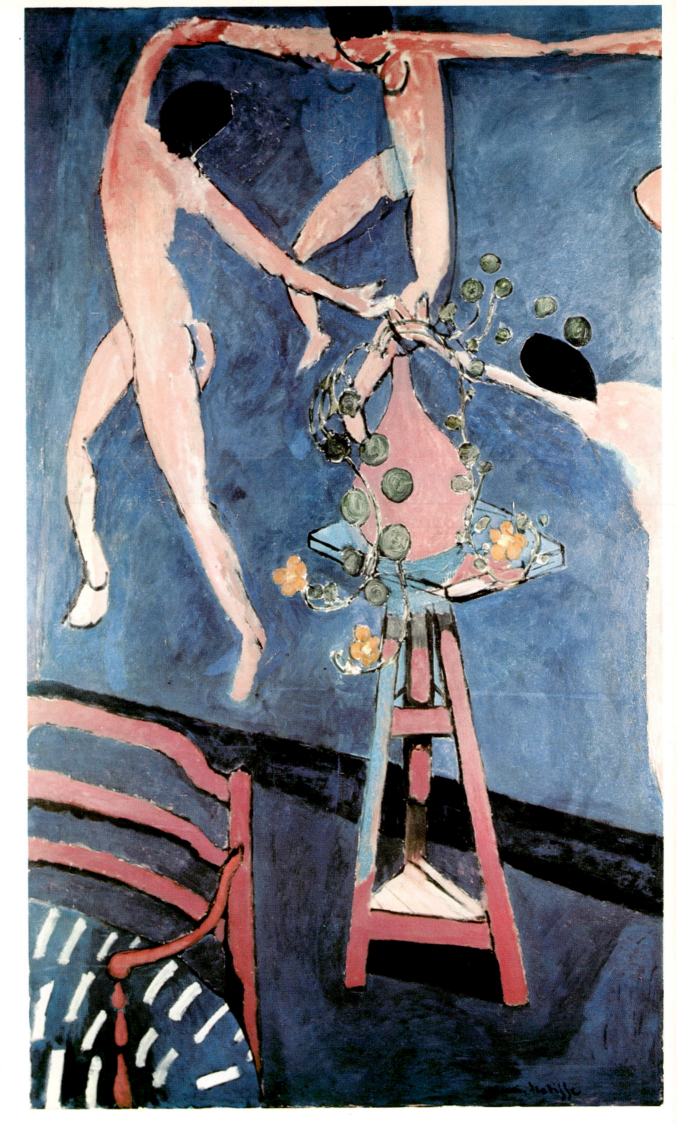

Color plate 3
Henri Matisse
NASTURTIUMS AND THE
DANCE. 1912. Oil on
canvas. 75¾ x 45".

The photographer Werner Bischof had a very broad contact with life. It is clear from his photographs that he also had great compassion for all he saw of human life. His photograph of a starving mother and her child, taken in India in 1951, is one of the most heart-rending ever taken. By coming close to his subject at a low angle, he was able to bring together the pleading hand and face of the mother. The gaze of the child brings the composition back to us.

35 Werner Bischof
HUNGER IN INDIA
1951

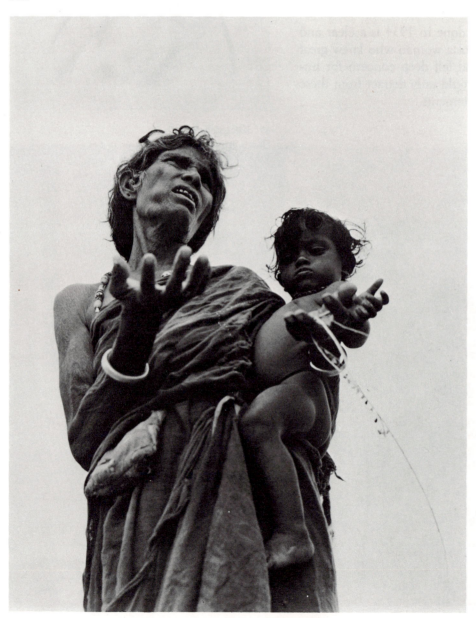

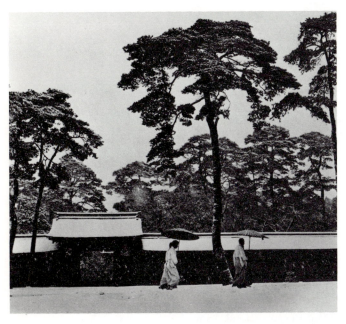

36 Werner Bischof
SHINTO PRIESTS IN TEMPLE GARDEN
Meiji Temple, Tokyo, 1951

In the same year, Bischof photographed Shinto priests walking through falling snow in a temple garden. By carefully selecting his distance from the figures, he shows their relationship to the trees, thus recording a classic image of a basic Asian attitude toward man in nature.

One of Bischof's last photographs was of a lone flute player in Peru. The lilting steps of the boy with his flute are captured with great lyric charm. A feeling for form, as well as a deep human understanding, made him able to protest or affirm the human condition by visually saying NO! or YES!

By discovering his own responses to life, the artist is able to give of himself so deeply that it is no longer just himself he is giving. The expressions of his experience become universal and therefore valuable and accessible to all.

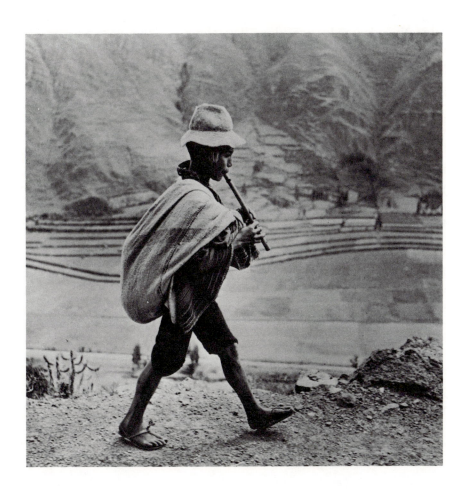

37 Werner Bischof
LONE FLUTE PLAYER
Peru, 1954

2

What do we respond to in a work of art?

VISUAL COMMUNICATION

Verbal language consists of agreed upon meanings connected to certain sounds that are learned through continuous repetition. Verbal language is highly abstract; it is not representational. Word symbols, in most cases, have no connection to the things to which they refer other than learned association. Therefore, when repetition stops verbal language is soon forgotten.

The world brought to us by our senses has meaning for us apart from formal language. When we speak of a "language of sound" or a "language of vision" we are referring to the elements and groupings of audible or visual phenomena to which humans react in generally similar ways. There are common human responses to much sensory experience. However, there are no visual or auditory languages based on specific, agreed-upon meanings apart from verbal languages. With the help of words we can analyze and therefore better understand the ways in which artists work with the elements of visual form in order to communicate certain meanings.

The basis of the visual arts is visual form. Artists and their audiences are conscious of their own responses to visual things. They are visually literate in that sense. Although we live at a time when there is great emphasis on visual images, many of us are still visually illiterate.

The first step toward becoming visually literate is to open up enough to realize what our senses are telling us. Enjoying the visual arts requires the ability to see, yet, as we have observed, few of us are given the chance to develop this ability.

Art is a form of communication. The artist interacts with his audience by way of the form he gives to his work. The artist is the source or sender. The work is the medium carrying the message. We must be receivers if the communication is to be complete.

Visual forms, like audible sounds, evoke responses in us whether they represent subjects or not. Many people are concerned more with subject than with form. Subject seems easier to identify with and therefore less demanding. But subject is a minor element in most of the arts. Without significant form subject is irrelevant.

An aim of this book is to help you arrive at the point where you do not need subject matter or verbal interpretation to recognize your own responses to visual form.

We humans are more than a collection of nameable parts. Each one of us is much more than all nameable things about us—our names, our physical appearance, and our accumulated knowledge and experience are all considerably less important than the total configuration, which is *you*, which is *me*. We are

alive, unique, and valuable beings because of the total working relationship among all aspects of each of us. This is similar to the working relationship established within a form worth being called a work of art.

There is much in common in being able to perceive and being able to create significant relationships. We experience the world in terms of relationships. Artists try to heighten the significance of these relationships. The elements of form within a work of art interact to create the relationships that give the work its effectiveness. In this way each of the visual elements becomes an aspect of a single form, which has a "life" of its own.

Clearly it takes action to put a work of art together. It is not so clear that appreciation is an act.

Most people mistakenly think that when they hear a piece of music, that they're not doing anything, but that something is being done to them. Now this is not true, and we must arrange our music and our art so that people realize that they themselves are doing it, and not something is being done to them.

John Cage[1]

FORM AND CONTENT

We guide our actions by reading the form and content of the people, things, and events that make up our environment. Form in its broadest meaning refers to the sum total of all perceivable characteristics of any given thing or situation. Content is the cause, the meaning, the life within the outer form. Content determines the form and is expressed by it. The two are inseparable. All form has some content and any content must have form.

When we see faces of people we do not know, we automatically draw conclusions about them from the way they look. If we have seen them before they will probably look familiar. This is an example of our amazing ability to memorize certain visual configurations that are important to us.

As we live, we compile a vast file of information on faces in our memories. From this we make judgments about the character of the people we see. Sometimes our judgments are wrong. But we cannot and should not stop making them for that reason. Rightly or wrongly, we feel that the form of a face gives us a clue to the content of that person.

Faces are loaded with meaning for us. Many other observations are not significant in the same way. Each face, like each seeable form, exists to express itself—to be seen for itself. And each form is part of the continuity of visible and invisible phenomena that make up our environment.

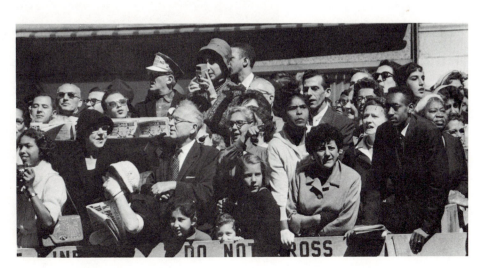

38 Charles Harbutt.
SPECTATORS. 1959.

Clouds, torsos, shells, peppers, trees, rock, smokestacks are but interdependent, interrelated parts of a whole, which is life.—Life rhythms felt in no matter what, become symbols of the whole.

Edward Weston, April 24, 1930[2]

Is Edward Weston's photograph of a green pepper meaningful to us because we like peppers so much? I think not. Weston has been able to create meaningful form on a flat surface with the help of a pepper. It is his sense of form that tells us how deeply he has experienced this pepper.

By exercising critical selection every step of the way, Weston finally achieved his goal of significant presentation of the thing itself. Weston felt strongly that he wanted to present, rather than interpret, the many natural objects he was working with at the time. He wanted to record his feeling for life as he saw it in the sheer aesthetic form of his subjects. In doing so he revealed with clarity and intensity what was there all along.

August 8, 1930

I could wait no longer to print them—my new peppers, so I put aside several orders, and yesterday afternoon had an exciting time with seven new negatives.

First I printed my favorite, the one made last Saturday, August 2, just as the light was failing—quickly made, but with a week's previous effort back of my immediate, unhesitating decision. A week?—yes, on this certain pepper—but twenty years of effort, starting with a youth on a farm in Michigan, armed with a No. 2 Bull's Eye Kodak, 3½ x 3½, have gone into the making of this pepper, which I consider a peak of achievement.

It is classic, completely satisfying,—a pepper—but more than a pepper. . . .[3]

39 Edward Weston. PEPPER #30. 1930.

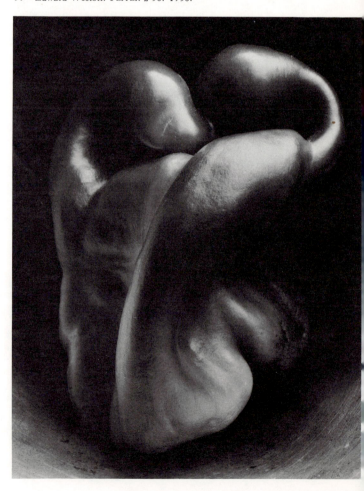

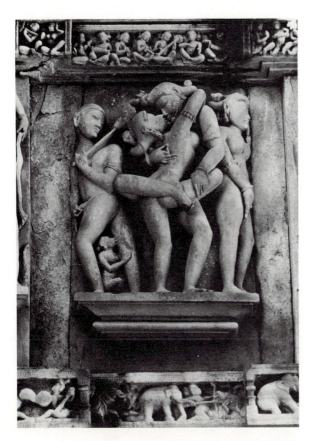

40 SCENE FROM KANDARYA TEMPLE,
 Mahadevā, India. c. 1000.

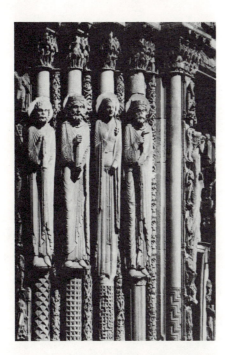

41 SAINTS AND ROYAL PERSONAGES. Facade of West
 Portal, Notre Dame de Chartres,
 Chartres, France, c. 1145–1170.

The temple carvings shown here were made by two anonymous sculptors, one Hindu, the other Christian.

The scene from Kandarya Mahadevā Temple in India seems to tell the worshiper that heaven or union with God is full of a kind of joy that is symbolically expressed by the physical pleasure depicted here. The natural beauty of the human figure is heightened by the symbolic exaggeration of maleness and femaleness. Fullness seems to come from within the rounded forms, heightening the sense of physical presence.

The saints and royal personages from the west portal of Chartres Cathedral are symbolic portraits of real individuals. They bid us to heaven by a very different route. Their tall, thin figures call our attention to spiritual concerns by a denial of the physical body. The human figure is scarcely suggested by the elegant vertical forms. A faint smile on the woman's face suggests inner peace.

These sculpted figures echo the cylindrical columns behind them, making a fine blend between architecture and sculpture. The figures from Chartres stand before their columns almost completely detached. Their gentle human heads show an early medieval move toward naturalism.

In spite of the great differences in form and content between the Hindu and Christian sculptures, their basic purposes are similar. They relate to an idea expressed in A.D. 1200 by Abbot Suger, the man responsible for starting the Gothic style of architecture in France. Suger believed that we could only come to understand God through the effect of beautiful things on our senses. He said, "The dull mind rises to truth through that which is material."[4]

In the seventeenth century, two imperial villas were constructed on opposite sides of the world. Both were surrounded by extensive gardens.

The supremacy of the French Sun King, Louis XIV, was symbolized by the elaborate architecture and gardens of Versailles. The king's authority, as suggested by the architecture, is projected outward across the landscape in vast, formal gardens. Louis XIV organized nature in this way as a grand gesture of his power.

The other imperial villa is Katsura, the Japanese palace near Kyoto. It was built under the direction of Prince Toshihito, and combines land, water, rocks, and plants in an irregular flow between man-made and natural objects. The walls are sliding screens which can be opened to allow interior and exterior space to blend.

When Katsura was constructed, the imperial family did not have much political power. The palace was a retreat, expressing the simplicity of tea taste in architecture.

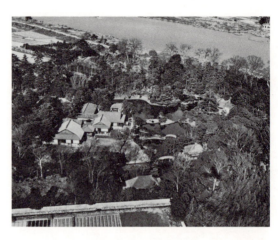

42a AERIAL VIEW OF KATSURA. 17th century.

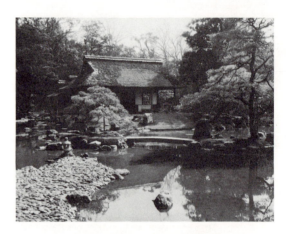

42b GARDENS AND
TEA HOUSE
AT KATSURA.

43 AERIAL VIEW OF VERSAILLES, France. 1624–1708.

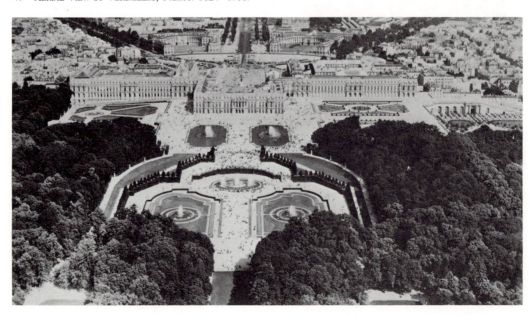

VISUAL ELEMENTS

Visual experience is one flow of complex inter-relationships. However, in order to discuss visual form, it will be necessary to recognize the potential of the various elements and their interactions. The number of elements and the terms used to identify them vary considerably among artists and teachers. We speak of them separately, but actually they are largely insep-arable. It is impossible to equate visual form with words. The words used here to designate visual elements are merely tools for discussing form: light, color, value, mass, space, time, motion, shape, texture, and line. They repre-sent an attempt to translate visual form into verbal symbols.

As we begin to analyze works of art, you may feel that the process is killing the art itself. Since works of art are not biologically alive, they have a good chance of getting back to-gether again visually—hopefully freshly per-ceived and enjoyed more than before they were taken apart.

It is important to remember that we are looking at *reproductions* of works of art, although they are being discussed as if they were originals.

There is a great difference between an actual work and a reproduction. Sometimes a repro-duction looks better than the original. A good color slide of a painting projected on a screen in a totally dark room will usually have more color brilliance than the original painting. Photographic reproductions of three-dimensional works, such as pieces of sculpture or buildings, become mere shadows of the orig-inals when they are reduced to two dimen-sions. Since actual motion cannot be repro-duced in a book, the presentation of kinetic sculpture and film must be superficial. Almost all works suffer when they are reproduced photographically because they lose the quality of the material from which they were made.

LIGHT

Light is a form of radiant energy. White light, as is found in the sun, contains all the light colors which make up the visible spectrum of the electromagnetic field. (See chart, page 40.) The visual world is defined by light. The source, color, intensity, and character of light determine the way things appear. Light reveals three-dimensional surfaces. As light changes, things that are illuminated seem to change, often dramatically, as is seen in the photo-graphs of the head of the sculpture of Lincoln.

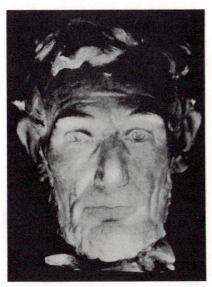

44a

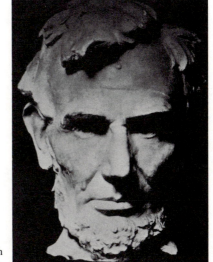

44b Daniel Chester French
Detail of ABRAHAM LINCOLN

When the monumental figure was first installed in the Lincoln Memorial in Washington D.C., the sculptor, Daniel Chester French, was disturbed by the lighting. The entire character of his figure was changed from the way he had conceived it because the dominant light falling on the figure came at a low angle through the open doorway of the memorial. Finally this was corrected by placing artificial lights in the ceiling above the figure that were stronger than the natural light coming through the doorway. Light alone had completely changed the character of Lincoln's sculpted face and, therefore, the viewer's whole concept of the man.

We are beginning to pay more attention to the kind of interior and exterior environmental light that we live with daily. Color, direction, quantity, and intensity of light have major effects on our moods. California architect Vincent Palmer has experimented with the effect on people of changes in the hue and intensity of interior light. He has found that he can modify the behavior of his guests by changing the light around them. Light quality changes the volume and intensity of their conversation and even the length of their visit.

Light is a key factor in photography, cinematography, television, stage design, architecture and interior design. As our awareness of light's potential has increased, light artists have become more in demand. At first, lighting designers were primarily technicians or engineers. Now, that is not enough. The light artist uses his material with the subtlety that the painter can bring to paint. (See page 227.)

VALUE

Value refers to the relative lightness and darkness of surfaces. The amount of light reflected from a surface determines its luminosity. The value range extends from white to black. Subtle relationships between light and dark areas determine how things look. In a picture value relates one area to another. Gradations of value can make things appear to have volume.

The value scale shows that we perceive *relationships*, not isolated forms. The grey circles are identical, yet they appear quite different depending on their relationship to the value of the background.

45 VALUE SCALE

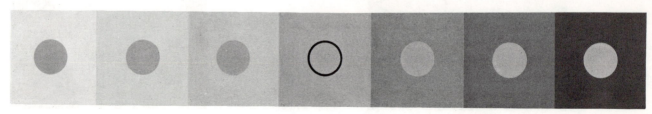

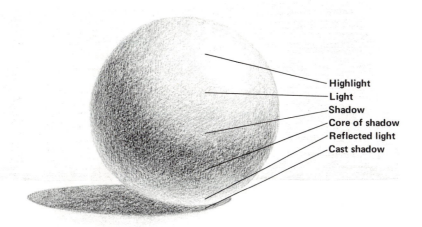

Highlight
Light
Shadow
Core of shadow
Reflected light
Cast shadow

46 SPHERE ILLUSTRATING LIGHT AND DARK SYSTEM

47 Pierre-Paul Prud'hon
STUDY OF A FEMALE NUDE
c. 1814. Black and white
chalk on blue-gray paper.
28 x 22 cm.

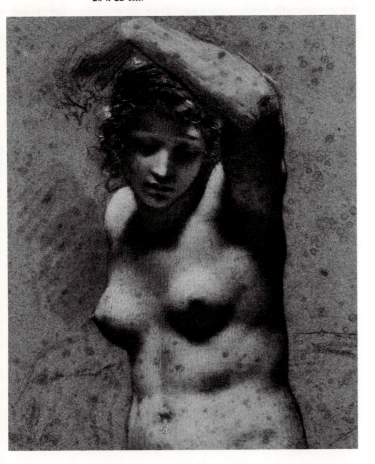

This drawing of light falling on a sphere illustrates how a curved surface is defined by light and shade. Gradations of light and dark that give the effect of roundness are called *chiar-*

oscuro. This word means light and dark, from the Italian *chiaro* (light) and *oscuro* (dark), and relates to the English words "clear" and "obscure."

Prud'hon gives the illusion of roundness to his figure by using black and white chalk on a middle-value blue-grey paper. Because the paper is a value halfway between white and black, he is able to let it act as a connective value between the highlights and shadows. If you follow the form of this figure you will see how it appears first as a light against a darker background (as in the right shoulder) and then as a dark against a lighter area (as in the under part of the breast on the same side). The background stays the same, appearing first dark, then light.

Look around you and you will see that all objects become visible in this way. Sometimes, as in the area between the shoulder and the breast on this figure, the edge of an object will disappear when its value at that point becomes the same as the value behind it, and the two surfaces merge into one.

Usually we do not see this because our minds fill in the blanks from experience. We *know* the form is continuous, so we see it as continuous.

Compositions in which forms are determined
by the effect of highlights and shadows rather
than by sharp outlines are based on chiar-
oscuro. This technique makes it possible to
create the illusion that the objects depicted on
flat surface are three-dimensional and free-
standing.

Strong value contrast emphasizes the dramatic
content of Zurbarán's ST. SERAPION. In simple
compositional terms, the major visual element
is a light rectangle against a dark background.
Light and dark qualities are powerful elements
in any design.

Minimal value contrast is seen in Malevich's
WHITE ON WHITE. The simplicity of
Malevich's minimal painting allows us to ex-
perience the tight relationship of one white
square to another.

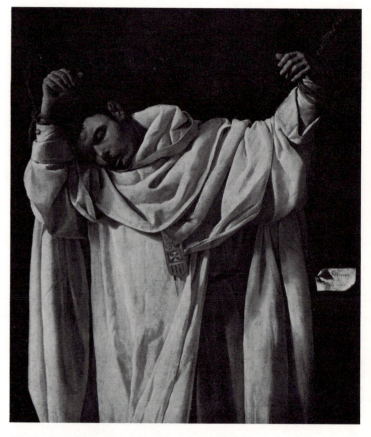

48 Francisco de Zurbarán. ST. SERAPION
1628. Oil on canvas. 47½ x 40¾".

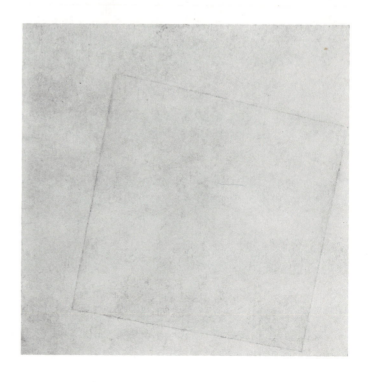

49 Kasimir Malevich
SUPREMATIST COMPOSITION: WHITE ON WHITE
c. 1918. Oil on canvas. 31¼ x 31¼".

COLOR

Color is an aspect of light. Color affects our emotions directly, modifying our thoughts, moods, actions, and even our health. Some painters of the past found color so dominating that they avoided pure colors to enable viewers to see the essence of the subject without being distracted. Fifty years ago color was used very little in everyday life in the United States. The French Impressionist painters and their followers led the way to the free use of color we enjoy today.

The Hindus, Greeks, Chinese, and certain American Indian tribes are known to have assigned colors to the elements symbolically. Leonardo da Vinci wrote, "We shall set down white for the representative of light, without which no color can be seen; yellow for earth; green for water; blue for air; red for fire; and black for total darkness."[5]

Such symbolic color associations were disputed following the Renaissance when the spiritual and physical were separated. In recent years artists as well as scientists have begun to study human responses to color: the visual, psychological, biological, cultural, historical, and metaphysical.

The psychic healer Edgar Cayce experienced a metaphysical response to color—particularly regarding colors related to "auras." An aura is thought to indicate the outer limits of a person's life energy force. It can be seen most strongly by a sensitive eye in the form of colored light emanating from the entire body. It is particularly visible around the head and shoulders. The long tradition of halos in both Western and Eastern art lends credence to the universal existence of auras for those who have not seen them. Spiritual or religious leaders would be expected to have strong auras. Our favorite colors may be those that complement our aura. Unknowingly, we may change our favorite color when our aura changes. Evidently the human ability to see color continues to expand. Some scholars believe humans have only recently developed the ability to see hues with the shortest wavelengths, such as blue, indigo, and violet.

When we look at a color we may disagree about what we see or, more specifically, how we name what we see. Each color and variation of that color has its own character. Yet we see a color only in relationship to other colors. Even the color of a single surface is affected by the color of the light illuminating that surface. Each of us responds in his own way to color. To many people yellow seems to be a happy, free color, while others experience the same yellow as soft and quiet. The quality can change, however, depending on the kind of yellow, its association with other colors, and the mood of the person seeing it. The painter Kandinsky felt that bright yellow can be shrill, and he pointed out that "the sour-tasting lemon and the shrill-singing canary are both yellow."[6]

The appearance of color in our surroundings is determined by a combination of light qualities, surface qualities, and our own experiences and attitudes. Actual objective color of a given thing is called local color. We seldom see true local color because our awareness of color is conditioned by preconceptions. The idea that the sky is blue, for example, can get in the way of our direct perception of a violet or yellow-orange sky. Words identify concepts and in turn play their part in determining color perception. In the Eskimo language there are at least seventeen words for white. By necessity the Eskimo perception of white is very refined.

Local color is also modified by its association with surrounding colors and by the degree and quality of light. As light decreases, individual colors become less distinct. In bright light, colors reflect on one another, causing changes in the appearance of local color.

Light colors on the electromagnetic spectrum are called hues. Hue designates a color in its pure form according to its specific wavelength. Spectrum-intensity red is spoken of as the hue red, as distinguished from the hue orange, its neighbor on the spectrum.

When white light is separated into its visible components by a prism, the hues of the spectrum appear as in a rainbow.

When colored light is combined it can eventually add up to white light. This is *additive* color mixture. Each hue that is added to a colored light mixture brings the mixture closer to pure white light. When the three light primaries are combined the result is white light. Light primaries are red, blue, and green. Red and green light when mixed make yellow light.

Our common experience with color is provided by reflective surfaces, not by pure prismatic light. Therefore, our emphasis in this book is on color in terms of reflective surfaces, and the changes on these surfaces caused by pigments and the light which illuminates them.

A red surface absorbs most of the spectrum except red, which it reflects. A green surface absorbs most of the spectrum except green,

which it reflects, and so on with all the hues.

If the complements red and green are mixed together in equal amounts in pigment form as paint or dye the result is grey, because almost all of the light of the spectrum is absorbed with little reflected. Red pigment absorbs green and green absorbs red. A red apple will look almost black under green light because most of the light is absorbed and very little is reflected.

Mixing color with pigment is quite different from mixing color with light. The more that pigments are mixed together the duller they appear, because they absorb more and more light as their absorptive qualities combine. This is *subtractive* color mixture.

COLOR WHEEL

The color wheel shown here is a contemporary version of the concept first discovered by Sir Isaac Newton. After Newton became aware of the spectrum, he found that both ends could be combined into the hue red-violet, making the wheel concept possible.

The wheel is divided into:

• Primaries: red, blue, and yellow. The three pigment hues that cannot be produced by a

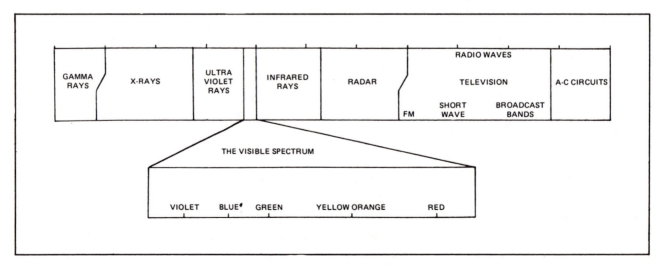

The Electromagnetic Spectrum

mixture of pigments are called primaries or pigment primaries. Although pigment primaries are generally considered to be red, blue, and yellow, each major color system now in use is based on a slightly different set of primaries. See 1 on the colorwheel, color plate 6.

• Secondaries: orange, violet, and green. The mixture of two primaries produces a secondary hue. Secondaries are midway between the two primaries of which they are composed. See 2 on the color wheel.

• Intermediates: red-orange, red-violet, blue-violet, blue-green, yellow-green, and yellow-orange. Their names indicate their components. Intermediates stand between the primaries and the secondaries of which they are composed. See 3 on the color wheel.

The three basic properties of color are demonstrated in the chart on color plate 6: hue, value, and saturation (or intensity). As discussed, hue refers to the particular wavelength of color to which we give a name. The term is important when distinguishing this aspect of color from the other two.

Value (see pages 36–38) can be the range from white through the greys to black, independent of color, or within hues and mixtures of hues.

Saturation refers to the purity of a hue. A pure hue is the most intense form of a given hue or color; it is the hue at its highest saturation. If white, black, grey, or another hue is added to a pure hue, saturation diminishes and intensity drops.

The blue-green side of the wheel is called cool and the red-orange side, warm. The difference between warm and cool colors is not perceptible to the touch, but colors are warm or cool by association. A room painted a warm color becomes warmed psychologically. Color affects our feelings about size as well as temperature. Cool colors usually appear to recede and warm colors appear to advance.

Black and white may be thought of as colors, but they are not hues. A complete black is the absence of light and therefore the absence of color. White, on the other hand, as light or a reflective surface, is the presence of the whole spectrum of all color. White, black, and their combination grey are achromatic or neutral colors.

Color groupings that provide certain kinds of harmonies are called color schemes. The most common of these are:

• Monochromatic: variations on one hue only. A pure hue combined with colors made by mixing the hue with varying amounts of white (tints) and varying amounts of black (shades) adds up to a monochromatic scheme based on that hue. For example, a group of red (pure hue) with pink (tint of red) and maroon (shade of red) would be called monochromatic. (Monochromatic color is used in plates 4 and 17.)

• Analogous: hues next to one another on the color wheel, such as yellow-green, green, and blue-green, each containing the hue green. (Analogous is used in plates 13 and 41.)

• Complementary: two hues directly opposite one another on the color wheel. Complementary hues when mixed form neutrals, but strongly contrast, often appearing to vibrate, when placed side by side as pure hues. The complement of one primary is obtained by mixing the other two primaries. The complement of yellow is violet, obtained by mixing red and blue. (Complementary is used in plate 1.)

• Polychromatic: several hues and their variations. When a painter chooses his palette he visualizes color schemes in terms of his familiarity with certain available pigment colors. Most artists work intuitively when determining a color scheme. (See color plate 5.)

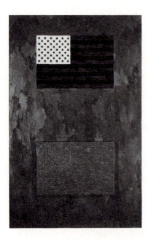

50 Jasper Johns
FLAGS
1965. Encaustic with raised canvas.
72 x 48″. *See color plate* 8.

An afterimage appears to the eye when prolonged exposure to a visual form causes excitation and subsequent fatigue of the retina.

Color afterimages are caused by partial color blindness temporarily induced in the normal eye by desensitizing one or two of its three red, green, and blue color receptors. For example, staring at a red spot for thirty seconds under a bright white light will tire the red receptors in that segment of the retina on which the red spot is focused and make them less sensitive to red light, or partially red-blind. Thus, when the red spot is removed a blue-green spot appears on a white surface because the tired red receptors react weakly to the red light reflected by that area of the surface, while the blue and green receptors respond strongly to the reflected blue and green light. On a neutral surface, therefore, the hue of the afterimage is complementary to the hue of the image or stimulus.

A more complex example of this phenomenon can be experienced by staring for about thirty seconds at the white dot in the center of the flag at the top of Jasper Johns' painting of a flag, then looking down at the black dot in the grey flag below. What do you see?

The appearance of a given hue changes radically according to its relationship with its surroundings. In INJURED BY GREEN, Anuszkiewicz painted a uniform pattern of dots in two sizes. Behind these the red-orange ground seems to change, but it does not. Intensity builds from the outer edges of the painting toward the center where we are "injured" by an area of yellow-green dots, which seems to pulse because it is almost identical to the background in value, yet almost opposite or complementary in hue. The blue tint of the dots in the outer border is slightly lighter in value than the background. The blue-green dots in the four triangular areas are slightly darker in value. If Anuszkiewicz had used straight blue-green, the complement of red-orange, rather than yellow-green in the center, he would not have achieved the startling subtle power that the painting now has, because value is as important as hue and saturation in the total effect of this Op painting.

My work is of an experimental nature and has centered on an investigation into the effects of complementary colors of full intensity when juxtaposed and the optical changes that occur as a result.

Anuszkiewicz[7]

51 Richard Anuszkiewicz
INJURED BY GREEN
1963. Acrylic on board. 36 x 36″.
See color plate 9.

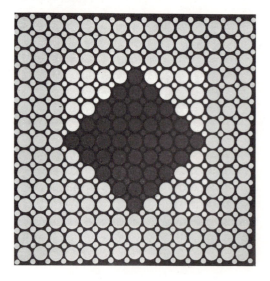

MASS

A two-dimensional area is a shape; a three-dimensional area is a mass. Mass is a major element in sculpture. In painting, it is merely implied. Like other visual elements, mass is an aspect of total form, not a separate entity.

The head of Venus in this detail of Botticelli's BIRTH OF VENUS shows how a master uses a whole range of visual elements in order to create an image of great elegance. The rhythmic grouping of lines for the hair is particularly effective. Venus' head, neck, and shoulders are simplified shapes. Some shading indicates the three-dimensional qualities of the figure. But it would be difficult to imagine

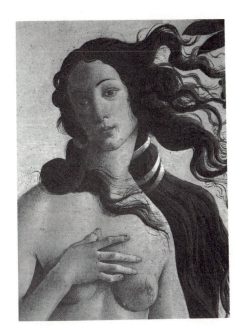

52 Sandro Botticelli
Detail of BIRTH OF VENUS
c. 1490. Oil on canvas.
See color plate 7 and illustration 212.

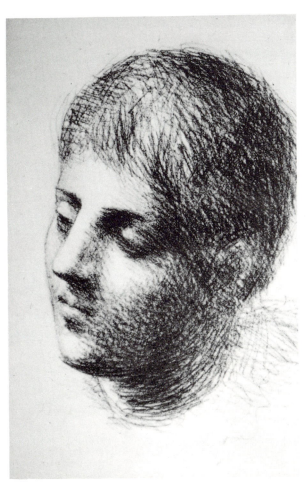

reaching behind this figure because Botticelli has emphasized the outlines or edge lines and underplayed the shading. Venus appears as a half-round rather than a fully three-dimensional mass. This is not a problem; it is simply a way of working. Everything in the painting works together in a shallow, decorative space.

Picasso's drawing of the head of a young man shows a use of lines that seem to wrap around in space, *implying* a solid or three-dimensional mass. The edge is underplayed to imply that the form is continuous in space. The drawing gives the appearance of mass because line acts to define surface directions and to build up areas of light and shade. Picasso's control over the direction and grouping of his lines makes it seem as if we were seeing a fully rounded head. Yet the vigor of Picasso's lines shows clearly that the work is a drawing on a flat surface before it is anything else.

53 Pablo Picasso
YOUNG MAN'S HEAD
1923. Charcoal and graphite. 24¾ x 19".

The easiest way to start seeing the expressive possibilities of mass is to study a few contrasting pieces of sculpture.

Great control was exercised over Egyptian artists during the long period in which this ancient culture lasted. One of the dominant characteristics of their architecture and sculpture was its massiveness. They sought this quality and perfected it because it fit their desire to make things look everlasting. Egyptian art is largely funerary. A common function of their sculpture was to act as a symbolic container for the soul of some important person, helping him to live forever.

The figure of QENNEFER is carved from black granite—a type of rock known for its strength and endurance. He is shown in a sitting pose with his knees drawn up and his arms folded. All this is implied with minimal suggestion. The piece is a strong symbol of permanence.

Figures by the contemporary sculptor Alberto Giacometti evoke no such feelings of permanence. MAN POINTING is a notable example of his work. The tall, thin figure appears eroded by time—barely existing. The amount of solid material utilized to construct the figure is minimal. The content seems to imply the tentative or impermanent nature of man caught between birth and death and eaten away by the void that surrounds him, threatened by non-being.

Existential philosophy developed in our century around a new consciousness of the ever-present threat of death and the importance of coming to terms with *now* as the only facet of existence that we can know. One of the key thinkers in existentialism was Jean Paul Sartre. He found Giacometti's work a major expression of this attitude. On a metal armature Giacometti built up then chipped away the plaster of his original pieces before they were cast in bronze. The artist saw the process as an almost hopeless struggle to create something that satisfied himself. His struggle was rooted in an awareness of the human predicament in modern times.

Ancient Egyptian and contemporary European and American cultures could hardly be more different in their commonly held attitudes toward the nature of life. This can be seen by the way mass is used in these two pieces of sculpture.

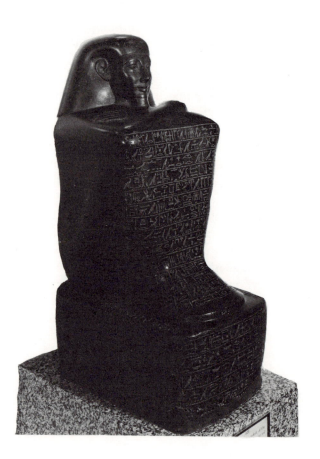

54 QENNEFER, STEWARD OF THE PALACE
c. 1450 B.C. Black granite. Height 2′9″.

55 Alberto Giacometti
MAN POINTING
1947. Bronze. Height 70½″.

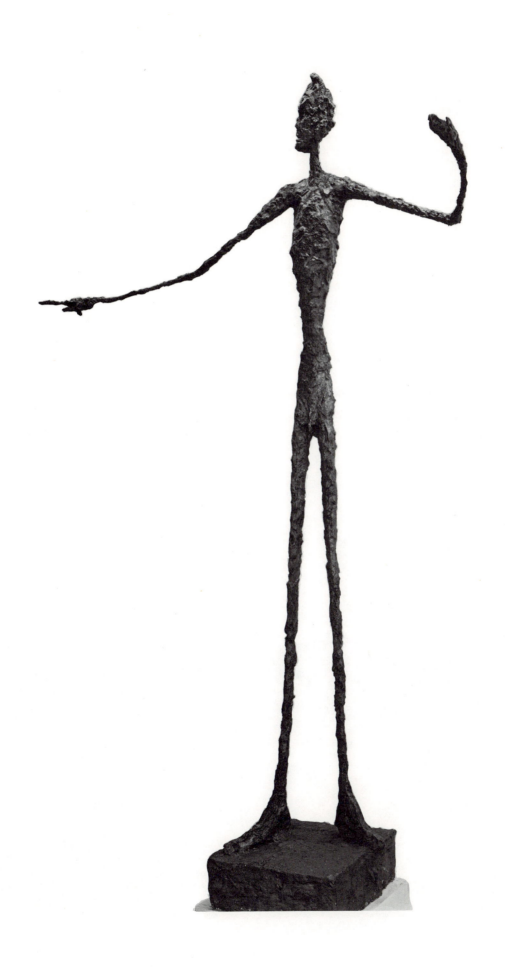

One of the characteristics of today's world is the variety arising from many antitraditional values. Unlike Egyptian culture, there are relatively few controls on society and, therefore, on artists. Thus, almost every conceivable kind of individual style can be seen today.

Henry Moore carved a reclining figure that is massive in a quite different way from Egyptian solidity and seems to have nothing in common with Giacometti's work. Moore's figure is like the windworn stone and bone forms that impressed him from his youth. Moore made his figure compact in its mass and at the same time opened up holes in the figure that allow space to flow around and through the stone. This gives the figure a timeworn quality. An active relationship exists between solid and void, positive form and negative space.

In Brancusi's BIRD IN SPACE mass is drawn out in a dramatic spatial thrust. Brancusi started working on this concept about a decade after the Wright brothers began the history of man's rapid movement in space and long before the world was filled with streamlined aircraft, cars, and pens.

56 Henry Moore
RECUMBENT FIGURE
1938. Green hornton stone. Height 54″.
See color plate 10.

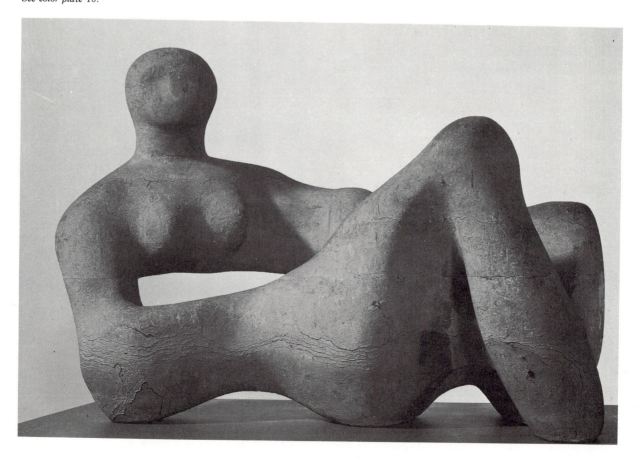

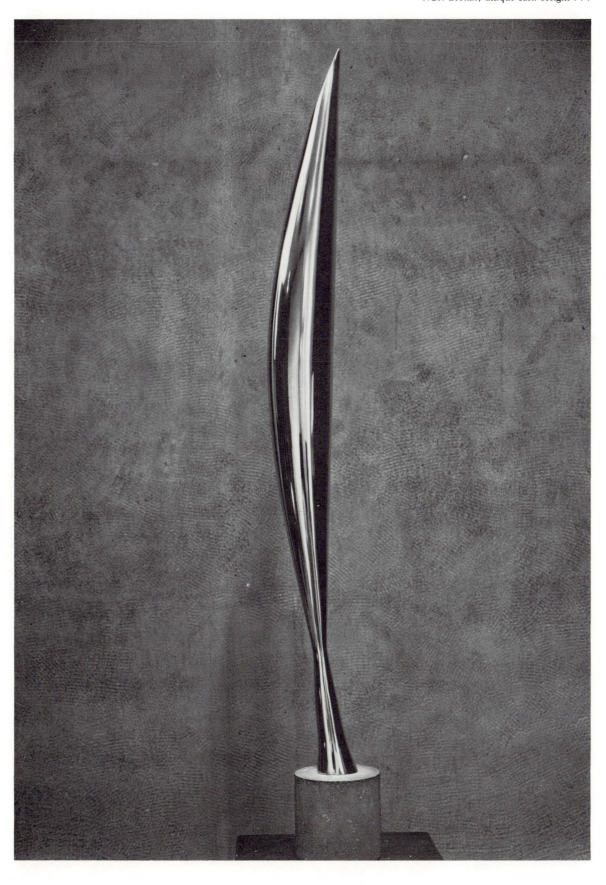

SPACE

The visual arts are referred to as spatial arts because visual elements are organized in space. Music is called a temporal art because in music elements are organized in time. Space is the indefinable, great, general receptacle of things. It is continuous and infinite and ever present. It cannot exist by itself because it is part of everything. I once naively asked a Japanese Buddhist priest and master calligrapher how he felt about space, and he answered, "What space? Parking space?"

The most physically apparent organization of space is found in architecture. We all spend much of our time within buildings, some of which can be thought of as architecture and many of which as just constructions. In some buildings space is defined by mass so that it contributes greatly to the quality of life within it. In many others the opposite is true.

58 Rommert W. Huygens. HOME IN WAYLAND, MASSACHUSETTS.

59 Peter Jefferson. COTTAGE IN THE BAHAMAS.

One of the first considerations about any building is the relationship it will have to the site and its climate. The houses shown here were built to relate well to their location. The house in Massachusetts looks and is comfortably enclosed against harsh winters. The house in the Bahamas is open in its form and reaches out to the friendly moderation of the weather. In each case mass and space work together and with the surroundings, providing a setting for enjoyable living.

The huge interior spaces created by the Gothic builders are some of the most impressive in the history of architecture. Space enclosed by mass is called volume. Here volume becomes the dominant expressive element in the structure. The vast vertical space dwarfs human scale, intensifying the difference between the infinite nature of God (or Heaven) and the finite quality of man. Gothic interior space also provided the perfect acoustical setting for music. Voices filled the cathedrals with tones of different pitch, sounding together in new harmonies.

Art and engineering are one in these great structures. This is ritual architecture—architecture in which the emphasis in the design is on celebrating an idea rather than simply enclosing a function.

60 ARCADES AND VAULTS OF NAVE AT REIMS CATHEDRAL, Reims, France. 1225–1299.

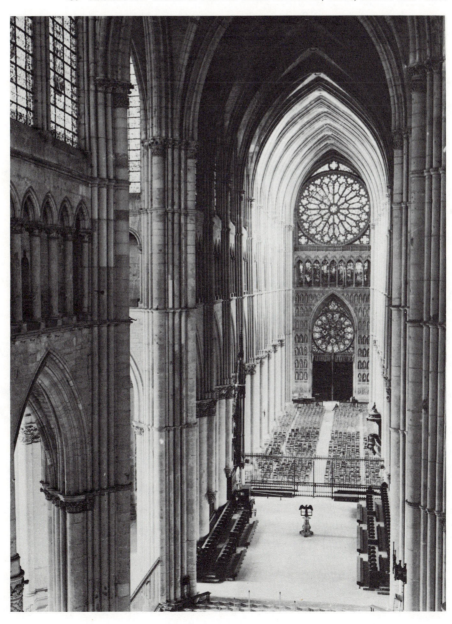

On the edge of the city of Kyoto in Japan, there
is a small garden within a garden that is part of
Ryōan-ji Temple. This garden is famous for its
quality. Yet it is not what we usually think of as
a garden. There are no plants. Abundant vege-
tation is all around, but this vegetation is sepa-
rated from the garden by a low wall. On the
surface Ryōan-ji Garden is just a flat rectangu-
lar area of raked gravel punctuated by a few
stones. In other words, it is mostly empty
space—a void. It was completed in 1491 by
Soami, who worked according to the ideals of
Zen Buddhism. The garden was conceived as a
place for quiet meditation. It still functions to
promote quiet inner reflection when emptied
of tourists and loud guides. It is a nothingness
garden, a great exterior space designed for
spiritual enlightenment.

61 RYŌAN-JI GARDEN. Kyoto, Japan, 1491.

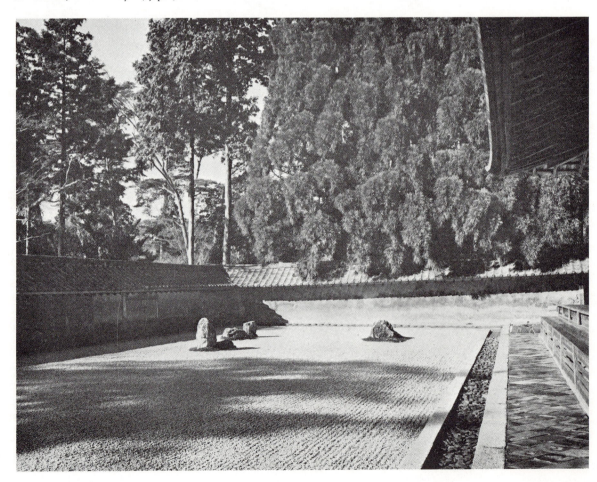

62 Mu Ch'i
SIX PERSIMMONS
c. 1269. Ink on paper. 14¼ x 17⁵/₁₆".

The common surfaces for drawings, prints, photographs, and paintings are flat or two-dimensional. Yet almost any mark or shape on a flat surface begins to give the illusion of depth or the third dimension.

For centuries, Asian painters have handled relatively flat or shallow pictorial space in very sophisticated ways. The great Chinese master Mu Ch'i painted six persimmons in such a way that the painting has been well loved for 700 years. The persimmons appear against a pale background that works both as flat surface and as infinite space. The painted shapes of the fruit punctuate the open space of the ground, reminding us of the well-placed rocks in the garden at Ryōan-ji.

Imagine what would happen to this painting if some of the empty space at the top were cut off. Space is far more than just what is left over after the important things have been laid down.

Some depth is indicated here. When shapes overlap, we immediately assume from experience that one is in front of the other. This is probably the most basic way of achieving the effect of depth on a flat surface.

In the first diagram the spatial effect of overlap is shown. In the second this effect is reinforced by diminishing sizes, thus giving the sense of greater intervening distance.

Another method of achieving the illusion of depth is with placement. When elements are placed low on the picture plane, they appear to be closer. This is how we see most things in actual space. As things move closer to us, they usually move farther below our eye level.

Medieval pictorial space was symbolic and dec-
orative, not intended to be logical or look real.
Toward the end of the fourteenth and the be-
ginning of the fifteenth centuries artists began
to follow Giotto's lead by attempting to con-
struct the illusion of actual space on flat sur-
faces. (See page 159.)

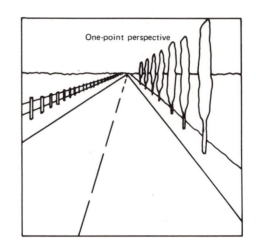

Looking closely at Puccinelli's painting of
TOBIT BLESSING HIS SON, can you tell whether
the angel is behind or in front of the son? It
does not really matter, of course; angels do not
have to live in logical space.

The word "perspective" is now frequently used
to refer to any method of organizing the ap-
pearance of three-dimensional forms in two-

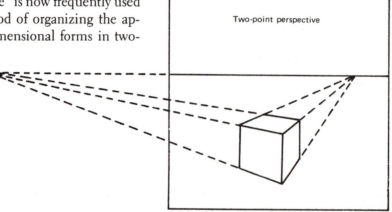

dimensional or pictorial space. It is correct to
speak of the perspective of Persian miniatures,
Japanese prints, Chinese Sung paintings, or
Egyptian paintings, although none of these
styles uses a system that is in any way similar to
Italian Renaissance perspective.

Linear perspective was developed by
fifteenth-century Italian architects and paint-
ers. It is a geometric system based on what one
eye sees at one moment in time fixed at one
place in space. The artists observed that paral-
lel lines appear to converge toward a common
point (the vanishing point) and that objects
grow smaller as they recede into the distance.

In a one-point perspective system all major
receding lines are parallel. Two-point perspec-
tive means that there are two sets of parallel
lines. There can be as many vanishing points
as there are sets of parallel lines.

63 Angelo Puccinelli
TOBIT BLESSING HIS SON
c. 1350–1399. Tempera on wood. 14⅞ x 17⅛″.

Here we see imagined architecture in the Renaissance style, providing a grand setting for the figures in Raphael's THE SCHOOL OF ATHENS. Raphael has achieved perfect balance here between interest in the group of figures and the pull into implied deep space created by linear perspective. The size of each figure is to scale according to his position in space, relative to the viewer, thus making the entire group seem very natural.

The great teachers of the School of Athens are Plato and Aristotle. We know that they are the most important figures in this painting because they are at the center of the series of arches and are framed by the one farthest away. Perhaps more important is the fact that they are placed on either side of the vanishing point, in a symmetrical composition based on one-point perspective. In other words, they are at the point of greatest spatial pull. Where we are pulled farthest back in space, they come forward, creating a dynamic tension in implied space.

Lines superimposed over the painting reveal the basic one-point perspective system used by Raphael. A cube in the foreground is not lined up with the architecture and is therefore seen with two vanishing points or in two-point perspective.

64 Raphael Sanzio
THE SCHOOL OF ATHENS
1509. Fresco. Approx. 26 x 18'

65 M. C. Escher. HAND WITH REFLECTING GLOBE. 1935. Lithograph. 32 x 21.5 cm.

M. C. Escher's lithograph HAND WITH RE-FLECTING GLOBE uses linear perspective inventively. By reflecting his own gaze, Escher emphasizes the origin of a linear perspective view. The mirrored surface of Escher's globe distorts normal perspective, giving a much more complete view of his room than could normally be seen from a single position, without eye movement. Four walls, the floor, and the ceiling are compressed into a single image. The lines defining these planes curve with the sphere's surface. The absolute center is the point between the artist's eyes. Whichever way he turns he is still the center. The ego is the core of his perception.

There is another kind of perspective which I call Aerial Perspective [now called atmospheric perspective] because by the atmosphere we are able to distinguish the variations in distance of different buildings, which appear placed on a single line. . . . You know that in an atmosphere of equal density the remotest objects seen through it, as mountains, in consequence of the great quantity of atmosphere between your eye and them—appear blue and almost of the same hue as the atmosphere itself when the sun is in the East.

Leonardo da Vinci[8]

Conditions of light and air change the appearance of objects as the distance between the observer and the object increases. This effect is called atmospheric perspective. It has been used in different ways by ancient Roman fresco painters, by European artists beginning in the fourteenth and fifteenth centuries, and by Chinese and Japanese painters, mostly during the period of the European Middle Ages.

The basis for atmospheric perspective is the fact that as objects get farther away from us they appear to be less distinct, cooler, or bluer in color, and more moderate in color saturation and in value contrast.

In THE HERDSMAN Claude Lorrain used atmospheric perspective effectively. The ground plane appears to recede from the base of the picture, which opens out on an implied deep space continuous to our own space. Interest is held in the foreground by the figure of the herdsman and his flock. The sun and its light come toward us from the distance, stopping us from going through the painting to infinity.

66 Claude Lorrain. THE HERDSMAN. c. 1655–1660. Oil on canvas. 47¾ x 63⅛".

In THE TURNING ROAD another kind of pictorial space is constructed. We are not led into this painting along the curving road. Our vantage point is high above the road's surface. Cézanne intentionally tipped up the road plane, making it a major shape in the composition. Other planes in the painting have also been changed in order to strengthen the dynamics of the picture plane. Color acts to determine the implied spatial position of the various planes. Cézanne's goal was to reconcile in his own way the three-dimensional reality of nature with the character of the flat picture surface on which he worked.

Cézanne's approach led the way to a total reexamination of picture space, after 400 years of the picture-as-a-window tradition. About 1907 Georges Braque and Pablo Picasso began developing a new kind of spatial configuration in their paintings. The new style completely abandoned the logical linear progression into implied depth that one finds in paintings in the Renaissance.

The style was called Cubism. HOUSES AT L'ESTAQUE is an early Cubist painting done by Braque in 1908. This is a twentieth-century landscape painting in which geometric shapes define a rush of forms that pile up rhythmically in shallow space. Buildings and trees seem interlocked in a spatial system that pushes and pulls across the picture surface.

From this point on, many artists paid more attention to events that they could make happen *across* the picture surface rather than *into* it. Logical, step-by-step progression into pictorial space was abandoned in Cubism. Painters used multiple vantage points to show more of a subject at one moment than was possible from a single, fixed position in space.

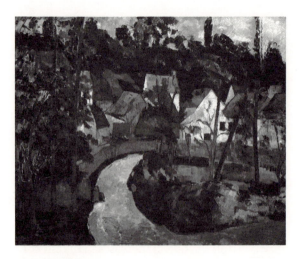

67 Paul Cézanne
THE TURNING ROAD
1879–1882. Oil on canvas. 23½ x 28½".
See color plate 11.

68 Georges Braque
HOUSES AT L'ESTAQUE
1908. Oil on canvas. 73 x 59 cm.

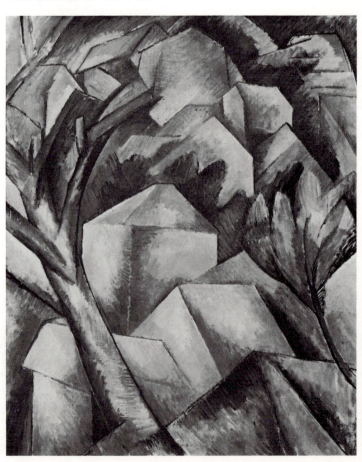

69 SOLOMON AND THE QUEEN OF SHEBA
c. 1556–1565. Persian miniature painting. 13½ x 9⅛".
See color plate 19.

70 Sassetta and assistant
THE MEETING OF SAINT ANTHONY AND SAINT PAUL
c. 1440. Tempera on wood. 18¾ x 13⅝".

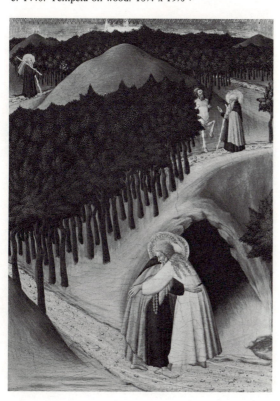

The Persian painter who created the miniature painting SOLOMON AND THE QUEEN OF SHEBA was interested in clearly showing all the important aspects of his subject without confusing things with illusions of deep space. I am sure spatial verisimilitude never occurred to him. Each thing is presented from the angle that shows it best. The result is an intricate organization of flat planes knit together in shallow space. The painting has its own spatial logic consistent with the Persian style. Persian perspective emphasizes narrative and richness of surface design.

TIME

Time is the period between events or during which something exists, happens, or acts. We recognize that both clock time and psychological time are significant yet often opposing concepts of time. To express actual time visually it is necessary to utilize space and motion. Implied time can be expressed by association.

Sassetta implied the duration of time in THE MEETING OF SAINT ANTHONY AND SAINT PAUL. Since the space is continuous we feel time must be also. There is a logical and parallel progression of both. Saint Anthony begins his journey far back in time and space at the city barely visible behind the trees. He comes into view first as he approaches the wilderness. Next we see him as he encounters the centaur. Finally he emerges into the clearing in the foreground where he meets Saint Paul. The road is painted to imply a continuous path of action.

Time in a painting can be seen instantly and wholly, whereas the physical experience of time in film is sequential. Cinematography is a visual art in which actual and implied time are the most important elements. The concept of time in cinema is discussed in detail under Cinematography, pages 96–98.

MOTION

Motion is action created by real or implied change of position.

Sassetta implied that Saint Anthony moved in time and space. In film, rapid sequences of still pictures are shown at a rate of twenty-four per second, creating the illusion of actual motion.

Motion, particularly in drawing and painting, can also become inseparably linked with the action of lines and the repetition of shapes and/or rhythmic actions. In sculpture moved by wind, water, or motors, motion is an actual and important visual element.

Imagine walking along a country road when suddenly you come upon a herd of small white blocks moving slowly along with battery-powered motors. The sculptor and filmmaker Robert Breer made these apparitions out of shaped blocks of styrofoam. Sculpture that moves in actual space and time is called kinetic or motion sculpture. See the work of Tinguely, page 228.

Anuszkiewicz' Op painting INJURED BY GREEN was designed to produce involuntary eye movement. See color plate 9 and discussion on page 42.

SHAPE

Shape refers to that aspect of form seen as a flat area, as in a silhouette. Marc Chagall's painting I AND MY VILLAGE is composed of simple geometric shapes. Chagall has abstract-ed the forms into triangles and circles. There are two families of shapes: geometric and or-ganic. But there is no hard dividing line be-tween the two groups. For example, it can be said that Chagall simplifies natural, irregular,

71 Robert Breer. FLOATS. 1966. Motorized styrofoam.

72 Marc Chagall
I AND MY VILLAGE
1911. Oil on canvas.
75⅝ x 59⅝".

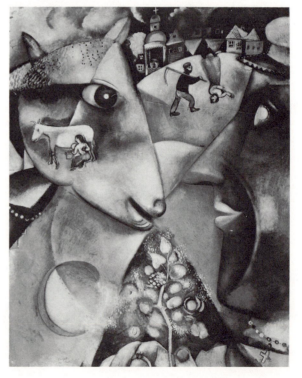

HUE

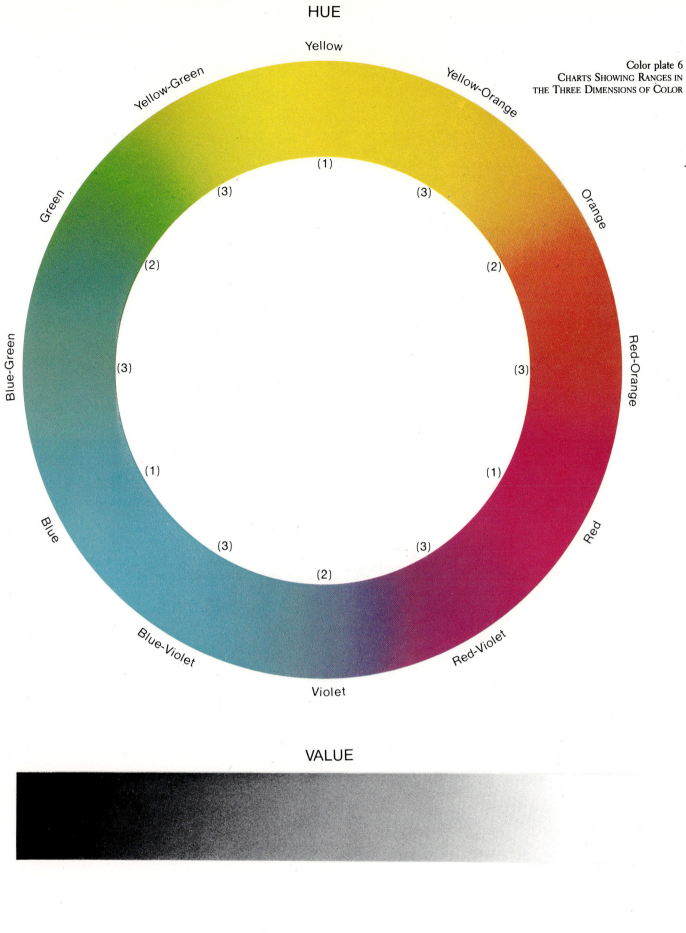

Yellow

Yellow-Green

Yellow-Orange

Color plate 6
CHARTS SHOWING RANGES IN
THE THREE DIMENSIONS OF COLOR

Green

Orange

(1)

(3) (3)

(2) (2)

Blue-Green

Red-Orange

(3) (3)

(1) (1)

Blue

Red

(3) (3)

(2)

Blue-Violet

Red-Violet

Violet

VALUE

SATURATION

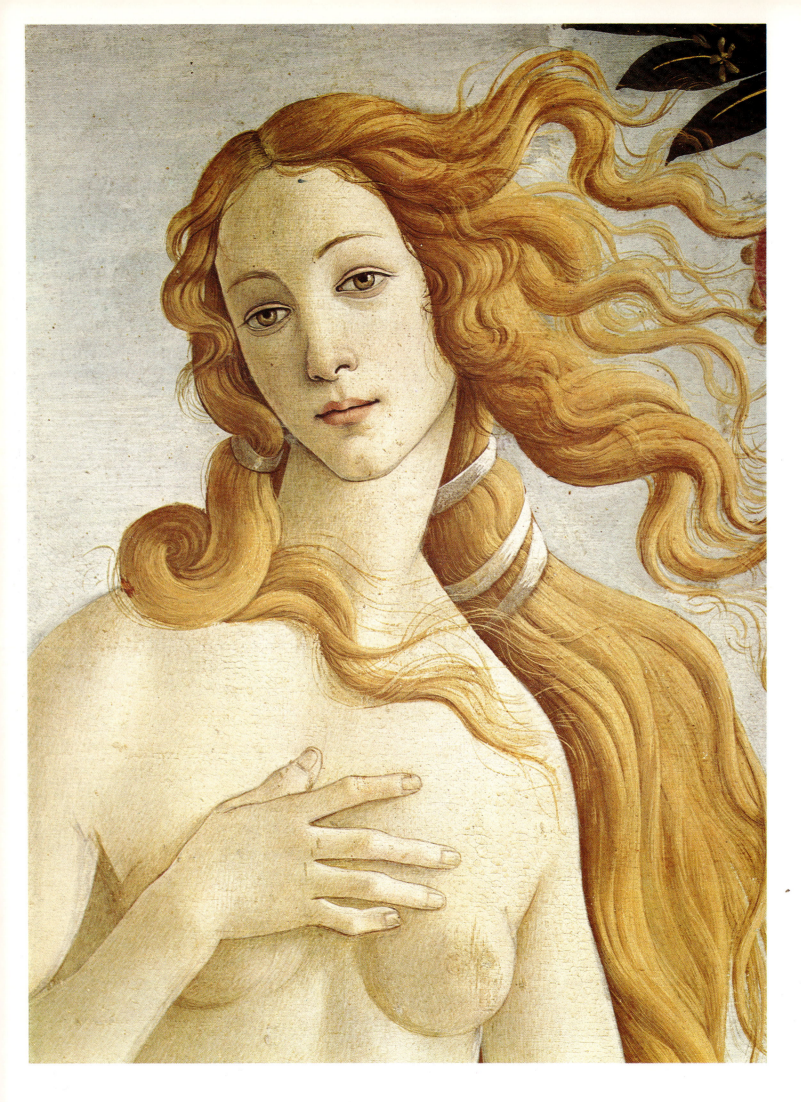

Color plate 7 Sandro Botticelli. Detail of Birth of Venus. c. 1490. Oil on canvas.

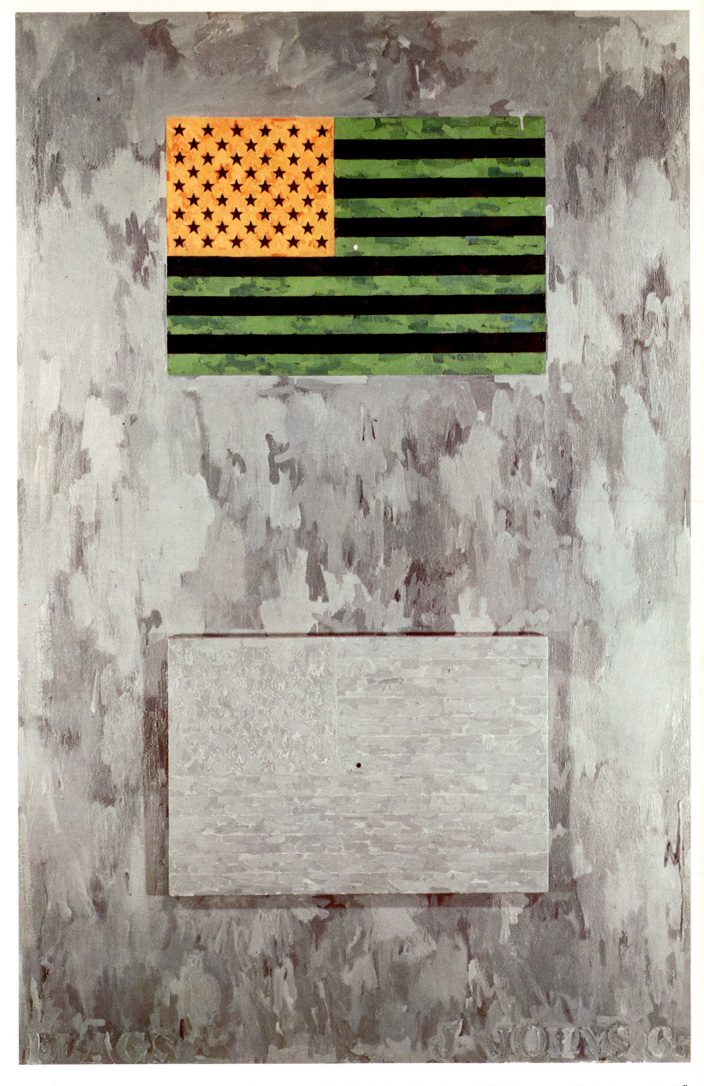

Color plate 8 Jasper Johns. FLAGS. 1965. Oil on canvas with raised canvas. 72 x 48".

Color plate 9 Richard Anuskiewicz. Injured by Green. 1963. Acrylic on board. 36 x 36″.

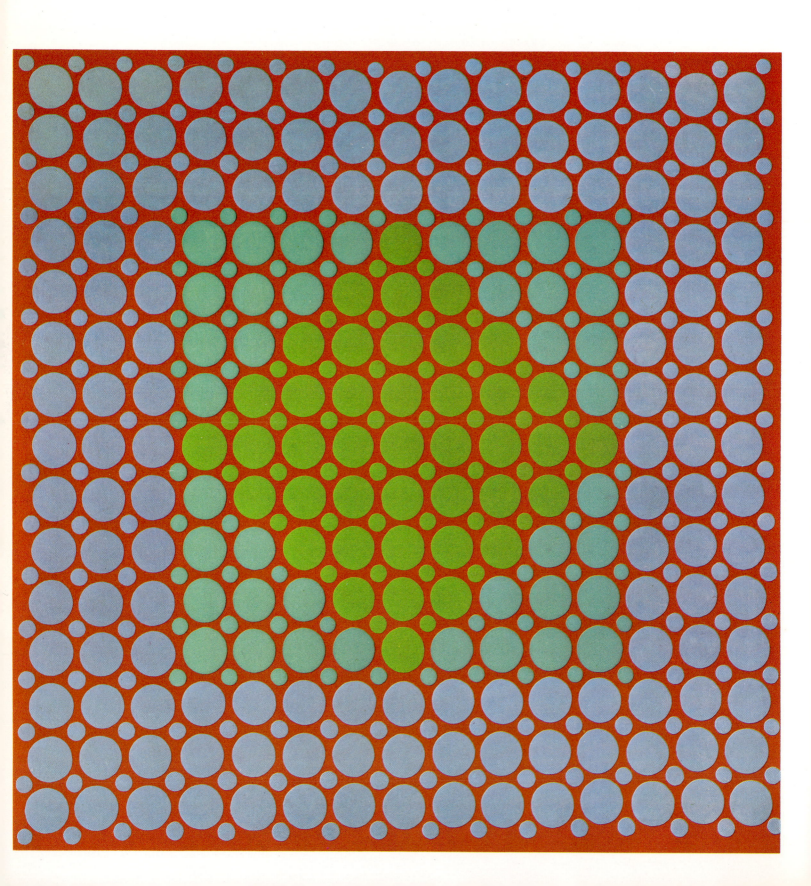

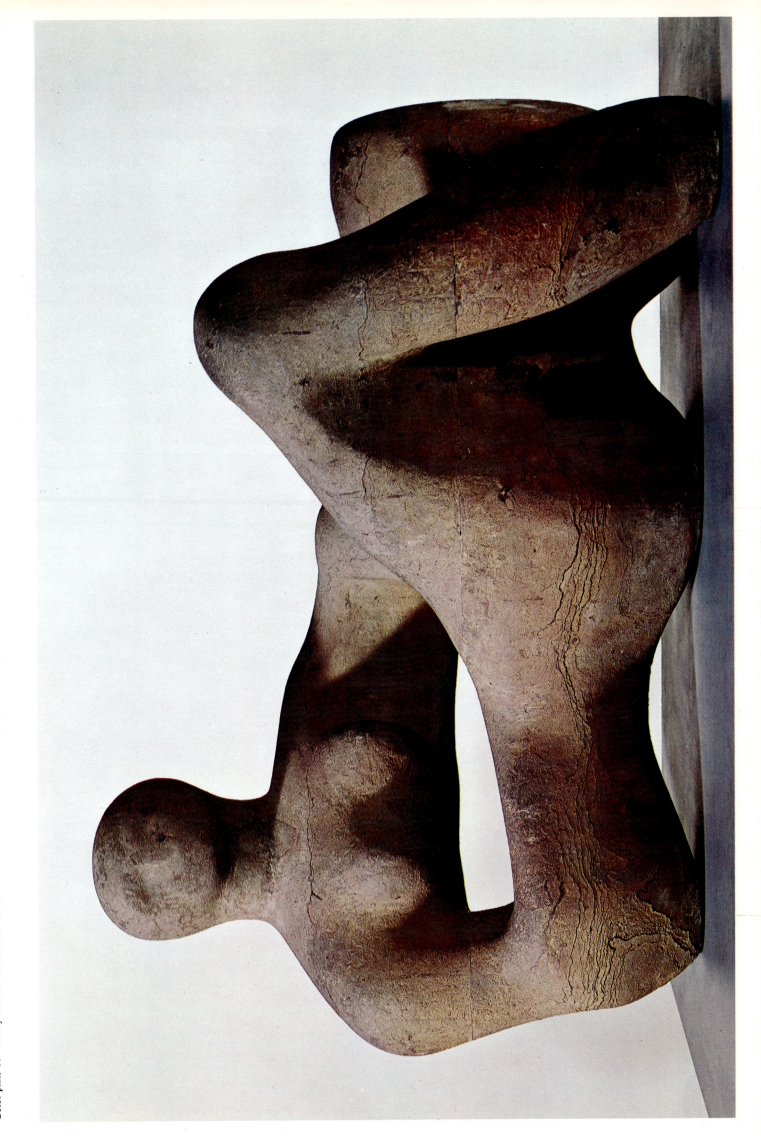

Color plate 10 Henry Moore. RECUMBENT FIGURE. 1938. Green hornton stone. Height 54".

Color plate 11
Paul Cézanne
THE TURNING
ROAD.
1879–1882.
Oil on canvas.
23½ x 28½".

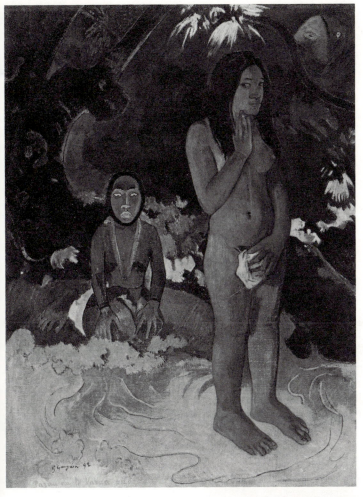

or organic shapes in order to strengthen their symbolic interaction. It can also be said that he softens the geometric regularity of the shapes in his compositions in order to create a more natural flow between the various parts.

Most artists have a personal style, which includes a preference for certain types of visual form. Gauguin evidently became attached to the unique shape that he used for the tree trunk in his painting WORDS OF THE DEVIL, because he used it also in FATATA TE MITI. The shape of the girl about to enter the water in FATATA TE MITI was reversed and used in one of his woodcuts.

73 Paul Gauguin
WORDS OF THE DEVIL
1892. Oil on canvas. 37 x 27″.

74 Paul Gauguin
FATATA TE MITI
1892. Oil on canvas. 26¾ x 36″.

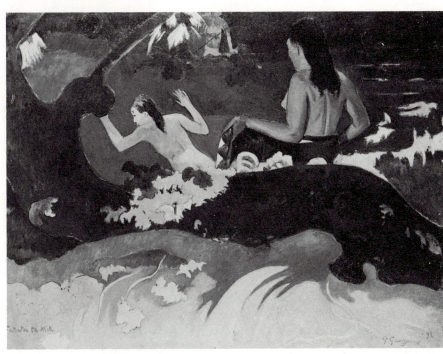

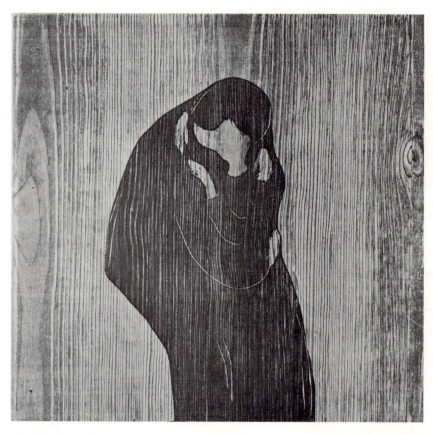

75 Edvard Munch
THE KISS
1897–1898. Woodcut. 467 x 465 mm.

76 Edvard Munch
THE KISS
1895. Dry point and aquatint. 343 x 278 mm.

During the same decade that Gauguin was doing much of his best work in Tahiti, the Norwegian painter Edvard Munch produced several works with the common subject of a couple in an embrace kissing one another. In the drypoint print (right), the couple stands before a window, their figures joined in a simple shape. By removing the line that would normally divide their faces, he has emphasized their unity.

In a later woodcut (above), he used two blocks of wood, printing one uncut. Wiped with just enough ink to bring out the grain, it serves as the background. He has here simplified his basic concept to its essence. Simplicity of this kind is difficult to achieve. Munch did not come to this result all at once; he let it evolve from one work to the next.

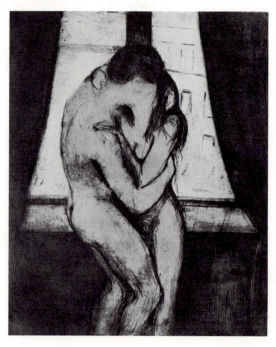

77 Rembrandt van Rijn.
HEAD OF SAINT MATTHEW. c. 1661.
Oil on wood. 9⅞ x 7¾".

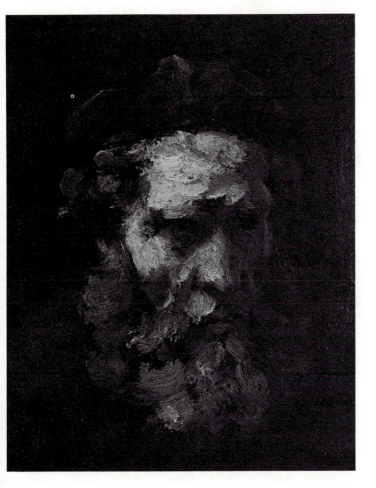

Holbein implies a variety of textures with paint in his portrait of Sir Thomas More. If we were blind we could not feel the softness of the fur or the velvet because the actual texture of the painting is smooth. Holbein has observed the variety of textures with great care. Notice how carefully he has portrayed the textures of the face alone.

Rembrandt applied his oil paint in thick strokes, creating both actual and implied tactile qualities. There is only a hint here of the textural difference between skin and hair, but there is a great deal of feeling demonstrated for the tactile possibilities of paint. The HEAD OF SAINT MATTHEW is constructed with oil paint to create illusionary light and shade. Many contemporary painters use even thicker paint

78 Hans Holbein
SIR THOMAS MORE
1527. Oil on wood. 29½ x 23¾".

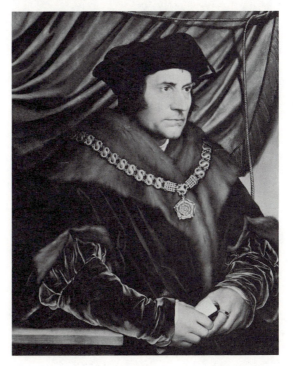

TEXTURE

Texture is surface quality revealed through the sense of touch. Wayne Miller's photograph of a baby being breast fed shows the beginning of our experience of texture (see page 12). Tactile experience is important to babies. It is much later that we learn to "feel" texture with our eyes.

Texture can be actual or implied. Actual texture can be experienced through the tactile sense without the aid of vision. Implied texture, as in a photograph or painting, must be seen to be felt. Munch used the real texture of wood to create an implied texture in THE KISS.

to develop exciting textural surfaces. (See de Kooning, color plate 38.) When paint the consistency of thick paste is applied directly to a surface, it is called *impasto*. Kandinsky used Impasto in BLUE MOUNTAIN. See color plate 32.

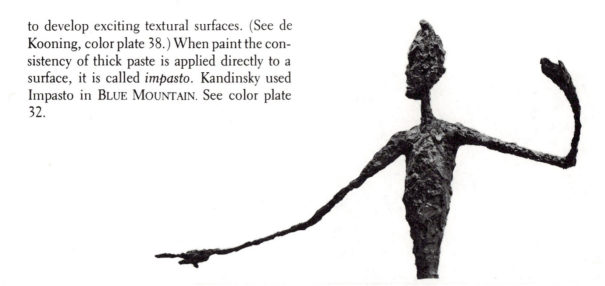

79 Detail of illustration 55.

80 Le Corbusier. NOTRE-DAME-DU-HAUT at Ronchamp, France. Interior.

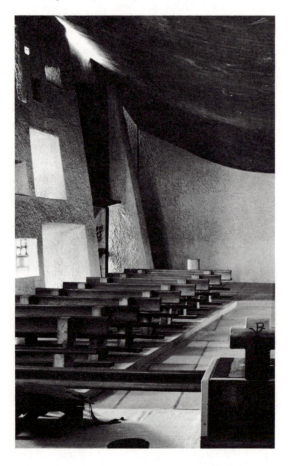

Texture in the three-dimensional arts is actual texture which we can feel with our hands as well as experience with our eyes. Used expressively, it communicates emotion and content to us, adding another dimension to our sensory experience. Some textures are inviting, making us want to run our hands over them. Others repel us. Compare Giacometti's eroding human flesh with the youthful skin of the figures in Rodin's THE KISS, a work which in itself has strong textural contrast. (See page 178.) Each artist used texture to heighten the emotional impact of totally different images.

In Le Corbusier's chapel at Ronchamp, smooth and rough concrete and wooden furnishings are contrasted to produce textural variations which appear almost organic. In contrast, buildings like Lever House (see page 117) offer a subtle interplay of smooth textures, producing a crisp, clean surface.

LINE

Line is the path left by a moving point. It is a visual path of action, the character of which is determined by the quality of the motion that created it. A line may vary in length, width, density, and direction, with each variation having its own character.

Line is a basic element in defining visual form. Line, like the other visual elements, represents a human concept employed in order to symbolize what is seen, felt, or imagined. Lines are marks with length on a two-dimensional surface, or they are the perceived edges of things in two- or three-dimensional space. Lines can appear smooth and flowing or nervous and erratic. They can be angry or happy, harsh or gentle.

On the previous page, Steinberg shows what happens to a highly irregular line when it is transformed as a result of undergoing a certain experience.

From the element of line come writing, drawing, and painting. These art forms have been interrelated for a long time, especially in China and Japan. The earliest form of written language was pictography or picture writing. Drawn, painted, and written lines were often created with flexible brushes and pens, which produced lines of varying thickness.

In the Orient, writing is often found on paintings. The quality of line created by the heart, hand, and brush working in unison expresses the depth of character and feeling of the person writing or painting.

Lettering was a highly developed art in Europe before the invention of the printing press. In fact, to "take pen in hand" was an important expressive act until the invention of the ballpoint pen.

82 Gibon Sengai
THE CRAB
c. 1800. Ink on paper.

The crab, not moving back and forth between good and evil as humans do, only moves sideways.

The crab makes his world
the harbor of Naniwa.
And goes sideways
through the reeds of good and evil.[9]

83 Unknown Chinese artist
A WAVE UNDER THE MOON
12th century. Ink on silk, detail of a scroll.

Lines on a flat surface can act as independent elements, define shapes, imply volumes, or suggest solid mass. Lines can be grouped to make patterns or portray shadows.

An unknown Chinese artist of the twelfth century painted A WAVE UNDER THE MOON. The small moon sets off a large area of rhythmically vibrating lines. The work is very close in feeling to that of some contemporary painters. (See page 225.)

84 Bill D. Francis. PEACOCK FEATHER.
1969. *See color plate 20.*

Implied lines are important elements in the composition of many works. One person pictured as looking at another suggests a line of contact between them. Although the line is not actually drawn, its force can be a major factor in the composition. In Chagall's painting I AND MY VILLAGE (see page 58), this type of implied eye-to-eye contact line is emphasized by the broken line.

All shapes having greater length than width are felt to have a core line or axis following the center of the form along its dominant dimension. In I AND MY VILLAGE objects like the cow's ears and the human figures have these axis lines acting as directions or paths of force in the picture. Notice how the ear at upper left picks up the diagonal line beginning below the cross at lower right.

Nature consists of forms having perfect coordination of all elements. The eye of a peacock feather is consistent in its design. Color, shape, line, and rhythm work together in a single harmonious unity. The segments of the feather work with each other and with the form of the bird to which it belongs. And the peacock acts as a colorful accent within the natural environment of which it is a part.

DESIGN

The process of ordering visual elements is called design or composition. Generally, to design means to prepare preliminary sketches or plans for a work, or to conceive and develop such ideas in one's mind. In a deeper sense, design is basic to each of the arts, structuring its elements into a consistent whole.

Design in nature and in art grows from within by inner necessity. In nature, survival depends on the interrelationship of a form with its function. The human body, like other forms of life, is consistent within itself. The design of the body is determined by its function, yet the design is more than mere utility. The body's function is expressed in the complex variety of its parts and in the interrelationships that bring those parts harmoniously together.

The origin of our need to design stems from the desire for harmony. Harmony is a refined form of order. The order is not necessarily apparent, but is always inherent—determined by the essential character of what is organized. Individually we define what is chaos and what is order. Each day our actions include many unconscious design decisions related to such things as where we live, what we wear, and how we eat. Design makes our environment comprehensible.

An artist develops his sense of design as part of a personal way of seeing, not as something tacked on after other things are considered. Each work of art derives its unity from a single unifying concept operating within it. This does not mean that every work must have an intellectual idea behind it. The unifying concept is often a strong, motivating feeling within the artist.

We may not be consciously aware of them, but several factors are involved in aesthetic experience. For example, the overall proportions and scale of a work of art affect the viewer immediately. Artists who paint exceptionally large canvases make use of the natural impact

of things that are larger than human scale. See Al Held's GREEK GARDEN on page 231.

When the size of any work is modified, as in this book, its character changes. By looking at reproductions, we can only imagine the impact the originals have. Size is an integral part of a work of art. Our senses register size as part of our overall responses—a small-sized work may have monumental impact; a large statue or painting may appear intricate or delicate. Our feelings about works of art change as their relationships to human scale change.

Everything that we perceive is relative. A tall man next to a short woman exaggerates the tallness and shortness of each. In the diagram the inner circle in both groups is the same measurable size, but appears different.

We perceive in terms of relationships. Our perception is meaningful to us because of our mental ability to create our own sense of wholeness. First a configuration appears, then the separate elements. The extraordinary phenomenon of perception is more than the combination of separate elements of sensation. Our ability to see things as a whole allows us to form a complete mental picture of something presented to our eyes only as a fragment. Overlapping shapes appear to be passing in front of

or behind other shapes. See the diagrams of overlapping circles on page 51. In the same way, similar shapes or colors are immediately associated with each other, even though they may be far apart. The eye of the viewer moves about, relating similar elements.

In the following pages design is presented primarily in terms of the organization of relationships on a picture plane. Three-dimensional design problems are different in kind as well as in complexity. The intention is simply to demonstrate some of the most fundamental principles of basic design. These principles can be applied to all design problems.

Our physical reactions to gravitational forces are applied to what we see. Shapes within a form appear to fall, be pulled, float, move, be free, or be confined. Jokes are often made about hanging nonobjective paintings upside down. It makes quite a difference, because as soon as something is turned its whole relationship to our world of up and down changes. Try turning the Barnett Newman on its side.

Verticals and horizontals repeat the human experience of standing and lying down. A horizontal line has a feeling of rest and inaction and provides a ground plane for a vertical. A vertical line is one of poise. The two together provide a deep sense of composure. Both horizontal and vertical lines are static.

Within this century several artists have limited the kind and number of elements in their work in order to concentrate on the expressive possibilities of one element. Barnett Newman has worked primarily with vertical bands for more than a decade. In the work reproduced here two vertical lines balance one another asymmetrically against a changing textural ground.

85 Barnett Newman
DRAWING
1959

86 Hans Holbein
ANNE OF CLEVES
1539. Oil on wood panel.

Holbein's portrait of ANNE OF CLEVES is a symmetrical composition of tightly interlocking shapes. Balance is obtained by the symmetrical placement of the shapes, organized along a central vertical axis, creating a feeling of formal dignity.

87 Pieter de Hooch
INTERIOR OF A DUTCH HOUSE
1658. Oil on canvas. 29 x 25".

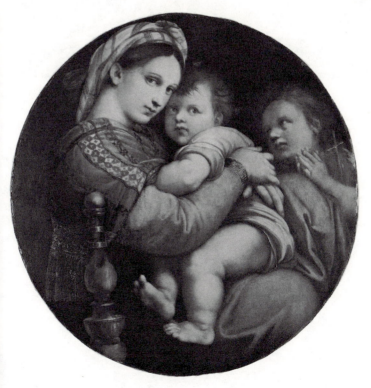

In INTERIOR OF A DUTCH HOUSE by Pieter de Hooch, there is a regular recurrence of rectangles. A definite rhythm is set up by the pattern of the floor and the windows. The rectangular theme repeats the horizontal and vertical directions that begin with the edges of the picture plane.

88 Raphael Sanzio
MADONNA OF THE CHAIR
c. 1514. Oil on wood. 2'4" round.

For contrast, notice how the basic shapes of Raphael's MADONNA OF THE CHAIR echo in curving rhythms the circular picture plane. The flowing curves running through this composition are stabilized by the single straight axis of the vertical chair post.

89 José Clemento Orozco
ZAPATISTAS
1931. Oil on canvas. 45 x 55″.

A progressive visual rhythm is set up across the picture plane in Orozco's ZAPATISTAS. The line of related figures acts as a sequence of diagonals grouped in a rhythmic pattern which expresses the aggressive force of oppressed humans in revolt.

Rhythm is used to provide continuity in the visual arts, as in music. It can provide flow, equanimity, and dramatic emphasis. Visual rhythm, like audible rhythm, operates when there is an ordered recurrence of shapes. Variations build on the major beat.

Goya was a great master who was sensitive to the dynamics of the picture plane. His remarkable etching, BULL FIGHT, is a good example of suspended action poised at a great moment of tension. Most of the interesting subject matter is concentrated in the left two-thirds of the rectangle. We are drawn to the point of emphasis by the intersecting horizontal and vertical lines behind the lower hand of the man on the pole. This linear movement seems to hold the picture together, in spite of the dramatic sense of movement given by the diagonal force lines of the bull and the man.

90 Francisco Goya
BULL FIGHT
1810–1815. Etching. 12¼ x 8⅛".

91 Henri de Toulouse-Lautrec
JANE AVRIL
c. 1893

The head is reduced in size to give the appearance of looking up at her across the footlights. Lautrec's sense of line, color, and shape, and his strong feeling for his subject, work together here to form a painting of great vitality.

If a work of art contributes to your experience, it has quality for you. Works of art that are considered great are those that have contributed to the experience of many people over a long period of time. Art's quality cannot be judged on the basis of how well it imitates the appearance of the world around us. Art is selection and interpretation, not imitation.

92 Henri de Toulouse-Lautrec
JANE AVRIL
1893. Oil on cardboard. 38 x 27".

Artists achieve quality in their work by applying critical evaluation to their own efforts.

Lautrec utilizes selectivity to bring life to his final painted image of Parisian nightclub star Jane Avril. A photograph, probably taken by Lautrec as a study, shows her smiling face, but becomes absurd below the chin. The axis of her figure is vertical, making the image static. Her arms, holding her right leg, are lost beneath her garments. Her right leg appears tacked to her shoulder by mistake, like something that might have happened in a game of Pin-the-Leg-on-the-Lady.

There are no such problems in Lautrec's oil sketch of the subject. He masterfully organized every detail into a dynamic whole. We sense the axis now as a figure S beginning at the left foot. Notice what a difference it has made to change the angle formed by the lower ankle into two diagonals. The diagonal of the lower leg leads us to the point where the right leg is now clearly supported by the curve of the arm.

3

What are the visual arts?

93 Kazuaki Tanahashi
HEKI
1965

A work of art may be anything made by humans in which appearance is a primary consideration of its creation. Certain materials and ways of working with them have long been favorites. Some of these are stone carving, clay shaping on a potter's wheel, oil painting on canvas, and ink and watercolor painting on paper.

Wood, stone, plastic, metal, glass, paper, paint, and clay are all materials. Each material has its own unique properties. A particular material, along with its accompanying technique, is called a *medium*. Each artist seeks that medium which best suits the ideas and feelings he wishes to express. The starting point may be the desire to work in a particular way with certain kinds of materials.

Years of direct observation and practical experience are necessary to understand thoroughly each discipline of the visual arts—the materials used, and the techniques appropriate to it. The development of a discipline is intimately connected with the limitations and possibilities inherent in the materials. Artists often combine or mix many materials and their accompanying techniques in one work. The result is then referred to as mixed media.

Newspapers, magazines, books, and brochures are considered to be print media; television and radio are broadcast media. Marshall McLuhan has called attention to the importance of media by pointing out that the communicative form of a message is often more important than its content.

DRAWING

Line is the fundamental element of drawing. To draw, in the most elementary sense, means to pull, push, or drag a marking tool across a surface in order to leave a mark.

Drawing is practiced by artists working in most disciplines as a basic means of expressing visual ideas quickly. The differences between drawing and painting are sometimes vague. In one sense painting is drawing with paint. Direct drawing is often necessary in the process of printmaking and in making relief sculpture. Cartooning is completely dependent on drawing. Drawing is also a separate discipline.

A drawing can function in one or all of the following ways:

- as a notation or record of something seen, remembered, or imagined;
- as a study for something else (sculpture, film, painting);
- as an end in itself.

Many drawings can be seen and enjoyed as self-sufficient works of art, in addition to serving one or both of the first two functions.

Giacometti drew his face as he saw it reflected in a nearby mirror, using the materials at hand—a ball-point pen and a napkin. The idea of exhibiting or selling this drawing was undoubtedly far from his mind. His primary impulse was to satisfy his compulsion to record what he saw and felt.

Anyone who is intrigued by the rich complexity of the visual world can develop that interest by drawing. Once involved, an artist draws whatever catches his eye or imagination. Many artists keep a sketchbook to serve as a visual diary. From it ideas may develop and reach

maturity as complete works, in drawing or in other media.

A drawing can act as the embryo of a complex work. A simple drawing can be to a building or a painting what a melody is to a symphony. When Le Corbusier did his early drawings for the chapel at Ronchamp, he had the shell of a crab lying on his drawing board. The drawing on the opposite page and the roof of the finished building reflect the character of the shell. (See page 221.)

94 Alberto Giacometti
SELF-PORTRAIT
1962. Ball-point pen on paper napkin. 7¼ x 5″.

95 Le Corbusier
DRAWING FOR NOTRE-DAME-DU-HAUT
Ronchamp, France, c. 1949

96 Pablo Picasso. FIRST COMPOSITION STUDY FOR GUERNICA.
May 9, 1937. Pencil. 9⅛ x 17⅞″.

GUERNICA is a very large painting, measuring more than eleven feet in height by twenty-five feet in length. Picasso did many preliminary drawings in preparation for the final painting. Forty-five of these are preserved, all but one dated to a particular day. Yet the overall concept of this complex work is contained in the very first drawing. If GUERNICA had never been painted, this drawing would have little significance. But as a study for such a painting, the drawing takes on meaning.

It is dominated by a woman with a lamp, which appears to be an important symbol to Picasso. She leans out of a house in the upper right. Below her the lines indicate a horse lying on the ground with its head thrown up in a gesture of agony. On the left a bull appears with a bird on its back. These major elements in the final painting are indicated with Picasso's rapid, searching lines. This study was probably drawn in a few intense seconds. It captures in sudden gestures the essence of the final painting. This drawing is the visual embryo of a complex work. (See page 210.)

Michelangelo made studies for the figure of the Libyan Sibyl, in preparation for painting the figure on the ceiling of the Sistine Chapel. The drawing is a record of search and discovery. Michelangelo carefully observed each part and put on paper a record of his observations. His understanding of anatomy helped him to define each part. The rhythmic flow between the head, shoulders, and arms of the figure is based on Michelangelo's feeling for aesthetic continuity as well as his attention to anatomical accuracy. The parts of the figure that he felt needed further study were done more than

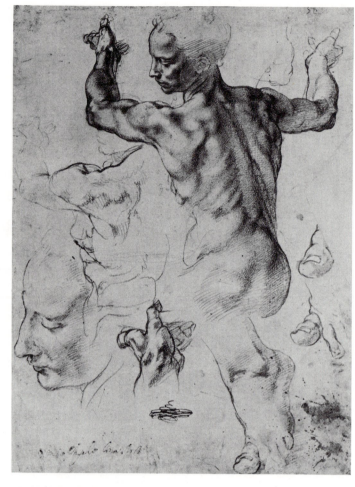

97 Michelangelo Buonarroti. STUDIES FOR THE LIBYAN SIBYL IN THE SISTINE CHAPEL CEILING. c. 1508. Red chalk. 11⅜ x 8⅜″.

98 Vincent van Gogh
CARPENTER
c. 1880

once. These include the muscles on the figure's left shoulder, the face, the foreshortened left wrist and hand, and the foreshortened big toe of the left foot, drawn three times on this one sheet.

Van Gogh, like Michelangelo, learned a great deal about visual form by drawing. Michelangelo had fully developed his artistic ability when he drew the studies of the Libyan Sibyl. Van Gogh was just beginning his short career as an artist when he completed this drawing of a carpenter. Both van Gogh and Michelangelo worked in ways that were true to themselves. They each left an account of their unique feelings and perceptions.

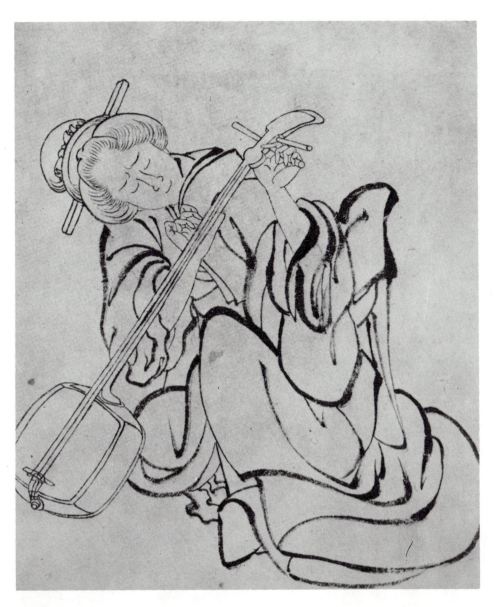

99 Hokusai
TUNING THE SAMISEN
c. 1820–1825. Brush drawing. 11 x 8⅞".

The nineteenth-century Japanese artist Hokusai wrote:

I have been in love with painting ever since I became conscious of it at the age of six. I drew some pictures which I thought fairly good when I was fifty, but really nothing I did before the age of seventy was of any value at all. At seventy-three I have at last caught every aspect of nature—birds, fish, animals, insects, trees, grasses, all. When I am eighty I shall have developed still further and will really master the secrets of art at ninety. When I reach one hundred my art will be truly sublime and my final goal will be attained around the age of one hundred and ten, when every line and dot I draw will be imbued with life.

(signed) Hokusai
"The art-crazy old man"[1]

Any person who can learn to write can learn to draw. Learning to draw is in some ways easier than learning to write because it is less abstract. The most important factors are interest, integrity, and the ability to see.

Each drawing tool and each type of paper has its own character. When they combine well with the skill of the person drawing and the idea to be expressed, the result will have merit.

Notice the different types of marks made by the drawing tools. Some lines, like those made by the flexible brush and crow quill pen, are varied and fluid. Others, like the crayon and charcoal, are soft and textured, while the pencil and rigid pens produce even, sharp lines.

Charles White used a realistic technique of cross-hatched ink lines to build up the figure's mass and gesture in a dramatic manner. Compare the expressive PREACHER with the totally different quality of Matisse's line drawing.

100 Charles White. PREACHER. 1952.
Ink on cardboard.
21⅜ x 29⅜".

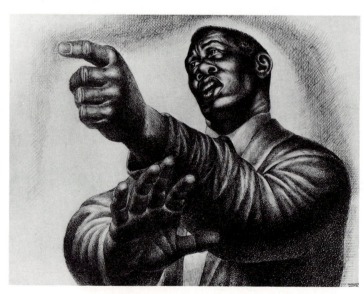

101

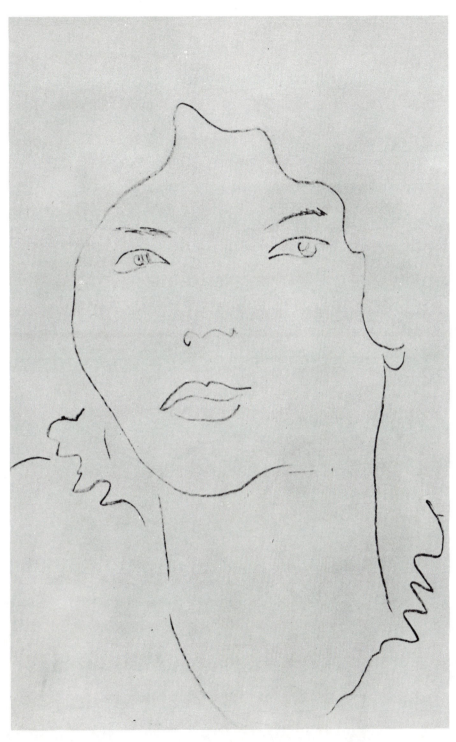

102 Henri Matisse
PORTRAIT OF I. C.
c. 1935–1945. Drawing.

Legend has it that someone saw a portrait draw-
ing by Matisse done with great economy of line
and asked with some disgust, "How long did it
take you to do this?" Matisse answered, "Forty
years."

Rembrandt used brush, ink, water, and paper to draw his wife, Saskia. The result is at once bold and subtle, representational and nonrepresentational, finished and unfinished. As a total image, it is complete. Compare the quick, spontaneous brush lines of his drawing with Sengai's ink sketch on page 159.

103 Rembrandt van Rijn
SASKIA ASLEEP
c. 1642. Brush and wash. 9½ x 8″.

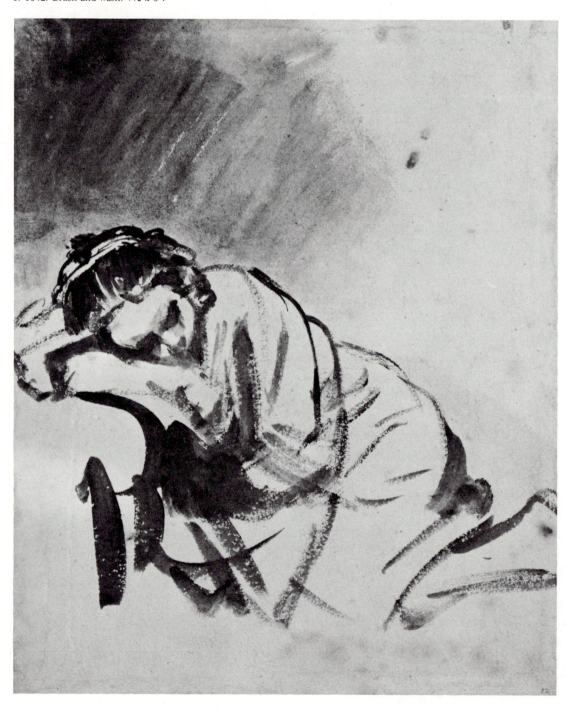

PAINTING

The nature of paint makes it possible to do certain things that cannot be done with other media. Traditional painting media consist of *pigments* that provide the range of colors and a *binder* that holds pigments together in suspension so that they can be applied to surfaces. Pigments are the same in each medium; only the binder changes—the binder is sometimes called the medium.

Pigments are dry coloring agents in powder form. The same pigments used in paint media are also the coloring agents for dry media such as crayons and pastels. Until recently pigments were earth colors and natural dyes. Today many pigment colors are produced synthetically.

Paints are usually applied to a flat *support*, such as stretched canvas for oils and paper for watercolors. The surface of the support may be prepared by *sizing* and *priming* to achieve a *ground* that will have the proper absorbency and permanence. A paper surface provides both the support and the ground for watercolor.

Sometimes it is hard to differentiate between drawing and painting. Rembrandt's drawing of SASKIA ASLEEP is halfway between the two. Large areas of ink are washed on like paint, contrasting with the active, brush-drawn lines.

The development of painting media has determined to a large extent the evolution of various kinds of visual images.

Each way of working has its own characteristics which influence the type of image the artist creates. We will look at several methods of painting.

ORIENTAL BRUSH PAINTING

Chinese brush painting is a watercolor method employing ink and color. The viewer as well as the artist is expected to know the basic visual elements and the attitudes that animate them.

Subject matter is secondary to form. Poetry is frequently written on the surface. Brush techniques are highly developed, both for the written word and for the painted subject. The quality of each stroke is considered as important as the total design. Landscape strokes and their rhythms have names such as raveled rope, raindrops, ax cuts, nailhead, and wrinkles on a devil's face. Timing and speed add to the unrepeatable quality of each stroke. In order to paint a landscape the artist is expected to spend time in quiet meditation outdoors until he becomes one with his subject. The painting is then done from memory.

Traditional Chinese painting is based on values upheld for centuries, with emphasis on perfecting brush technique. In this, Chinese painting contrasts with Western painting in which changing values have brought about frequent changes in technique. Young painters spend several years copying the works of earlier artists in order to fully assimilate the rich tradition they inherit. Artists are also interested in adding their individual interpretation to traditional themes.

104 Fan K'uan
TRAVELERS
ON A MOUNTAIN PATH.
c. 990–1030. Hanging
scroll, ink on silk.
Height 81¼″.

In Fan K'uan's TRAVELERS ON A MOUNTAIN PATH, the brushwork suggests trees with textured shapes that emphasize the powerful structure of the mountain. The stylized waterfall acts as an accent in the design.

WATERCOLOR

Watercolor paintings are made by applying pigments suspended in a solution of water and gum arabic to a white surface. Rag papers are the preferred supports. Paper quality is important because the whites in the painting depend on the lasting whiteness of the paper. Paint is laid on in thin transparent washes or in opaque strokes for detail. When employed carefully, watercolors provide a medium well suited to spontaneous application. In spite of the simple materials involved, it is not an easy medium to handle because it does not allow for easy correction. Watercolor paint must be applied quickly, and cannot be worked over without losing its characteristic freshness.

Both transparent washes and opaque areas are used in John Marin's DEER ISLE—MARINE FANTASY. Foreground and distance merge in a pattern of dynamic dark and light shapes. Jagged edges play off against softer flowing lines. The fluid spontaneity of watercolor makes it a favorite medium for landscape painters, who use it to catch quick impressions of outdoor light.

FRESCO

Fresco is an ancient wall-painting technique in which pigments suspended in water are applied to a damp lime-plaster surface. It is an exacting technique which was used by the Romans and became popular again in the Renaissance for decorating church walls.

The artist has to work quickly in the wet plaster, and generally prepares a full-size drawing which is transferred to the wall before painting. Since the plaster dries quickly, only the portion of the wall which can be painted in one day is prepared, with joints usually arranged along the edge of figures. The pigment and the plaster combine and, if properly prepared, create a smooth, extremely durable surface. Not all pigments can be used in fresco, for some, especially the blues, interact with the lime and eventually change color.

105 John Marin
DEER ISLE—MARINE FANTASY
1917. Watercolor. 19¼ x 16″.

106 Diego Rivera. Detail of NEW WORKERS' SCHOOL MURALS. 1933. Fresco.

Since no changes can be made after the paint is applied to the fresh plaster, the artist must know exactly what he wants to portray. Giotto's DESCENT FROM THE CROSS on page 159 is a fresco, as is this detail of Rivera's social statement. The Mexican revival of the fresco technique, led by Diego Rivera in the 1920s, influenced many Americans to try the ancient method again.

TEMPERA

Tempera paint uses an emulsion (a mixture of oil and water) as a binder. This emulsion may contain glue, gum, casein, egg, or egg and oil. Most tempera paints are water-thinned, yet relatively insoluble when dry. They are good for working in precise detail and will not yellow or darken with age. Their main disadvantages

are color changes during drying and difficulty in blending and reworking. The crisp, luminous quality of egg tempera cannot be matched by any other traditional painting medium. See Andrew Wyeth's THAT GENTLEMAN, page 216.

OIL

The paintings at Lascaux caves (see color plate 24) were made by mixing earth pigments with animal oils. During the Renaissance in Europe, painters began using vegetable oil made from the seed of flax, linseed, as a binder. Linseed oil has the advantage of not changing color as it dries. This factor plus its flexibility has made it a favorite medium for 400 years.

Oil paint is usually diluted for application with a mixture of linseed oil, varnish, and turpentine. It can be applied thickly or thinly, wet into wet or wet into dry. Applied thinly mixed with varnish, it is excellent for building up deep transparent surfaces through a technique called glazing. Oil paint can also be applied as a thick pastelike material, which may be given added body and texture with the addition of inert substances like sand. This is called impasto. See Rembrandt's HEAD OF SAINT MATTHEW, page 61. The slow drying time of oil medium allows for reworking and blending colors directly on the painting surface. The wide range of application possible with oil paint has led to personal styles of painting in which brush strokes act as a kind of signature for the painter. To see the wide range of styles possible with oil paint compare Vermeer's subtly glazed colors in color plate 2 with Hale Woodruff's slashing brush strokes.

ACRYLIC

New synthetic painting media are now in wide use. The most popular are acrylics, in which the pigments are suspended in acrylic polymer medium, providing a fast-drying, flexible film that can be opaque or transparent. It is relatively permanent, even out-of-doors, and may

107 Hale Woodruff. SHRINE. 1967. Oil on canvas with gold leaf. 20 x 40".

be applied to a wider variety of surfaces than traditional painting media. Most acrylics are water-thinned and water-resistant when dry. Unlike oil paint, acrylics do not darken or yellow with age. Their rapid drying can be an advantage or a disadvantage, depending on the artist's manner of working.

New color brilliance has been achieved through the use of acrylic paints. See Anuszkiewicz' INJURED BY GREEN, color plate 9, and Frankenthaler's INTERIOR LANDSCAPE, color plate 41.

PRINTMAKING

Printmaking began with the desire to make multiple images of a single work of art. It is now a creative medium in its own right. Because our lives are full of images that are printed as multiples, it is difficult for us to imagine a time when the only pictures ever seen were one-of-a-kind originals.

This book was reproduced by a mechanical printing method called offset lithography. Lithography was not developed until early in the nineteenth century, but multiple printing was used in China as early as 200 B.C. and in Europe by the end of the fifteenth century.

Until this century, multiple image-making procedures usually included artist, artisans, and laborers. As photomechanical methods of reproduction developed, handwork by artists played an increasingly minor part in the process. Images of original works were no longer drawn or cut into the printing surface by hand copying. Artists, however, have themselves continued earlier printmaking processes in order to take advantage of the unique properties inherent in the printmaking media and to make their works less expensive and more readily available to the public by designing and printing "multiple originals."

The signature of the artist on the print is a mark of his approval of its quality. Frequently, two numbers are placed on the print in this manner: 6/20. The second number tells how many prints are in the edition, while the first signifies the order in which that particular print was pulled.

The idea of original prints may be slightly unrealistic in a world which is flooded with reproductions of great sophistication. It is now possible to duplicate works like ink drawings or watercolors mechanically with such perfection that the reproduction is almost indistinguishable from the original. Printing can now be done on rough-textured, curving, or fragile surfaces. Three-dimensional works can also be reproduced with almost perfect accuracy.

Reproductions may look better or worse than the original. Often a reproduction of a two-dimensional work looks different because its visual qualities are affected by such factors as paper, printing method, cropping, and size. Only within the last twenty years have high-quality color reproductions become commonplace. The art of the world comes to us through these reproductions.

There are four basic printmaking methods: *relief*, *intaglio*, *planographic*, and *stencil*. All are continually changing and expanding in capability as printmakers combine traditional methods and add new ones.

108 Kitagawa Utamaro
MOTHER AND CHILD WITH NOISEMAKER.
1801. Color woodcut. 37.6 x 24.4 cm.

The woodcut process lends itself to designs with bold lines and large areas of dark, light, and color. The multiple blocks necessary for most color prints require careful *registration* to ensure that each color is exactly placed.

Woodcuts have been made in quantity in Japan since the sixteenth century. Many of the printmakers who are well known today created prints as guides to popular entertainment. The prints were often portraits of famous geishas or actors.

German artist Emil Nolde made a woodcut print called PROPHET in 1912. Each bold cut in the block reveals the expressive image of an old man and also the natural character of the wood itself.

The contemporary artist Carol Summers produced another kind of woodcut image. His bold shapes and rich colors work together with assurance. The character of cut wood is not a significant aspect of this image. (See color plate 14.)

109 Emil Nolde
PROPHET
1912. Woodcut. 12⅝ x 8⅞".

INTAGLIO

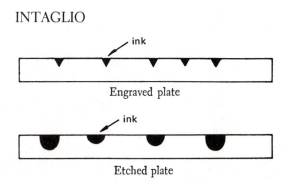

Engraved plate

Etched plate

Intaglio printing is in a sense the reverse of relief because areas below the surface hold the ink. The design to be printed is either etched into a metal surface by "biting" with acid or incised by "engraving" lines into the surface with sharp tools. The plate is coated with ink using a dauber. The surface is then wiped clean, leaving ink only in the cuts. Intaglio processes most frequently used are *etching* and *engraving*.

RELIEF

In a *relief* process the parts of the printing surface not meant to carry ink are cut away, leaving the design to be printed in relief at the level of the original surface. This surface is then inked and the ink is transferred to paper with pressure. Relief processes include *woodcuts, wood engravings, linoleum cuts,* and *metal cuts*.

An etching is made by drawing lines through a soft material made of beeswax and lampblack, which covers a copper or zinc plate. The plate is then placed in acid. Where the lines expose the metal, acid eats into the plate, making a groove that varies in depth according to the strength of the acid and the length of time the plate is in the acid.

In metal engravings, the lines are cut into the plate with a tool called a burin. This process takes strength and control. The precise lines of an engraving are not as fluid or relaxed as

etched lines due to the differences in the two processes.

Compare the line quality in Rembrandt's etching, CHRIST PREACHING, with the line quality in Dürer's engraving, KNIGHT, DEATH AND DEVIL. The hard precision of Dürer's lines seems appropriate to the subject of the print. It is an image of the Christian soldier going with steadfast faith to the heavenly city of Jerusalem.

Rembrandt's gentle compassion is evident in the relaxed quality of his etched lines.

110 Rembrandt van Rijn
CHRIST PREACHING
c. 1652. Etching. 6¹/₁₆ x 8⅛″.

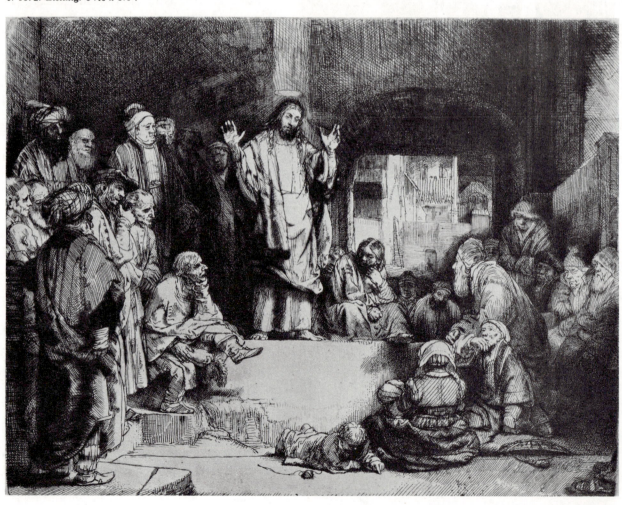

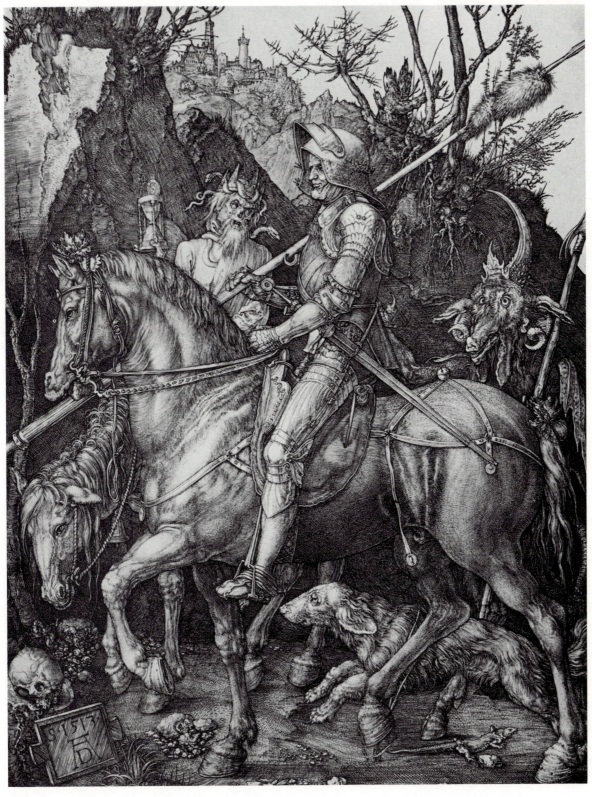

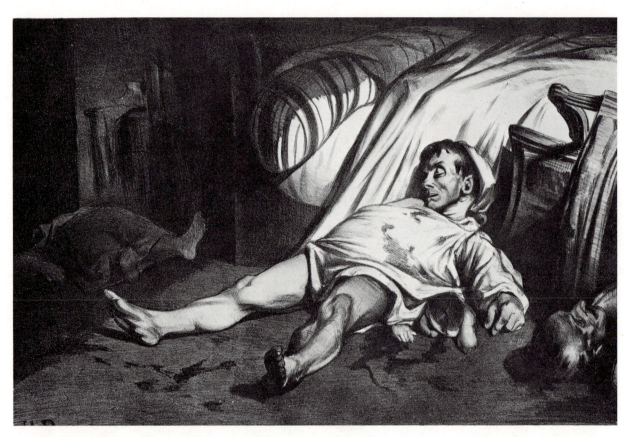

112 Honoré Daumier. TRANSNONAIN STREET. 1834. Lithograph. 11¼ x 17⅜″.

PLANOGRAPHIC

In the *planographic* method the printing surface is left flat, as the name implies. *Lithography* is the major form of planographic printing.

It is often difficult to distinguish a lithograph from a drawing because the image is drawn on the surface of the stone or plate without any biting or cutting of lines. This directness makes lithography faster and more flexible than other methods.

A print can be pulled from a single plane because of the chemical antipathy of water and grease. Lines or areas are drawn or painted on smooth, fine-grained limestone or a plate with a special absorbent surface.

An image is created with crayons, pencils, or inks containing a greasy substance. The surface is then chemically treated so that the drawing is fixed to become part of the upper layer of the stone. The surface is dampened with water and inked. The ink is repelled by the moisture, but adheres to the greasy area of the image. When this surface is covered with paper and run through a press, a printed image of the original is produced.

In TRANSNONAIN STREET Daumier reconstructed a contemporary event that occurred during a period of civil unrest in Paris in the 1830s. The militia claimed that a shot was fired from a building on Transnonain Street. The soldiers responded by entering an apartment and killing all the occupants. Daumier's lithograph was published the following day.

Color plate 13
Alice Parrott
RED FORM
1967. Wool.
Approx. 36 x 70″.

Color plate 12
Toshiko Takaezu
CERAMIC POT
1971. Height 13″.

Color plate 14
Carol Summers
CHEOPS
1967. Woodcut.
29³/₁₆ x 21″.

Color plate 15 Eliot Porter. TAMARISK AND GRASS. 1961.

Color plate 16 Gordon Parks. BOY IN GRASS. 1968.

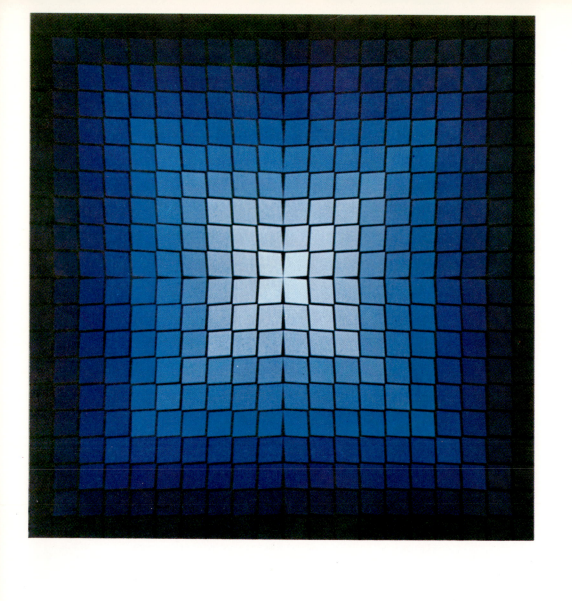

Color plate 17 Victor Vasarely. UNTITLED. 1967. Serigraph. 23½ x 23½".

Color plate 18 Isamu Noguchi. CUBE. 1969. Painted welded steel and aluminum. Height 28'.

STENCIL

Stencils are familiar as a means of transferring letters and other shapes to a flat surface. An *aperture* is cut in a nonporous material, then held firmly against a surface and pigment is brushed through the opening, leaving a corresponding image. Complex shapes must be planned so that connecting links prevent parts from dropping out. Early in this century stencil technique was improved by adhering the stencil to the underside of silk fabric stretched across a frame. Colored inks are forced through the open pores of the fabric from the top, leaving the design on the paper or cloth below. No press is necessary. The term *serigraph* is used to distinguish an artist's print from a commercial reproduction, which is called a *silk-screen process* print.

Serigraphy, or silk-screen printing, is well suited to the production of multiple color images. Each separate color change requires a different screen, but registering and printing are relatively simple. Victor Vasarely's nonrepresentational geometric paintings and prints used optical illusions to create impressions of rhythmic movement years before Op became a named style. Such kinetic effects are produced in the eye of the viewer. (See color plate 17.)

The latest development in screen printing is the photographic stencil or *photo silk screen*, achieved by attaching light-sensitive gelatine to the screen fabric. A developing solution and exposure to light make the gelatine insoluble in water. The gelatine is exposed to light through a film positive or drawing on acetate. The soluble, unexposed areas are then washed away, leaving open areas in the fabric that allow the ink to pass through to the print surface. See Rauschenberg's mixed media painting with photo silk-screen images, page 217.

PHOTOGRAPHY

Photography means light-writing or light-drawing. We are so constantly bombarded by a flood of photographic images that we are not aware of the effect this medium has had on our ways of seeing. Much of our view of life—and, therefore, our way of life—is recorded, challenged, and changed by that relatively simple device, the camera. The camera has provided a profusion of ready-made images, which may dull our vision. Yet, it has also made fresh ways of seeing possible. In spite of the fact that many people now own cameras, it is rare to see an original photographic print of high quality.

The basic concept of the camera preceded actual photography by more than 300 years. The development of photography was motivated by the Renaissance desire to approach nature scientifically, to capture on a flat surface particular aspects of visual reality at a given moment. The camera is like a mechanical replica of the human eye. The major difference is that the eye brings a continual flow of changing images which are recorded by the brain, whereas the camera depends on light-sensitive film to record an image, and only one still image at a time can be picked up.

The camera is a scientific device and an artistic tool. It can record the surface of the moon, the interior of the human heart, or the exact visual details of some unrepeatable moment in history. It can bring to any subject the aesthetic sensibilities of the person who selects and captures the particular image. When this happens, the image created clarifies and intensifies reality so that the visual idea is communicated and retained by the viewer. The artist-photographer seeks significant form in the

DIAPHRAGMS OR LENS OPENINGS SHOWING CHANGING APERTURES

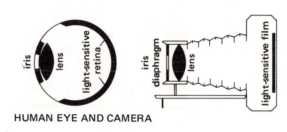

HUMAN EYE AND CAMERA

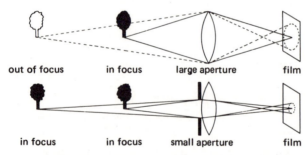

CHANGES IN DEPTH OF FIELD WITH APERTURE
ADJUSTMENTS

shifting images that pass before him. Looking through the camera, he seeks aesthetic reality within the actual world. He is able to clarify and enrich the personal experience of others by presenting images that come from his own personal experience. With the aid of the camera, he reveals and interprets what he sees.

Color becomes a liability for many photographers. It can weaken a photograph by acting as a superficial afterthought, or it can so tantalize the man behind the camera that he

forgets about the other aspects of form, without which color has no meaning.

Eliot Porter sees color and light as integral aspects of form. In his photograph, TAMARISK AND GRASS (see color plate 15), the two elements produce a subtle pattern of horizontal and vertical lines. This segment of nature would usually go unobserved.

Gordon Parks does many things well. He is a poet and a musician as well as a photographer. He was a professional basketball player and piano player before he bought his first camera. In the photograph reproduced here, Parks' enthusiasm for life is readily apparent. Through color and selective focus, he brings attention to that singular moment when the whole world was centered on a pet beetle crawling across the landscape of a boy's face. (See color plate 16.)

There are some things that we could not see at all without photography. The exposure time for Harold Edgerton's photograph of a milk splash was 1/100,000 of a second. He dropped a ball and lit the event with the intense light of a stroboscopic lamp for a microsecond, thereby stopping the action.

113 Harold Edgerton
MILK SPLASH RESULTING FROM DROPPING A BALL
1936

A work of art is created by a subtle, complicated process of selection based on knowledge, feeling, and intuition. When Michelangelo carved a figure, he made thousands of decisions as he sought to reveal that figure in the block of marble. When a photographer like Werner Bischof (see page 28) creates a photograph, he makes thousands of choices in order to arrive at the point at which he releases the shutter and captures a memorable image.

In the 1930s the photo essay became an important part of journalism. The factual images presented in the form of documentary photographs have had impact on society. Many photographers have led the way, as artists, toward a renewed concern with social reform.

In AT THE TIME OF THE LOUISVILLE FLOOD, Margaret Bourke-White confronts us with the brutal difference between the glamorized life of advertising promises and the actual reality people faced. The wide range of her creativity is demonstrated by the differing images in these two photographs.

Margaret Bourke-White brought her full artistic perception to the creation of the photograph CONTOUR PLOWING. The large curving shape that dominates the composition is powerful enough to make a lasting impression. The rhythmically vibrating furrow lines and the tiny scale of the plows add a human element. The airplane and the space vehicle have provided a new vantage point from which to see the natural beauty of the earth and the creative and destructive patterns of human enterprise.

114 Margaret Bourke-White. AT THE TIME OF THE LOUISVILLE FLOOD. 1937.

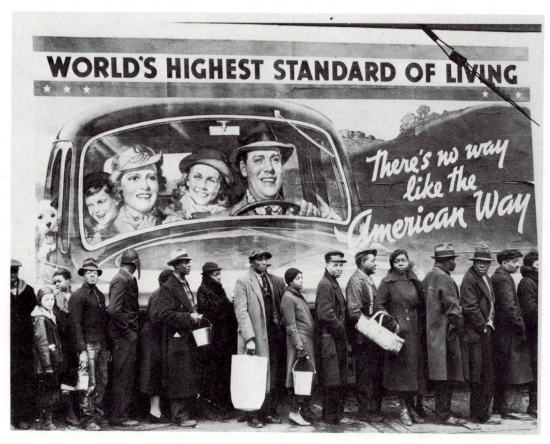

115 Margaret Bourke-White. CONTOUR PLOWING. 1954.

CINEMATOGRAPHY

The art of motion pictures is the art of making pictures move. Whether they are in black-and-white or color, silent or accompanied by sound, animated or live-action, movies are essentially thousands of little pictures projected on a screen so fast that they give us the illusion of movement. Movies seem to move because of the function of the eye known as the *persistence of vision*. When we look at a bright light and then close our eyes, we seem to be able to see the light after our eyes are closed. What we are seeing is an *afterimage* (see page 42). Afterimages occur when the retinas of our eyes retain for a moment the image we were experiencing. If the succeeding image is only a little different from the one that went before, we get the impression that what we are looking at is moving. This happens when we turn the pages of a flip book. Each picture differs only slightly from those that precede it—just

enough to give the illusion of movement when the book pages are flipped.

Eadweard Muybridge first put this discovery to use. Muybridge was a photographer who was engaged by Leland Stanford to settle a disagreement Stanford had with a friend. Stanford believed that when a horse trots there is a point at which all four hooves are off the ground at once. Stanford's friend disagreed.

Muybridge lined up twenty-four still cameras alongside a race course. Each camera was fixed with a wire to be tripped by the horse's front hooves, causing the horse to be photographed twenty-four times as he trotted. Stanford was only interested in the photograph that proved him right. But in settling the disagreement, Stanford helped introduce a revolutionary idea—that of the motion picture. For Muybridge found that if he projected all twenty-four pictures in rapid succession, the horse seemed to move!

116 Eadweard Muybridge
GALLOPING HORSE
1878

That was in 1877. Soon others began to film with motion-picture cameras. The new cameras were equipped to take several pictures in a row printed on long strips of flexible film. When the strips of film were developed and projected at the same rate of speed at which they were taken, the subjects photographed seemed to move naturally. One such early film is of a man named Fred Ott, sneezing.

Early newsreels were similar to the reports we see on television today. Early fiction films, however, were quite different from today's movies. Like many new art forms, cinema in its infancy was not considered respectable. In order to make up for this slight, early filmmakers tried to make their movies look like filmed theatrical performances. Actors made entrances and exits in front of a fixed camera as though it were the eye of a great audience watching them on stage.

Cinematography and television have made the photographic image move. The camera is still the basic tool. All of the visual elements previously discussed (see page 35–65) occur in films. The major elements in cinema are time, motion, and space. There is also the very important nonvisual element of sound. In the twentieth century, when time consciousness has become acute, film media has added to that awareness. Cinema time is flexible, like mental time. Film can compress and expand time and can go forward and backward in implied time.

By creating the effect of motion with photographic images, films produce the most vivid appearance of visual reality since art began. Motion greatly increases our sense of participation. When motion is synchronized with

117 W. K. Dickson. FRED OTT'S SNEEZE. 1894.

sound, two major facets of total sensory experience are joined. The photographic image, plus sound and motion, make cinema and television highly persuasive media. These media can convince us that we are actually seeing events occur as they do in life.

TELEVISION

Television is the electronic transmission of still or moving photographic images with sound by means of cable or wireless broadcast. Today it serves primarily as a distribution system for the dissemination of advertising, news, and entertainment—in that order of importance. Television has its own characteristic advantages and disadvantages. Like photography and cinematography, it uses light impulses collected by a camera. The television camera is unique, however, because it converts lightwaves into electricity. Most of the visual arts produce images manually or mechanically; television produces and transmits images electronically. Lightwaves collected and converted by television cameras can then be stored on magnetic *videotape* for instantaneous or later transmission to receivers.

Multiple audiovisual equipment can be mixed instantaneously with live elements on television. This, along with the modification of images through such methods as electronic feedback, gives TV the potential for even greater flexibility and more complex and immediate forms than cinema. Television time can incorporate cinema time and can also bring us events instantly, or "live." On July 20, 1969, approximately 400 million people around the world watched the astronauts landing on the moon.

The potential of television as a creative medium of communication has barely been explored. Network television most often sacrifices imagination for saleability. Commercials get the most attention because they are where the money is. For higher levels of televi-

sion communication, television's ways of creating form need to be separated from its use as a way of making money.

The space exploration program has speeded up the development of lightweight television cameras and recording and transmission equipment. What television will be like in the future may well depend on this new lightweight gear. It offers the chance to break with the traditional heavy equipment and with the economic demands of network broadcasting. With this equipment a more direct approach is possible. It is now feasible to leave the studio more easily. Team work is becoming less necessary. Experimentation and individual expression are facilitated. Television is expected to replace much of what cinematography is now doing because it can be less expensive and more flexible. Many filmmakers are already using video as a kind of sketch pad.

118 APOLLO 16 ASTRONAUTS SALUTING FLAG
ON THE MOON.
April 1971

DESIGN

The traditional, functional objects of Japan exhibit a high degree of design sophistication, even when the object is a disposable wrapping such as the one shown here.

Everything that man creates needs to be designed either before or during the process of its construction. This process is often spontaneous. After a work is finished, we respond to the quality or lack of quality in its design.

Design is also a professional discipline of the visual arts. Designers are paid to apply their knowledge of design to a wide variety of objects and spaces. As the buying public becomes more visually aware, it demands, and often gets, a wider selection of well-designed graphics, objects, and spaces.

119 Ludwig Mies van der Rohe. BARCELONA CHAIR. 1929. Chrome plated steel bars, leather. 29½″ high.

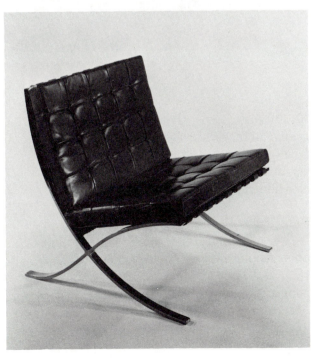

120 RICE STRAW EGG CONTAINER Yamagata Prefecture, northern Japan Photograph: Michikazu Sakai

Chair design is important to us, both for appearance and physical comfort. The architect Ludwig Mies van der Rohe designed a chair in 1929 that has become a classic. It is sculptural and comfortable.

121

122

ADVERTISING DESIGN

Another field of work is advertising design. It has been estimated that the average American adult is assaulted by a minimum of 560 advertising messages each day. And we are building up our communications machinery in order to transmit an even richer array of images at an even faster rate.

"Commercial art" was a common term for this professional discipline. Now it is often called "graphic design" because it may involve more than the design of advertising images.

In advertising, the arts frequently work together. In that sense television advertising is a kind of operatic art form that calls upon writers, musicians, and actors, as well as directors, cameramen, and graphics designers.

Printed visual advertising was not widely used before this century. A writer, a designer, and often an illustrator or photographer work as a team to achieve the final ad. Both of the accompanying ads have been effective. They offer strong propaganda on two sides of an argument. One may have been designed to counteract the other.

SOME THINGS TO CONSIDER IN A
PERCOLATOR DESIGN

123 Richard I. Felver. PERCOLATOR DESIGN. 1972.

INDUSTRIAL DESIGN

Industrial design is art working within industrial media. An industrial designer can work on things as simple as a bottle cap or as complex as an information-processing system. Always he needs to be able to learn anew, becoming familiar with how the object he is designing is fabricated and must work, and how it can become meaningful, economical, and a contribution to living processes. This means designing so that the relationship between the object and the people who use it provides a means, rather than a hindrance, to human fulfillment.

This sketch shows a few of the specific details and possibilities that a designer must consider when trying to comprehend the design of any common yet always complex object, for example, the coffee percolator.

According to the concept of planned obsolescence, the exterior design of a manufactured object is changed, not to improve the quality of the object, but to lure consumers into buying because they feel the one they own is out of date. This is styling, as opposed to design.

124 WOMAN SPINNING
Kathmandu, Nepal, 1970

our metal utensils, the close relationship between the maker and the object was lost, and with it much of the beauty.

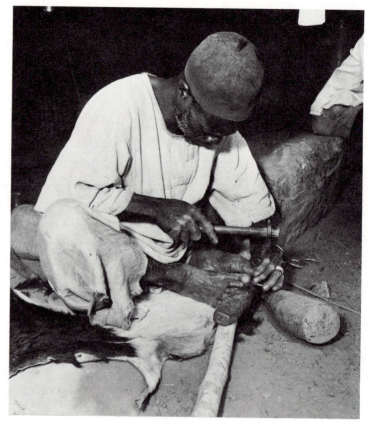

125 SMITH FROM NORTHERN DAHOMEY
1969

The crafts practiced today link us with a long tradition. If the fossil fuels and metal ores that now support our industrialized society run out, we may again depend on the crafts to provide for our daily needs, as they have done throughout much of human history.

From the days when someone first wove a simple basket from reeds, or pinched some clay into a pot and found that fire hardened it, the crafts were an integral part of everyday life. Until the Industrial Revolution, no one saw them as separate, or as "minor" arts, as they are called today. As much artistic thought went into the painting on a Greek vase as into a wall painting. When machines took over weaving our cloth, making our dishes and stamping out

Handmade articles can have a quality that enhances the spiritual aspects of life. Many people are discovering the lasting satisfaction that comes from using their own hands to create objects for everyday use. This trend is evidently much more than a passing fad—it is part of the foundation of a new era. Ceramics and weaving have been the most widely practiced of the crafts, but the recent revival has reintroduced a wide variety of other crafts, including jewelrymaking, enameling, and glassblowing.

CERAMICS

Ceramics is the art and science of making objects from clay. The earth provides a variety of clays that can be mixed with one another and refined in order to obtain the desired body and plasticity. Ceramics range from coarse raku and stoneware to fine porcelain. Clay has long been a valuable material for man. It offers ample flexibility and relative permanence because of its capacity to harden when exposed to intense heat.

A craftsman in clay is usually called a potter. Potters create functional pots or purely sculptural forms by hand building with slabs or coils of clay or by "throwing" forms on a hand-, foot-, or motor-driven wheel.

Ceramics is one of the oldest crafts, and was highly developed in ancient China and Egypt. Originally pots were made by pinching or building up with coils, but when the potter's wheel was developed, craftsmen could produce faster and with more uniformity. When a piece of pottery is thoroughly dry, it is fired in a kiln. The heat turns it chemically into a hard, stonelike substance. Glazes are usually added for color and texture between the first and second firings. The silica in the glaze vitrifies under heat and forms a glassy, waterproof surface.

Native American potters still create pots by the coil method, smoothing them by hand into extremely subtle shapes.

FIBER ARTS

Threadlike fibers, both natural and synthetic, are the basic materials for a variety of forms produced by processes such as weaving, stitching, knitting, crocheting, and macraméing (knotting).

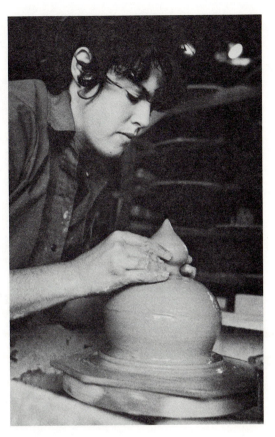

126 POTTING

127 Toshiko Takaezu
CERAMIC POT
1971. Height 13".
See color plate 12.

128 WEAVING

Weaving, like ceramics, was developed when early man made the shift from hunter to farmer. Garments made from cloth became a necessity when skins were no longer available for warmth.

The basic processes of making cloth, from spinning to weaving, are relatively easy to learn, and materials can be inexpensive. Weaving may be complex or simple. A large floor loom capable of accommodating wide yardage can take several days to set up before weaving can begin. On a simple hand loom, a small weaving can be finished in a few hours.

All weaving is based on the interlacing of the lengthwise fibers, the warp, and of the cross fibers, the woof. Patterns are created by changing the numbers and placement of the threads which are interwoven.

129 Alice Parrott
RED FORM
1967. Wool.
Approx. 36 x 70".
See color plate 13.

Looms vary in complexity from the simple frame loom used by Navajo women to create blankets and rugs, to large tapestry looms capable of weaving hundreds of colors into intricate images.

130 Macraméing

We think of macramé as a modern craft, used to make belts, plant hangers, purses, and wall hangings. Actually, it was developed centuries ago as a functional art to make carrying bags, fishing nets, and slings to carry gourds as water containers. Later, sailors on sailing ships spent leisure hours perfecting many types of knotting techniques. These have all been adapted today to make decorative articles.

Processes such as silk-screen printing, batiking, and tie-dying enhance cloth surfaces in a variety of ways that cannot be achieved through any weaving technique.

The process of printing designs on cloth by stamping was used in very early cultures. Later, travelers to India brought to Europe the technique of printing cloth designs from carved wood blocks. Mass printing of cloth today is done by high-speed roller presses, but artists still use some of the ancient methods.

Batik is based on a resist process in which wax is applied to the fabric to keep it from absorbing the dye. Subtle designs using many colors can be created by using numerous applications of wax and several dye baths.

Silk screening (see page 91) can also be used to transfer designs to cloth. Tie-dye techniques create patterns on cloth by a process of tying or sewing folds of fabric, which keeps the dye from penetrating selected areas of the cloth.

131 Batiking

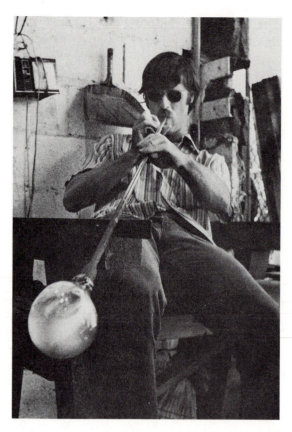

132 GLASSBLOWING

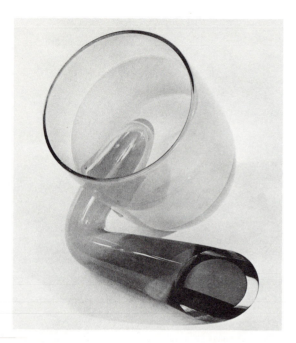

133 Marvin Lipofsky,
GLASS SCULPTURE, LT6. 1972.
Off-hand blown glass. 10 x 15 x 13″.

GLASS

Glass is made of sand, lime, and soda, fused together by heat. When it is melted it can be formed easily by blowing or pressing into molds. Elaborate colored blown glass pieces have been made in Venice since the Renaissance, while simple utilitarian bottles were produced in Colonial America. Today there is a revival of interest in the craft on the part of artists who use it to create new objects expressive of our times.

The medieval method of setting pieces of colored glass in lead and iron frames to create windows for Gothic cathedrals has been revived as well. Artists like Matisse (see color plate 3, near text page 27) and Chagall (see page 58) have executed commissions for colorful windows in churches and synagogues.

JEWELRY

Humans have had the urge to decorate themselves with jewelry throughout history. Sometimes it was for beauty's sake, sometimes to carry their wealth, and sometimes to impress people with their power.

Today's jeweler uses many of the ancient techniques of hammering, soldering, casting, and enameling.

This jewelry is made of aluminum, a comparatively modern metal usually associated with industrial products. It is first carved in styrofoam, a mold is then made from the carving, and as the heated metal is poured into it, the styrofoam vaporizes. Since aluminum is light, the jewelry can be larger than would be possible with heavier metals.

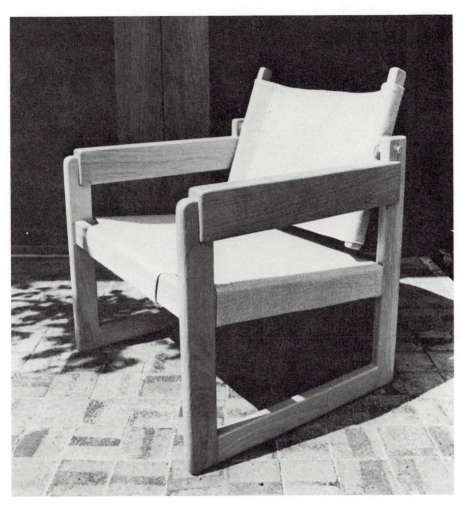

134 Tom Hirai
CHAIR
1975

135 Edward Brownlee
BRACELET, PENDANT AND RING
1973. Cast aluminum.

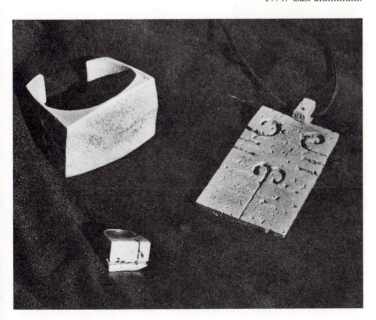

HANDMADE FURNITURE

Most of the furniture in our homes today is produced by industrial methods based on mass production. This does not mean that it cannot be well designed. See the Mies van der Rohe chair on page 99. But those who have the skills to make their own furniture, or are in a position to commission artists to create custom furniture for them, can enjoy the experience of one-of-a-kind handcrafted furniture in their own homes.

136 Isamu Noguchi.
BIG BOY. 1952.
Karatsu ware. 7⅞ x 6⅞″.

SCULPTURE

Freestanding sculpture seems more physically real than any of the visual arts existing on a two-dimensional plane, because it occupies actual three-dimensional space.

When sculpture projects from a background surface, it is not freestanding, but in *relief*. In *low-relief* sculpture, the projection from the surrounding surface is slight and no part of the modeled form is undercut. In *high-relief* sculpture, at least one-half of the natural circumference of the modeled form projects from the surrounding surface. High-relief sculpture begins to look like sculpture that is freestanding. As sculpture enters the fully three-dimensional space that we occupy, it appears to change as we move.

Most coins are small works of low-relief sculpture (see page 110). Sometimes sculpture is hand-sized and designed to be touched, yet

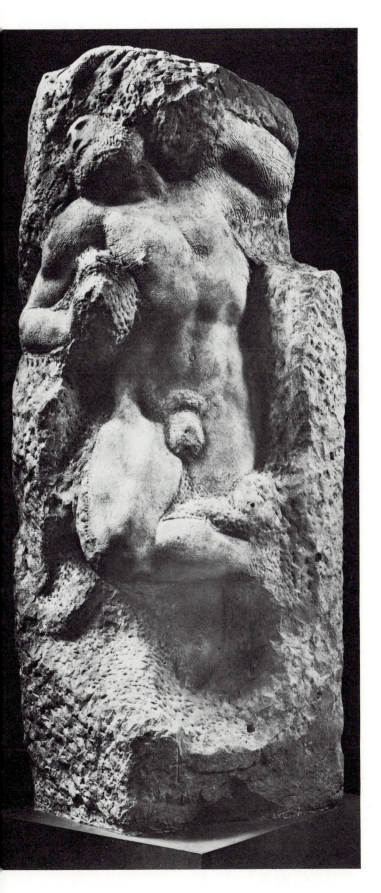

137 Michelangelo Buonarroti
UNFINISHED SLAVE
1530–1534. Marble. Life-size.

has a monumental quality because of its design. This is true of much prehistoric sculpture. Or, sculpture can actually be monumental in size. The Sphinx of ancient Egypt is a good example. Colossal Buddha figures of China, Japan, and Southeast Asia are equally impressive.

Modeling is an *additive* process in which pliable material such as clay or wax is built up from inside a final outer form. Sagging can be prevented by starting with a rigid support called an *armature*. The emaciated figures of Giacometti's lonely people are first built on a metal armature, then cast in bronze (see page 45).

To create his expressive sculpture, BIG BOY, Noguchi pinched clay to form the hands, legs, and feet, and rolled out a slab of clay, which became the garment worn by the child. This slab was pressed into the other pieces of clay to form a single unit. Modeling, cutting, and assembling were used to achieve the final result.

The process is *subtractive* when sculptural form is created by cutting or carving away material. Michelangelo preferred this method. For him, the act of making sculpture was a process of finding the desired form within a block of stone. In his UNFINISHED SLAVE, it seems as if this process is continuing as we watch. The figure symbolizes the human spirit as it struggles against the marble that imprisons it. Close observation of the chisel marks on the surface reveals Michelangelo's steps toward more and more refined cutting.

It takes considerable foresight to work this way. Each material has its own character and must be approached on its own terms. The

138 BENIN HEAD, Nigeria.
16th century. Bronze casting.
8⅜" high.

Any material which will harden, such as clay diluted with water, molten metal, concrete, or plastic, can be cast. The process of preparing the mold for casting varies, depending on the material to be used.

When the mold is ready, the liquid is poured into it. If a large object is to be cast in bronze, like Giacometti's MAN POINTING, page 45, the process is extremely complicated. In the past the artist and his assistants did the work of the actual casting of bronze. Today, except for small pieces which can be cast solid, most artists turn their original over to foundry experts to be cast.

The Greek silver coin, although only about one inch in diameter, is a sensitive portrait of a young man idealized to represent Apollo, the sun god. At Benin, in Nigeria, bronze casting was used in the sixteenth century to cast likenesses of royal personages. The decoration, although elaborate, helps to center our attention on the expressive features of the simplified face.

139 APOLLO
c. 415 B.C. Silver coin. Diameter 1⅛".

stonecarver must apply his strength and endurance to unyielding material. In wood carving, grain presents special problems and unique results. Both wood and stone must be carefully selected beforehand if the artist is to realize his intended form.

The process of casting to produce sculpture, jewelry, coins, ceremonial vessels, and other useful objects was highly developed in ancient China, Greece, Rome, and parts of Africa. It has been used extensively in western Europe since the Renaissance.

All casting involves the use of a mold made from the original work. The original may be made in clay, wax, plaster, or even styrofoam.

Before this century the major sculpture techniques were modeling, carving, and casting. Since Picasso constructed his cubist GUITAR in 1912 (see page 190), assembling methods have become widely used. In some cases preexisting objects are brought together in such a way that their original identity is still apparent, yet transformed when seen in a new context. This type of assembled sculpture is called *assemblage*.

In Picasso's BULL'S HEAD, the creative process has been distilled to a single leap of the imagi-nation. The components of this assemblage are simply a bicycle seat and handlebars. The finished work is based on a particular kind of empathy with things, which is far from common. The metamorphosis of ordinary manufactured objects into animal spirit is still happening for the viewer.

Since 1930, cutting and welding metals such as iron, steel, and aluminum have developed and become widespread. Equipment such as the oxyacetylene torch greatly facilitates these developments.

140 Pablo Picasso. BULL'S HEAD. 1943. Bronze. Height 16⅛".

141 Richard Lippold
VARIATION WITHIN A SPHERE, No. 10: THE SUN
1953–1956. Gold-filled wire construction, 22k.
11 x 22 x 5½'.

The form of sculpture changes as technology develops new materials and processes and makes them available to imaginative sculptors.

Lippold's THE SUN is a beautiful and technically amazing piece of work. Its complex linear form is assembled from several thousand feet of gold-filled wire. The eleven-foot height puts the center of the structure at about eye level. Light is reflected from the shimmering gold surfaces and translucent planes built up with wire. The pure mathematical precision of this construction creates a symbolic image of radiant energy.

Alexander Calder was among those who gave renewed life to the blacksmith's ancient craft.

Calder pioneered kinetic sculpture. Since 1932 he has designed wire and sheetmetal constructions that are moved by natural air currents. Duchamp christened them "mobiles." The traditional emphasis on mass is replaced in Calder's work by an emphasis on shape, space, and movement.

142 Alexander Calder. THE GATES OF SPOLETO. 1962. Steel. Height 65'7", width 45'11", depth 45'11".

143 Takis
ELECTROMAGNETIC SCULPTURE
Paris, 1960, modified 1965. Metal.

THE GATES OF SPOLETO has shapes related to Calder's early mobiles. He calls this type of structure a "stabile." The cutout sheetmetal pieces are motionless planes, yet their shapes set up directional forces that intersect and project, giving the whole sculpture a lively quality. Monumental scale and openness invite the viewer to move through the work. Sculpture again becomes architectural.

Magnetic force plays an important role in the kinetic work of Takis. A suspended sphere moves and pauses around the electromagnet that turns on and off.

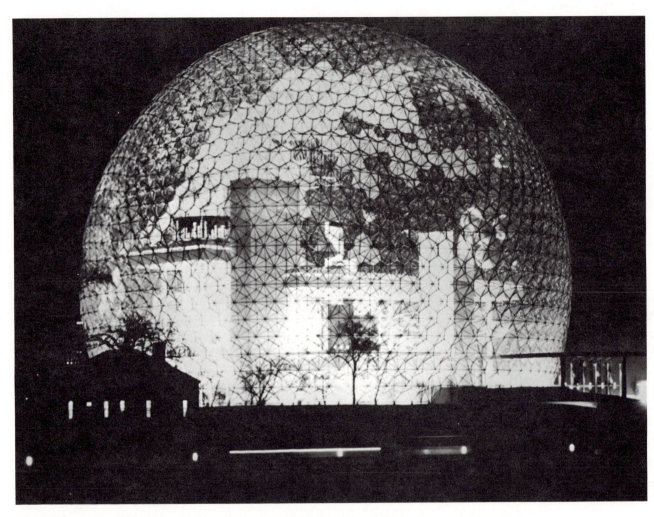

144 R. Buckminster Fuller. U.S. PAVILION, EXPO '67. Montreal.

ARCHITECTURE

Architecture, like sculpture, is three-dimensional form, and both disciplines utilize space, mass, texture, line, light, and color. While sculpture is most often seen from the outside, architecture is experienced from the inside as well as the outside. The sculptural form of a building works best when generated from within—determined by those functions that the structure intends to serve.

Natural forms exhibit high design quality because their perceivable characteristics and their function are aspects of a single form. In each natural substance that we perceive, pro-

cess or function brings the form into being and is in turn made possible by the form. In architecture, man gives form to shelters, which in turn express and enhance their functions. Architecture, then, is the art and science of designing habitable, sculptural structures in which appearance is just one of many inseparable functions.

Most human structures have been built without the aid of architects. Structures like the communal house in Brazil are usually produced without the interference of style or the eccentricities of personal mannerisms. In their purity, such forms are seen by some contemporary architects as inspiration for a style of architecture that is honest and functional.

145 KALAPALO INDIAN HOUSE. Aifa, central Brazil, 1967.

Buckminster Fuller's geodesic domes were inspired by tetrahedrons found in nature. One of Fuller's domes can be erected from lightweight, inexpensive materials in a very short time. Usually a skeleton is constructed of small, modular, linear elements joined together to form single planes, which in turn join together to form the surface of the dome. The resulting structure can be covered with a variety of materials to make the enclosed space weatherproof.

Of all the visual arts, architecture affects our lives most directly. It determines the character of the human environment in major ways. As you read the words printed here you are probably within a building. How does it feel? How does it look? Does it provide for and enhance the function for which it was intended?

To be architecture, a building must achieve a working harmony between the factors that call it into being and are in turn affected by its existence. We instinctively seek structures that will shelter and enhance our ways of life. It is the work of architects to create buildings which are not simply inert enclosures. They can be as communicative to the perceiver as other visual arts.

The experiences offered by architecture begin with an awareness of how structures feel to the senses. Basic physical sensations related to up and down, in and out, high and low, narrow and wide come into play.

Buildings contribute to human life when they provide durable shelter, augment their intended function, enrich space, complement their site, suit the climate, and stay within the limits of economic feasibility. The person who pays for the building and defines its function is an important member of the architectural team. That person is the client. Often his understanding of architectural possibilities is so limited that he becomes a liability. In any creative effort in which more than one individual is involved, the weakest link is the person who is unaware of what is possible. Thus, clients must bear partial responsibility, along with architects, for the often mediocre design of contemporary buildings.

In the nineteenth century, architecture in Europe and the United States was dominated by the revival of Greek, Roman, Gothic, and Renaissance styles.

Sometimes a complete copy of an earlier building was constructed. More often, architects borrowed elements from a variety of sources, designing buildings from the outside in, with more thought given to the facade than to the function of interior spaces. (See the MERCHANTS' EXCHANGE, page 145.)

New building techniques and materials, as well as new functional needs, demanded a fresh approach to structure and form. The men who met this challenge during the last 100 years were strong, articulate thinkers, who developed a philosophy of architecture closely linked in their minds to social reform. The movement began to take shape in commercial

146 Louis Sullivan
WAINWRIGHT BUILDING
St. Louis, 1890–1891.

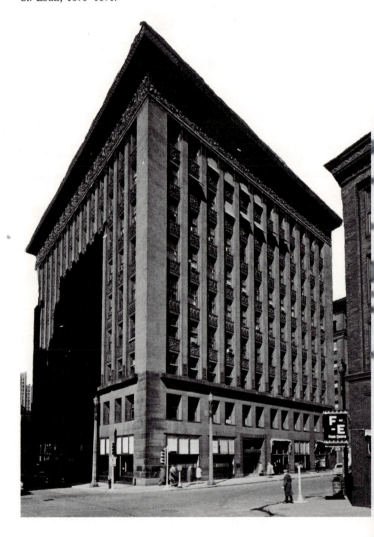

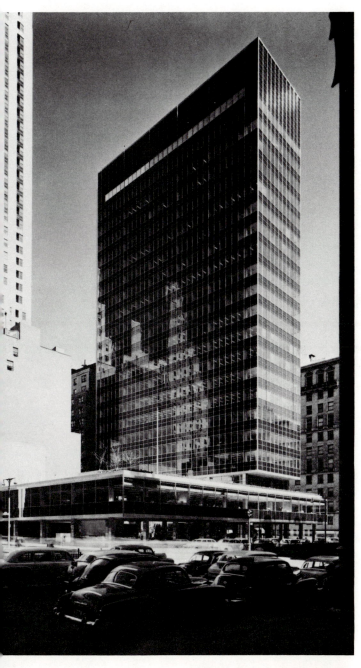

147 Gordon Bunshaft of Skidmore,
Owings, and Merrill
LEVER HOUSE
New York City, 1950

architecture, became symbolized by the sky-scraper, and found its first opportunities in Chicago, where the big fire of 1870 cleared the way for a new start.

One of the architects exploring striking new forms was Louis Sullivan (1856–1924). He was Frank Lloyd Wright's teacher and did more than anyone to develop that unique twentieth-century form, the "skyscraper," or "high rise," as we now know it. Although these names suggest severity of an inhuman scale, Sullivan's work does not have that character.

Sullivan's first skyscraper, the Wainwright building in St. Louis, was made possible by the invention of the elevator and the development of the steel frame. It breaks with nineteenth-century tradition in a bold way. The exterior design reflects the internal steel skeleton and emphasizes the vertical height of the structure.

The interdependence of form and function is basic to nature and to all well-designed human forms. Louis Sullivan's idea that "form follows function"[2] helped to break from reliance on past styles and made it possible for young architects to rethink architectural design from the inside out.

Lever House in New York shows a much later version of the multistoried office building. The austerity of the structure is softened by the open, parklike space provided in the setback.

Louis Sullivan's philosophy has been employed with varying results. On the one hand, it has become a sterile formula for many architects today, who make design decisions purely on the basis of order books and profit margins. On the other hand, it is the basis of the continuing integration of design and industrial production for small-scale industrial objects and for larger environmental forms. During the last decade or so, there has been a growing interest in the methodology of environmental design, leading to several techniques of programming, in which an attempt is made to list and respond to as many functional influences on the form as possible.

From early pole shelters to complex buildings like these built for the Olympics in Tokyo, architecture has expressed cultural values as well as structural methods.

Some of the values behind Japanese culture can be traced to Neolithic times. Shinto beliefs have provided a frame of attitudes within which man works in harmony with nature. The Shinto temple complex at Ise embodies these values and has acted as a prototype for later Japanese architecture. The RECONSTRUCTION OF THE NEOLITHIC HOUSE shows the origin of this temple architecture.

The shrines at Ise were built at least as early as A.D. 685 and have been rebuilt every twenty years since then. Wood for the structure is taken from the surrounding forest with gratitude and ceremonial care. As a tree is cut into boards, the boards are numbered so that the wood that was united in the tree is together in the building. No nails are used. The wood is fitted and pegged. Surfaces are left unpainted. The main shrine of Ise combines heroic simplicity with rich subtlety. The refined craftsmanship, sculptural proportions, and spatial harmonies are rooted in a seemingly timeless religious and aesthetic discipline.

A valuable comparison can be made between the architecture of Ise and that of the Parthenon (see page 144). Bauhaus architect Walter Gropius once asked, "What are the deep shadows hanging over Ise as against the limitless radiance of the Parthenon?" The Japanese architect Kenzo Tange answered:

This question . . . touch[es] upon the essence of Japanese culture as compared to Western culture, namely the contrast between an animistic attitude of willing adaption to and absorption in nature and a heroic attitude of seeking to breast and conquer it.[3]

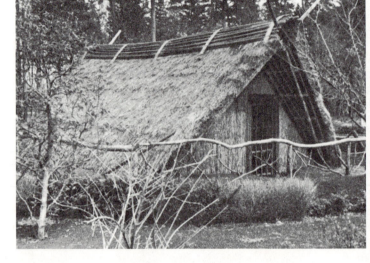

148 RECONSTRUCTION OF THE NEOLITHIC HOUSE
Kyokodan, Musashino, Japan
3rd century B.C.–6th century A.D.

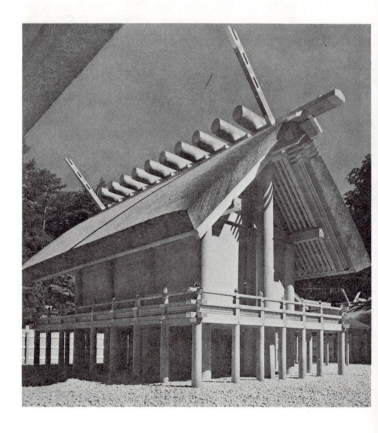

149 SHRINES AT ISE
Main Sanctuary from northwest
c. 685, rebuilt every 20 years

a

b

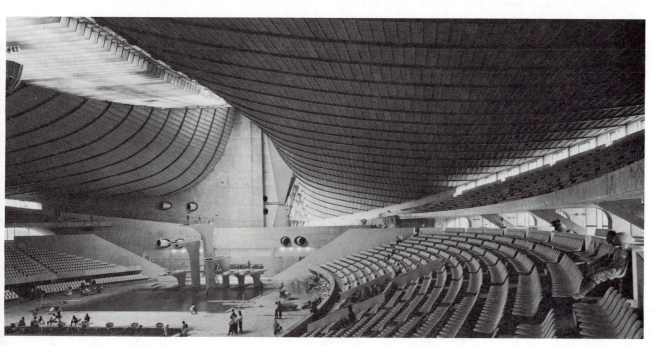

c

150 Kenzo Tange. OLYMPIC STADIUMS. Tokyo, 1964. (a) Exterior, Natatorium; (b) Aerial view; (c) Interior, Natatorium.

Tange's own work includes the design of many single buildings and, recently, the design of cities. (See page 130.)

The indoor stadiums built in Tokyo for the 1964 Olympics show the harmony Tange achieves between spatial, structural, and sculptural requirements. The main building houses a huge swimming pool. With the aid of structural engineer Yoshikatsu Tsuboi, Tange created an open interior space with a seating capacity of 15,000. The roof is suspended from cables carried by huge concrete abutments at either end of the building. Pipelike forms in the end wall are for air-conditioning the interior. They act, along with the diving boards, as sculptural accents to the sweeping curves of the hanging roof.

BASIC STRUCTURAL SYSTEMS

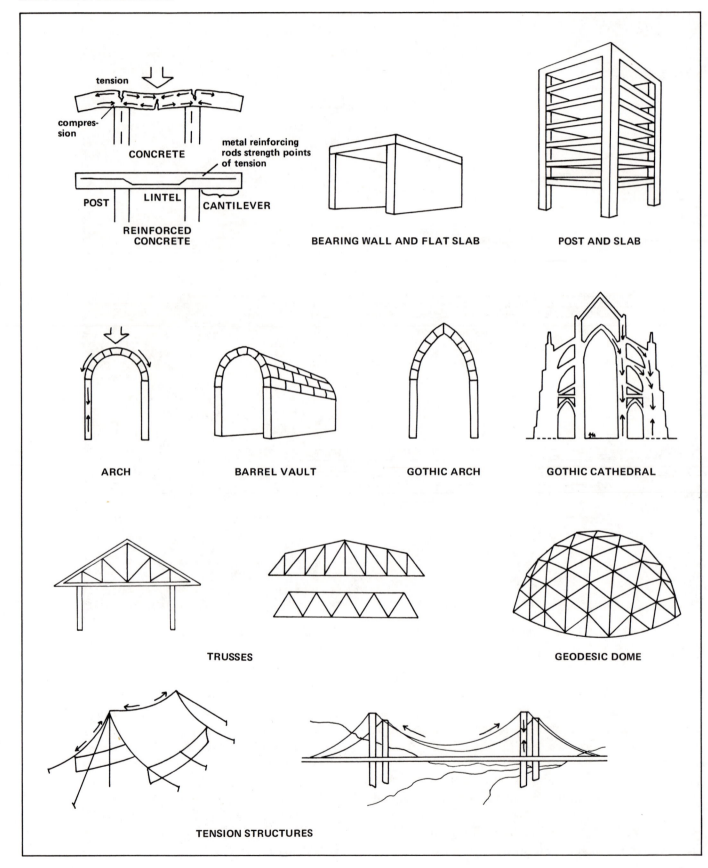

tension

compres-
sion

CONCRETE

metal reinforcing
rods strength points
of tension

POST LINTEL CANTILEVER

REINFORCED
CONCRETE

BEARING WALL AND FLAT SLAB

POST AND SLAB

ARCH

BARREL VAULT

GOTHIC ARCH

GOTHIC CATHEDRAL

TRUSSES

GEODESIC DOME

TENSION STRUCTURES

To achieve their purposes, architects manipulate solids and voids. As solid masses change in form, our feelings about them change. Straight edges tend to feel hard, curving edges soft. The brick and concrete architecture of the Romans was composed of many solid masses, in contrast with the lighter, more airy quality of Gothic masonry. Traditional Japanese houses have sliding screens for both interior and exterior walls, providing flexibility in the flow of space according to seasonal changes and the desires of the householder. Contemporary architects have available many strong yet lightweight materials that make it possible to enclose space with minimal structures of considerable flexibility.

In recent years there has been an unhealthy division between art and engineering. A few structural engineers, such as Pier Luigi Nervi and Buckminster Fuller, are leading the struggle to bridge this gap by developing architectural forms that will be appropriate to the human situation in the immediate and long-range future. Underlying the work of these men is the feeling that structural necessity and beauty must be considered simultaneously.

The methods of support used in a building determine the character of the final form. These methods are based on physical laws and have changed little since man first started to build.

Architecture is *construction* and as such it cannot evade obedience to all the objective limitations imposed by the materials it uses and to those laws, not made by men, which govern their equilibrium.

Pier Luigi Nervi[4]

The world's architectural structures have been devised in relation to the objective limitations of materials. Structures can be analyzed in terms of how they deal with downward forces created by gravity. In the effort to enclose space, they may be designed to withstand primarily the stresses of compression (→ ←), tension (← →), bending (()), or the com-

bination of these in different parts of the structure. There are dozens of basic variations of these structure types, such as shells, folded form castings. The diagrams on the opposite page illustrate some of the most common structural systems.

151 Detail of FORTIFICATIONS AT SACSAHUAMAN
Cuzco, Peru, c. 1450

Shelter for individual families is also a concern of architects, although for centuries most homes have been built by craftsmen and family members.

When water and stream power were harnessed to run mills, precut standardized lumber caused a revolution in home building. In the United States, the framed house became in many ways a modular home. We now buy lumber, plywood, wallboard, and milled windows in standard sizes. Elements like cabinets, which were once hand-crafted on the site, are now factory produced. Even an architect-designed, custom-built house contains many standardized components.

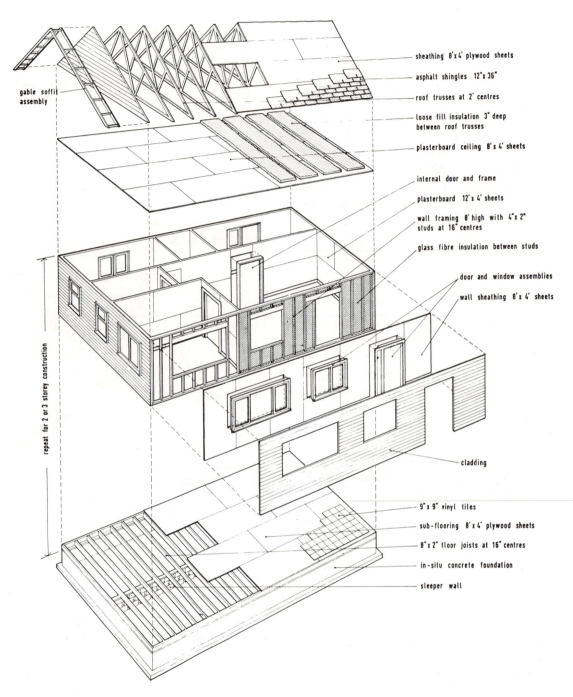

sheathing 8' x 4' plywood sheets

asphalt shingles 12" x 36"

roof trusses at 2' centres

loose fill insulation 3" deep
between roof trusses

plasterboard ceiling 8' x 4' sheets

internal door and frame

plasterboard 12' x 4' sheets

wall framing 8' high with 4" x 2"
studs at 16" centres

glass fibre insulation between studs

door and window assemblies

wall sheathing 8' x 4' sheets

gable soffit
assembly

repeat for 2 or 3 storey construction

cladding

9" x 9" vinyl tiles

sub-flooring 8' x 4' plywood sheets

8" x 2" floor joists at 16" centres

in-situ concrete foundation

sleeper wall

152 STANDARDIZED CONSTRUCTION UNITS

In this century, a great deal of effort has gone into the development of prefabricated housing as a major aspect of the transition of architecture from handcraft to industrial production. Although prefabrication still offers the major hope for combining quality with low cost, poor design has been common in most prefabricated houses. There remains, however, an urgent international need for both high-quality and low-cost housing.

Color plate 19 SOLOMON AND THE QUEEN OF SHEBA. c. 1556–1565. Persian miniature painting. 13½ x 9⅛".

Color plate 20 Bill D. Francis. Peacock Feather. 1969.

Color plate 21 Pomo Feathered Basket. California, c. 1945.
Diameter, 2⅝"; diameter of mouth, 2"; depth 1¹/₁₆".

Color plate 22 Canoe Prow Ornament. Maravo Lagoon, New Georgia, Solomon Islands,
collected 1929. Wood with mother-of-pearl. Height 6½". Photograph by Axel Poignant.

Color plate 23
FACSIMILE OF
POLYCHROME CATTLE.
Jabbaren, Tassili-n-
Ajjer, Sahara Desert,
?–c. 4000 B.C.

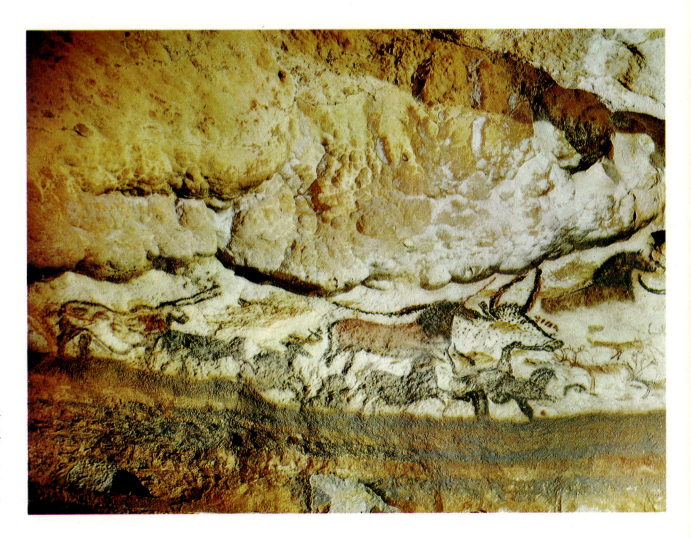

Color plate 24
LEFTHAND WALL,
GREAT HALL OF
BULLS.
Lascaux Caves,
Dordogne, France,
c. 15,000–10,000 B.C.
Polychrome rock
paintings.

Color plate 25
Claude Monet
IMPRESSION: SUNRISE
1872. Oil on canvas.
19½ x 25½".

Color plate 26
Auguste Renoir
LE MOULIN DE LA
GALETTE.
1876. Oil on canvas.
51½ x 69".

Form and function are handsomely joined in the adjustable prefabricated houses produced by Techbuilt Corporation of Cambridge, Massachusetts. Many floor plans are possible because flexibility is built into each model. In the model shown here, the two upper floor bedrooms over the living room can be omitted if the family has no children. If the family has children, these rooms can be added. The floor plan can be changed again after the children are grown.

153 Techbuilt Corporation
PREFABRICATED THREE-BEDROOM HOUSE
24 x 36', 1,728 sq. ft.

Good designers know how indoor environments affect people who use them. The quality of the spaces we occupy can cause us to be cheerful or discouraged. Man enhances the quality of his living space by developing and utilizing his sensitivity to relationships in physical space.

Important considerations for any interior design include size, shape, arrangement of space, the relationship between inside and outside space, texture, and color. The theory is that a good interior designer brings out the inherent design wishes of his client and does his best to make these ideas work.

The life-style of the individuals who will live in certain interior spaces should determine the design of those spaces. Because of this, some of the best interior design is done by individuals for themselves. When you know what you like and why you like it, there is no end to the quality that you can build into a home or work space.

The character of the living area of the Nicoll residence is largely determined by the architectural space. Structural clarity in the building is echoed in the strong simple forms of the furnishings.

154 William Kenzler. Interior, NICOLL RESIDENCE. 1963.

155 Cortez Corporation. MOTORHOME. 1972.

Many people in this changing society are seek-ing the flexibility of a house that can be moved. The "mobile home" is in fact rarely mobile. In its common use, the mobile home is a poorly designed prefabricated house that is never moved after initial installation. The 1970 cen-sus showed that about 3 percent of the popula-tion now live in mobile homes. Mobile homes could still be moveable but designed so that they would enhance rather than detract from their surroundings. Actual mobility has been achieved with converted trucks, vans, buses, campers, and motor homes.

Although our society is undergoing a period of rapid change, much contemporary architec-ture is inflexible and permanent. Flexibility and impermanence might be more appropriate to the changing patterns of use for residential, commercial, and institutional structures.

Expensive monumental school buildings are still being built, resulting in campus architec-ture that is too rigid to meet the changing needs of education.

La Verne College badly needed buildings to hold classrooms, studios, and a gym. The cost of conventional buildings proved prohibitive, so school officials decided to build two tentlike structures. The roofs are made of Teflon-coated fiberglass, hung from steel poles and cables.

156 The Shaver Partnership and Bob Campbell & Company.
TENT STRUCTURE.
La Verne College, La Verne, California.
1973.

ENVIRONMENTAL DESIGN

As we move outside of buildings, it is apparent that the general accumulation of man-made structures creates a landscape that frequently demonstrates lack of harmony with itself and with the natural setting.

The man-made environment is all the objects and places built or shaped by man. As such it is a composite design—an environmental design that includes indoor and outdoor spaces and the organization of objects within those spaces. We build the larger components of this environment to provide shelter from the elements; privacy; places and facilities for our activities; the manufacture of goods; and the transportation of people, things, and utilities.

The life of the human body depends on fuel, energy, and waste systems. The man-made environment extends these biological systems on an immediate scale in buildings and on a larger scale in cities, states, and countries.

The form of the environment is determined by our size, needs, desires, activities, values, and life-styles, as well as the land on which we build, the climate, the materials with which we build, and our methods of construction.

157 Ambrogio Lorenzetti. VIEW OF A TOWN. c. 1338–1340. Painting on wood. 9 x 13⅛″.

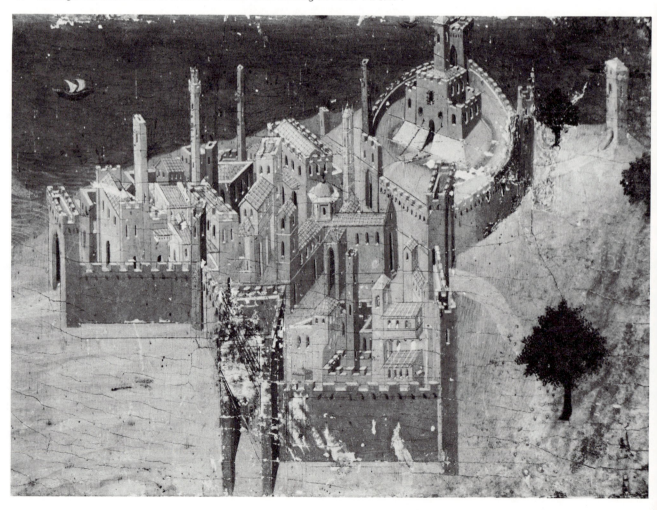

In the past, urban centers grew slowly to meet needs for protection, trade, and communication. Unchanging life-styles and firm traditions created human-scaled environments like the one depicted in the painting by Lorenzetti.

Now, our urban areas are constantly changing and growing. Rapidly constructed suburban developments are annexed to the city, creating a ring of bedroom commuter towns for miles around the urban area.

As a pattern of land use, urban sprawl is the rule, not the exception. Daly City, just south of San Francisco along the California coast, represents thousands of places where open space is rapidly being devoured.

If any life-enhancing order is to come from this frantic growth, we must act swiftly to control this cancer.

The new discipline of environmental design covers a broad category of interdependent disciplines that include architecture, landscape architecture, urban planning, and regional planning. It deals with the design of subdivisions, new towns, master plans for cities, and regional plans. Some thinkers like Buckminster Fuller are asking us to think of design in a global sense. This does not mean that we should redesign the world. It means that we must think of our designs as part of a total world harmony that begins with the natural order.

158 Donald W. Aitken. DALY CITY. c. 1960.

159 Le Corbusier
DRAWING FOR CITY OF THREE MILLION
1922

Two mechanical inventions which have had enormous influence on the design of our environment are the elevator and the automobile. The car has made horizontal growth possible. The affluent have been able to escape into the suburbs, leaving in their path unplanned urban sprawl like that in Daly City.

Huge areas of land have also been appropriated for freeways and interchanges. The freeways themselves become barriers between parts of cities, creating new kinds of ghettos where neighborhoods used to flow naturally into each other.

We are now seriously questioning our commitment to the automobile and its accompanying freeways and highways as the major means of ground transportation. The city of San Francisco has voted to stop all freeway building, turning down millions of dollars in federal and state aid. It is even considering tearing one freeway down.

Since Louis Sullivan built the first skyscraper, cities have grown skyward at an incredible rate. Urban crowding and vertical growth have reached their ultimate development in New York.

In 1922 Le Corbusier foresaw that the high rise *could* be used constructively to centralize apartment towers on expensive land so that open space for parks could be planned around

them. His CITY OF THREE MILLION was designed with humans in mind. In Corbusier's plan, housing was split between widely spaced tall towers at subway stops, and low-level garden apartments. Industry was banished to the outskirts, and business was to be concentrated in towers at the center. At that time Corbusier saw machine efficiency as the best solution to housing problems. Unfortunately, his ideas have been misunderstood, sterilized and standardized to the point that many high rise developments throughout the world have become like prisons.

These illustrations reveal the great difference between the original concept and its usual present application.

160 HYGIENIC APARTMENTS IN
THE MAN-MADE DESERT.

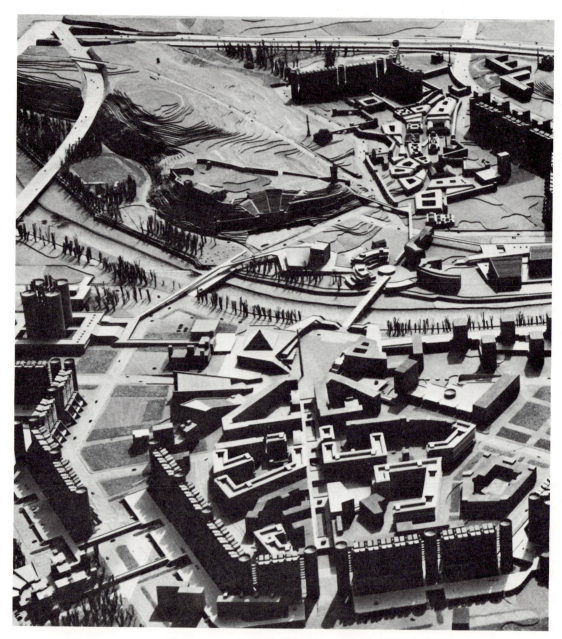

162 Kenzo Tange. PLAN FOR RECONSTRUCTION OF SKOPJE, YUGOSLAVIA. 1965.

Kenzo Tange's plan for Skopje, Yugoslavia, follows the idea of separating pedestrian spaces from vehicular traffic and utilizing high-rise concentrations in order to provide open space on the ground. Influenced by the organic irregularity of Le Corbusier's late style, Tange has designed urban areas which have variety within irregular masses and spaces, giving his plans a human character.

City Planner Victor Gruen has diagramed a possible future city that would function as a cellular structure, radiating around a central core. Broken lines indicate mass transit leading out from urban centers represented by clusters of black dots. Speckled areas are for park areas.

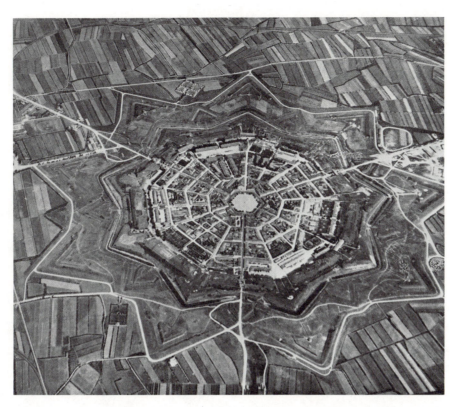

163 AERIAL VIEW OF PALMANOVA, ITALY
1593

SCALE 0 2 4 6 MILES

LEGEND
A Airport
─ Railroad
▨ Industrial Area
------ Rapid Transit

● Urban Centers
CR Connections with National
 Railroad-Network
CH Connections with National
 Highway-Network

 Regional Parks
 City Recreation } Open Space
 Local Recreation

164 CLEMATIS VIRGINIANA
Transverse section of a young stem showing
combination of hexagonal, radial, and concentric
symmetries.

165 Victor Gruen and Associates
METROCORE AND ITS TEN CITIES
1966

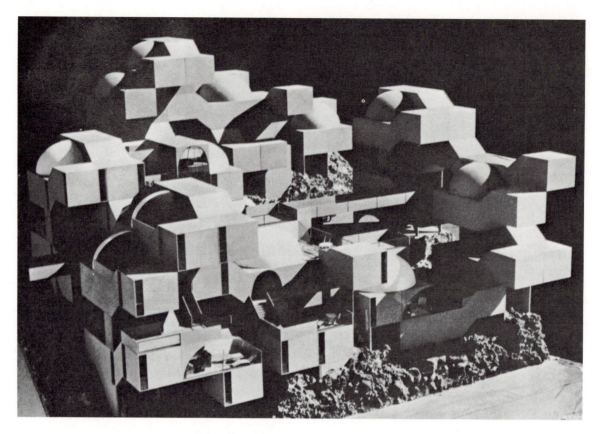

166 Moshe Safdie
MODEL OF HABITAT ISRAEL
1969

Moshe Safdie has designed new answers to urban housing problems. His first notable work was the apartment complex, Habitat, built at Montreal's Expo '67. Safdie's primary concern is for structures that meet human needs in humane ways. In his Habitat Israel, he uses prefabricated modular apartment units that can be stacked in different configurations. Private garden terraces, walkways, and covered parking areas are included. The design allows for a dense population, yet provides many of the advantages of single, unattached dwellings.

167

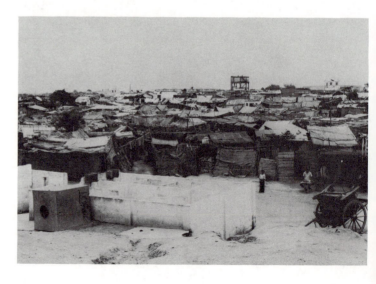

Environmental designer Constantinos Doxiadis points out the need for housing the world's growing population. Showing the accompanying photograph, he says, "The greatest part of humanity lives in conditions similar to these. This is the main architectural problem."[5] It is estimated that 90,000 people live on the sidewalks of Bombay alone.

4

What was art like in the past?

A WORLD VIEW

To me there is no past or future in art. If a work of art cannot live always in the present it must not be considered at all. The art of the Greeks, of the Egyptians, of the great painters who lived in other times, is not an art of the past; perhaps it is more alive today than it ever was. Art does not evolve by itself, the ideas of people change and with them their mode of expression.

Pablo Picasso[1]

Art history is OUR history. It is the story of how human beings have lived, felt, and acted in widely separated parts of the world and differing periods of time. If we open ourselves to looking at art, nothing can speak more directly to us across the years than a painting or carving. We can actually see the tool marks made by a Solomon Islander's hands on a piece of wood, or the brush strokes placed by Rembrandt's hand on a painting. The work of art is a direct physical link between us and the person who molded a clay pot thousands of years ago. Art from the past exists as physical objects, living in the present. The animals painted on the rocks in 4000 B.C. were considered to be "modern art" then. What we call modern today has roots in many cultures, going far back in time.

168 FACSIMILE OF POLYCHROME CATTLE. Jabbaren, Tassili-n-Ajjer, Sahara, c. 4000 B.C. Detail of rock painting. *See color plate 23.*

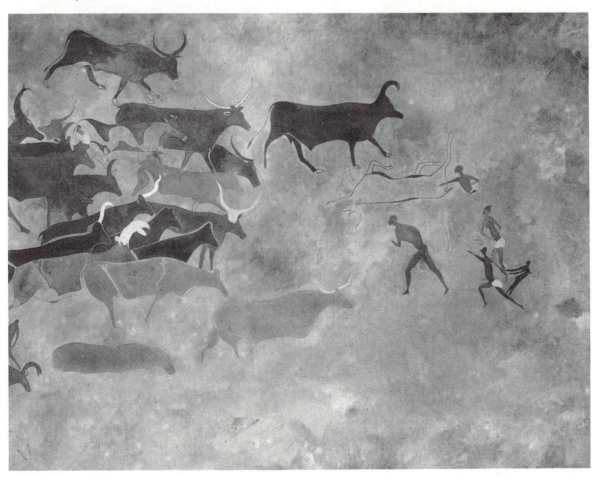

This chapter will provide a glimpse of the attitudes and art of some of these cultures and historic periods, helping us to see how people lived, felt, thought, and expressed themselves. We all tend to be locked into our own beliefs, our own history. The habit of considering our people, language, and history as THE people, THE language, and THE history is as common now as ever, even though today our awareness of other cultures is increasing tremendously through revolutionary communication like satellite television.

An understanding of art of the past helps us see beyond this limited self-interest because works of art embody the essence of their times and places, and are themselves uniquely accessible "facts" of history. Works of art and artifacts are often the only way we can study a culture, so what we know about it is influenced by our understanding of its art. In turn, our sensitivity to art is increased by some knowledge of the culture from which it came.

Separated by time or space from the hardware of technological cultures, humans live and have lived for millennia in close association with the forces of nature. In order to get food, to control their environment in a limited way, they made tools. They also tried, through art, to identify with and control the powerful animals, the energies of wind, rain, and fertility—all the mysteries which surrounded them. In this sense, art is a kind of magic—a form-creating ritual intimately related to what we now call religion. The rock paintings in the Sahara and in Europe may well have been an attempt to gain power over the animals needed for food.

Painting isn't an aesthetic operation; it's a form of magic designed as a mediator between the strange, hostile world and us, a way of seizing the power by giving form to our terrors as well as our desires. When I came to that realization, I knew I had found my way.

Pablo Picasso[2]

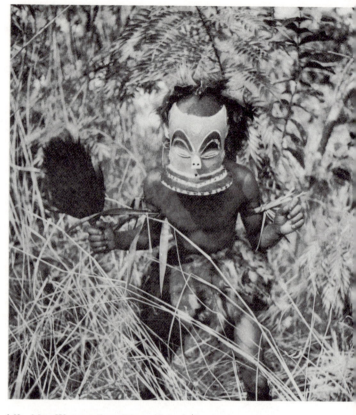

169 MAN WEARING LION MASK. Zaire region, West Africa, c. 1950. Wood.

The man of the Zaire region of West Africa wears a lion mask to symbolize the spirit of the lion. He believes he is a lion. Wearing it, he shares a psychic identity with the animal, receiving some of its power in the process. In highly technological cultures we have cut ourselves off from such associations, depriving ourselves of a basic link with the natural world. But these psychic associations still persist in our unconscious even though we ignore them.

The ivory mask from Benin, Nigeria was carved in the sixteenth century, but modern versions of it are still worn at the oba's (king's) waist during important ceremonies. The crown consists of a row of beads inspired by the strange appearance of Portuguese men. "Civilized" Europeans were amazed when

170 IVORY MASK
Benin, Nigeria
16th century. Height 9″.

Art probably began when early people found pieces of wood, stone, bone, and other objects that were useful as tools. Some of them were no doubt highly treasured. If one was lost, stolen, or broken, another like it had to be found. At that point someone probably realized that it was easier to make a copy than to find a replacement. This was the beginning of man as the maker of things. It was also the beginning of representational art. The first "artist" made a copy or *re-presentation* of the desired object that was no longer available.

After developing this ability to make copies of natural objects, someone must have figured out that a copy could be refined to increase its usefulness. Over a period of many generations, the design of the artifact was refined to the form best suited to its function. This process extracted the tool's essential usefulness from its original natural form and exaggerated that usefulness. The result was an *abstraction* of the original form.

they saw Benin sculptures, palaces, and city plans because they could not imagine how such refined art could come from people they had considered "naked savages" living in mud and straw huts. Europeans believed that these were "tribal" peoples caught in a stage of human development low on the evolutionary scale. Their feelings of superiority can be put in perspective by realizing that the art of Gothic cathedrals was created by the hands of people who also lived in simple huts, and had been looked upon as barbaric tribesmen by the "civilized" peoples of the Mediterranean only a few centuries before.

Some of the earliest signs of the presence of humans on earth were symbolic marks made on surfaces with fingers and tools. Sometimes hands were imprinted or traced on the surfaces of caves. This was one way in which images were recognized and developed. Making marks and recognizing images must have formed the basis on which art developed.

171 POMO STORAGE BASKET. California, 19th century.
Coiled basketry.

172 PAINTED AND GLAZED EARTHENWARE VASE
Ziwiye, Iran, 8th–7th century B.C.
Height 43.5 cm., diameter of mouth 11 cm.

For many people in different times and differing cultures, art fills the gap between what is known and what is felt. Art is magic. It has physical form, yet it contains spirit. In some societies, birds appeared as messengers between the physical world of the living and the spiritual world of deceased ancestors. In the canoe prow from the Solomon Islands, the bird seems to guide the men, acting with them as a protective spirit, watching out for shoals and reefs. (See color plate 22.)

The ancient Chinese bronze container was probably used to hold wine for sacred rites. It depicts a bear or tiger spirit. Because the man's head is almost within the ferocious jaw of the beast, it appears that he is about to be devoured. But his hands are relaxed, and he is holding on to the monster for protection. Perhaps the most fascinating aspect of this work is the contrast between the gentle wonder expressed on the man's face and the aggressive, protective power of the animal.

The sculpture from the Solomons and the Chinese vessel both express man's faith in the power of art to provide safety in a mysterious and threatening world.

After learning to carve tools, early humans discovered how to make baskets and clay vessels for gathering and storing food. Unlike our contemporary society, which refers to useful art as separate from "fine art," there was no separation between art and function in the mind of the potter in the eighth century B.C. who lovingly decorated the jar in Iran. The Pomo Indian woman who wove the intricate designs into the basket, and the woman who made the decorated feathered gift basket enjoyed the process of making them visually pleasing. (See color plate 21.) The surface decoration grew out of the weaving process, incorporating the natural colors and textures of bark, roots, grasses, and feathers into the design. Women were responsible for the highest artistic achievements in the Pomo culture.

173 CANOE PROW ORNAMENT
Maravo Lagoon, New Georgia, Solomon Islands, collected 1929. Wood with mother-of-pearl. Height 6½". Photograph by Axel Poignant.
See color plate 22.

174 CHINESE SACRAL VESSEL. c. 1500–1059 B.C. Cast bronze. Height 14″.

175 FACSIMILE OF CHUMASH INDIAN ROCK PAINTING. Santa Barbara, California area, c. 1500–1900.
Photograph: Campbell Grant.

There is no one line of development in art history. Within a given culture there are progressions toward the perfection of an idea, but these progressions are frequently isolated from one another by time and distance, and by radical shifts in attitude.

A common vocabulary of visual symbols is found in all human cultures. The rock paintings from California and the wall paintings from Jordan are from opposite ends of the world, done about 6,000 years apart. Yet they appear to be variations of a shared symbolic language of visual form. As we study them, we are not troubled by classifications like East or West, ancient or modern. They act as a point of departure for understanding similarity, contrast, sequence, and change in the history of art. Both of them are highly abstract, and in places, nonrepresentational.

All art is abstract in the sense that it is not possible for an artist to reproduce an exact equivalent of what he sees. But what is generally called *abstract art* is art based on preexisting objects, in which the natural image of the subject is changed or distorted. It assumes that there is a communicative value in visual form that exists independent of recognizable subject matter. As a verb, *to abstract* means to take from, to extract the essence of a thing or an idea.

A *representational* work is based on a depiction of the appearance of things, in which objects in the everyday world are presented again or represented. (Also called *naturalistic, realistic,* and *figurative.*)

A *nonrepresentational* work rejects the representation of appearances. It presents a visual configuration without reference to anything outside itself. (Also called *nonfigurative* and

176 Detail of POLYCHROME WALL PAINTING
From house in Teleilat Gahssul,
Valley of the Jordan River, Jordan, c. 4000 B.C.

of fabric with many threads weaving in and out, each becoming part of a continuing tapestry of human history which now is becoming a worldwide experience.

There is a pattern in art history which can be followed back to prehistoric times, showing stylistic changes following one another in cycles. At the same time, there are themes which are reinterpreted in different cultures and periods. Examining some of these themes will show us the manner in which they varied from culture to culture.

EXPRESSIVE ART

Certainly all art is expressive, but when the expression of individual or collective emotion is the most important element in the art, it is usually referred to as Expressionistic.

Joan Miró, in his NURSERY DECORATION, depicted people and animals as simple, abstract shapes in much the same way that the Chumash Indians gave form to their image of the world. Miró's painting is also highly expressive. It suggests both a child's nighttime panic and Miró's response to the horrors of the Spanish Civil War.

nonobjective.) Art terminology is not standardized, but for the purposes of this book these terms are most often used.

At various times in history the emphasis in visual art has been on abstract or representational or nonrepresentational. The Renaissance belief that art should represent the appearance of the everyday world is widely assumed to be the normal approach to art. Yet, if we take a world view of art history, the Renaissance concept is simply a provincial development and not a norm at all. It is a learned way of seeing.

Western art history is like the corner of a piece

177 Joan Miró
NURSERY DECORATION
1938. Oil on canvas. 2'7½" x 10'6".

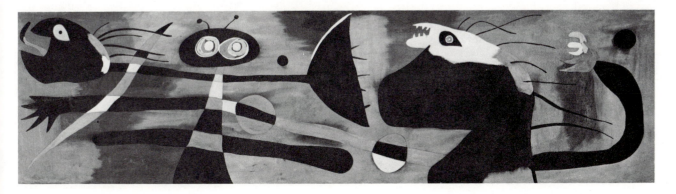

178 STANDING BUDDHA
5th century. Red sandstone. Height 5'3".

The mystical energy and compassion of Christ is given symbolic force in the early twelfth-century relief carving over the central doorway of Saint Madeleine Cathedral at Vézeley, France. The linear folds of drapery covering the figure are different from those of the Buddha, even though the drapery style in both of these carvings can be traced back to Greco-Roman origins. The rendering of the drapery is highly abstract. The folds swirl and eddy in rhythmic patterns that are charged with vitality.

179 Detail of CHRIST OF THE PENTECOST
Saint Madeleine Cathedral, Vézelay, France
1125–1150. Stone. Height of tympanum, 35½".

From early paintings and sculpture to this fifth century Buddha, on into the twentieth century, we find expressive abstractions in art. Early Buddhism, as well as Christianity, did not favor the worship of images. Eventually, however, icons were needed as support for contemplation, so images of the Buddha appeared. Buddhist sculpture varies considerably in style according to the culture that produced it. As Buddhism moved from India to Southeast Asia and across Central Asia to China, Korea, and Japan, it influenced, and in turn was influenced by, the religious and aesthetic traditions with which it came in contact.

The standing Indian Buddha shown here was carved in red sandstone in the fifth century A.D. The simplified mass of the figure seems to push out from within. Its rounded form is set off by a sequence of flowing curves that are repeated rhythmically down across the figure. The drapery seems wet as it clings to and accentuates the round softness of the body beneath. In contrast to the intense energy implied by the linear folds of Christ's robes, these lines express feelings of inner peace achieved through calm communion with universal truth.

In Hindu belief, Shiva is the Supreme Deity, encompassing all things. For this reason Shiva takes various forms in Hindu sculpture. Reproduced here is an image of Shiva as Nātarāja, Lord of the Dance, performing the cosmic dance within the orb of the sun. As he moves, the universe is reflected as light from his limbs.

Movement is implied in such a thorough way that it seems contained in every aspect of the piece. Each part is alive with the rhythms of a dance tradition that has been strong in India for several thousand years. The multiple arms are used expressively to increase the sense of movement.

In his book THE DANCE OF SHIVA, the great Indian art historian Ananda Coomaraswamy poetically describes the nature of Shiva's dance:

In the night of Brahma, Nature is Inert, and cannot dance till Shiva wills it: He rises from His rapture, and dancing sends through inert matter pulsing waves of awakening sound, and lo! matter also dances appearing as a glory round about Him. Dancing, He sustains its manifold phenomena. In the fulness of time, still dancing, He destroys all forms and names by fire and gives new rest. This is poetry; but none the less, science.[3]

180 SHIVA NĀTARĀJA
11th century. Bronze. 43⅞ x 40".

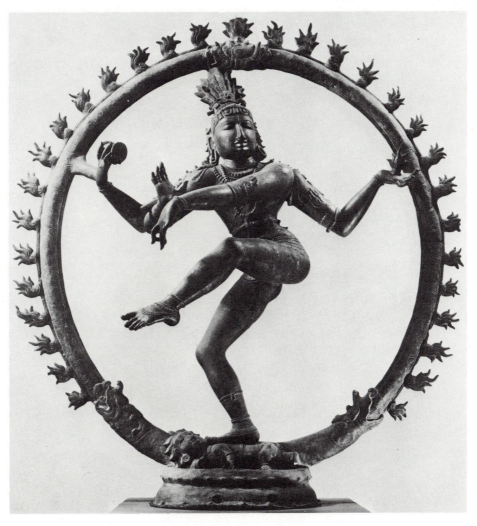

High in the center of the dome of the Monastery Church at Daphne, Greece, there is a Byzantine mosaic depicting Christ as the Ruler of the Universe. This awesome spiritual work, created in the eleventh century, is one of the most powerful images of Christ in existence. The huge scale of the figure emphasizes its religious importance to the worshipers. Christ appears within a circle against a gold background. The artist has exaggerated the features of His face with bold, black outlines. The large eyes, nose, and mouth work together to form an expression of omnipotence. This flat, linear symbol of Christ as Divine Ruler was

designed with such skill and feeling that it has become an image of lasting strength and appeal.

A row of windows circles the base of the dome, giving light to the church. The mosaic surfaces depend on the direction of light from the windows and from artificial sources such as candlelight. Each small tessera—glass, marble, shell, or ceramic—was placed on the adhesive surface, carefully tilted to catch the light. This produced a shimmering, luminous surface.

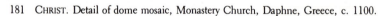

181 CHRIST. Detail of dome mosaic, Monastery Church, Daphne, Greece, c. 1100.

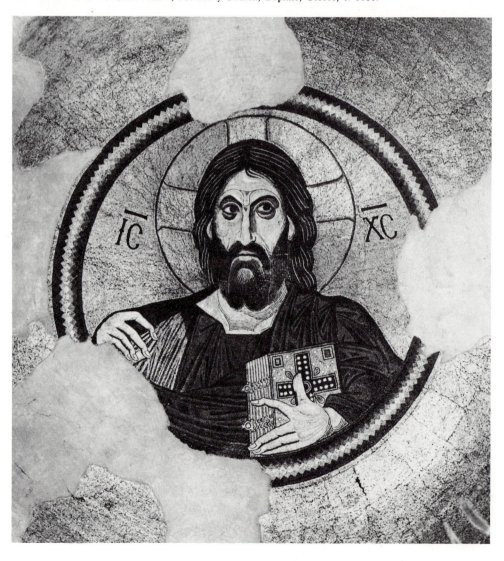

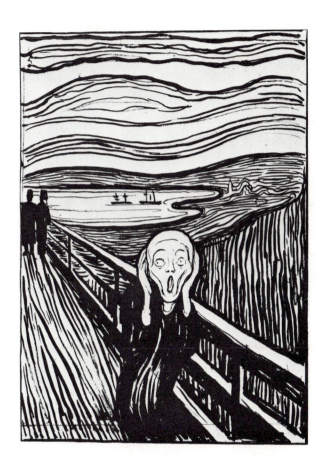

182 Edvard Munch
THE SHRIEK
1896. Lithograph. $20^{11}/_{16}$ x $15^{13}/_{16}$".

With this powerful image, we see Expressionism used in a totally different but no less powerful way than in the religious sculpture at Vézelay. (See page 140.)

Edvard Munch, a Norwegian, traveled to Paris to study and view the works of his contemporaries, especially Gauguin, van Gogh, and Toulouse-Lautrec. What he learned from them, particularly from Gauguin, enabled him to carry Expressionism to an even greater level of intensity.

His great work, THE SHRIEK, was completed in at least two versions—as a painting and as a lithograph. It is difficult to imagine a more powerful image of anxiety. The major human figure could be anyone caught in complete isolation, fear, and loneliness. Despair reverberates throughout the picture, carried by continuous linear rhythms.

SOCIAL ARCHITECTURE

As early humans left their nomadic lives behind them and settled into agricultural society, life became more stable. Religious impulses and the power of the priest-kings led to large buildings which required coordinated community efforts to achieve. Thousands of Egyptians worked on temples and pyramids. Buildings on the Acropolis in Athens consumed a large part of the city's funds.

The city-state of Athens was the center of ancient Greek civilization when the culture was at its height. Above the city on a large outcropping of rock called the Acropolis, the Athe-

In differing ways, the Buddhist, Hindu, and Christian images expressed deep religious emotions—feelings which were shared by devout followers. Frequently, the figures were placed in religious buildings to instruct the faithful, or to direct their thoughts toward worship or contemplation.

At the end of the nineteenth century in Western Europe, art centered on individual humans and their feelings, rather than on representations of religious figures revered by large cultural groups. The significant art of the time was rarely used in public buildings to evoke collective responses. The artist felt alienated from the industrial and commercial society around him, and his work reflected this alienation.

183 Ictinus and Callicrates. PARTHENON, View from northwest.
Athens, Greece, 447–432 B.C.

nians built one of the world's most admired structures. Today, even in its ruined state, the Parthenon continues to express the high ideals of the people who created it.

This temple, one of several sacred buildings on the Acropolis, was designed and built as a gift to Athena Parthenos, protectress of the Athenian navy, goddess of wisdom, arts, industries, and prudent warfare. It expressed the gratitude of the Athenians for naval and commercial success.

The Parthenon exhibits the refined clarity, harmony, and simplicity that come from the heart of the Greek tradition. The relationship of its parts is similar to the democratic structure of the Greek city-state and it reflects the Greek ideal of human proportion found in the sculpture of the same period. When Ictinus and Callicrates designed the building, they were following a well-established tradition in temple design. The Greeks spent generations improving their basic architectural vocabulary. In the Parthenon the Greek temple form reached a state of perfection.

It was the focal point for large outdoor religious festivals. Rites were performed on altars placed in front of the eastern entrance. The interior space was designed to house a forty-foot high statue of Athena which laymen were permitted to view through the eastern doorway. Only temple priests were allowed inside.

The architects took advantage of natural light in designing the building. The axis of the building was carefully calculated so that on Athena's birthday the rising sun coming through the huge east doorway would fully illuminate the gold-covered statue.

Greek temples have been copied for centuries. Sometimes they are used for religious buildings, but more often for commercial or governmental structures which have nothing to do with the original purposes of the Greek temple design. The MERCHANTS' EXCHANGE is an example of nineteenth century Greek revival architecture.

The Romans were empire builders, and although some of their religious buildings, like the Pantheon (see page 146), were impressive, their most characteristic contribution was in the development of large engineering projects.

The Romans built roads and waterways over much of southern Europe. The aqueduct called le Pont du Gard at Nimes, France, shows how the Romans used the arch as a basic structural device to create functional forms of great beauty. The first level of the high structure served as a bridge for foot traffic, while water was carried in a conduit at the top.

184 MERCHANTS' EXCHANGE. Philadelphia, 1832–1834.

185 LE PONT DU GARD. Nimes, France, A.D. 15 Limestone. Height 161′, length 902′.

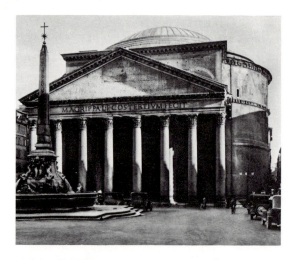

186 PANTHEON
Rome, 118–125. Concrete and marble.

The Pantheon was built to house images of all the Roman gods. Its simplicity of design and its immensity make it one of Rome's most important buildings. The walls of the circular concrete and brick building are fourteen feet thick, to support the huge dome which is constructed of horizontal layers of brick set in mortar. These are reinforced by a series of arches that converge in the dome's crown, leaving a central opening called an *oculus*.

Another domelike structure, the Buddhist Stupa of Sanchi in India, is solid. Its form echos the sensuous contours of the hills around it. The devout circumambulate it, following the direction of the sun, thereby physically experiencing the building. Developed from early burial mounds, its mass symbolizes the world mountain.

187 THE GREAT STUPA
Sanchi, India, c. 10 B.C.–A.D. 15

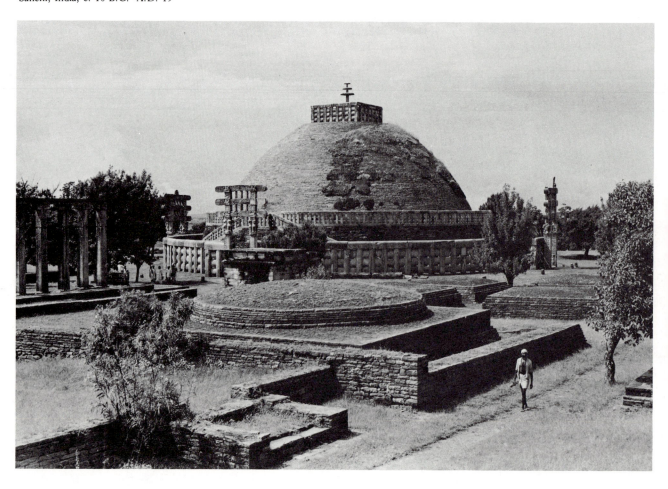

In Europe, during the early Middle Ages, the stone arch of Roman architecture influenced the development of new forms. Stone vaults replaced fire-prone wooden roofs, allowing the new structures to span wider spaces more safely. Walls were heavy in order to counteract the thrust of the vaults, and the small windows let in little light. These fortresslike Romanesque churches and monasteries offered Christians refuge in a hostile world.

In the mid-twelfth century, the pointed arch was developed. Combined with the ribbed groin vault and the flying buttress, it allowed for greater interior height and larger window spaces. The buttresses carried the tremendous weight of the vault laterally and downward to the ground, relieving the walls of some of their load-bearing function, making possible *curtain walls* of stained glass which filled the interior with rich luminous color.

The entire community worked on a church like Notre Dame de Chartres, but the people who began its construction never saw it in its present form. In continued to change and grow for more than 300 years. There is no quarrel between art and engineering in the Gothic cathedral. They are one.

In Italy during the fourteenth and fifteenth centuries art and architecture reflected a developing humanistic philosophy. *Renaissance* means "rebirth" in French, and describes the great revival of interest in the art and ideas of ancient Greece and Rome.

The Italian artist Filippo Brunelleschi studied Roman ruins and developed a new architectural style expressing the dignity of man rather than the omnipotence of God. His design for the Pazzi family chapel became a model for an architectural style that spread throughout Europe. Completely breaking with the Gothic tradition, its balanced horizontal and vertical forms are totally different from the soaring vertical thrusts of Gothic cathedrals. With it, Brunelleschi brought rational clarity and a more human scale back to architecture.

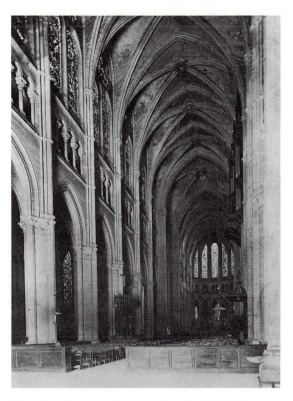

188 NOTRE DAME DE CHARTRES. France, 1145–1513. Interior. Nave, approx. height 122', width 53', length 130'.

189 Filippo Brunelleschi
PAZZI CHAPEL. Florence, 1429–1430.

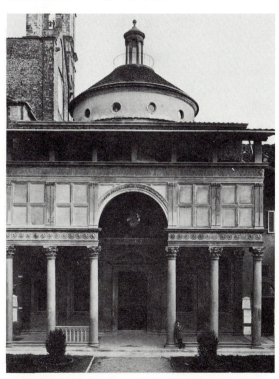

190 INTERIOR OF A MANEABA
Drumond Island, Gilbert Islands, 19th century

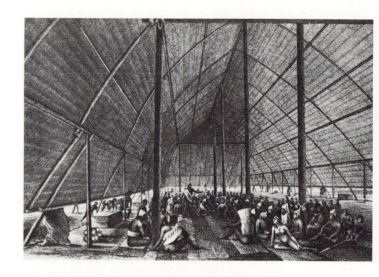

Gothic cathedrals, such as Chartres, were the center of community life. They were used as meeting places for people doing business, for lovers, for lectures, and concerts apart from their sacred role.

Throughout history, related structures have performed these important functions. Rituals and community activities took place in the great meeting halls in the Gilbert Islands. As trade developed, there was a need for sheltered areas where people could gather to sell, buy, and socialize. The Greeks built covered walkways around large open spaces, providing shelter from the sun. In rainy medieval Europe, large wooden buildings with open sides provided multipurpose shelter without inhibiting foot traffic.

Nineteenth-century Europe inclined toward the revival of various historical architectural styles such as Greek and Roman for its cultural, governmental, and commercial activities. But in 1850 an unusual building was created for an international industrial exhibition in England. Joseph Paxton used the new methods of the industrial age, prefabricating iron, glass, and wooden sections to be assembled at the building site. Paxton's successful innovation provided the background, renewing the concept that the function of a building should be expressed in its form. This became the basic architectural ideal of the twentieth century.

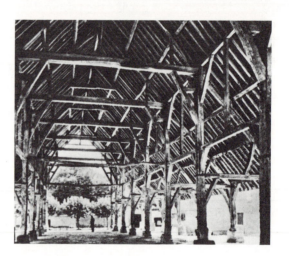

191 MARKET HALL AT MEREVILLE, France
15th century

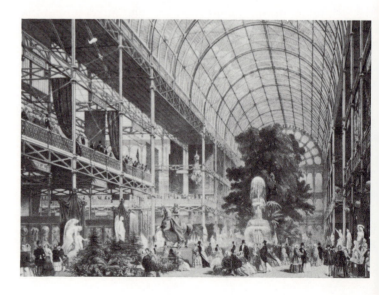

192 Sir Joseph Paxton. CRYSTAL PALACE.
Interior view. 1850–1851. Cast iron and glass.
Width 408′, length 1,851′.

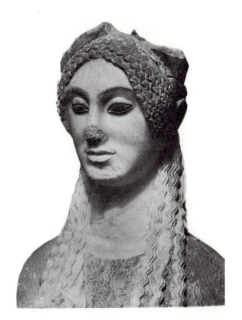

193 Detail of KORE 674.
Athens, Greece.
c. 500 B.C. Painted marble.

HUMAN FACES

The human face, with its infinite variety of expression, has fascinated sculptors throughout history. We can learn a great deal about the way people of differing cultures saw themselves by looking at their representations of faces.

Sometimes the portraits were individual humans; sometimes they were idealizations of humanity, representing gods. Often they were, like this early Greek *kore* (maiden), dedicated to the sanctuary of a god or goddess. Some of the original bright paint with which all Greek sculpture was covered remains on the face of this young girl from the Acropolis in Athens, giving her smile an added vitality.

A detail of the head of the god Hermes, finished about 330 B.C., shows the famous classical Greek ideal profile. This does not represent a man, but rather a godlike man, seen again and again in Greek sculpture. The ideal man and woman were, for the Greeks, the link between themselves and what they believed to be the basic order of the universe. They saw the gods in their own images.

194 Praxiteles
Detail of HERMES AND THE INFANT DIONYSIUS
c. 330–320 B.C. Marble. Height 7'1".

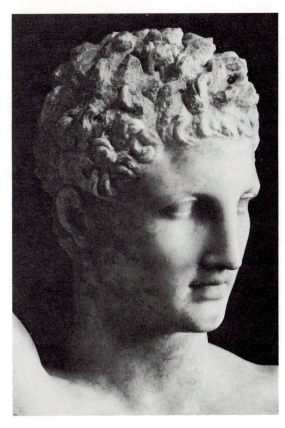

In the Hellenistic period (323–100 B.C.) following the decline of classical Greek culture, sculpture became more dynamic and more representational. Portraiture was more common than in the earlier periods. This portrait head, part of a full-length statue of an unknown individual, is not an abstract god-hero, but a mature human personality. The sculptor depicted the inner man and his personal emotions. These portraits were generally commissioned by wealthy merchants for their own satisfaction, not to please the gods.

The Romans were a practical and materialistic people, and their art reflects this. Many pieces of Greek sculpture were brought to Rome as trophies of war, and a process was devised by the inventive Romans to copy them. Greek artists were enslaved to create the ornate and sensual forms demanded by private Roman citizens, as well as to teach Roman artists their techniques.

But not all Roman art was imitative. Roman portraiture achieved a high degree of individuality rarely found in Greek sculpture. This representational style probably grew out of the Roman custom of making wax death masks for the family shrine. Later, these images were recreated in marble to make them more durable. Roman sculptors keenly observed and recorded those physical details and imperfections that gave character and individuality to each person's face.

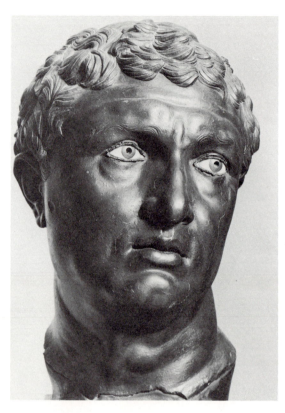

195 PORTRAIT HEAD
c. 80 B.C. Bronze. Height 12¾".

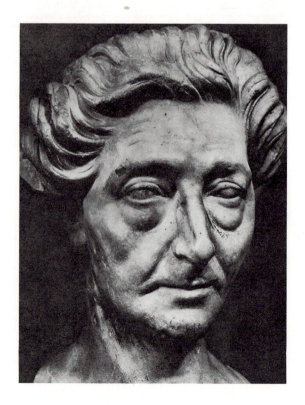

196 FEMALE PORTRAIT
54–117. Marble. Life-size.

Throughout most of Japan's history its sculpture was stylized and simplified. With the aggressive militarism of the Kamakura period (A.D. 1185–1333), a new style of art emerged which emphasized realism. One of the greatest artists of the time was the sculptor Unkei. His portraits are made of thin pieces of wood that have been joined, carved, and painted.

In contrast to the calm visage of Muchaku, the detail of the face of Michelangelo's David re-

veals an inner struggle. Possibly it represents the anxiety created by the new Renaissance humanism in which humanity, rather than God, becomes the center of the universe.

Thus, we can see how, in different cultures and different historical periods, the sculptor's image of the human face reflects that culture's self-image and the value which it gave to the individual.

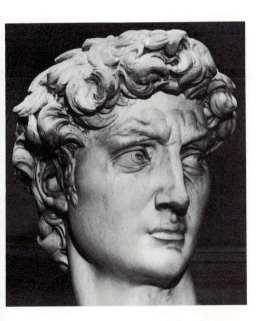

197 Michelangelo. DAVID.
1501–1504. Marble. Height 18'.
Detail.

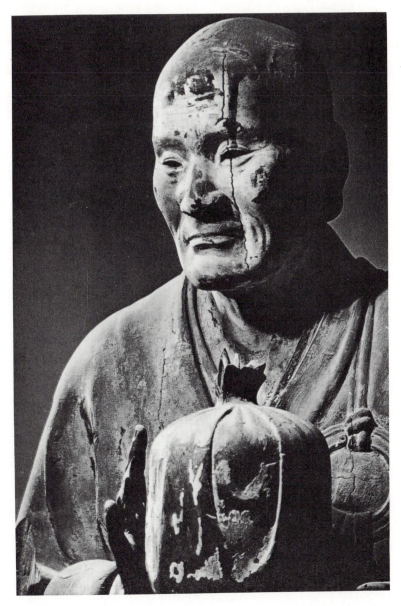

198 Unkei. Detail of MUCHAKU. c. 1208.
Wood. Height 75".

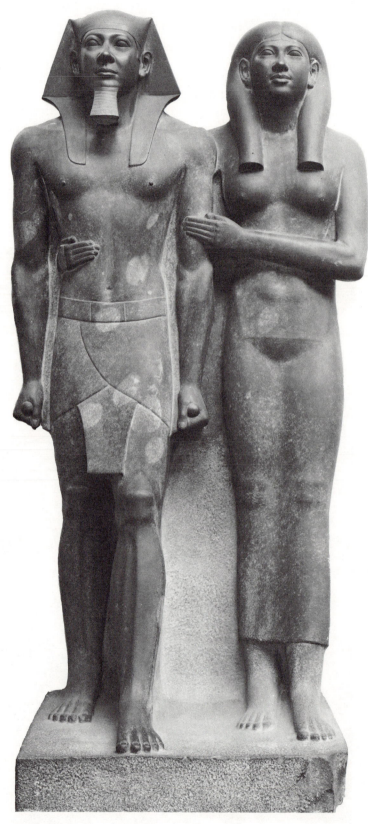

199 KING MYCERINUS AND QUEEN. c. 2525 B.C. Painted slate. Height 4′8″.

200 MAN PLAYING A SYRINX
Cyclades Islands, Greece, 2600-2000 B.C.
Marble. Height 10½".

HUMAN FIGURES

The human figure has been a subject for
sculptors throughout history. As we have seen,
some treated it either in an expressive or rep-
resentational manner. Others adopted a more
simplified approach. Highly abstract stone
carvings believed to be fertility figures were
found in prehistoric caves. In many parts of the
world similar clay figures were fashioned at an
early stage in human history.

We know little about the life and traditions of
the Bronze Age people who inhabited the Cyc-
lades, a group of islands near Greece in the
Aegean Sea, from about 2600 B.C. to 1100
B.C. The only evidence of this culture in-
cludes numerous nude marble figures found in
simple stone tombs. These carved figures range
in size from a few inches in height to life size.
Most of them are female. Both male and
female figures were refined to a sophisticated
geometric abstraction of human form. The
one shown here depicts a man playing pan-
pipes. The strong frontality in this work is typi-
cal of Cycladic sculpture.

Geometric abstraction is also apparent in the
Egyptian sculpture of Mycerinus and his
queen, done about 2500 B.C. The sculptor
paid considerable attention to human
anatomy, yet he stayed within the traditionally
prescribed geometric style, thus making his
figures representational, as well as expressing
strength, clarity, and lasting stability.

The couple is locked together in a frontal pose
that had been established for such royal por-
traits. The base reveals the shape of the slate
block from which the figures were carved,
while the presence of the original block is still
felt in the overall attitude of the figures.

From the late seventh to the late fifth century B.C., Greek art revealed influences from Egypt and the Near East in life-sized male and female figures. They followed the rigid frontal position which is a direct adaptation of the stance of Egyptian figures. However, this *kouros* (youth) is not attached to the original block of stone as are the Egyptian figures. It is free-standing. The Greeks were primarily concerned with perfecting physical life and the human body. The so-called archaic smile on his face accentuates a quality of aliveness not found in Egyptian sculpture.

Within 100 years after the date of the *kouros* figure, Greek sculpture became increasingly active and natural. The bronze SPEAR BEARER by Polyclitus was cast about 450 to 440 B.C. This marble Roman copy demonstrates the full awareness of anatomy and ideal proportions that the sculptor brought to his work. It is an example of the completely developed classical Greek style. The SPEAR BEARER does not stand at attention with the left leg forward as the Egyptian and early Greek figures did, but tilted so that the hips and shoulders are no longer parallel. This flexible pose created a more relaxed human stance. The major divisions of the body are set off from one another in a natural balance.

Much later, during the Italian Renaissance, Michelangelo Buonarroti carved the eighteen-foot David from a single block of marble. We identify with David, for he represents man—man as he rediscovered himself in the Renaissance. Imagine looking up at his tremendous figure. Although the influence of Greek sculpture is apparent, it is certainly not an idealized Greek figure. David appears genuinely concerned with whether or not he can defeat the giant Goliath.

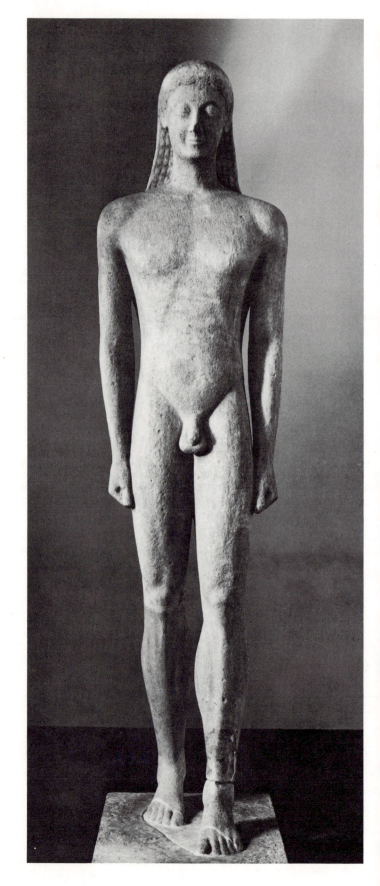

201 STANDING YOUTH
Melos, Greece, c. 540 B.C. Marble.

Color plate 27
Vincent van Gogh
THE SOWER
1888. Oil on canvas.
17⅞ x 22½".

Color plate 28 Paul Gauguin. Two Nudes on a Tahitian Beach. 1892. Oil on canvas. 35¾ x 25½".

Color plate 29
Georges Seurat
SUNDARY AFTERNOON
ON THE ISLAND OF LA
GRANDE JATTE.
1884–1886.
Oil on canvas.
81 x 120⅜".

Color plate 30
Paul Cézanne
MONT SAINTE-
VICTOIRE.
1904–1906.
Oil on canvas.
25⅝ x 31⅞".

Color plate 31 Gustav Klimt. THE KISS. 1908. Oil on canvas. 71 x 71″.

202 Michelangelo. DAVID.
1501–1504. Marble. Height 18'.

203 Polyclitus
SPEAR BEARER
c. 450–400 B.C. Copy in marble. Height 6'6".

204 Joachim Patinir. REST ON THE FLIGHT INTO EGYPT. 1515–1524. Oil on wood. 6¾ x 8⁵/₁₆″.

205 Jacob Isaac van Ruisdael. WHEATFIELDS. c. 1670. Oil on canvas. 39⅜ x 51¼″.

206 Wang Hui
DEEP IN THE MOUNTAINS
1692. India ink and pale color on paper.
43¾ x 19⅛".

LANDSCAPE

Works of art can also reveal varying human attitudes toward the environment. In all three of these paintings, human figures are humble in scale, becoming an integral part of the natural environment.

Joachim Patinir was probably one of the first Europeans to treat landscape as the main subject. Earlier, landscape had been merely a background for religious scenes. Patinir's subject is still religious, but the landscape becomes more important than the figures of the Holy Family.

The Dutch painter Jacob van Ruisdael invites us to take an imaginary walk into his painting. The great spaciousness of the cloudy sky sets off the seemingly endless flow of the land. Space is a major element, and everything in the picture emphasizes its vastness.

Wang Hui's painting comes late in a Chinese tradition which lasted more than 1,000 years. In this tradition, man is only a small part of the universe, while nature is seen as consisting of powerful alternating positive and negative forces. When man is humble he fits comfortably within these universal forces and becomes one with nature.

Wang Hui followed the brush conventions of earlier Chinese masters. Each stroke of the brush derives from calligraphy and is a symbol of a natural form. The artist tried to be sensitive to the forces of nature so that his spirit would become right and strong, allowing his insight and vitality to pass through the work to the viewer.

In later European painting, the shifting light of the outdoors was the main preoccupation of a whole school of painters, the Impressionists. (See page 170.)

BEYOND THE KNOWN WORLD

The large herds of big game roaming Europe thousands of years ago were the major source of food which early man had to hunt in order to survive. On the curving surfaces of cave walls the hunter-artist discovered animallike rock formations which were frequently emphasized by drawing, painting, or carving. Animals, large and small, were painted in a representational style. The images were based on keen observation. Paleolithic man must have gained confidence by creating images of the creatures that were so crucial to his life. By doing this, man himself advanced from creature to creator. (See color plate 24.)

These paintings, generally considered to be magical or ritual art, were probably man's way of dealing with the overwhelming struggle to survive, and with his own sense of helplessness before forces he could neither control nor understand.

In the same way, Navajo sand painting is a way of influencing unknown forces affecting the health of the human body.

208 NAVAJO SAND PAINTING

207 FOREQUARTERS OF BULL,
Lascaux Caves, France
15,000–10,000 B.C.
See color plate 24.

Giotto di Bondone was part of a changing attitude toward religion developing in Italy in the early fourteenth century. Gothic art had been dominated by a belief in a heaven-centered religion. New interest in Greek and Roman thought led to a more human-centered vision of the world. Giotto turned away from the flat, stylized images of medieval painting to a three-dimensional naturalism which reached full maturity in the Renaissance.

209 Giotto di Bondone. THE DESCENT FROM THE CROSS.
c. 1305. Fresco. 78¾ x 78¾".

Giotto's people appear as sculptural forms in
an implied space that seems continuous with
the space we occupy. Their expressions show
personal responses to the death of Christ. From
his work came the tradition of making a paint-
ing like a window looking out on nature. This
form of treatment was not radically challenged
until the development of Cubism in the early
twentieth century.

A completely different type of religious image
has been generated more recently by the ideals
of Zen Buddhism. Priest and painter Sengai is
now famous for his direct and forceful visual
epigrams of Zen thought. (See also page 64.)
This one depicts the story of Rinsai, who,
when he experienced enlightment, struck his
teacher.

210 Gibon Sengai
THE FIST THAT STRIKES THE MASTER
c. 1800. Ink on paper.

211 Leonardo da Vinci. THE LAST SUPPER. c. 1495–1498. Fresco. 14'5" x 28'¼".

The new spirit of Renaissance humanism is revealed by comparing THE LAST SUPPER with the Byzantine mosaic of Christ (see page 142). The Byzantine Christ is far away in a dome; Leonardo's Christ is sitting across the table at eye level. The Byzantine mosaic is an abstract icon. Leonardo, however, wanted to paint a likeness of Christ in an earthly setting so he placed THE LAST SUPPER in a Renaissance interior. In his painting the natural world of everyday appearances becomes one with the supernatural world of divine harmony. The style of the work could be defined as representational on the surface, but as geometric abstraction within. The painting relates to classical Greek art in which representational Naturalism is organized according to rules of proportion, based on geometric harmonies.

We find ourselves looking into the image of a real room, just after Christ declares, "One among you will betray me." The Apostles are deeply shaken by this accusation, yet, in spite of their agitation, the overall feeling of the painting remains calm. This calm seems to emanate from the quiet figure of Christ, but the background contributes to this feeling.

The interior space is based on a one-point linear perspective system, with the single vanishing point, infinity, exactly in the middle of the composition, behind the head of Christ. This places Christ directly in front of the point of greatest spatial pull.

In his TREATISE ON PAINTING, Leonardo wrote that the "figure is most praiseworthy which by its action best expresses the passions of the soul."[4] In contrast to the distraught figures surrounding Him, Christ is shown with arms outstretched in a gesture of submission which makes His image appear as a stable triangular shape expressing eternal calm.

SECULAR ART

Another major painting completed in Italy in the late fifteenth century is Sandro Botticelli's BIRTH OF VENUS. Gothic and Greek styles are brought together here in a new synthesis. In this painting the Roman goddess of love is gently blown to shore in a large shell, propelled by two zephyrs. By centering the figure of Venus, Botticelli placed her in the position of importance which had been held for centuries by the Virgin Mary. Church patronage was still important, but many patrons such as the Medici, who commissioned this painting, hired artists to sculpt and paint for their homes. These patrons were influential men of politics and commerce who were not interested solely in sacred subjects.

We are more enchanted with the vitality of Venus than by the myth about her. Botticelli understood anatomy, light, and color. He also understood how to achieve great lyric beauty by keeping the background relatively flat and by distorting the figures to emphasize their grace. The many flowing lines add life and movement to the painting, while the vertically curving figure of Venus contrasts with the horizontal line of the sea.

The artist expressed the Renaissance spirit in his humanistic treatment of "pagan" subject matter. The human body became the true subject, painted with sensuous joy.

212 Sandro Botticelli. BIRTH OF VENUS. c. 1490. Tempera on canvas. 5′8⅞″ x 9′1⅞″. *See color plate 7.*

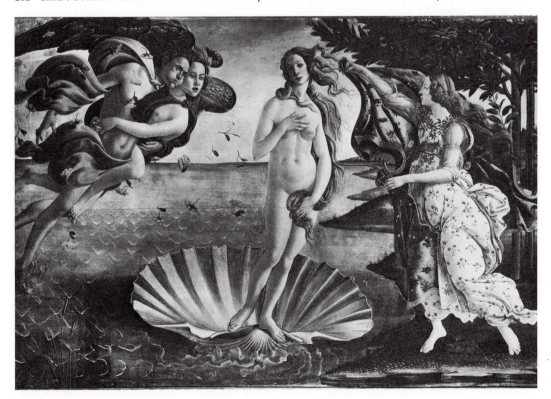

As we move into what is called the High Renaissance, secular subjects become more popular, and humanity becomes at least as important as divinity. This portrait of Marco dei Vescovi was painted by his grandaughter, Marietta Tintoretto, daughter of the painter Jacopo Tintoretto. It was long believed to have been painted by her father, but in 1920 her initial was discovered on it. It represents a complete change from the Gothic view of humanity facing the day of judgment when sinners were sent to the flames of hell. Here we have a loving portrait of two generations—the inward-looking old man, and the young boy looking out toward the life ahead of him. Marietta Tintoretto's life itself illustrates the new importance of the individual. Taught by her father, she was able to achieve international fame, and was invited to the French and Spanish courts. However, she married a jeweler and remained in Venice working with her father until her death in 1590.

The secularization of art continued throughout the seventeenth century.

Vermeer and Rembrandt in the Low Countries (color plate 2 and 61) painted portraits of the wealthy, and the rich interiors of merchant homes. Velázquez, in Spain, was painter to the royal family, excelling in rendering them in their silks and satins. (See page 23.) There was, of course, religious art. Rembrandt's etchings of the life of Christ were strong religious statements. (See page 88.) But art no longer relied wholly on the church for its support. In fact, most art was commissioned by the wealthy and the aristocracy. By the early eighteenth century, painting had become either a decorative and frivolous adjunct to their lives, or a solemn recording of their pretentious faces.

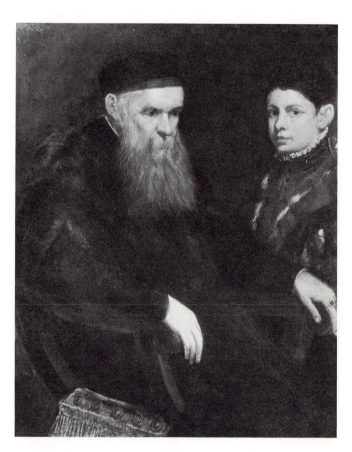

213 Marietta Tintoretto.
PORTRAIT OF AN OLD MAN
AND A BOY.

The light, airy colors of the Rococo style in France were particularly suited to the escapist life of the court. Elegantly paneled interiors of palaces and wealthy homes were decorated with golden shells, garlands of flowers, and gay paintings. The word *rococo* comes from the French word *rocaille*, which refers to the shells and rocks used for ornament in garden grottos. The curved shapes of the shells were copied in architectural ornament and furniture, and also influenced the billowing shapes in paintings.

It was a period known as the Enlightenment or the Age of Reason. Reason was a mental faculty that could be developed by those who chose to do so. It did not mean cold intellectuality, for it encompassed common sense, good

judgment, the development of taste, and the ability to question freely. It was during this time that the fruits of rationalism — scientific knowledge and the ideals of freedom — became available to the people. The artistic creations of this period are highly irrational — an apparent contradiction — yet their curving natural forms express the new sense of freedom. This luxurious life of the aristocracy ended abruptly with the French Revolution.

The early work of the Spanish painter, Francisco Goya, was influenced by the French Rococo, yet beneath this light style, his personal insight and intensity asserted itself. Goya was well aware of the French Revolution, and personally experienced some of its aftermath.

Because his sympathies were with the French Revolution, Goya welcomed Napoleon's invading army. He soon discovered that this

214 Jean-Honoré Fragonard
THE BATHERS
c. 1765. Oil on canvas. 25¼ x 31½".

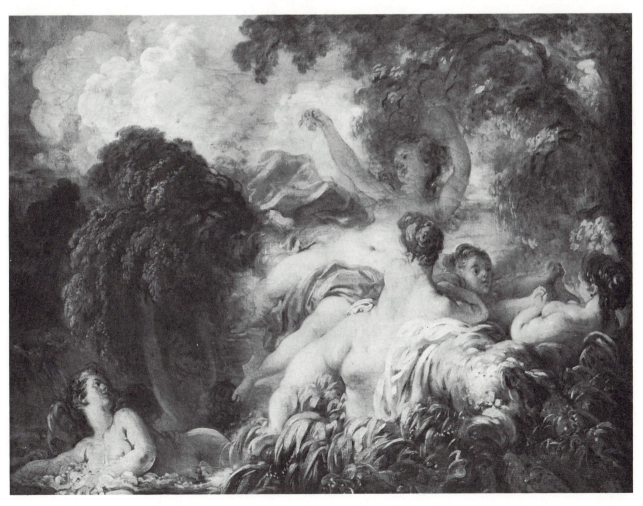

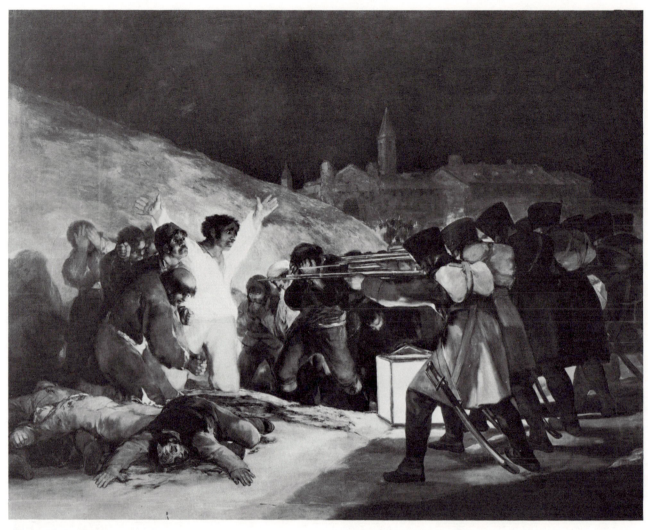

215 Francisco Goya. THE THIRD OF MAY 1808. 1814. Oil on canvas. 8'9" x 13'4".

army of occupation was destroying rather than defending the ideals he had associated with the revolution. Madrid was occupied by Napoleon's troops in 1808. On May 2, a riot occurred against the French in the Puerto del Sol. Officers fired from a nearby hill and the cavalry was ordered to cut down the crowds. The following night a firing squad was set up to shoot anyone who appeared in the streets. These events marked the beginning of a sequence of brutalities that were to be vividly and bitterly expressed by Goya in his powerful indictment of organized murder. THE THIRD OF MAY 1808 was painted in February 1814.

The painting is large — eight feet, nine inches by thirteen feet, four inches — and yet it is so well conceived in every detail that it delivers its meaning in a single, visual flash. Throughout the long hours necessary to complete such a large work, Goya maintained the intensity of his original feelings. The essence of the scene is organized and given impact by bold patterns of light and dark. A wedge of middle value is formed by the edge of the hill and the edge of the lighted area on the ground. This wedge takes our glance immediately to the soldiers. From their dark shapes we are led by the light and the lines of the rifle barrels to the man in

white. The entire picture is focused on this man in the white shirt. As more people are forced into the light for execution, he raises his arms in a final gesture of defiance. The irregular shape of his shirt is illuminated by the hard, white cube of the soldier's lantern. Cold regularity marks the faceless firing squad, in contrast with the ragged group forming the target.

Goya was appalled at the massacre. Although it is not known whether he saw this particular incident, he did see many similar brutalities. His visual sensitivity, magnified by deafness, made war experience all the more vivid. The painting is neither an heroic reconstruction of history, nor a glorified press photograph. It is history—clarified, intensified, and given lasting form through art.

In contrast to Goya's intense political statement, Couture's huge painting, ROMANS OF THE DECADENCE, is a romantic subject in a neoclassical setting, typical of nineteenth-century French academic art. Academic art follows formulas laid down by an academy or school. This painting represents the dying gasp of concepts that had been worked and reworked since the Renaissance. Couture was a success because he fed the sexual needs produced by Victorian society. As they looked at the painting, they could allow themselves to enjoy it sensuously because it was clearly intended as a moralizing picture. But vast changes in art were about to topple the influence of the Academy.

216 Thomas Couture. ROMANS OF THE DECADENCE. 1847. Oil on canvas. 15'1" x 25'4".

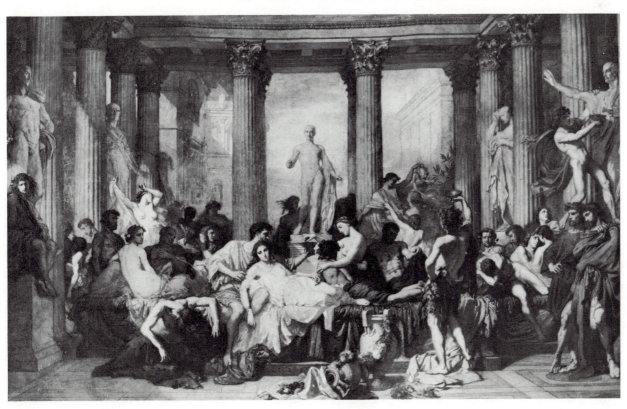

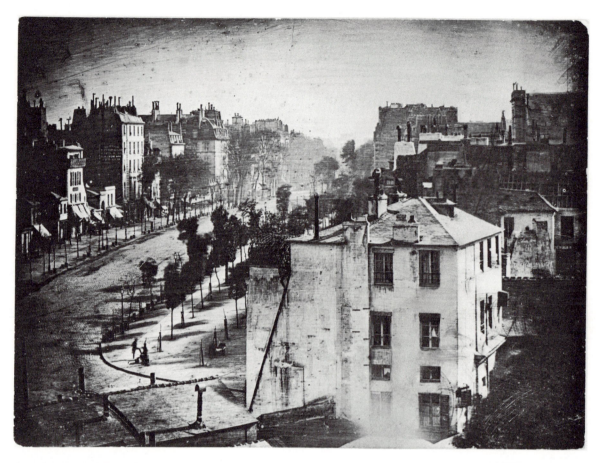

217 Louis Jacques Mandé Daguerre
LE BOULEVARD DU TEMPLE
Paris, 1839. Daguerreotype.

THE CAMERA

The nineteenth century also brought with it the Industrial Revolution, whose inventions completely changed the daily life of Western Europe. One which greatly affected art was the development of the camera. Photography emerged as a visual medium in its own right during the third decade of the nineteenth century. In 1826, Joseph Nicéphore Niepce had produced the first true photograph by holding an image made with light on a sheet of pewter. During the following decade, Louis Jacques Mandé Daguerre perfected the system for fixing a light-created image on the flat surface. The images produced by this process were known as daguerreotypes.

At first, photography could only be used to catch images of stationary objects. Then exposure time went from hours down to minutes. In this view of Paris in 1839, the streets appear deserted because moving figures made no lasting light impressions on the plate. However, one man, having his shoes shined, stayed still long enough to become part of the image. You can see him in the lower left, one of the first humans to appear in a photograph. It was a great moment in history. Now images of actual things could be recorded without the skillful hand of an artist, who was in this way freed from the role of recording visual appearances. Some artists felt that the new medium constituted unfair competition that spelled the death of art, but actually it marked the beginning of a period when art once again would become accessible to all.

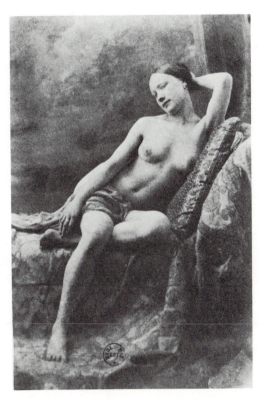

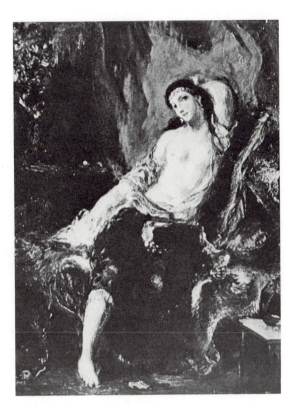

218 Eugène Delacroix
PHOTOGRAPH FROM ALBUM. 1855.

219 Eugène Delacroix. ODALISQUE.
1857. Oil on canvas.

The French romantic painter Eugène Delacroix was one of the first to recognize the difference between camera vision and human vision. He understood the unique qualities of each. He saw the camera and the photograph as a benefit to artists. Delacroix drew and painted from daguerreotypes and paper prints. He could set up a composition and have it photographed. He saw the daguerreotype as a mirror of the object in which details, usually overlooked when drawing from nature, reveal their true character in light and shade. Thus, a photograph rather than a drawing became the basis for a painting.

Thomas Eakins' photograph of a man making a running jump is more interesting historically than as a work of art, yet it was a key step toward cinematic vision in which motion becomes a major element.

220 Thomas Eakins. NUDE ATHLETE IN MOTION. 1884–1885.

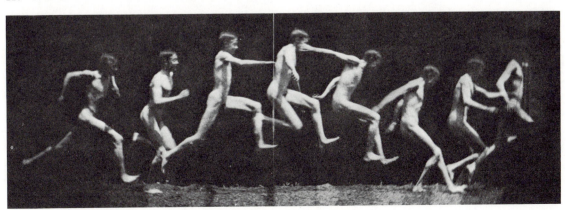

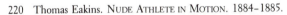

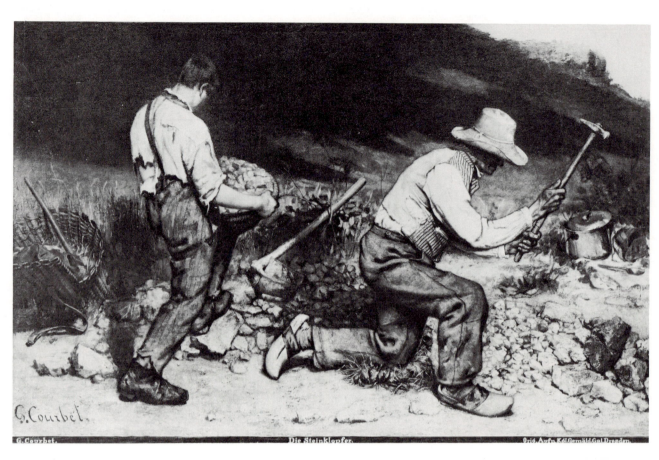

221 Gustave Courbet. THE STONE BREAKERS. 1849. Oil on canvas. 5′5″ x 7′10″.

NEW WAYS OF SEEING

In a total rejection of romantic and neoclassical formulas, Gustave Courbet neither idealized the work of breaking stones, nor dramatized the struggle for existence. He simply said "Look at this." His style of stark realism focuses on representing an equivalent of the retinal image. This approach had been used before the nineteenth century, notably in Flemish and Dutch painting. But in the 1850s Courbet gave this style new vigor by employing direct technique and objective vision to represent images of contemporary life. Portable, slow-drying oil colors became available in 1841 with the invention of the collapsible tin tube. This made it possible for artists to paint outdoors without preliminary drawings or preconceived plans. Courbet was one of the first to

work directly from nature. He looked at the physical reality of the immediate everyday world, choosing his subjects to fit his visual realism and his enjoyment in painting textures. His figures are contemporary, ordinary people. Strong feeling would only detract from the immediacy of the painting. When this work was hung in Paris in 1850, it was attacked as inartistic, crude, and socialistic, but with it Courbet paved the way for a new way of seeing.

The revolution that occurred in painting in the 1860s and 1870s has sometimes been referred to as the Manet Revolution. Edouard Manet was a student of Couture. Compare Couture's ROMANS OF THE DECADENCE (page 165) with Manet's GARE SAINT-LAZARE. It is difficult to believe that the paintings were done at about the

same time. Manet rejected most of what his teacher stood for. His study of the refined, flat shapes of Japanese art (see page 86) helped him to create paintings based on a new concept of the importance of the picture plane. Manet minimized illusionary space, giving full power to value and shape. His direct brushwork and choice of commonplace subjects reflect Courbet's influence. If Courbet painted the present, Manet painted *in* the present. He was an independent, who, through his interest in light, in everyday visual experience, and the fresh use of visual form, led the way into Impressionism.

222 Edouard Manet
GARE SAINT-LAZARE
1873. Oil on canvas. 36¾ x 45⅛".

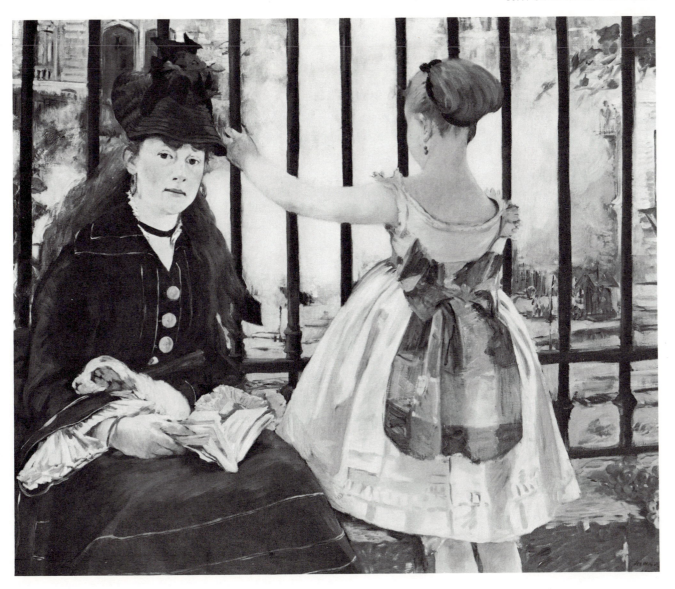

IMPRESSIONISM

In 1874 a group of young artists who were denied the right to show in the official French academy exhibit hung their work in a photographer's studio. They were primarily interested in the momentary effect of light playing over the natural world. Landscape and ordinary scenes painted in varying atmospheric conditions and times of day were their main subjects. They were dubbed "Impressionists" by a critic who objected to the sketchy quality of these paintings, exemplified by Claude Monet's IMPRESSION SUNRISE.

Joyous people savoring the delights of a moment, encouraging us to live fully in the present, were typical subjects of Impressionist paintings. Auguste Renoir, in MOULIN DE LA GALETTE (see color plate 26), painted such a moment with brilliant color and dancing light.

223 Claude Monet
IMPRESSION: SUNRISE
1872. Oil on canvas. 19½ x 25½".
See color plate 25.

224 Claude Monet
WATER-LILIES, GIVERNY
1906. Oil on canvas. 34¼ x 36¾".

Claude Monet painted with free strokes of rich color. In his paintings, a violet area may be made up of violet, blue purple, and touches of pure red. The eye of the viewer mixes the colors, and the result is a vibrancy which cannot be achieved with paint mixed on the palette. The effect was startling to eyes used to the muted colors of academic painting.

Monet continued to paint in the Impressionist manner after others of the group such as Renoir, Degas, Morisot, and Cézanne had moved on to develop individual styles. From about 1890 to his death in 1926, he painted the water lilies in his garden, making the reflective light and color on the pond and on the lilies a basis for paintings of lyrical richness. The free use of color and vigorous brush strokes of the Impressionists were to influence the Abstract Expressionist painters of the mid-twentieth century.

225 Edgar Degas
PLACE DE LA CONCORDE. c. 1873. Oil on canvas. 31¾ x 47⅜".

Edgar Degas was a member of the Impressionist group in Paris, but he saw things in his own way and remained on its fringes. He went further in his presentation of the fleeting world, using a camera as a studio tool. Degas was intrigued by the way in which the camera fragmented the things seen in actual, continuous space. In PLACE DE LA CONCORDE we see people grouped by chance on a street. Degas based his composition on the accidental quality of normal visual experience, as well as on the spontaneous poses captured by the camera. He chose to paint marginal events, as though the meaning of any main event is expressed by the people on the sidelines and by the surrounding empty spaces.

The implied lines set up by the directions in which the dog, the girls, and the man are looking act as axes of force in the composition. Everyone is looking in a different direction! At the far left a man appears, cut off by the top and side edges of the picture plane, giving the impression of a candid photograph. If we study the composition carefully, we realize that the center of interest is in the empty area just in front of the dark doorway in the distant wall. The quality of Degas' vision and his sense of meaning in interrelationships help us to see the revealing impact of certain common visual occurrences that are usually ignored.

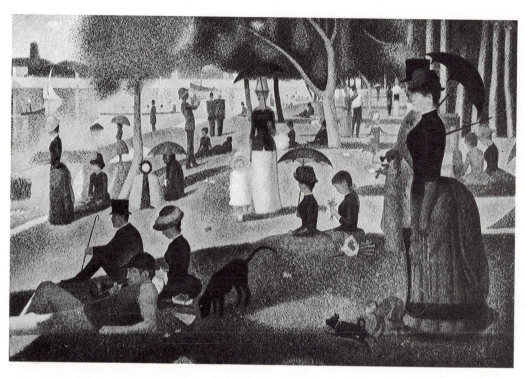

226 Georges Seurat. SUNDAY AFTERNOON ON THE ISLAND OF LA GRANDE JATTE. 1884–1886. Oil on canvas. 81 x 120⅜″. *See color plate 29.*

POSTIMPRESSIONISM

Postimpressionism refers to the composite of styles that followed Impressionism between 1880 and the turn of the century. Painters who had tried Impressionism early in their careers came to feel that solidity of form and composition had been sacrificed for the sake of light and color. They sought a new balance. Postimpressionism is a confusing term because it refers to a complex of reactions to Impressionism, rather than a single style. There were two dominant tendencies during the period, Expressionism and Formalism.

Four men stand out in retrospect: Paul Gauguin, Vincent van Gogh, Georges Seurat, and Paul Cézanne.

Gauguin and van Gogh brought emotional intensity and spontaneity to their work. They used bold color contrasts, shapes with abruptly changing contours, and, in van Gogh's case, swirling brush strokes. They were the romantics, the expressionists. From them developed the twentieth century school of Expressionism.

Seurat and Cézanne were more interested in structure and rational clarity. They were the Classicists or Formalists. Both organized visual form in order to achieve a new formal clarity.

Seurat's large painting SUNDAY AFTERNOON ON THE ISLAND OF LA GRANDE JATTE has the subject matter, the broken brushwork, and the light and color qualities of Impressionism. But this painting is not of a fleeting glimpse; it is a structural design worked out with great precision. Seurat set out to systematize the broken color of Impressionism and to create a more rigid organization with clearly edged, simplified forms. His system was called Pointillism. With it, Seurat tried to develop and apply a scientific painting method that would make the intuitive approach obsolete. He arrived at his method by studying the principles of color optics being discovered at the time. He applied his paint in tiny dots of color to achieve optical mixture. This method had a direct influence on modern color printing, in which tiny yellow, red (magenta), blue (cyan), and black dots give the appearance of full color.

227 Vincent van Gogh
THE SOWER
1888. Oil on canvas. 17⅜ x 22⅛". *See color plate 27.*

228 Vincent van Gogh after Hiroshige
PLUM TREES IN BLOSSOM
1888. Oil on canvas. 55 x 46 cm.

Van Gogh and Gauguin learned the methods of Impressionism. They learned about color and about the vitality of broken brushwork. Soon, both men were using color with excitement, not to record soft impressions of light, but to employ color as a means of emotional expression.

We have already mentioned the influence of Japanese prints on Western painting in the late nineteenth century. (See page 169.)

Van Gogh shows us how and what he learned from the Japanese artist Hiroshige. His copy of PLUM TREES IN BLOSSOM is quite accurate. In his painting of THE SOWER, van Gogh demonstrates his newly acquired sense of bold, simple shapes and flat color areas. The wide band of a tree trunk cuts diagonally across the composition as a major shape, its strength balancing the sun and its energy coming toward us with the movement of the sower.

It is not necessary for an artist to work with a conscious knowledge of all the visual elements and how they interact. These interactions can be intellectually formulated most thoroughly after the creative work is completed. A strong desire to share personal experience motivated van Gogh. After tremendous struggle with materials and techniques, he finally reached the point at which he was able to put his intensity on paper and canvas. "The artist does not draw what he sees but what he must make others see."[5]

Van Gogh used startling color in an effort to express his emotions. He wrote:

Instead of trying to reproduce exactly what I have before my eyes, I use color more arbitrarily so as to express myself forcibly . . . I am always in hope of making a discovery there to express the love of two lovers by a marriage of two complementary colors, their mingling and their opposition, the mysterious vibrations of kindred tones. To express the thought of a brow by the radiance of a light tone against a sombre background.[6]

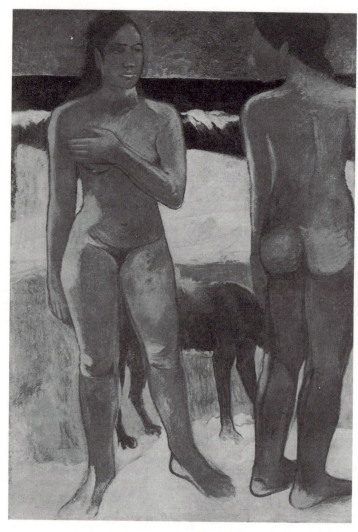

229 Paul Gauguin
Two Nudes on a Tahitian Beach
1892. Oil on canvas. 35¾ x 25½". *See color plate 28.*

Gauguin, like van Gogh, was interested in what happened across the picture surface, and felt that implied deep space would only detract from his design. He used flat, simple areas of color. Unlike the Impressionists, he was not interested in catching natural light, saying:

A word of advice: don't paint too much direct from nature. Art is an abstraction! Study nature, then brood on it and think more of the creation which will result, which is the only way to ascend towards God—to create like our Divine Master. [7]

In painting, one must search rather for suggestion than for description, as is done in music. . . [T]hink of the highly important musical role which colour will henceforth play in modern painting. [8]

Gauguin's painting, Two Nudes on a Tahitian Beach, has a shallow spatial feeling, in spite of the fact that the subject suggests a background of infinite space. Within the large areas of color there are subtle variations, but the values are close enough so that the areas read as flat shapes. The figures are solid, yet the black lines around them keep them on the surface of the picture plane. Gauguin's use of color had an important influence on twentieth-century painting. His views on color were prophetic. (See page 182 and color plate 32.) The subject, as he said, was only a pretext for symphonies of line and color.

They are intended absolutely! They are necessary and everything in my work is calculated, premeditated. It is music, if you like! I obtain by an arrangement of lines and colours, with the pretext of some sort of subject taken from life or from nature, symphonies, harmonies which represent nothing absolutely real in the vulgar sense of the word, which express directly no idea, but which provoke thoughts, without the help of ideas or images, simply through the mysterious relationships which exist between our brains and these arrangements of lines and colours. [9]

Gauguin escaped the industrialized world of Europe by fleeing to the romantic South Seas in an attempt to return to a more natural life. Other artists found their subjects in the less pleasant aspects of city life.

Jacob Riis armed himself with a camera in order to record the misery of a world no one really wanted to look at. For Riis, art was a way of calling attention to and thereby helping to change conditions of suffering that appalled him. In holding this attitude he was unique

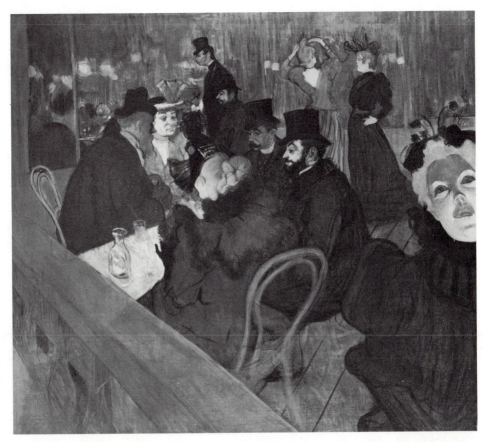

231 Henri de Toulouse-Lautrec
AT THE MOULIN ROUGE
1892. Oil on canvas. 48⅜ x 55¼″.

230 Jacob Riis
BANDIT'S ROOST. c. 1888

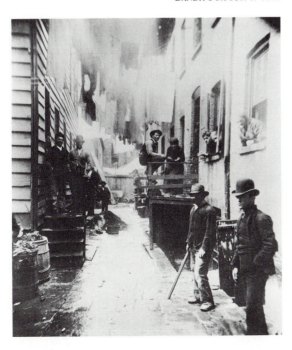

among the prominent photographers of the day, who sought merely to imitate the artistic effects of painters. Riis realized that the photographic medium would enable him to produce strong images of the actual living environment of New York's slum dwellers.

Henri de Toulouse-Lautrec painted in the gaslit interiors of Parisian night clubs and brothels, frequently catching their atmosphere in moments of deep human drama. His quick, long strokes of color define a world of sordid gaiety. He used unusual angles, photographic cropping of images such as the face on the right, and vivid color to heighten our feelings about the people he painted. He, like Gauguin and van Gogh, influenced the later Expressionists.

Of the many great painters working in France during the last twenty years of the nineteenth century, it is said that Cézanne had the most lasting effect on the course of painting. Because of this he is referred to as the "Father of Modern Art."

Cézanne, like Seurat, was more interested in the structural or formal aspects of painting than in its ability to render emotions. He shared the Impressionists' practice of working directly from nature. But in his later work he wished to achieve a lasting formal image. "My aim," he said, "was to make Impressionism into something solid and enduring like the art of the museums."[10] He worked for a new synthesis between nature and a thorough study of past masterworks, particularly the paintings by Poussin. As Cézanne said, "I want to do Poussin over again from nature."[11]

233 Paul Cézanne
MONT SAINTE-VICTOIRE
1904–1906. Oil on canvas. 25⅝ x 31⅞".
See color plate 30.

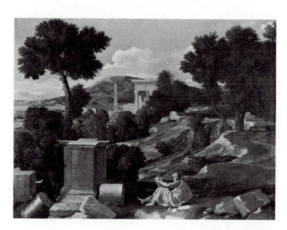

232 Nicholas Poussin
SAINT JOHN ON PATMOS
1645–1650. Oil on canvas. 40 x 52½".

Cézanne shared with Seurat the desire to make something lasting out of the discoveries of the effects of light and color. They based their work on direct observation of nature and they both used visibly separate strokes of color to build their richly woven surfaces of paint. Seurat's highly demanding method was not popular among younger artists. Cézanne's open strokes, however, were part of a fluid system of form-building that offers a whole range of possibilities to those who study his work.

Cézanne achieved a method of designing the picture's space by carefully developing exactly the right relationships between separate strokes of color. His approach gave a new life to the surfaces of his own paintings and to innumerable painted surfaces by other artists since that time.

234 Paul Cézanne
THE GULF OF MARSEILLES, SEEN FROM L'ESTAQUE
c. 1891. Oil on canvas. 31¾ x 39¼".

Cézanne also gave new importance to the compositional problems which the Impressionists tend to ignore. Landscape was one of his main interests, but unlike the Impressionists, his subjects were merely point of departure. He went beyond the reality of nature, organizing it in his own way to create a new reality on the picture surface. In THE GULF OF MARSEILLES, SEEN FROM L'ESTAQUE we can see how he flattened space. The distant landforms stop our eyes and return them to the foreground. We can also see how he simplified the houses into almost geometric masses. Compare this painting with Monet's IMPRESSION SUNRISE on page 170, to see how Cézanne moved away from Impressionism.

The young painters who were coming to study in Paris at the turn of the century looked to Cézanne to help them develop new ways of seeing, new ways of organizing form. Out of these experiments and Cézanne's analytical approach to painting would grow the new twentieth-century style of Cubism.

5

What is the art of our time?

235 François Auguste René Rodin
THE KISS. 1886–1898. Marble. Height 5'11¼".

TWENTIETH-CENTURY ART

I can think of no meaningful way to present art history in the twentieth century as a single, chronological sequence. The art and the life that goes with it in any period are more like a collage than a line, particularly in a complex, contradictory time like ours.

THE KISS by Auguste Rodin and THE KISS by Constantin Brancusi represent a major transition in the tradition of figurative art. One is representational; one is geometric abstraction. Rodin was the great master of sculpture in the second half of the nineteenth century, while Brancusi held the same position for the first half of the twentieth.

Brancusi carved two figures kissing in a solid embrace. The work was originally commissioned as a tombstone by a couple who must have loved each other very much. The work does not portray an ego-building image of erotic love. Rather, it is a symbol of the inner union that occurs when two people love each other in such a continuing and unselfish way that they achieve oneness.

236 Constantin Brancusi
THE KISS
1908. Limestone. 23 x 13″, depth 10″.

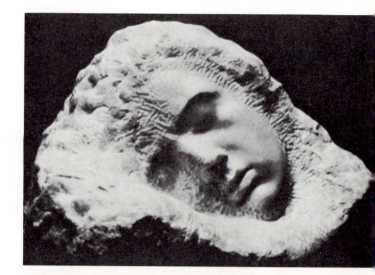

Brancusi's SLEEPING MUSE of 1906 has a quality similar to Rodin's romantic naturalism. In 1908 he completed THE KISS and in 1911 he finished a second version of the SLEEPING MUSE. THE NEWBORN, finished in 1915, has the refined simplicity of a powerful conception stripped to its essentials. Brancusi said, "Simplicity is not an end in art, but one arrives at simplicity in spite of oneself, in approaching the real sense of things. . . ."[1]

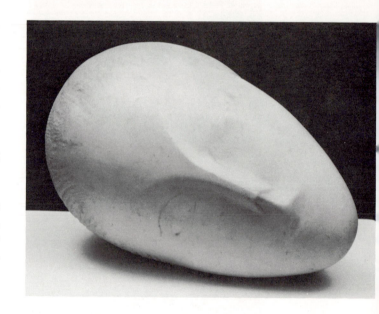

These three works span ten years of Brancusi's evolution toward the kind of elemental form for which he is known. Seen together they illustrate the transition between representational and nonrepresentational emphasis that occurred in much early twentieth-century art.

237 Constantin Brancusi
 SLEEPING MUSE
1906. Marble. 6½ x 12".

238 Constantin Brancusi
 SLEEPING MUSE
1909–1911. Marble. Height 11½".

239 Constantin Brancusi
 THE NEWBORN
1915. Marble. Length 8½", height 6".

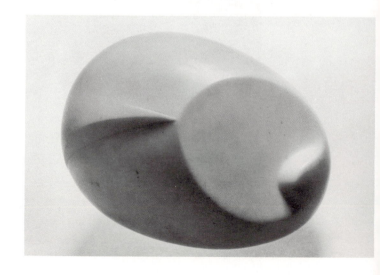

240 Gustav Klimt
THE KISS
1908. Oil on canvas. 71 x 71". *See color plate 31.*

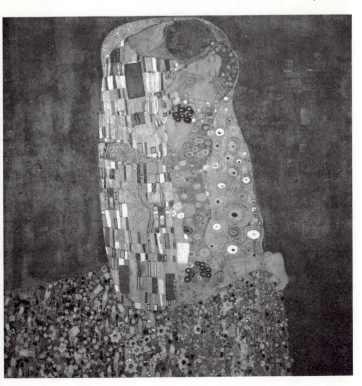

The transition from representational to abstract styles is bridged in another way by Gustav Klimt. In his painting, THE KISS, there is some of the abstract boldness that we find in Munch's woodcut of the same name (see page 60), and some of the romantic representational quality of Rodin's sculpture. It is unusual to find representational and abstract styles combined so effectively. Most artists would not attempt it. The heads, hands, and feet are realistically portrayed, while the bodies are only suggested beneath a rich color pattern that is organized within simple shapes against a plain background.

Between 1901 and 1906, comprehensive exhibits of the works of van Gogh, Gauguin, and Cézanne were held in Paris. Many of the younger artists were influenced by their work and consequently developed styles in which expressive distortions were emphasized by the use of violent color. When their works were first shown together in 1905, a critic angrily called them *Les Fauves* (the wild beasts). This pleased them greatly.

Henri Matisse, like most of the other young, experimental European painters, had training in the representational academic style. But he was drawn to light and bright color after seeing the Impressionists, and by the early 1900s he had become one of the most avant garde of painters. In NASTURTIUMS AND THE DANCE, discussed on page 25 (color plate 3), we can see his Fauve color.

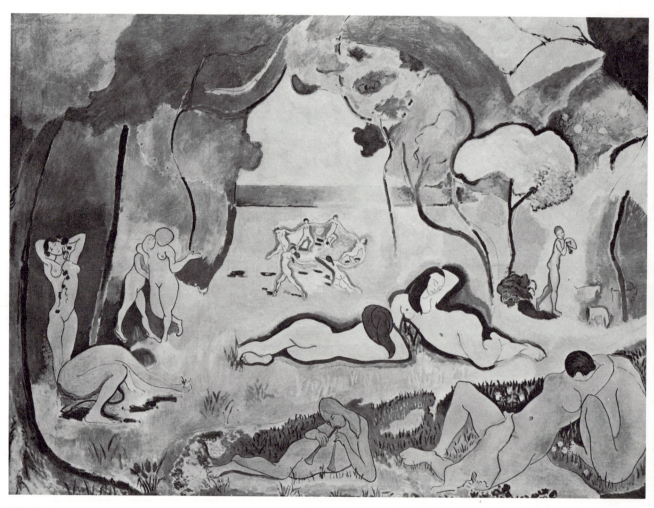

241 Henri Matisse. JOY OF LIFE. 1905–1906. Oil on canvas. 68½ x 93¾".

In THE JOY OF LIFE, the formal composition of more traditional painting is combined with rich color and bold rhythmic lines and shapes. The simple, childlike quality of the form serves to heighten the joyous content, while the seemingly careless depiction of the figures is based on a profound knowledge of human anatomy and drawing. They are placed in a structured composition which shows the continuing influence of Cézanne.

Wassily Kandinsky, a Russian, abandoned law to become a Fauve painter. He believed that a painting should be "an exact replica of some inner emotion"[2] and in BLUE MOUNTAIN, painted in 1908, he created a "choir of colors."[3]

Figures on horseback move through an imaginary landscape of rich color, calling our attention to the pure enjoyment of visual form existing for its own sake. By 1910, Kandinsky had abandoned representational subject matter entirely in order to concentrate on the expressive potential of visual form freed from associations. He tried to free painting to the extent that music was free.

Music does not have to be like something pre-existing or already known to be great. In fact, representational music is rare. We enjoy music because of the rhythmic harmonies and melodies that it contains. The relationships created by the composer and given life by the performer are what please us about music. We

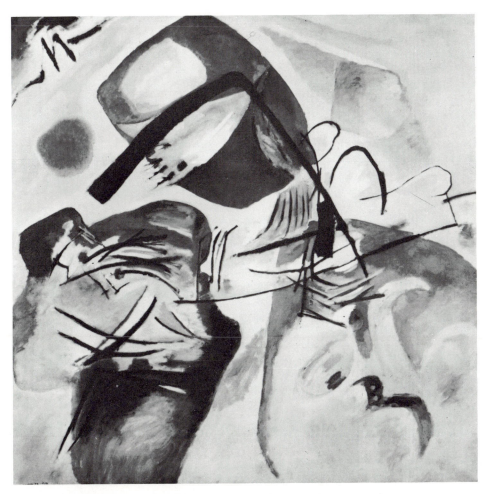

242 Wassily Kandinsky. WITH THE BLACK ARCH, No. 154. 1912. Oil on canvas 74 x 77⅛".

would never think of asking a musician, "What is that supposed to be?"

By calling his painting WITH THE BLACK ARCH, No. 154, Kandinsky refers to the dominant visual element, which is the major subject of the painting. It is the same as a composer calling his work Opus No. 48 in C Minor.

243 Wassily Kandinsky
BLUE MOUNTAIN
1908. Oil on canvas. 42 x 38½". *See color plate* 32.

244 Alfred Stieglitz. THE STEERAGE. 1907.

Alfred Stieglitz, an American photographer, was reconsidering the geometry of composition on the picture plane as Picasso began taking the steps that led to Cubism. When Picasso saw Stieglitz' photograph THE STEERAGE he said, "This man is trying to do the same thing that I am."[4]

THE STEERAGE looked chopped up to many people. Some of the artist's friends felt that it should have been two photographs, rather than one. But Stieglitz visualized the complex scene as a pattern of interacting forces of light, shade, shape, and direction. Aboard a liner headed for Europe, he saw the composition of this photograph as "a round straw hat, the funnel leaning left, the stairway leaning right, the white drawbridge with its railings made of circular chains, white suspenders crossing on the back of a man on the steerage below, round shapes of iron machinery, a mast cutting into the sky, making a triangular shape. . . . I saw a picture of shapes and underlying that the feeling I had about life."[5] He rushed back to his cabin to get his camera, hoping the composition would remain. It had, and he made the photograph, which he considered his best.

Stieglitz made his own move toward realizing the potential of an overall picture-plane geometry, freed from the continuous, linear flow of Renaissance perspective.

At the same time, the American architect Frank Lloyd Wright was designing his prairie houses, in which the rigid boundaries between interior and exterior space give way to a spatial flow and interaction that has much in common with Cubism.

In the ROBIE HOUSE of 1909, Wright created long, horizontal lines that end in exaggerated, overhanging roofs. The lines repeat an irregular pattern throughout the building, keeping the structure in tune with the flat land that surrounds it. The long eaves reach out into exterior space, working with the diagonally placed windows and open floor plan, allowing interior space out and exterior space in, in a continuous exchange. To get a feeling of how far ahead of his time Wright was, imagine the new 1909 horseless carriage that might be parked in front of this house the year it was completed.

245 Frank Lloyd Wright. ROBIE HOUSE. Chicago, 1909.

In 1913 Kandinsky described how deeply he was affected by the discovery of subatomic particles.

A scientific event cleared my way of one of the greatest impediments. This was the further division of the atom. The crumbling of the atom was to my soul like the crumbling of the whole world.[6]

At this time, major changes were taking place in the way man looked at the world. The physicist and chemist, Marie Curie, and her husband Pierre, discovered the radioactive element radium in 1898. Einstein changed the concepts of time and space with his theory of relativity, published in 1905. In 1908 the Wright brothers began modern aviation history by flying a power-driven glider. During this period artists were breaking down visual preconceptions. New styles now came forward in rapid profusion.

In 1906 Pablo Picasso painted a self-portrait that had a unique quality of simplicity not seen before in his work. Picasso had mastered techniques of representational drawing before he was fifteen years old, and by 1901, when he was twenty and living in Paris, his paintings showed that he had assimilated the influences of Postimpressionist painters like Toulouse-Lautrec, Degas, van Gogh, and Gauguin.

By the time he was twenty-five, Picasso began to paint with strong, simple curved lines which define the edges of flat planes. The bold planes of and above the eyelids of his self-portrait clearly show his changing style. Influenced by African and Oceanic sculpture, Picasso moved into a new world of visual images. THE YOUNG LADIES OF AVIGNON shows the radical break Picasso made with the past. Tradition required a depiction of objects from one point of view, but here the figures are seen from many viewpoints combined in one painting.

The shifting planes are Picasso's exaggerated adaptation of Cézanne's restructuring of objects in space on a two-dimensional surface.

246 CHIEF'S STOOL Baluba, Belgian Congo
Probably 19th century. Wood. Height 21".

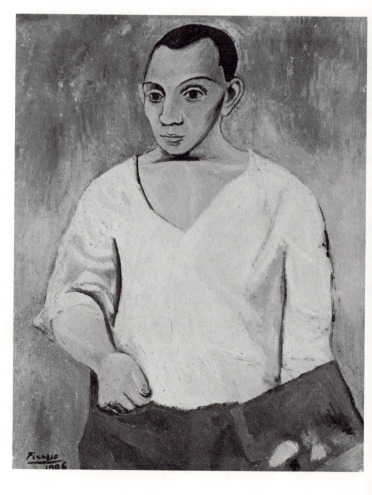

247 Pablo Picasso SELF-PORTRAIT
1906. Oil on canvas. 36½ x 28¾".

Color plate 33 Lyonel Feininger. The Glorious Victory of the Sloop "Maria". 1926. Oil on canvas. 21½ x 33½".

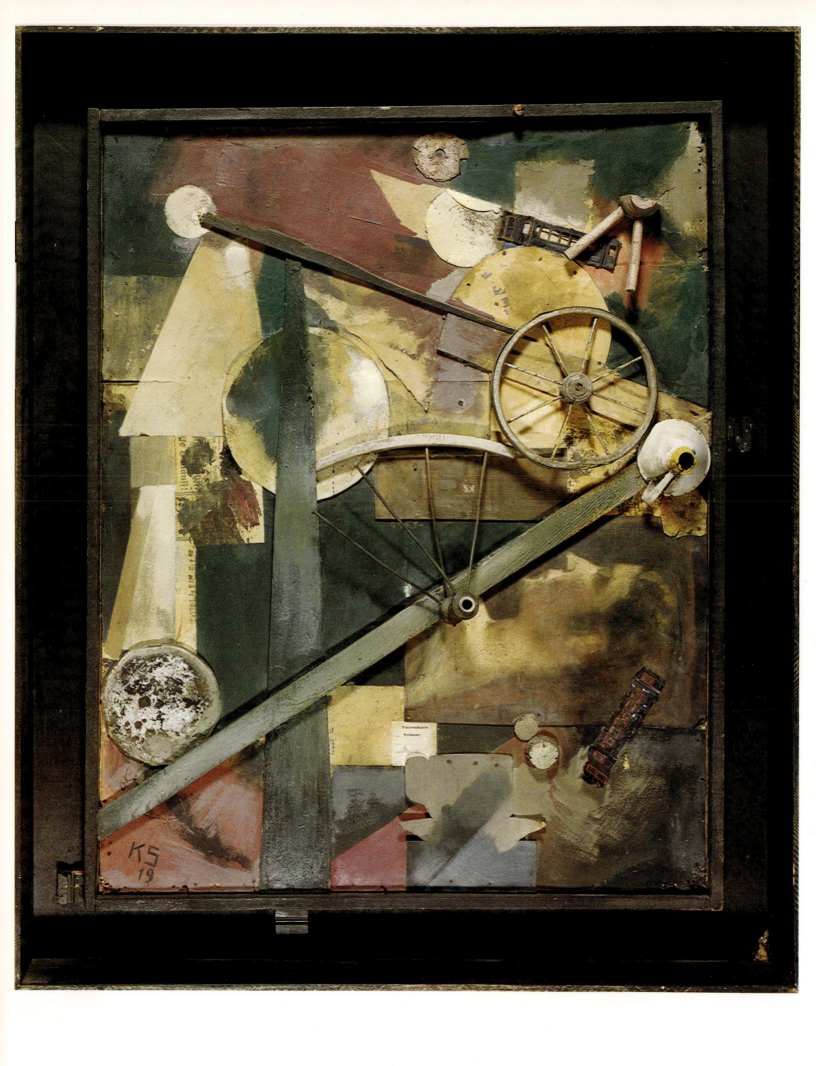

Color plate 35 Kurt Schwitters. CONSTRUCTION FOR NOBLE LADIES. 1919. Mixed media assemblage of wood, metal, and paint. 40½ x 33″.

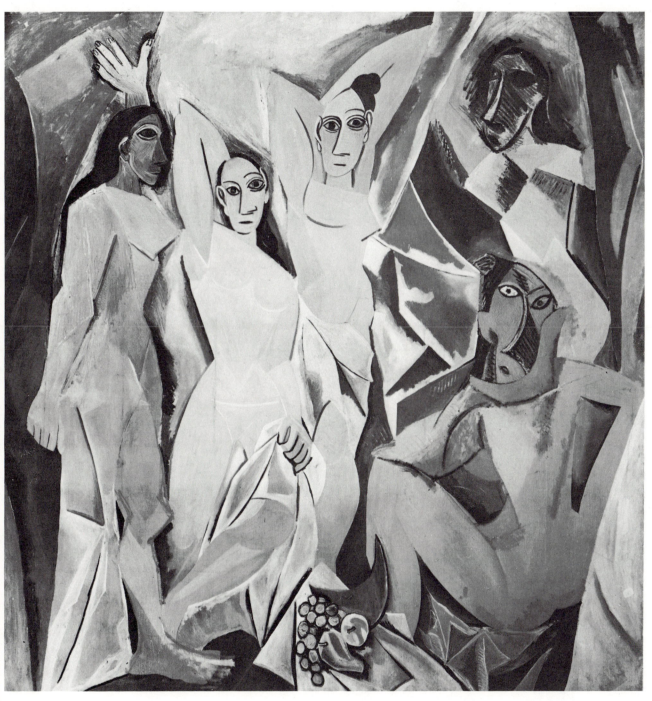

248 Pablo Picasso. THE YOUNG LADIES OF AVIGNON. 1907. Oil on canvas. 8′ x 7′8″.

Picasso's paintings blasted the accepted European ideal of beauty by adopting some of the abstract power of African form. Picasso's closest friends were astonished by his new approach. Even Braque, who did as much to develop Cubism as Picasso, was appalled when he first saw THE YOUNG LADIES OF AVIGNON in 1907. Braque commented, "You may give all the explanations you like, but your painting makes one feel as if you were trying to make us eat cotton waste and wash it down with kerosene."[7]

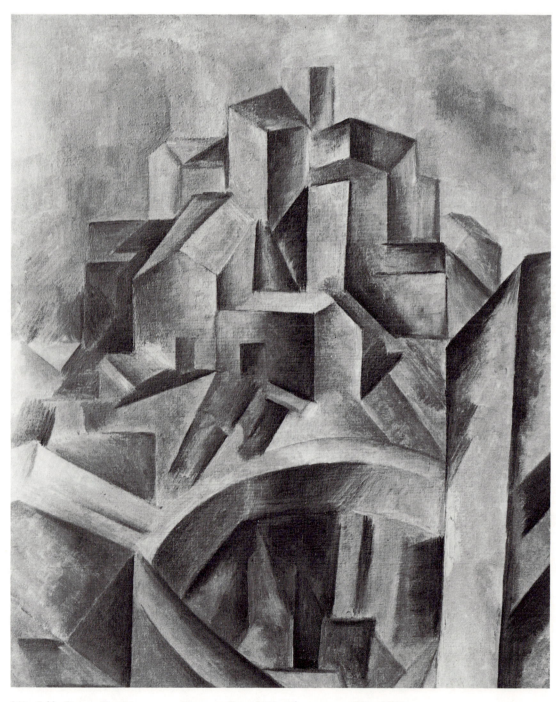

249 Pablo Picasso. THE RESERVOIR AT HORTA DE EBRO. 1909. Oil on canvas. 31⅞ x 25¼".

Cézanne combined direct observation of nature with a new respect for the flat character of the picture plane. European painters since the fifteenth century had been judged on their ability to give the illusion of depth on flat surfaces. Now this basic premise was challenged, and the beauty and integrity of the surface itself was reaffirmed. Painters in Europe thus rejoined the majority of the world's artists who throughout history have cared little about creating illusionary space.

Cézanne, Manet, and the Postimpressionists led the way and Picasso and many others carried the idea even further.

A revealing comparison between Cézanne's painting of a hill town, finished in 1886, and Picasso's painting of a similar subject done in 1909, twenty-three years later, shows the progression from Cézanne's Postimpressionist style into the Cubist style developed by Picasso and Braque. (See page 56.) In Cézanne's THE GARDEN, the planes shift and interweave. In Picasso's THE RESERVOIR AT HORTA DE EBRO, the planes are stripped of representational detail and act as elements in an almost independent pattern of geometric shapes.

The Cubists were convinced that the pictorial space of the flat plane of the two-dimensional surface was unique—a form of space quite different from natural space.

Picasso's painting of a clarinet player, painted in 1911, is a fine example of what is sometimes referred to as Analytical Cubism.

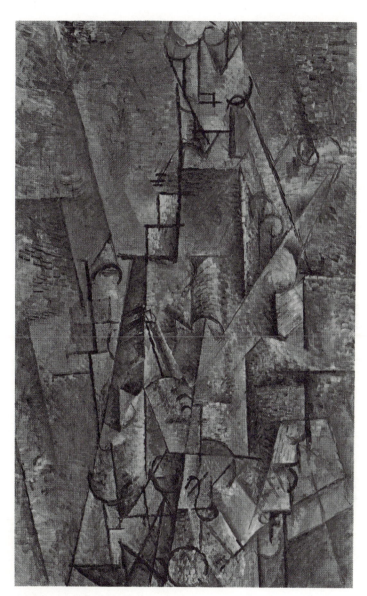

251 Pablo Picasso THE CLARINET PLAYER
1911. Oil on canvas. 42 x 26½".

250 Paul Cézanne THE GARDEN
1885–1886. Oil on canvas. 31½ x 25¼".

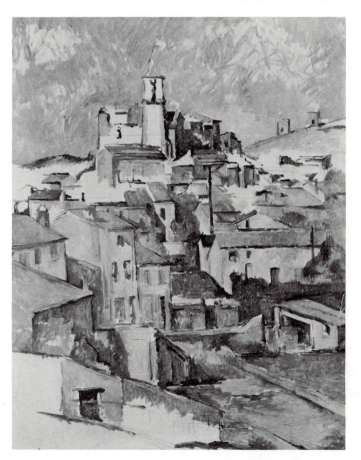

In order to concentrate on the formal reconstruction of the subject, Picasso used a limited range of neutral tones. Strong color would be out of place in these intellectual translations of three-dimensional form. Restrained color was also a reaction away from Fauvism. The surface of the painting is activated entirely by interwoven planes that often seem both opaque and transparent. The subject and the background interpenetrate one another in shallow space, which seems to move as much in front of the picture plane as behind.

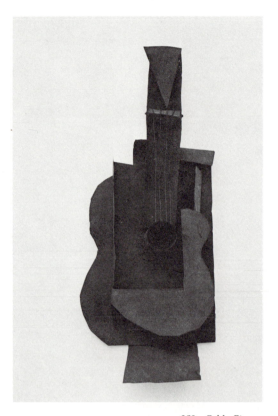

252 Pablo Picasso
GUITAR
1911–1912. Sheet metal and wire. 30¾ x 13¾ x 7¼".

In 1912 Analytical Cubism gave way to greater interest in textural surfaces, bold cutout shapes, and greater use of color. This style was later called Synthetic Cubism. Instead of representing surfaces with paint, actual two-dimensional objects were often used. Pieces of newspaper, sheet music, wallpaper, and similar items came into the work, not represented, but actually presented. These painted and pasted paper compositions were called *papier colle* by the French and later became known in English as *collage*.

When Picasso constructed his GUITAR out of sheet metal and wire in 1911 or 1912, he began what has become a dominant trend in twentieth-century sculpture. Before Picasso's Cubist GUITAR, most sculpture was modeled or carved. Now much of contemporary sculpture is created by assembling methods. According to Picasso, this sculpture was completed before he did any work with collage.

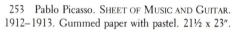

253 Pablo Picasso. SHEET OF MUSIC AND GUITAR.
1912–1913. Gummed paper with pastel. 21½ x 23".

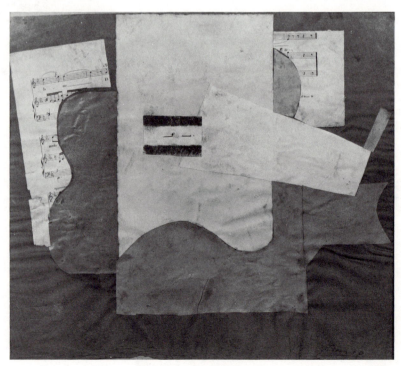

The Cubists caused a radical change in Western art by shifting the basis for image making from natural appearances to abstract geometric order. The Dutch painter Piet Mondrian took the next step. Inspired by Cubism's inner logic, he gradually went beyond Cubist references to subject matter until he arrived at an austere personal style based on the beauty of basic visual relationships, independent of references to objects in the external world. Mondrian's search for "pure" visual expression through nonobjective form was similar to Kandinsky's, although Kandinsky's approach was freer and more emotional than Mondrian's. (See Kandinsky, page 183.)

When he painted HORIZONTAL TREE he concentrated on the rhythmic curves of the branches and on the patterns of the spaces created between the branches. He became more aware of the strong expressive character of simple horizontal and vertical lines, creating two-dimensional rectilinear shapes.

254 Piet Mondrian
HORIZONTAL TREE
1911. Oil on canvas. 29⅝ x 43⅞".

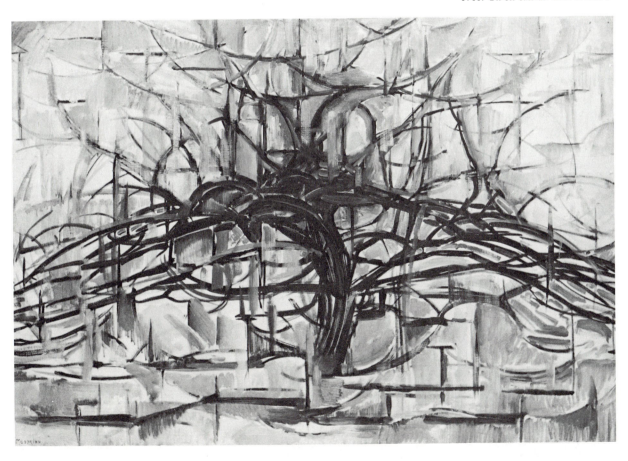

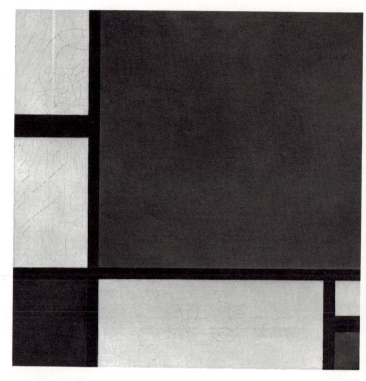

255 Piet Mondrian
COMPOSITION WITH RED, YELLOW AND BLUE
1930. Oil on canvas. 19 x 19".
See color plate 34.

The new art has continued and culminated the art of the past in such a way that the new painting, by employing "neutral," or universal forms, expresses itself only through the relationships of line and color.[8]

For Mondrian, these universal elements were straight lines and primary colors. Mondrian was able to create major works using only black horizontal and vertical lines of varying width and the three primary colors, red, yellow, and blue, against a white background. One of these is COMPOSITION WITH RED, YELLOW AND BLUE, completed in 1930. It exemplifies his most mature style, in which three simplified elements—line, shape, and color—combine to create images of significance.

Mondrian distilled his sense of design from the complex relationships of daily visual experience. His style was a way of getting at the universal core of our intuitive experience of form. Mondrian felt that he was expanding the possiblities of visual expression by using elements which in themselves would evoke responses deeper than those coming from representations of specific objects. In his search, he reached for new ways to express the nature of man.

Mondrian's style was shared by his circle of friends. In 1917 they founded a magazine called DE STIJL (The Style). Mondrian wanted the new art to be "collective, impersonal and international."[9] Although De Stijl originated in painting, its influence can be seen in the design of buildings, books, interiors, clothing, and many other articles of daily use.

The search for a language of visual form that was stripped to its essentials was carried on by architects as well as painters between 1910 and 1940. One of the leaders in the development of the International style was Le Corbusier. He was a painter, an architect, and a city planner.

With the simple drawing shown here, the young Le Corbusier demonstrated the structural skeleton of a reinforced concrete house. This idea made it possible to vary the placement of interior walls and the nature of exterior coverings, since neither one plays a structural role. Le Corbusier's sense of the beautiful was inspired by the efficiency of machines and a keen awareness of the importance of spaciousness and light. Also reflecting the influence of the De Stijl group are the buildings of the German school of art called the Bauhaus, which were designed by Walter Gropius in 1925.

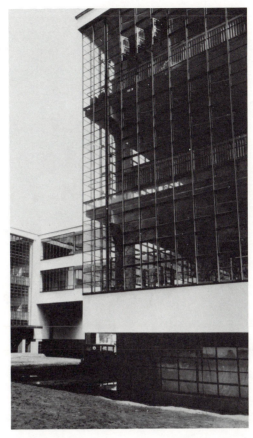

257 Walter Gropius
THE BAUHAUS. Dessau, Germany, 1925.

256 Le Corbusier
DOMINO CONSTRUCTIONAL SYSTEM
1914–1915

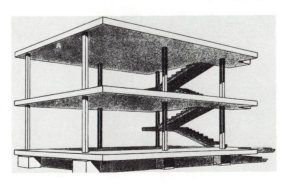

In the photograph above, see how the reinforced concrete floors, supported by interior steel columns, allow for a non-load-bearing curtain wall of glass. The exterior and interior of the building are presented simultaneously in a design of opaque and transparent overlapping planes similar to the use of planes found in Cubist painting.

Simplicity has become a major tenet of twentieth-century architecture and product design. Many of the impersonal buildings in our cities today developed from the philosophy of the Bauhaus and Le Corbusier.

258 Marcel Duchamp. NUDE DESCENDING A STAIRCASE, #2. 1912. Oil on canvas. 58 x 35".

259 Jacques Henri Lartigue. GRAND PRIX OF THE AUTOMOBILE CLUB OF FRANCE. Dieppe, France, 1912.

The French artist Marcel Duchamp and the Futurist painters of Italy brought the dimension of motion to Cubism. Creating a sense of movement and rhythm is as important in the art of the Western twentieth century as it was in India several thousand years ago. (See Shiva, page 141.)

Film is much better suited for depicting motion than is painting. However, Duchamp's NUDE DESCENDING A STAIRCASE works well in a way that a film cannot. Utilizing sequential, diagonally placed, Cubist images of the same figure, the painting presents the symbolic movement of a figure through space, seen all at once, in a single, rhythmic progression. Because of our sense of gravity, the diagonal placement intensifies the feeling of movement.

The Italian Futurists were excited by the beauty of speed made possible by technology. In 1909, Marinetti, a poet, proclaimed in the MANIFESTO OF FUTURISM: "The world's splendor has been enriched by a new beauty; the beauty of speed . . . a roaring motorcar . . . is more beautiful than the VICTORY OF SAMOTHRACE."[10]

In 1912, the same year that Duchamp painted NUDE DESCENDING A STAIRCASE, a young French photographer named Jacques Lartigue took one of many photographs of his father in action.

Cubism is a way of seeing. Cubism has been for the twentieth century what the development of linear perspective was for the fifteenth. After the original analytical phase of Cubism, many painters adopted its basic spatial concept. One of them was Fernand Léger. In his painting called THE CITY, he used Cubist overlapping planes in compact, shallow space to create a complex symbol of city rhythms and intensities.

In today's cities, the buildings, signs, people, and traffic crowd together between reflective surfaces, in a giant assemblage of overlapping,

260 Fernand Léger
THE CITY
1919. Oil on canvas. 7'8" x 9'9".

disjointed forms. To the eye, these phenomena join in a collage experience that is part of the same spatial awareness explored by Cubism. The style has given us a relevant way of experiencing the world we live in.

In Cubism, a painting became an object in its own right. The Cubist approach led to further abstractions, and to nonrepresentational painting, although it was also used by painters for whom subject matter was important.

Feininger's painting of sailboats racing on open water is Cubist in design. Geometric shapes, mainly triangles, move over the surface, woven into strong unity by straight lines of force that run from edge to edge across the picture plane. Size difference in the sails adds to the illusion of depth.

261 Duane Preble
REFLECTIONS
1972

262 Lyonel Feininger
THE GLORIOUS VICTORY OF THE SLOOP "MARIA"
1926. Oil on canvas. 21½ x 33½".
See color plate 33.

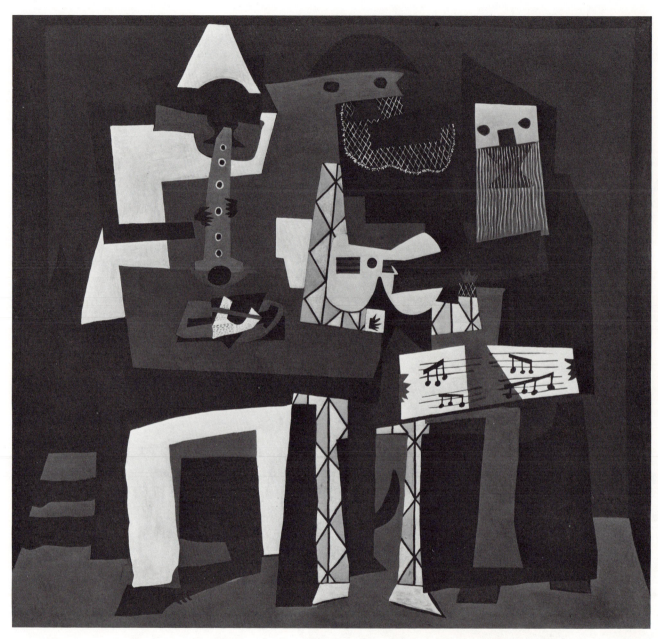

263 Pablo Picasso. THREE MUSICIANS. 1921. Oil on canvas. 6'7" x 7'3¾".

The THREE MUSICIANS by Picasso is created in the flat, decorative style of Synthetic Cubism. The painting is an abstraction that acts as a culmination of the style as a whole. Its form is heavily influenced by the cutout shapes of Cubist collages. It was painted by Picasso at the same time that he was working with the style and subject matter of Greco-Roman antiquity, creating figures with the appearance of great bulk and solidity. See YOUNG MAN'S HEAD, page 43.

Many historians find Picasso's work difficult to deal with, because he shifted from style to style, using one approach, and then another. Yet, now, as we look back over his career, the dramatic shifts in attitude all seem part of Picasso's fantastic inventive abilities.

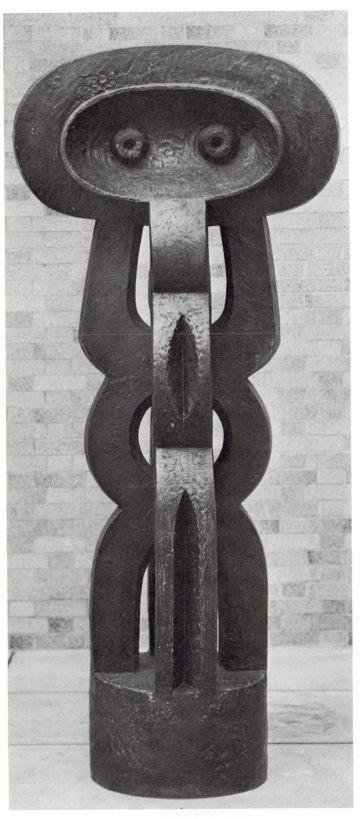

264 Jacques Lipchitz
FIGURE
1926–1930. Bronze. Height 85¼".

Two of the figures in THREE MUSICIANS are the traditional characters of French comedy — Pierrot, in white, playing a recorder, and brightly costumed Harlequin in the center, playing a guitar. The third figure wears a black monk's habit and a veiled mask, and sings from the sheet of music he holds. Behind the trio a black dog lies with tail raised. They might be happy figures, yet they become solemn and majestic because of the predominance of sombre colors and the monumental size of the picture.

For the sculptor Jacques Lipchitz "Cubism was essentially a search for a new syntax."[11] He came to Paris from Poland just as the style was developing. His seven foot, one and one-quarter inch FIGURE of the late 1920s, however, is not really Cubist. The figure's bold symmetry seems to have an organic as well as a geometric basis. But the sculpture could not have existed without Cubism, just as van Gogh's THE SOWER (see page 173) could not have been created without Impressionism.

The taller than life-sized piece has an awe-inspiring presence. It has the power we might expect to find in a votive figure from Africa or the South Pacific. Here the power comes from Lipchitz' sense of his own time. A viewer asked Lipchitz to explain his work. "It wouldn't help you," the sculptor answered. "If I were to explain it in Chinese, you would tell me you didn't know Chinese, and I would tell you to learn Chinese and you will understand. Art is harder than Chinese. Anyone can look—you have to learn to see."[12]

This is a symbol of humanity in the twentieth century. It seems closely related to the figure in Munch's THE SHRIEK (see page 143).

Dada is a word that identifies an art attitude that began to emerge during the nineteenth century and was finally christened in 1916. This attitude is different from the rational search for absolute or pure form. It is not a style.

Dada was not a school of artists, but an alarm signal against declining values, routine and speculation, a desperate appeal on behalf of all forms of art, for a creative basis on which to build a new and universal consciousness of art.

Marcel Janco[13]

After Duchamp painted the NUDE DESCENDING A STAIRCASE (see page 194) in 1912, he became increasingly dissatisfied with the accepted framework for art. He said, "I have forced myself to contradict myself in order to avoid conforming to my own taste."[14] Duchamp was not alone. As European society moved inexorably into World War I, many people felt compelled to react. As the actual fighting began, artists counterattacked with their art.

While the thunder of guns rolled in the distance, we sang, painted, glued and composed for all our worth. We are seeking an art that would heal mankind from the madness of the age.

Hans Arp[15]

Dada began in poetry and painting, then carried into sculpture, architecture, photography, film, music, and graphic design. But more than an art form, "Dada was a metaphysical attitude . . . a sort of nihilism . . . a way to get out of a state of mind—to avoid being influenced by one's immediate environment, or by the past; to get away from cliches—to get free." (Marcel Duchamp.)[16]

In his effort to free himself from the past, Duchamp declared all art a swindle, and exhibited his first non-art "ready-made," BICYCLE WHEEL.

Duchamp felt that you cannot separate art from other man-made things. He recognized selection as the primary ingredient of art. In his BICYCLE WHEEL, an assemblage of 1913, he applied both of these ideas to produce a work

that has caused much controversy and has stirred considerable thought. Its components are simply a bicycle wheel and a kitchen stool. It is a conceptual work from Duchamp's fertile imagination. It took only a simple operation to join the wheel frame to the stool. The stool provides a static base for the movable wheel. This is the first mobile of the twentieth century.

265 Marcel Duchamp
BICYCLE WHEEL
Replica of 1913 original, 1951. Assemblage: metal wheel 25½",
mounted on painted wood stool 24¾"
high, overall height 50⅜".

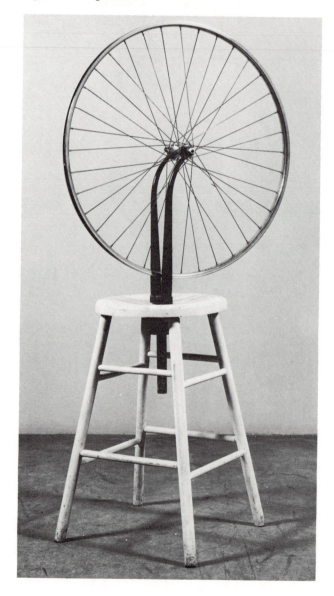

The wheel and the stool still say whatever they said before, by themselves. Yet this expression is now subordinate to what they communicate as a combined form. Through their new association and by the placement of this work in galleries and museums as an art object, a strong change has occurred in the way we perceive them. Functional preconceptions have been cleared away. We now see the things themselves.

For Duchamp, mechanically produced, man-made things were a reservoir of potentially un-self-conscious art objects. In this view a reproduction of the MONA LISA was a "ready-made" thing, in the same class as bicycle wheels and kitchen stools and bottle racks.

L.H.O.O.Q. is a "corrected" ready-made by Duchamp. Corrections took the form of a moustache and goatee done in pencil and a

266 Marcel Duchamp. L.H.O.O.Q. 1919.

267 Man Ray
THE GIFT
Replica of 1921 original, c. 1958.
Flatiron with metal tacks. 6⅛ x 3⅝ x 4½".

new title. The unusual title gives a possible clue as to why the MONA LISA has been smiling all these years. It is a pun in French, comprehensible only to those who can say the letters in a flowing sentence with perfect French pronunciation. Translated into English, it reads, "She has a hot tail." Duchamp's irreverence helps get art, and therefore life, back to a fresh start.

Man Ray, an American, was a friend of Duchamp's. His Dada works include paintings, photographs, and assembled objects. In 1921, in Paris, Man Ray saw a flatiron displayed in front of a shop selling housewares. He purchased the iron, a box of tacks, and a tube of glue. He glued a row of tacks to the smooth face of the iron and entitled it THE GIFT. This particular Dada assemblage tweaks the viewer's mind in a unique way. Utilitarian objects are transformed into useless irony.

In the past, the major subjects for art were gods (or God), nature, and man, and the interrelationships between them. It was not until the twentieth century that man-made things became a frequent subject for art.

It is not surprising that this shift in emphasis has occurred in art during an age when man has surrounded himself with objects of his own making, even objects that go on making objects. Modern man has spent more time, thought, and energy on the acquisition, use, and maintenance of manufactured things than he has on God, nature, or himself.

The twentieth-century emphasis on things has been apparent in art in two ways. First, as noted above, artists have ceased using traditional subjects that hold little meaning for them or for their public, and in some cases have even stopped using recognizable subjects altogether. To some, the appearance of the visual world has become either not to their liking or uninteresting, compared to the possibilities of independent visual form. Secondly, artists have confronted the most unlikely sources of inspiration. They have gone to man-made things, to the most common artifacts of mass production, and have found in them symbols of crass materialism in some cases, and universal continuity and spirit in others. These attitudes have formed what has been called the art of things.

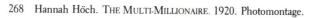

268 Hannah Höch. THE MULTI-MILLIONAIRE. 1920. Photomontage.

269 Kurt Schwitters
CONSTRUCTION FOR NOBLE LADIES
1919. Mixed media assemblage of wood, metal, and
paint. 40½ x 33″. *See color plate 35.*

Paradoxically, the art of things has developed concurrently with the concept of a work of art as an independent thing, free to express itself without reference to external subject matter.

When Picasso and Braque put actual preexisting things, such as pieces of rope and scraps of newspapers, into their work, they began one development in the art of things, which includes works of *collage* and *assemblage* (see page 111). Things are not represented, but are themselves presented, in a new context.

Another direction moves from collage into photomontage. In THE MULTI-MILLIONAIRE, by the Dadaist Hannah Höch, man, the artifact-making industrialist, stands as a fractured giant among the things he has produced.

Kurt Schwitters was a master of Dada collage. From 1917 until his death in 1948, he created images out of timeworn objects discarded by society. His assembled junk was designed to destroy the sacred standards of art. He asked us to look again at these cast-off objects. They are familiar old things returned to us, freed from their past functions and associations, and, therefore, visible again in a different context. Schwitters made his attitude clear in the following statement:

I could not, in fact, see any reason why one should not use the old tickets, driftwood, cloakroom numbers, wires and parts of wheels, buttons and old lumber out of junk rooms and rubbish heaps as materials for paintings as well as the colors that were produced in factories.[17]

Paul Klee intentionally freed himself from the accumulation of history by digging deeply into his own being in an effort to begin all over again. The self-portrait that he drew in 1919 goes well with this statement, written in his diary in June 1902:

It is a great difficulty and great necessity to have to start with the smallest. I want to be as though newborn, knowing nothing, absolutely nothing, about Europe; ignoring poets and fashions, to be almost primitive. Then I want to do something very modest; to work out by myself a tiny formal motive, one that my pencil will be able to hold without any technique.[18]

Paul Klee remained an independent artist all his life. He was able to tap the resources of his own unconscious, creating fantastic images years before Surrealism became a group style.

. . . everything vanishes round me and good works rise from me of their own accord. My hand is entirely the implement of a distant sphere. It is not my head that functions but something else, something higher, something more remote. I must have great friends there, dark as well as bright. . . . They are all very kind to me.[19]

In Klee's painting of the BATTLE SCENE FROM THE COMIC OPERA "THE SEAFARER," Sinbad the Sailor fights three monsters of the unknown in a battle that has universal human implications.

The marvelous line patterns and rich color are common to Klee's small paintings.

270 Paul Klee
SELF-PORTRAIT
1919. Colored sheet, pen, and wash. 9 x 5¼".

271 Paul Klee
BATTLE SCENE FROM THE COMIC OPERA
"THE SEAFARER"
1923. Colored sheet, watercolor, and oil drawings.
15 x 20¼". *See color plate 36.*

The Italian metaphysical painter Giorgio de Chirico is another artist who, on his own, anticipated Surrealism.

THE MYSTERY AND MELANCHOLY OF A STREET, of 1914, is perhaps his greatest work. De Chirico used distorted linear perspective to create an eerie space peopled by faceless shadows. The painting speaks the symbolic language of dreams, mystery, and ominous silence. According to the artist:

Everything has two aspects: the current aspect . . . which ordinary men see, and the ghostly and metaphysical aspect, which only rare individuals may see in moments of clairvoyance and metaphysical abstraction.[20]

In the 1920s a group of writers and painters gathered to proclaim the omnipotence of the unconscious mind. Their goal was to make this

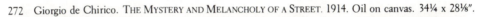

272 Giorgio de Chirico. THE MYSTERY AND MELANCHOLY OF A STREET. 1914. Oil on canvas. 34¼ x 28⅛".

273 Salvador Dali. PERSISTENCE OF MEMORY. 1931. Oil on canvas. 9½ x 13″.

aspect of the mind visible. The group was in-debted to the irrationality of Dadaism and the incredible creations of Chagall, Klee, and de Chirico.

As Surrealism expanded the horizons of the present, it found important ancestors in the past. One of the most imaginative of these was Hieronymus Bosch.

Surrealism refers to the artists' concern for the superreality of the unconscious mind.

Among the prominent members of the Sur-realist group were Miró and Dali. Picasso took part in the first exhibit, but did not remain in the style long. Although Dali is perhaps the best known of these men, he joined the group late and was considered by many Surrealists to be too flamboyant to be taken seriously.

In PERSISTENCE OF MEMORY Salvador Dali evokes the eerie quality of dream experience. Mechanical time wilts in a deserted landscape of infinite space. The warped, headlike image in the foreground may be the last remnant of a vanished humanity.

Joan Miró and Dali, both Spaniards, represent two opposite tendencies operating in Sur-realism. Dali used illusionary deep space and

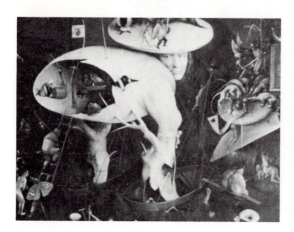

274 Hieronymus van Acken Bosch
THE GARDEN OF WORLDLY DELIGHTS.
Detail of right panel. c. 1500. Oil on wood.

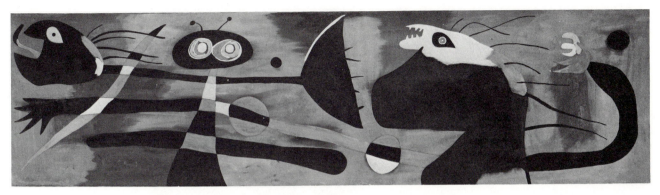

275 Joan Miró
NURSERY DECORATION
1938. Oil on canvas. 2'7½" x 10'6".

276 René Magritte
PORTRAIT
1935. Oil on canvas. 28⅞ x 19⅞".

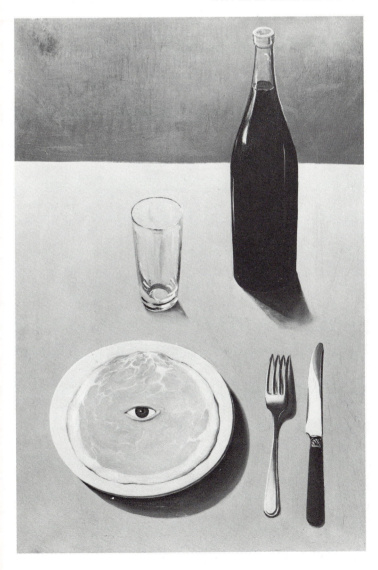

representational techniques to make the impossible seem possible. This approach can be called Representational Surrealism. In contrast, Miró used abstract, suggestive elements, giving the widest possible play to the viewer's imagination. His style can be called Abstract Surrealism. He referred just enough to monsters to evoke memories of the universal fears of childhood. Children respond easily to Miró's paintings. The bold, organic shapes in NURSERY DECORATION are typical of his mature work. The wild, tormented quality is unusual for this painter and probably reflects Miró's reaction to the times. This painting was completed within a year of Picasso's GUERNICA. (See page 210.)

In Belgium the Surrealist movement was led by René Magritte, who based his work on an illogical form of magical realism, similar to Dali's in surface appearance, but quite different in content. In Magritte's paintings the macabre quality found in Dali's work is replaced by wit and playfulness. Everything depicted in PORTRAIT is ordinary. The impact of the painting comes from the strange placement and perspective which transfers these everyday objects into an *extraordinary* image.

In the early 1920s many New World artists went to Europe to study, returning afterward to work in styles influenced by European art. The Depression and growing isolationism changed that. At the same time, the Mexican mural school of the late 1920s led by Diego Rivera and José Clemente Orozco (see pages 84 and 70) influenced American artists to turn to their own culture and country for subject matter.

During the Depression years of the 1930s the United States Government maintained an active program of subsidy for the arts. The Farm Security Administration hired photographers to record the eroding dustbowl and its work-worn inhabitants. One of these photographers, Dorothea Lange, also documented the hopelessness of the urban unemployed in such monumental photographs as A DEPRESSION BREADLINE, SAN FRANCISCO.

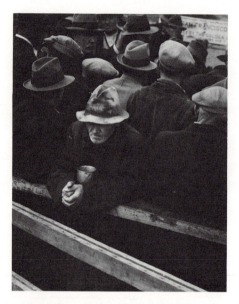

277 Dorothea Lange
A DEPRESSION BREADLINE, SAN FRANCISCO, 1933.

The Works Progress Administration commissioned artists to paint murals in public buildings all over the United States.

278 Georgia O'Keeffe
BLACK CROSS, NEW MEXICO
1929. Oil on canvas. 39 x 30".

Georgia O'Keeffe's paintings of the American Southwest are stark and powerful, painted in her own personal abstract style which seems to grow out of the harmony she perceived in nature rather than a personal search for pure form. Compare her work with that of Mondrian. (See pages 191 and 192.)

A school of regional painting also developed in the United States, exemplified by Grant Wood's AMERICAN GOTHIC. (See page 2.)

David Alfaro Siqueiros was a younger member of the Mexican school of social protest painting. An activist who helped organize an artists union, he was imprisoned for his political activities. He pioneered the use of synthetic paints and industrial materials in art.

In ECHO OF A SCREAM he created a haunting image of horror. A child cries out against the inhumanity of war. Its universal message constitutes a ringing protest against societies which allow children to be killed by so-called adults at

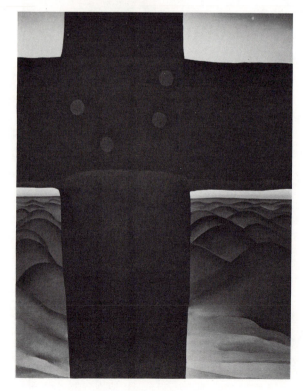

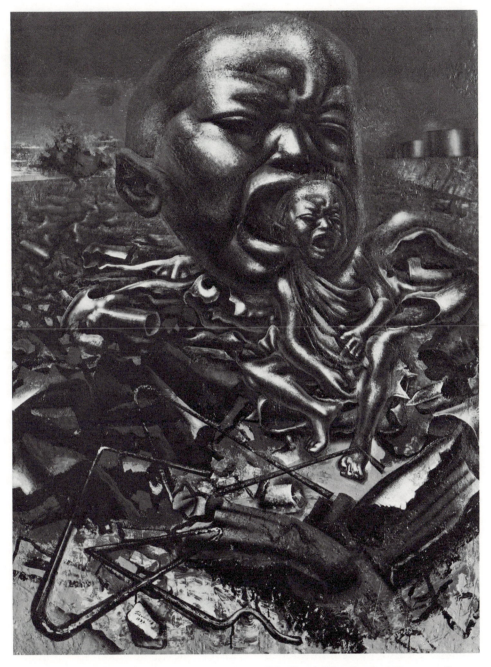

279 David Alfaro Siqueiros. ECHO OF A SCREAM.
1931. Duco on wood. 48 x 36".

war. Siqueiros painted in a realistic style which dealt with social problems. But, as opposed to the prescribed Social Realism of totalitarian countries, his painting was a protest made all the more powerful by his Surrealist violence and symbolic color.

This painting was completed in the same year as Picasso's antiwar statement, GUERNICA. (See following page.)

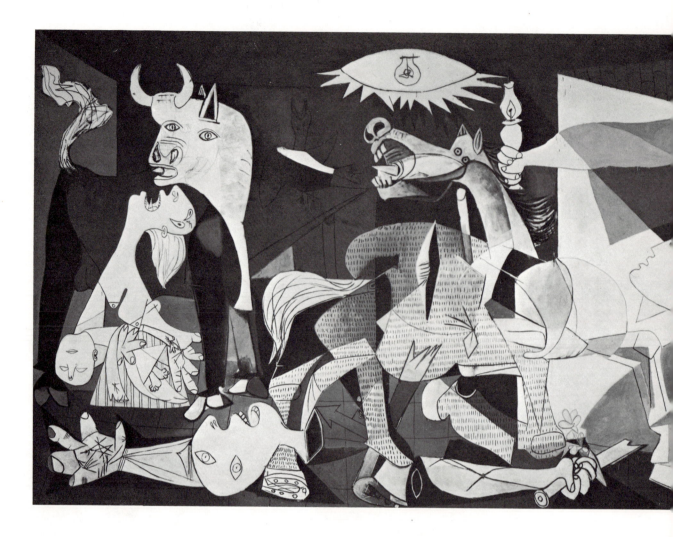

Picasso continued to produce a great volume of innovative drawings, paintings, prints, posters, and sculptures throughout the 1920s and into the early 1930s. Many of these works were filled with distortions and metamorphoses. In 1937, while the Spanish Revolution was in progress, Picasso was commissioned by the Spanish democratic government to paint a mural for the Spanish government building at the Paris Exposition. For several months, he was unable to start work. Suddenly, on April 26, 1937, he was shocked into action by the experimental mass bombing of the defenseless Basque town of Guernica. To aid his bid for power, General Franco allowed Hitler to test his war machinery on the town of Guernica as a demonstration of military power. It was the first incidence of saturation bombing in the

history of warfare. The bombing occurred at night. According to witnesses, one out of every seven people in the town was killed.

Picasso was appalled by this brutal act against the people of his native country. In retaliation, he called upon all his powers to create the mural GUERNICA as a protest against war.

Although GUERNICA stems from a specific incident, it has universal significance, and is viewed today as a work of tremendous religious importance. It is a powerful visual statement of protest against man's inhumanity to man.

The painting covers a huge canvas measuring twenty-five feet, eight inches in length and eleven feet, six inches in height. It occupies an

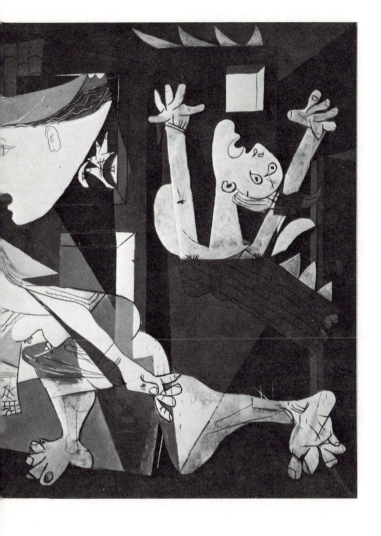

280 Pablo Picasso
GUERNICA
1937. Oil on canvas. 11'5½" x 25'5¼".

entire wall in the Museum of Modern Art in New York City.

GUERNICA is done in somber blacks, whites, and grays, stark symbols of death and mourning. A large triangle is imbedded under the smaller shapes, holding the whole scene of chaotic destruction together as a unified composition. The predominantly triangular shapes and the shallow space are Cubistic. Some of the textural patterns are reminiscent of newsprint.

For Picasso, Cubism was a tool, not a master. He took the Cubist concept from the early intellectual phase through its synthetic period, and here uses it to create a symbol of great emotional intensity.

During the 1940s, while the Nazis occupied France, Picasso maintained his studio in Paris. For some reason, he was allowed to paint, even though his art was considered highly degenerate by the Nazis. The German soldiers harassed him, of course. One day they came to his door with a small reproduction of GUERNICA. They asked, "Did you do this?" Picasso replied, "No, you did."[21]

During the same war years, Picasso made this statement: "No, painting is not done to decorate apartments. It is an instrument of war for a means of attack and defense against the enemy."[22]

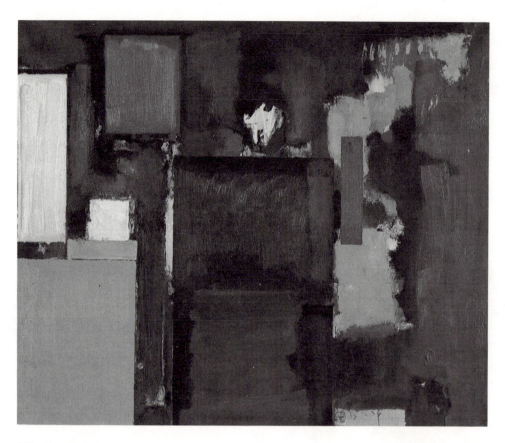

281 Hans Hofmann
THE GOLDEN WALL
1961. Oil on canvas. 60 x 72½". *See color plate* 37.

German artist Hans Hofmann, along with many other European refugees, was a leader in turning New York into the new art center of the 1940s. He was an innovator of action painting, applying his paint with free gestures. Hofmann based his spontaneity on years of visual experience. When he was over sixty, Hofmann began to produce his finest paintings. His large canvases glow with the power of his vision. In THE GOLDEN WALL, warm color is set off by cool accents. Rectangles are played off against irregular shapes.

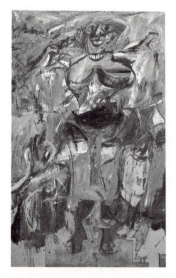

282 Willem de Kooning
WOMAN AND BICYCLE
1952–1953. Oil on canvas. 76½ x 49".
See color plate 38.

Nonrepresentational art came into its own in the United States during the 1940s. The expressive strength of van Gogh, the brushwork and rich color surfaces of Monet's late canvases, and, particularly, Kandinsky's rejection of representational subject matter and his expressive freedom, all formed part of the background against which Abstract Expressionism grew. Miró's Abstract Surrealism was a major influence on Abstract Expressionism. In

New York about 1943, few painters were attracted to the austere, hard-edge abstractions of Mondrian. Rather, they turned to Kandinsky's expressive approach, creating works saturated with emotion.

It is easy to perceive the influence of Miró and Kandinsky (see pages 207 and 183) in de Kooning's series of paintings of women. WOMAN AND BICYCLE is more representational than Miró's or Kandinsky's paintings. It has a dominant quality of brutal energy.

These paintings are overpowering because of their size and the obviously slashing attacks with which they were painted. De Kooning began one of these woman paintings by cutting a gleaming artificial smile from an advertisement and attaching it to the canvas for the mouth of the figure. In WOMAN AND BICYCLE, the toothy smile is repeated in a savage necklace capping a pair of tremendous breasts. (See color plate 38.)

The dynamic form of de Kooning's painting is closely related to the moving energy of Jackson Pollock's surfaces. The subject of Pollock's paintings is the act of painting itself and the energy of the paint. This approach, known as action painting, is characteristic of much of the work of the Abstract Expressionists. Pollock's painting, No. 14, was done by flinging paint onto the canvas rather than brushing it on.

283 Jackson Pollock. No. 14. 1948. Enamel on wet gesso. 23¾ x 31″.

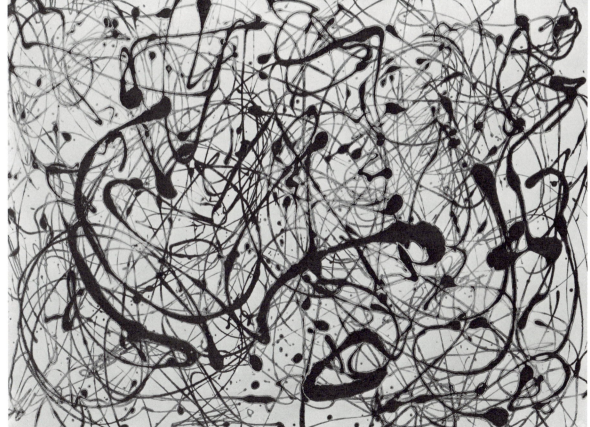

Because Pollock dripped, poured, and flung his paint, many people felt that he had no control. Actually, he exercised control and selection by the rhythmical, dancing movement of his body.

Mark Tobey was one of the oldest members of the Abstract Expressionist group. He studied Chinese art, and lived in the northwestern part of the United States, where he was physically and intellectually closer to Asia than to Europe. In 1947 he wrote a statement summarizing his position:

Our ground today is not so much the national or the regional as it is the understanding of this single earth. . . . America more than any other country is placed geographically to lead in this understanding, and if from past habits of behavior she has constantly looked toward Europe, today she must assume her position . . . toward Asia, for in not too long a time the waves of the Orient shall wash heavily upon her shores.[23]

In addition to the influence of Tobey's outlook, several of the New York painters were fascinated by their own discoveries of Asian art and religion. Zen Buddhism was particularly influential in their development.

A dominant element in much of Abstract Expressionism is the expression of the artist's inner life through bold use of calligraphic line. In this sense many of their paintings are like giant signatures.

284 Mark Tobey
EDGE OF AUGUST
1953. Tempera on composition board. 48 x 28".

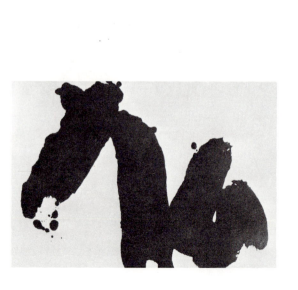

285 Yuichi Inoue
CALLIGRAPHY BUDDHA
1957

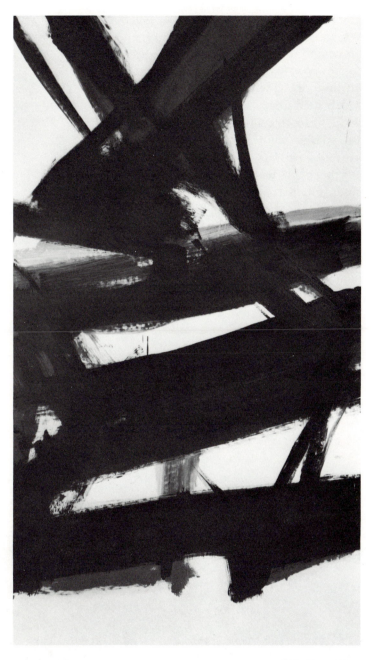

286 Franz Kline
HORIZONTAL RUST
1960. Oil on canvas. 86½ x 49″.

This attitude toward line, which is apparent in the painting of Franz Kline, has been basic to Chinese and Japanese writing, or calligraphy, for thousands of years. There is a mutual influence going back and forth between Asia and the West that has been of great benefit to both cultures. The result is a growing international style based on shared beliefs, yet rich in its own variety.

The major characteristic of art today is variety.
We are still too close to know who the most
important artists of the last twenty years are.
Andrew Wyeth may well be one. Using the old
medium of egg tempera, which has not been
widely used since its replacement by oil paints
in the fifteenth century, Wyeth has done what
any master painter must do. He has con-
structed a painting in which each visual rela-
tionship works with the motivating concept to
create an image of quality. Although every
detail of this painting is highly representation-
al, it is more than that. Wyeth has selected and
defined the elements working together in THAT
GENTLEMAN to make it much more than a
mere copy of the subject. Wyeth explains, ". . .
feel that the more you get into the textures of
things the less you have to clutter up the com-
position with a lot of props. When you lose
simplicity, you lose drama."[24]

287 Andrew Wyeth. THAT GENTLEMAN. 1960. Tempera on board. 23½ x 47¾".

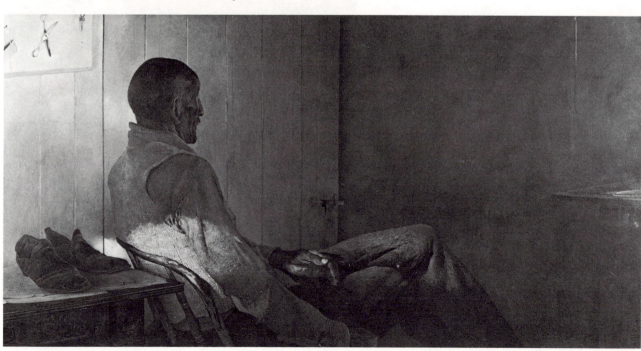

288 Robert Rauschenberg. TRACER. 1964. Mixed media. 84 x 60″.

Robert Rauschenberg was a leader in the trend toward what came to be known as Pop Art. In the mid-1950s, he began incorporating actual, identifiable, three-dimensional objects in paintings that were otherwise Abstract Expressionist in form. By so doing, he again brought attention to the aesthetic capacity of mundane things. He called these works *combines*. Rauschenberg's collages relate to the work of Kurt Schwitters. (See page 203.) About 1962 Rauschenberg began to reproduce borrowed images from art and life with the aid of the new photographic silk-screen printing. These he combined with brushwork on large canvases. His TRACER of 1964 is a key work of this type.

289 Tom Wesselmann
STILL LIFE NO. 33
1963. Paint and collage. 11 x 15'.

Soon Rauschenberg was joined by others who shared his dissatisfactions with the denial of common visual reality in Abstract Expressionism. These painters rejected the personal and emotional expressions of the action painters, and returned again to the visual environment that had been avoided by their predecessors. Instead of rejecting the mundane ugliness of the man-made environment, they accepted it.

Pop Art's media sources include the comic strip, the advertising blowup, the branded package, and the visual clichés of billboard, newspaper, movie house, and TV.

The artifacts that are the dominant subject matter of Pop Art take a central position in our time similar to the position held by Christian subjects during the Renaissance. The difference is that Michelangelo was intensifying faith in a religion, while artists like Tom Wesselmann are exposing the shallowness of our faith in things.

The size of the paintings, and the boldness of single visual components within them, have carried over from Abstract Expressionism. Yet, in contrast to the emotional warmth of Abstract Expressionism, Pop painters such as Lichtenstein, Rosenquist, Warhol, and Wesselmann

Color plate 36
Paul Klee
BATTLE SCENE FROM
THE COMIC OPERA
"THE SEAFARER".
1923. Colored sheet,
watercolor, and oil
drawings. 15 x 20¼".

Color plate 37
Hans Hofmann
THE GOLDEN WALL
1961. Oil on canvas.
60 x 72½".

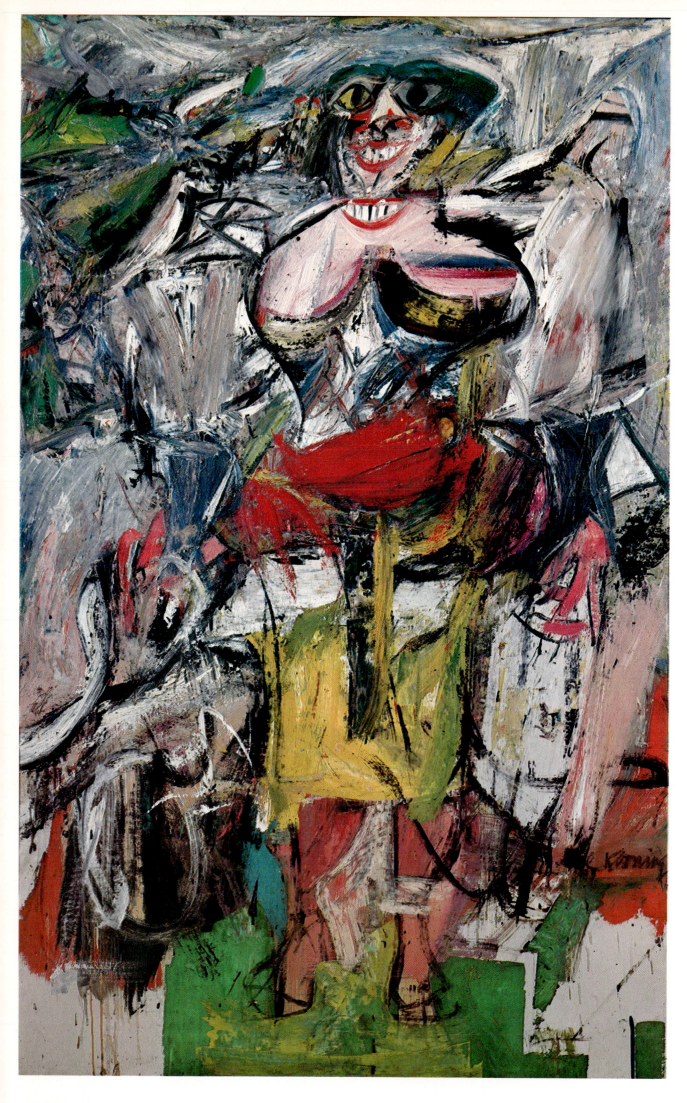

Color plate 38 Willem de Kooning. WOMAN AND BICYCLE. 1952–1953. Oil on canvas. 76½ x 49″.

Color plate 39
Thomas Wilfred
LUMIA SUITE, OP. 158
(two stages). 1963–
1964. Light composi-
tion projected against
a screen. 6 x 8′.

Color plate 42 NASA. THE WORLD. North and South America photographed from
Applications Technological Satellite at a 22,300-mile altitude, November 18, 1967.

use skill in creating cool, mechanical images, hiding all evidence of their personal touch. They often use photographic silk-screen stencils and airbrush techniques to achieve their images.

The Coke bottle is a most commonplace object in today's world. An archeologist of the future who digs up the remains of our present civilization will find so many Coke bottles that he may assume they were used in some sort of common fertility ritual! Marisol used an actual bottle in her assemblage. Other artists commented on the Coke culture in paintings and photographs.

290 Marisol. LOVE. 1962. Plaster. Life-size.

291 Ivan Masser. THE PAUSE THAT REFRESHES. Kenya, 1964.

292 Claes Oldenburg. Sculpture in the Form of a Trowel Stuck in the Ground. 1971. Height 40'.

It is fairly easy to divide artists into stylistic groups, but the practice is valuable only up to a point. Ultimately each person gives form to individual experience. Claes Oldenburg can be called a Pop sculptor, but that label merely suggests his point of view.

Oldenburg calls our attention to the amazing character of ordinary man-made things by taking them out of context, changing their scale, or by transforming them from hard to soft. A garden tool becomes a monument in his Sculpture in the Form of a Trowel Stuck in the Ground, overwhelming us with its exaggerated scale in an ordinary setting.

Successive styles in the arts frequently react to the style that precedes them. In this way the new style expresses the changing character of the times. Pop Art was in part a reaction against the highly personal, often nonobjective nature of Abstract Expressionism, whereas Abstract Expressionism was itself a reaction to the cool impersonality of the purist paintings of Mondrian and others.

In architecture Le Corbusier led a reaction away from the cold geometric functionality of the International style, which he helped to develop. (See pages 117 and 193.) The bold, organic, free form of his chapel at Ronchamp has some of the expressive character of the prehistoric dolmen, also believed to be a religious structure. Le Corbusier's highly sculptural building renews and celebrates the human spirit, putting emotion back into contemporary architecture.

293 DOLMEN OF MANÉ-KERIONED
Carnac, Morbihan, France, 3000–2000 B.C.

294 Le Corbusier. NOTRE-DAME-DU-HAUT. Exterior. Ronchamp, France. 1950–1955.

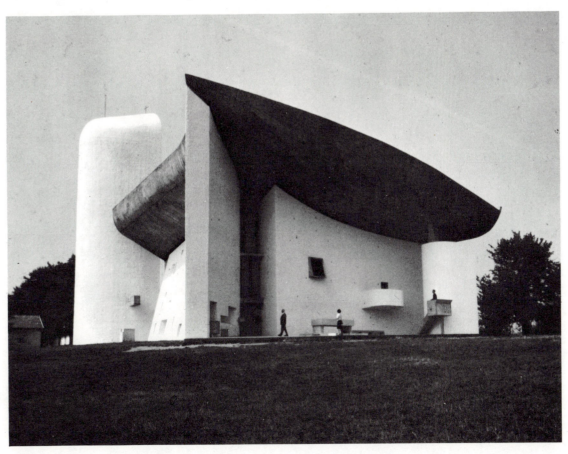

Variety of image, concept, and materials was characteristic of figurative sculpture of the 1950s and 1960s just as it was of figurative painting. (See pages 216, 217 and color plate 38.)

The poignant personal feelings expressed in the bronze by Marianna Pineda are in strong contrast to the alienated twentieth-century human in George Segal's machine-made environment. The cool, blank anonymity of the cast unpainted plaster people in Segal's environments are in turn contrasted with the plastic colors of Luis Jiménez' sculpture. The slick surfaced epoxy resin of THE AMERICAN DREAM emphasizes Pop culture's media-created sex-object woman and America's love affair with the automobile. In opposition, we now see Pineda's strong, seeking woman as reaching for an integration of her femininity and her strength.

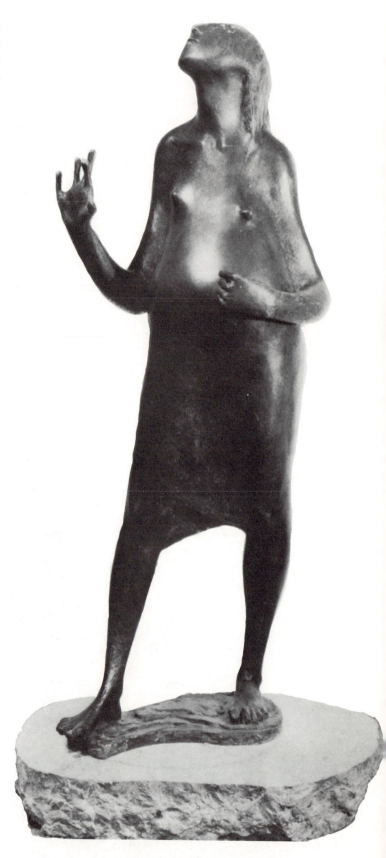

295 Marianna Pineda
SLEEPWALKER
1950. Bronze. 38" high.

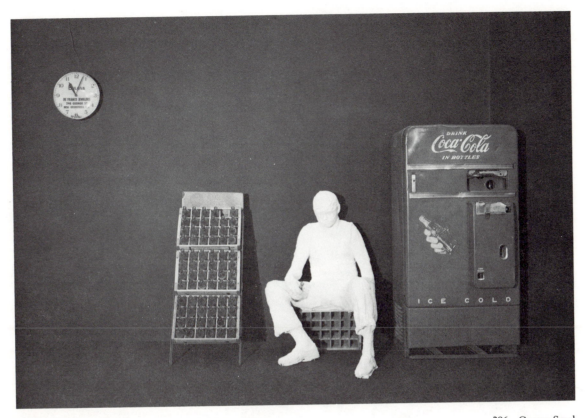

296 George Segal
Detail of THE GAS STATION
1963. Plaster and mixed media.
8'6" x 24' x 4'.

297 Luis Jiménez
THE AMERICAN DREAM 1967–69.
Fiberglass resin epoxy coating,
first of five castings. 3' high.

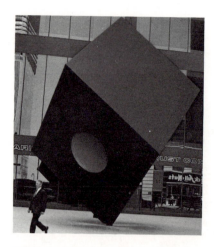

298 Isamu Noguchi. CUBE. 1969. Painted welded steel and aluminum. Height 28′. *See color plate 18*

Isamu Noguchi's distorted CUBE engages the viewer in the dynamics of balance, bold color, and shaped space. The sculpture's simple mass is influenced by one related to a sculpture style of the sixties called Minimal Art. (See Tony Smith's CUBE, page 230.) Its huge proportions allow it to interact with the skyscraper.

Ben Cunningham goes beyond the usual rectangular format for a painting in PAINTING FOR A CORNER. His combination of reflective and nonreflective surfaces creates a new kind of illusionary space. Numerous artists work with free-standing panels, reflective and relief surfaces, and with shaped canvases that move in three-dimensional space. Their work breaks down the line between painting and sculpture.

299 Ben Cunningham. PAINTING FOR A CORNER. 1948–1950. Oil on canvas. 25½ x 36½″. 25½ x 21½″.

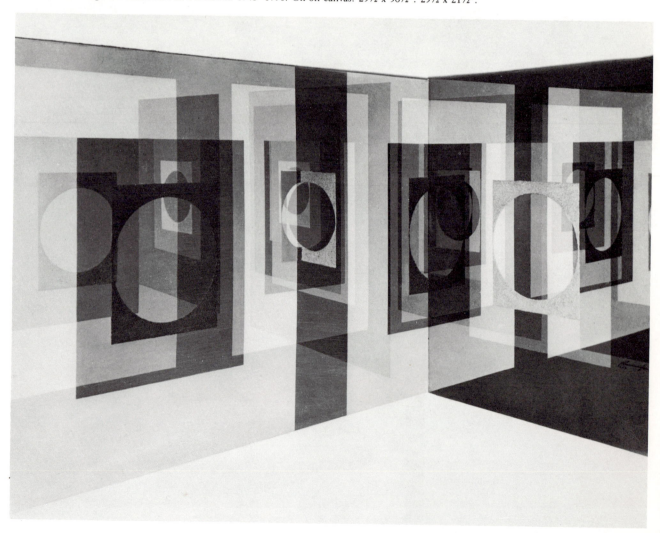

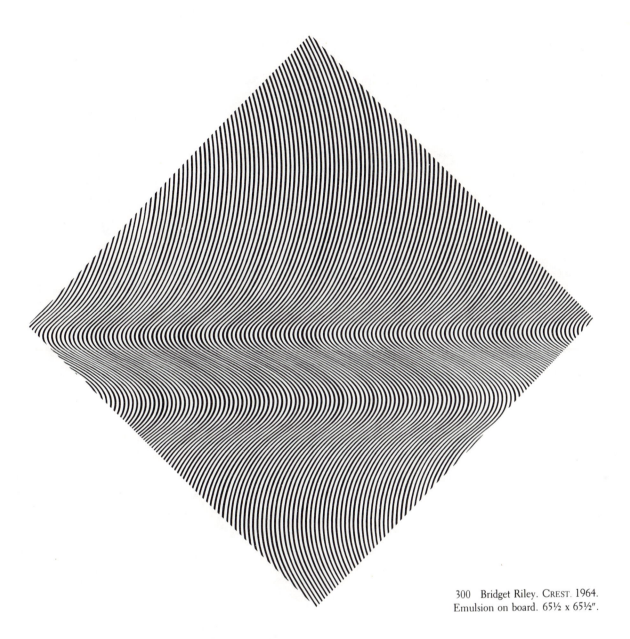

300 Bridget Riley. CREST. 1964.
Emulsion on board. 65½ x 65½".

Painters have also sought maximum effectiveness with minimal means. In painting there is more than one way to make a surface come to life. The action painters used thick paint and bold brushwork to develop dynamic surfaces. Then the optical or Op painters pushed surface movement even further. The dynamic tension of their geometric images exists only in the eye of the beholder. A primary aim is to stretch vision by producing kinetic visual sensations that are not actually present in the initial image. These eye movements are involuntary.

The Op artist's emphasis on scientific exploration of optical phenomena is even farther than Pop from the idea of personal expression. Painters like Vasarely (see color plate 17) and Bridget Riley explore the field of pure optical experience with the cool precision and anonymity of engineers. In CREST Riley combines the movement of the diagonal edges of the picture plane with the dynamic energy of the linear surface rhythms. Compare her precise impersonal painting with the expressive effect of the similar wavelike pattern in the WAVE UNDER THE MOON, painted in twelfth-century China. (See page 65.)

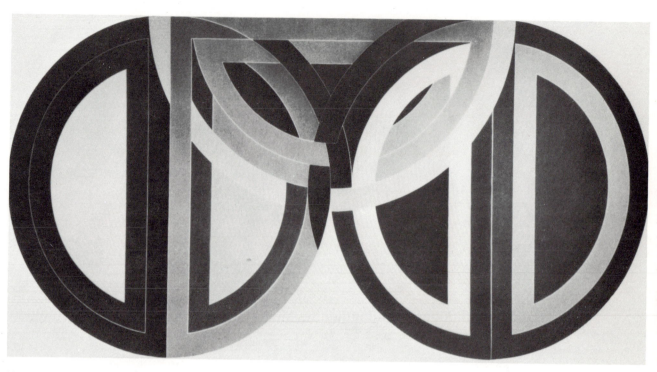

301 Frank Stella. HIRAQLA 1. 1968. Polymer and fluorescent polymer paint on canvas. 10 x 20'.

Ever since Cubism broke with the Renaissance concept of deep space, some painters have tried to push the limits of flatness, rather than depth. Almost any mark on a flat surface will begin to give the appearance of depth. Frank Stella has tried to conteract that fact by using interwoven bands of color. The interwoven pattern of intense color pulls together into a tight spatial sandwich. Although the colors tend to either advance or recede, each is pulled to the surface again because of its placement in the overlapping visual weave.

Acrylic paint revitalized color in painting in recent years. Helen Frankenthaler's work evolved during the height of Abstract Expressionism. The use of acrylic paints made it possible for her to stain huge canvases with thin layers of intense color. She spread liquid colors out across unprimed canvas, where they soaked in, becoming part of the fabric. Her main concern is the potential of colors and shapes. Today Frankenthaler is a leader of color field painting, in which fluid areas of paint provide an environment of color.

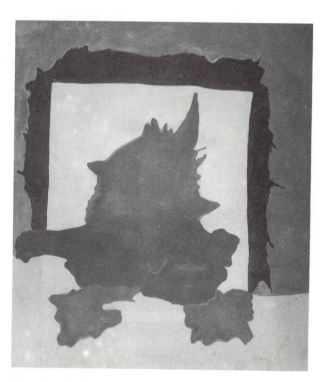

302 Helen Frankenthaler
INTERIOR LANDSCAPE
1964. Acrylic on canvas. 103¾ x 92¾". *See color plate 41.*

About 1967 a few artists began experimenting with laser light. The laser beam consists of a straight, narrow band of light, organized in direction and totally pure in hue. Because of its coherent nature the laser beam remains narrow indefinitely. A variety of pure light sculpture pieces have been produced with this new medium.

Laser light has also provided a new form of photography called holography. With holography it is possible to reconstruct a fully three-dimensional light image or hologram. There is no camera or lens involved. The hologram is a recording of lightwave interference patterns.

Light shows presented with rock and other forms of contemporary music became popular in the mid-1960s. The drug culture produced a vibrant, emotional style of art that appeared most frequently in posters advertising rock music concerts and accompanying light shows. The flamelike curvilinear forms of turn-of-the-century art provided inspiration. Psychedelic art was the popular informal partner of Op.

303 Thomas Wilfred
LUMIA SUITE, OP. 158 (two stages)
1963–1964. Light composition projected against a screen. 6 x 8'. *See color plate 39.*

Since Edison invented the electric light bulb in 1879, it has been possible to control light. Light is a medium, not a style. Its use in art is not a new idea. Twenty-five centuries ago Pythagoras visualized the silent motion of the heavenly bodies as visual music and called it "the music of the spheres." Isaac Newton speculated on a possible connection between the vibrations of sound and light in an art of "Color Music."

Thomas Wilfred was one of the first to conceive of light art as an independent aesthetic language. He called it "lumia." His experiments in 1905 led to the development of the "Clavilux Lumia," an instrument on which he played the first public recitals in 1922 in New York City, and later throughout the United States, Canada, and Europe. His mechanically recorded compositions are now exhibited in museums and art collections.

304 Wes Wilson. THE SOUND. 1966. Silk screen.

Kinetic art is art that changes as you look at it or touch it. The term "kinetic" applies to a wide range of styles in which motion is an important element. Form and content in contemporary kinetic art ranges from cool precision to the happy absurdity of Jean Tinguely's mechanical junk sculpture.

The Swiss sculptor Tinguely creates machines that do just about everything except work in the manner expected of machines. In 1960 Tinguely built a large piece of mechanized sculpture that he put together from materials gathered from junkyards and stores around New York City. The result was a giant assemblage designed to destroy itself at the turn of a switch. The sculpture was appropriately called HOMAGE TO NEW YORK: A SELF-CONSTRUCTING, SELF-DESTROYING WORK OF ART.

Another mixed-media art form that came into prominence in the early 1960s was the "happening." Artists, who saw easel painting and fixed-object sculpture as irrelevant, found they could involve their audience in works that can best be described as experimental participatory theater. The resulting dramas had Dada and Surrealist overtones.

The term "happening" was first used in the United States by Allan Kaprow. Like Duchamp, the creators of happenings wanted to force the viewer to be involved with his environment. No help is given to the viewer, who is expected to find his own answers. Strictly speaking, happenings are drama with "structure but no plot, words but no dialogue, actors but no characters, and above all, nothing logical or continuous."[25] Unlike Dada and Surrealist events, the first happenings were frequently nihilistic without a relieving sense of humor.

Festivals of all kinds can be considered happenings. In a broad sense, if they contribute to human experience, they act as art. Street protests can work as happenings. If the participants have a sense of symbolic drama, the effect can be powerful.

305 Jean Tinguely. HOMAGE TO NEW YORK: A SELF-CONSTRUCTING, SELF-DESTROYING WORK OF ART. 1960

306 ANTI-AUTO POLLUTION DEMONSTRATION OUTSIDE COLISEUM, NEW YORK CITY,
WHERE THE ANNUAL AUTO SHOW WAS ON. April 1971.

The Russian painter Malevich was the grand-father of Minimal Art. He worked with Cubism for awhile, then pioneered this purist approach in 1913, when he painted "nothing more or less than a black square on a white background. . . . It was not just a square I had exhibited," he explained, "but rather the expression of nonobjectivity."[26] (See Malevich's related painting WHITE ON WHITE, page 38.)

During the last fifteen years, a number of painters and sculptors have reduced the complexity of their designs to a minimum by concentrating on simple geometric structures. Minimal Art forces us back on our inner resources by giving us fewer elements to consider. Minimal artists often create massive *things*, invading space and confronting the viewer with their presence.

Sculptor Tony Smith was one of the first to explore the possiblities of large inert objects. Smith challenged another preconception about the nature of art by removing himself completely from the process. He merely ordered a six-foot cube by telephone. The size, mass, material and method produce a heavy visual statement.

Most of us have strong emotional attachments to the idea that a work of art is a unique object, an original, made only once by the artist's own hands. Actually, artists have been designing things that were made by artisans for thousands of years. Architects have rarely, if ever, tried to construct a building by themselves. In Japan, popular color woodcut prints have been produced by artist teams. The artist-designer, the publisher, the wood engraver, and the colorist were all responsible for the final print. In filmmaking, large groups must work to produce the finished product. The idea of a single original created by the hands of one artist is irrelevant in this context.

We live in a world of reproductions. Nearly everything we come into contact with is designed by one person and mass-produced by others. In an environment full of mass-produced things, a one-of-a-kind-thing, obviously made by hand, is refreshing. This is why the crafts are now enjoying greater popularity.

The multiple original concept has now grown from printmaking into sculpture (see Printmaking, page 86). Bill's sculpture of polished stainless steel, called DOUBLEMENT, has been produced by industrial methods in a numbered edition of 200 copies. This particular work can almost be considered a Minimal multiple.

Al Held cuts off his shapes at the edge of the picture plane in such a way that they seem even more gigantic than they actually are. The figure in this photograph shows the scale of his painting, GREEK GARDEN.

307 Tony Smith
DIE
1962. 6 x 6'.

308 Max Bill
DOUBLEMENT
1970. Polished stainless steel. 15 x 15 x 15″.

309 Al Held. GREEK GARDEN. 1966. Acrylic on canvas. 12 x 56′.

In a capsule history of the visual arts we can only mention the most notable public arts of our time: photography, cinematography, and television. These arts play a major role in contemporary life, yet to weave them into this tapestry of painting, sculpture, and architecture would be confusing. While the camera arts are the dominant popular forms of our time, their quantity makes it difficult to find those works that are of sufficient quality to be called art in the full sense of the word. Both film and television are kinetic forms that respond to the demands of mechanized urban life. Their transitory character fits with the complex technology that supports them. What will be their significance to future man?

The quality of impersonal neutrality found in many camera images has been the basis for the recent style of painting descriptively labeled Photorealism.

It is represented here by Don Eddy's PRIVATE PARKING X. (See color plate 40.)

In the late 1960s many serious artists tried to abandon the established circuit of galleries, dealers, patrons, and museums by creating noncollectable works. Permanence, long a major concern in the visual arts, had become less important to artists. The process of creating art thus became as important as the product, culminating in Conceptual Art, in which the original idea *about* a work of art becomes the art.

Conceptual Art is one aspect of a strong recent tendency to conceive works that relate to interior and exterior spaces, not as isolated wall pieces or floor pieces, but as environmentally inclusive forms. Earth artists such as Dennis Oppenheim manipulate the land. Whether this art is permanent or impermanent, beneficial or destructive to the land, depends on the sensibility of the individual artist.

310 Dennis Oppenheim. CANCELED CROP. 1968.

Our sensibilities as viewers ultimately decide what is of lasting value in the arts.

Society takes what it wants. The artist himself doesn't count, because there is no actual existence for the work of art. The work of art is always based on the two poles of the onlooker and the maker, and the spark that comes from that bipolar action gives birth to something—like electricity. But the onlooker has the last word, and it is always posterity that makes the masterpiece. The artist should not concern himself with this, because it has nothing to do with him.

Marcel Duchamp[27]

6

How can art help renew our hope for the future?

Art reflects who we are. It is how we present ourselves to the world. The art objects which surround us are an extension of ourselves, and what we feel about life. That is why it is important to extend our awareness into the environment, to see what kind of picture it reflects.

Artists continue to renew and extend our experience. Artists who appear ahead of their time are among the few who are truly *with* their time. They tell the society what is happening to it, and act as an early warning system, revealing signs of danger and decay in a sick age. Other artists offer hope for the new era which is already beginning.

All the arts are environmental in the sense that they help determine the quality of our living areas. As we have shown in chapter 3, professionals affect the outdoor environment on a large scale. These include: architects who are responsible for the design of buildings and groups of buildings; landscape architects who plan open green spaces; graphic designers who determine how street signs will look; industrial designers who are responsible for the appearance of manufactured objects ranging from street furniture to transportation systems; and urban and regional designers who plan ordered relationships between each of these diverse physical elements.

Some professionals create more problems than they solve. But even the best professionals cannot solve environmental problems alone. Their efforts are outweighed by the force of the economic, political, and social values of the culture as a whole.

This means YOU and ME—all of us, whether we work together or apart. In the sense that what we do changes our surroundings, we are all environmental designers.

Your environment is your self-portrait. It begins with your attitudes about life. Simply by being alive, you make a difference. You are part of the problem, *and* part of the solution.

How you care for or neglect your own body is a starting point. A healthy man or woman complements and is a part of the beauty of nature. Your smallest acts change how you live. Eating, washing, combing your hair, deciding what to wear—all have an effect on your environment.

How we organize the interior spaces in our lives also makes a difference in how we feel about ourselves, and what we project onto the outer environment.

Outside the home or work environment, we affect community design when we move from place to place. The pattern of footpaths, sidewalks, streets, and bus or train routes are generated by our travel patterns. As we change these habits, the transportation corridors of the city and region will eventually reflect these changes for better or worse.

311 Linda Wiig. ARTIFICIAL FORMULA. 1968. Photograph.

From room to region, from small decisions about personal health and appearance to large physical and political decisions affecting entire continents and oceans, we shape our surroundings and they in turn shape us.

In areas of the nonindustrial world which still exist today, the material culture of people is made by craftsmen whose work reflects shared values and feelings. Within a community built in this way, each person knows that everything that is not nature-made was made and can be made again by people like themselves. (See pages 115, 118, and 121.) In the manufactured world most of us live in now, this is not true. Other people working with machines make our buildings, our furniture, our utensils. The

touch of their hands can rarely be seen or felt. Living in this type of setting can make us feel that the built environment is just *there* and cannot be changed. This feeling we have of not being in control of our surroundings is one of the causes of today's environmental crisis.

Art is concerned with the quality of life. What we call *life* is an interaction between ourselves and our surroundings. It is a *relationship*. The quality of that relationship determines whether there will be life or death, and if there is life, whether it will be worth living.

The most basic relationship is between ourselves and the land. Our current abuse of the land is largely the result of our attitude that land is a commodity to be owned, bought, sold, and consumed. If we can see the land as part of an ecological system of which we are but a small part, we will use it with greater respect. We can learn an attitude of humility toward, and rapport with, the natural world from the native peoples of North America and the Pacific whose land we have appropriated. This is the only way our land and those who live on it can survive the impact of modern egotistical man. We must design *with* nature.

The ability of early humans to identify with the environment and to act out the drama of life in drawing, carving, mime, and song, calmed their fears and hungers and intensified their joys. To create art called for intuition, imagination, memory, skill, and the imitation of natural forms. Today we have the same human needs. But because we are not aware that we are also involved in creating our environment, we often feel that we cannot improve it. Enclosed as we are in the machine-made world, it is difficult to realize that we *are* still nature-made and nature-supported creatures.

We have gradually learned to manipulate nature to our own will, to move from creature to creator, to make things in order to survive, and finally to move beyond survival to a life of leisure and culture. Now our powers of manipulation are so great that in exercising them carelessly we have often denied and even destroyed the sources of life itself. We have become a thing-oriented society, and our things threaten to destroy us.

Tools extend our power. Today's tools give us the awesome power to transform the world, greatly magnifying the impact of our choices.

Our next step is to use this power to make our man-made environment a work of art—a work of harmony and delight, capable of promoting rather than destroying the health and well-being of all who share it. Not for one above or against another, but *for* one another.

Given the growing array of environmental problems facing us today, it is no wonder that many of us feel despair. Perhaps worse than despair is the illusion that we can escape the crisis by abandoning our wasted places for fresh ones. Another form of escape is the withdrawal which can occur when the environment becomes so bad that it pollutes our senses and anesthetizes our perception.

Through art we can come back to our senses. We can again be in touch with feelings, while avoiding total despair or the need for escape. As art keeps us in touch with what is, and what can be, it enriches our experience, and gives a quality of rightness to the things we make. In making art we produce forms that are the human extension of nature within us. It is important that we bring back to life our collective sense of design which has become dulled through many generations of progressive disuse.

Our aesthetic awareness can be developed to the point that there is no need to draw a line between the art of everyday life and the art of the museum. When we surround ourselves with the elements of a life-style we have consciously chosen as being enjoyable, the best in us is reaffirmed. As we experience our decision-making capacity, our critical sensibilities are strengthened. Our taste grows more discriminating as we use it.

The things we decide to make or buy every day involve selection. In a free society, taste and public demand play a large part in determining how things are designed. Everything we wear or use from toasters to transportation systems is designed with the consumer in mind. And you are the consumer. By deciding *not* to buy a product because it is not attractive, you are affecting its design, and even its future existence.

Now that you have a greater understanding of the visual arts and their possibilities, you can consciously employ this new awareness to improve the quality of your immediate surroundings as well as the larger community environment which you share with others. This action will affirm and strengthen the best in you. It will begin a constructive cycle that grows into a self-generating give-and-take between yourself and your place of living.

312 Roy DeCarava. Untitled. c. 1950.

313 Dana Chandler, Jr. KNOWLEDGE IS POWER.—STAY IN SCHOOL.

When you become aware of how your surroundings and your relationships to them affect your feelings and even your health, you can begin to take a more active role in saving and renewing the good and changing the bad.

It is becoming clear that peacefulness, beauty, and order play a part in maintaining our physical and mental health. One of the most dangerous aspects of concentrated urban environments is the lack of confirmation of the worthwhile self. Being forced to live in a dingy apartment in a crowded neighborhood makes a person feel that she or he is not worth much.

A new mural filled with color and symbolic importance can give the community, and particularly those who participate in its creation, a sense of pleasure and new strength.

314 Ansel Adams. MOON AND HALF DOME, YOSEMITE NATIONAL PARK, CALIFORNIA. c. 1960.

If we are to stand the stresses of urban life, some direct contact with nature may be vital to us. The need for protected areas was understood as early as 1898 by John Muir, naturalist, conservationist, and pioneer spokesman for the national parks and founder of the Sierra Club.

"Thousands of tired, nerve-shaken, over-civilized people are beginning to find out that going to the mountains is going home; that wildness is a necessity; and that mountain parks and reservations are useful not only as fountains of timber and irrigating rivers, but as fountains of life."[1]

But nature must also be close to us. Maintaining a wilderness mountain area is vital, but it does not help people who, for economic or physical reasons, cannot go to it. We need nature where it can be enjoyed each day. The regular occurrence of open space combined with vegetation can help to meet the city-dweller's need for relief from pollution of the senses. In a park, one can open ears, eyes, and nostrils without fear of being overwhelmed.

Abundant plant life gives the country its beauty. More can be done with plants around, between, and even on, city buildings. Some high-rise structures have been designed to be covered with vines, and other buildings have elaborate roof gardens. Parking garages can have parks on their roofs. The Oakland Museum in California is roofed with a series of garden terraces providing space for outdoor sculpture, and pleasant places in which to sit and rest or eat.

315　Kevin Roach & Associates. OAKLAND MUSEUM. 1969.

316

We can take steps to bring the country to the city. We can plant community vegetable gardens in vacant lots or even front yards. Neighborhoods could be joined together by bike trails following now-vacant land along power and railway rights-of-way.

Footpaths could be placed along rivers and streams which have not yet been lined with concrete.

San Antonio, Texas, decided to develop its river for people-use. There was much argument about how to deal with the San Antonio River that flowed through the heart of the city. Some said that it should be encased in concrete and built over in order to provide more commercial space. Others wanted to take advantage of its inherent charm by providing park space, a continuous walkway, boating facilities, and restaurants along the river's edge. Fortunately for the city, the people who believed in the river's potential won the argument.

In San Antonio, the river is now a delight to all those who live there.

What kind of positive action can you work on in your community?

▶ Find vacant lots. See if the owners will allow and help you and your friends to clean them, plant some flowers, and build temporary sculptural play equipment from old railroad ties and telephone poles. Perhaps this will spark enough interest so that you and your community can raise the money to buy these spaces for permanent parks.

▶ Urge your city recreation department to develop a continuing program to buy vacant lots for small neighborhood parks all over the city.

▶ Organize your block to plant trees and flowers. Get everyone, young and old, involved in it—digging, planting, and watering. Get your city to use your taxes to help pay for the materials if possible.

▶ Urge your city to improve its mass transportation system to get cars off the streets.

▶ Entice people out of their cars by urging your community to develop foot and cycle paths that are safe and attractive.

▶ Urge your city and state governments to require that a percentage of the money appropriated for government buildings be set aside for art and its maintenance. Go to hearings to be sure that they choose art that you will enjoy.

▶ Approach businesses, urging them to budget money for art in places where the community can enjoy it. Then give them the kind of publicity that will get other businesses to join in.

▶ Organize neighborhood art groups. Get workshops going that involve people in the art process. Petition your city government (the art commission if you have one) to hold hearings in each neighborhood to find

317 RIVER WALK. San Antonio, Texas. 1969.

318 C. W. Felix, coordinator.
WALL, ESTRADA COURTS HOUSING PROJECT. 1973.

out what the people want. (Believe it or not, this works.) Pressure city hall to appropriate money for art classes, little theater, dance, and music groups.

▶ Organize your neighborhood art workshop to paint murals on walls. Either arrange for local professional artists to do the work, or ask them to design and supervise a group effort.

These are actions others have taken to save the best and change the worst.

It only takes a few people to get things started. Reach out to find others who are willing to work for *change*. It may be hard at first, but as the results begin to show, more and more people will become excited and get involved.

It won't happen without you. You have to take action, stay with it, harass, plead, push, go to hearings, organize letter and telephone campaigns. But you will be a part of something that will make a difference.

To act effectively as agents in our own future, we must first *see* and *feel*. Art provides the tools for going beyond the bald facts of the world. If understood and employed by many, the ideas, values, and approaches that constitute the basis of the visual arts could help transform our surroundings into something viable and satisfying. We create art. Art creates us.

319 M. Paul Friedberg and Associates.
VEST POCKET PLAYGROUND
AND NATURE STUDY CENTER.
New York City, 1968.

List of color plates

1 A CHILD'S PAINTING OF A TREE. Nearest text page 26.

2 Jan Vermeer. THE ARTIST IN HIS STUDIO. Nearest text page 26.

3 Henri Matisse. NASTURTIUMS AND THE DANCE. Nearest text page 27.

4 Kasimir Malevich. YELLOW QUADRILATERAL ON WHITE. Nearest text page 27.

5 Pierre Bonnard. DINING ROOM IN THE COUNTRY. Nearest text page 27.

6 CHARTS SHOWING RANGES IN THE THREE DIMENSIONS OF COLOR. Nearest text page 58.

7 Sandro Botticelli. Detail of BIRTH OF VENUS. Nearest text page 58.

8 Jasper Johns. FLAGS. Nearest text page 58.

9 Richard Anuskiewicz. INJURED BY GREEN. Nearest text page 59.

10 Henry Moore. RECUMBENT FIGURE. Nearest text page 59.

11 Paul Cézanne. THE TURNING ROAD. Nearest text page 59.

12 Toshiko Takaezu. CERAMIC POT. Nearest text page 90.

13 Alice Parrott. RED FORM. Nearest text page 90.

14 Carol Summers. CHEOPS. Nearest text page 90.

15 Eliot Porter. TAMARISK AND GRASS. Nearest text page 90.

16 Gordon Parks. BOY IN GRASS. Nearest text page 91.

17 Victor Vasarely. UNTITLED. Nearest text page 91.

18 Isamu Noguchi. CUBE. Nearest text page 91.

19 SOLOMON AND THE QUEEN OF SHEBA. Nearest text page 122.

20 Bill D. Francis. PEACOCK FEATHER. Nearest text page 122.

21 POMO FEATHERED BASKET. Nearest text page 122.

22 CANOE PROW ORNAMENT. Nearest text page 122.

23 FACSIMILE OF POLYCHROME CATTLE. Nearest text page 123.

24 LEFTHAND WALL, GREAT HALL OF BULLS. Nearest text page 123.

25 Claude Monet. IMPRESSION: SUNRISE. Nearest text page 123.

26 Auguste Renoir. LE MOULIN DE LA GALETTE. Nearest text page 123.

27 Vincent van Gogh. THE SOWER. Nearest text page 154.

28 Paul Gauguin. TWO NUDES ON A TAHITIAN BEACH. Nearest text page 154.

29 George Seurat. SUNDAY AFTERNOON ON THE ISLAND OF LA GRANDE JATTE. Nearest text page 155.

30 Paul Cézanne. MONT SAINTE-VICTOIRE. Nearest text page 155.

31 Gustav Klimt. THE KISS. Nearest text page 155.

32 Wassily Kandinsky. BLUE MOUNTAIN. Nearest text page 186.

33 Lyonel Feininger. THE GLORIOUS VICTORY OF THE SLOOP "MARIA." Nearest text page 186.

34 Piet Mondrian. COMPOSITION WITH RED, YELLOW AND BLUE. Nearest text page 187.

35 Kurt Schwitters. CONSTRUCTION FOR NOBLE LADIES. Nearest text page 187.

36 Paul Klee. BATTLE SCENE FROM THE COMIC OPERA "THE SEAFARER." Nearest text page 218.

37 Hans Hofmann. THE GOLDEN WALL. Nearest text page 218.

38 Willem de Kooning. WOMAN AND BICYCLE. Nearest text page 218.

39 Thomas Wilfred. LUMIA SUITE, OP. 158 (two stages). Nearest text page 218.

40 Don Eddy. PRIVATE PARKING X. Nearest text page 219.

41 Helen Frankenthaler. INTERIOR LANDSCAPE. Nearest text page 219.

42 NASA. THE WORLD. Nearest text page 219.

Chronological guide
to works of art

15,000–10,000 B.C. FOREQUARTERS OF BULL, PAINTED GALLERY, 158

15,000–10,000 B.C. LEFTHAND WALL, GREAT HALL OF BULLS, color plate 24

8th–7th centuries B.C. PAINTED AND GLAZED EARTHENWARE VASE, 136

c. 4000 B.C. FACSIMILE OF POLYCHROME CATTLE, 133, color plate 23

3000–2000 B.C. DOLMEN OF MANE-KERIONED, 221

2600–2000 B.C. MAN PLAYING A SYRINX, 153

c. 2525 B.C. KING MYCERINUS AND QUEEN, 152

c. 1500–1059 B.C. CHINESE SACRAL VESSEL, 137

c. 1450 B.C. QENNEFER, STEWARD OF THE PALACE, 44

c. 540 B.C. STANDING YOUTH, 155

c. 500 B.C. KORE, detail of, 149

c. 450–400 B.C. Polyclitus, SPEAR BEARER, 155

447–432 B.C. Ictinus and Callicrates, view of PARTHENON from northwest, 144

c. 415 B.C. APOLLO, 110

c. 330–320 B.C. Praxiteles, HERMES AND THE INFANT DIONYSIUS, detail of, 149

3rd century B.C.–6th century A.D. NEOLITHIC HOUSE, reconstruction of, 118

c. 80 B.C. PORTRAIT HEAD, 150

c. 10 B.C.–15 A.D. THE GREAT STUPA, 146

15 LE PONT DU GARD, 145

54–117 FEMALE PORTRAIT, 150

118–125 PANTHEON, 146

5th century STANDING BUDDHA, 140

c. 685 SHRINES AT ISE, Main Sanctuary from northwest, 118

8th century CARICATURE FROM CEILING OF HORYU-JI, NARA, JAPAN, 9

c 990–1030 Fan K'uan, TRAVELERS ON A MOUNTAIN PATH, 82

11th century SHIVA NĀTARĀJA, 141

c. 1000 SCENE FROM KANDARYA TEMPLE, 33

12th century Unknown Chinese artist, A WAVE UNDER THE MOON, 65

c. 1100 CHRIST, 142

1125–1150 CHRIST OF THE PENTECOST, detail of, 140

1145–1170 SAINTS AND ROYAL PERSONAGES, façade of west portal, Notre Dame de Chartres, 33

1145–1513 NOTRE DAME DE CHARTRES, interior, 147

1200 ENTHRONED MADONNA AND CHILD, 19

c. 1208 Unkei, MUCHAKU, detail of, 151

1225–1299 ARCADES AND VAULTS OF NAVE AT REIMS CATHEDRAL, 49

c. 1269 Mu Ch'i, SIX PERSIMMONS, 51

c. 1305 Giotto di Bondone, THE DESCENT FROM THE CROSS, 159

c. 1338–1340 Ambrogio Lorenzetti, VIEW OF A TOWN, 126

c. 1350–1399 Angelo Puccinelli, TOBIT BLESSING HIS SON, 52

15th century MARKET HALL AT MEREVILLE, FRANCE, 148

1429–1430 Filipo Brunelleschi, PAZZI CHAPEL, 147

c. 1440 Sassetta and assistant, THE MEETING OF SAINT ANTHONY AND SAINT PAUL, 57

c. 1445 Andrea Mantegna, THE MADONNA AND CHILD, 19

c. 1450 FORTIFICATIONS AT SACSAHUAMAN, detail of, 121

c. 1490 Sandro Botticelli, BIRTH OF VENUS, 161; detail of, 43; color plate 7

c. 1490 Leonardo da Vinci, CARICATURE, 9

1491 RYŌAN-JI GARDEN, 50

c. 1495–1498 Leonardo da Vinci, THE LAST SUPPER, 160

16th century BENIN HEAD, 110

16th century IVORY MASK, 135

c. 1500–1900 FACSIMILE OF CHUMASH INDIAN ROCK PAINTING, 138

c. 1500 Hieronymus van Aeken Bosch, THE GARDEN OF WORLDLY DELIGHTS, detail of right panel, 206

c. 1500 TLAZOLTÉOTL, 18

1501–1504 Michelangelo Buonarroti, DAVID, 155, detail of, 151

c. 1508 Michelangelo Buonarroti, STUDIES FOR THE LIBYAN SIBYL IN THE SISTINE CHAPEL CEILING, 76

1509 Raphael Sanzio, THE SCHOOL OF ATHENS, 53

1513 Albrecht Dürer, KNIGHT, DEATH AND DEVIL, 89

c. 1514 Raphael Sanzio, MADONNA OF THE CHAIR, 69

1515–1524 Joachim Patinir, REST ON THE FLIGHT INTO EGYPT, 156

1527 Hans Holbein, SIR THOMAS MORE, 61

1530–1534 Michelangelo Buonarroti, UNFINISHED SLAVE, 109

1539 Hans Holbein, ANNE OF CLEVES, 68

1555 Michelangelo Buonarroti, DEPOSITION FROM THE CROSS, 22

c. 1556–1565 SOLOMON AND THE QUEEN OF SHEBA, 57, color plate 19

c. 1568 Pieter Brueghel, THE PAINTER AND THE CONNOISSEUR, 24

c. 1585 Marietta Tintoretto, PORTRAIT OF AN OLD MAN AND A BOY, 162

1593 AERIAL VIEW OF PALMANOVA, ITALY, 131

17th century KATSURA, gardens and teahouse at; aerial view of, 34

1624–1708 AERIAL VIEW OF VERSAILLES, FRANCE, 34

1628 Francisco de Zurbarán, SAINT SERAPION, 38

1630 Rembrandt van Rijn, SELF POR-TRAIT IN A CAP, OPEN MOUTHED AND STARING, 23

c. 1642 Rembrandt van Rijn, SASKIA ASLEEP, 80

1645–1650 Nicholas Poussin, SAINT JOHN ON PATMOS, 176

c. 1652 Rembrandt van Rijn, CHRIST PREACHING, 88

c. 1655–1660 Claude Lorrain, THE HERDSMAN, 55

1656 Diego Rodrigues de Silva Veláz-quez, THE MAIDS OF HONOR, 23

1658 Pieter de Hooch, INTERIOR OF A DUTCH HOUSE, 69

c. 1661 Rembrandt van Rijn, HEAD OF SAINT MATTHEW, 61

c. 1665 Jan Vermeer, THE ARTIST IN HIS STUDIO, 24, color plate 2

c. 1670 Jacob Isaac van Ruisdael, WHEAT-FIELDS, 156

1692 Wang Hui, DEEP IN THE MOUN-TAINS, 157

c. 1765 Jean-Honoré Fragonard, THE BATHERS, 163

Probably CHIEF'S STOOL, 186
19th Century

c. 19th century AFRICAN SCULPTURE, detail of, 18

19th century INTERIOR OF A MANEABA, 148

19th century POMO STORAGE BASKET, 135

c. 1800 Gibon Sengai, THE CRAB, 64

c. 1800 Gibon Sengai, THE FIST THAT STRIKES THE MASTER, 159

1801 Kitagawa Utamaro, MOTHER AND CHILD WITH NOISEMAKER, 86

1810–1815 Francisco Goya, BULL FIGHT, 71

c. 1814 Pierre-Paul Prud'hon, STUDY OF A FEMALE NUDE, 37

1814 Francisco Goya, THE THIRD OF MAY 1808, 164

c. 1820–1825 Hokusai, TUNING THE SAMISEN, 77

1832–1834 MERCHANTS' EXCHANGE, 145

1834 Honoré Daumier, TRANSNONAIN STREET, 90

1839 Louis Jacques Mandé Daguerre, LE BOULEVARD DU TEMPLE, 166

1847 Thomas Couture, ROMANS OF THE DECADENCE, 165

1849 Gustave Courbet, THE STONE BREAKERS, 168

1850–1851 Sir Joseph Paxton, CRYSTAL PALACE, interior view, 148

1855 Eugène Delacroix, PHOTOGRAPH FROM ALBUM, 167

1857 Eugène Delacroix, ODALISQUE, 167

1872 Claude Monet, IMPRESSION: SUN-RISE, 170, color plate 25

c. 1873 Edgar Degas, PLACE DE LA CON-CORDE, 171

1873 Edouard Manet, GARE SAINT-LAZARE, 169

1876 Auguste Renoir, LE MOULIN DE LA GALETTE, color plate 26

1878 Eadweard Muybridge, GALLOPING HORSE, 96

1879–1882 Paul Cézanne, THE TURNING ROAD, 56, color plate 11

c. 1880 Vincent van Gogh, CARPENTER, 76

1884–1885 Thomas Eakins, NUDE ATHLETE IN MOTION, 167

1884–1886 Georges Seurat, SUNDAY AFTER-NOON ON THE ISLAND OF LA GRANDE JATTE, 172, color plate 29

1885–1886 Paul Cézanne, THE GARDEN, 189

1886–1898 François Auguste René Rodin, THE KISS, 178

c. 1888 Jacob Riis, BANDIT'S ROOST, 175

1888 Vincent van Gogh, THE SOWER, 173, color plate 27

1888 Vincent van Gogh after Hiroshige, PLUM TREES IN BLOSSOM, 173

1890–1891 Louis Sullivan, WAINWRIGHT BUILDING, 116

c. 1891 Paul Cézanne, THE GULF OF MARSEILLES, SEEN FROM L'ESTAQUE, 177

1892 Paul Gauguin, FATATA TE MITI, 59

1892 Paul Gauguin, TWO NUDES ON A TAHITIAN BEACH, 174, color plate 28

1892 Paul Gauguin, WORDS OF THE DEVIL, 59

1892 Henri de Toulouse-Lautrec, AT THE MOULIN ROUGE, 175

1893 Henri de Toulouse-Lautrec, JANE AVRIL (oil on cardboard), 72

1894 W. K. Dickson, FRED OTT'S SNEEZE, 97

1895 Edvard Munch, THE KISS (drypoint and aquatint), 60

1896 Edvard Munch, THE SHRIEK, 143

1897–1898 Edvard Munch, THE KISS (woodcut), 60

1904–1906 Paul Cézanne, MONT SAINTE-VICTOIRE, 176, color plate 30

1904 Pablo Picasso, A MOTHER HOLDING A CHILD AND FOUR STUDIES OF HER RIGHT HAND, 20

1905–1906 Henri Matisse, JOY OF LIFE, 182

1906 Constantin Brancusi, SLEEPING MUSE, 180

1906 Claude Monet, WATER-LILIES, GIVERNY, 170

1906 Pablo Picasso, SELF-PORTRAIT, 186

1907 Pablo Picasso, THE YOUNG LADIES OF AVIGNON, 187

1907 Alfred Stieglitz, THE STEERAGE, 184

1908 Constantin Brancusi, THE KISS, 179

1908 Georges Braque, HOUSES AT L'ESTAQUE, 56

1908 Wassily Kandinsky, BLUE MOUNTAIN, 183, color plate 32

1908 Gustav Klimt, THE KISS, 181, color plate 31

1909–1911 Constantin Brancusi, SLEEPING MUSE, 180

1909 Pablo Picasso, THE RESERVOIR AT HORTA DE EBRO, 188

1909 Frank Lloyd Wright, ROBIE HOUSE, 185

1911–1912 Pablo Picasso, GUITAR, 190

1911 Marc Chagall, I AND MY VILLAGE, 58

1911 Piet Mondrian, HORIZONTAL TREE, 191

1911 Pablo Picasso, THE CLARINET PLAYER, 189

1912–1913 Pablo Picasso, SHEET OF MUSIC AND GUITAR, 190

1912 Marcel Duchamp, NUDE DESCENDING A STAIRCASE, #2, 194

1912 Wassily Kandinsky, WITH THE BLACK ARCH, NO. 154, 183

1912 Jacques Henri Lartigue, GRAND PRIX OF THE AUTOMOBILE CLUB OF FRANCE, 195

1912 Henri Matisse, NASTURTIUMS AND THE DANCE, 25, color plate 3

1912 Emil Nolde, PROPHET, 87

1913 Pierre Bonnard, DINING ROOM IN THE COUNTRY, color plate 5

1913 Marcel Duchamp, BICYCLE WHEEL, 200

1914–1915 Le Corbusier, DOMINO CONSTRUCTIONAL SYSTEM, 193

1914 Giorgio de Chirico, THE MYSTERY AND MELANCHOLY OF A STREET, 205

1915 Constantin Brancusi, THE NEWBORN, 180

1916–1917 Kasimir Malevich, YELLOW QUADRILATERAL ON WHITE, color plate 4

1917 John Marin, DEER ISLE — MARINE FANTASY, 83

c. 1918 Daniel Chester French, ABRAHAM LINCOLN, detail of, 35

1919 Marcel Duchamp, L.H.O.O.Q., 201

1919 Paul Klee, SELF-PORTRAIT, 204

1919 Fernand Léger, THE CITY, 196

1919 Kurt Schwitters, CONSTRUCTION FOR NOBLE LADIES, 203, color plate 35

1920 Hannah Höch, THE MULTIMILLIONAIRE, 202

1921–1954 Simon Rodia, WATTS TOWERS, 11

1921 Pablo Picasso, THREE MUSICIANS, 198

1921 Man Ray, THE GIFT, 201

1922 Le Corbusier, DRAWING FOR CITY OF THREE MILLION, 128

1923 Paul Klee, BATTLE SCENE FROM THE COMIC OPERA "THE SEAFARER," 204, color plate 36

1923 Pablo Picasso, YOUNG MAN'S HEAD, 43

1924 Käthe Kollwitz, DEATH SEIZING A WOMAN, 27

1925 Walter Gropius, THE BAUHAUS, 193

1926–1930 Jacques Lipchitz, FIGURE, 199

1926 Lyonel Feininger, THE GLORIOUS VICTORY OF THE SLOOP "MARIA," 197, color plate 33

1928 Constantin Brancusi, BIRD IN SPACE, 46

1929 Georgia O'Keeffe, BLACK CROSS, NEW MEXICO, 208

1929 Ludwig Mies van der Rohe, BARCELONA CHAIR, 100

1930 Piet Mondrian, COMPOSITION WITH RED, YELLOW AND BLUE, 192, color plate 34

1930 Edward Weston, PEPPER #30, 32

1930 Grant Wood, AMERICAN GOTHIC, 2

1931 Salvador Dali, PERSISTENCE OF MEMORY, 206

1931 José Clemento Orozco, ZAPATISTAS, 70

1933 Dorothea Lange, A DEPRESSION BREADLINE, SAN FRANCISCO, 208

1933 Diego Rivera, NEW WORKERS' SCHOOL MURALS, detail of, 84

1934 Käthe Kollwitz, SELF-PORTRAIT, 27

c. 1935–1945 Henri Matisse, PORTRAIT OF I.C., 79

1935 M. C. Esher, HAND WITH REFLECTING GLOBE, 54

1935 René Magritte, PORTRAIT, 207

1936 Harold Edgerton, MILK SPLASH RESULTING FROM DROPPING A BALL, 93

1937 Margaret Bourke-White, AT THE TIME OF THE LOUISVILLE FLOOD, 94

1937 Pablo Picasso, GUERNICA, 211-212, detail of, 20

1937	Pablo Picasso, HEAD (study for GUERNICA), 9
May 9, 1937	Pablo Picasso, FIRST COMPOSITION STUDY FOR GUERNICA, 75
1937	David Alfaro Siqueiros, ECHO OF A SCREAM, 209
1938	Joan Miró, NURSERY DECORATION, 139, 207
1938	Henry Moore, RECUMBENT FIGURE 46, color plate 10
1943	Pablo Picasso, BULL'S HEAD, 111
c. 1945	POMO FEATHERED BASKET, color plate 21
1945	Saul Steinberg cartoon, vi
1946	N. R. Farbman, BECHUANALAND, 4
1947	Alberto Giacometti, MAN POINTING, 44, detail of, 62
1948–1950	Ben Cunningham, PAINTING FOR A CORNER, 224
1948	Wayne Miller, MOTHER AND BABY, 12
1948	JACKSON POLLOCK, No. 14, 213
c. 1949	Le Corbusier, DRAWING FOR NOTRE-DAME-DU-HAUT, 75
c. 1950	Roy DeCarava, UNTITLED, 236
1950	Marianna Pineda, SLEEPWALKER, 222
c. 1950	MAN WEARING LION MASK, 134
1950–1955	Le Corbusier, NOTRE-DAME-DU-HAUT, exterior, 221; interior, 62
1950	Gordon Bunshaft of Skidmore, Owings, and Merrill, LEVER HOUSE, 117
1951	Werner Bischof, HUNGER IN INDIA, 28
1951	Werner Bischof, SHINTO PRIESTS IN TEMPLE GARDEN, 29

1951	Marcel Duchamp, BICYCLE WHEEL (replica), 200. See 1913.
1952–1953	Willem de Kooning, WOMAN AND BICYCLE, 212, color plate 38
1952	Henri Matisse, BLUE NUDE III AND BLUE NUDE IV, 26
1952	Isamu Noguchi, BIG BOY, 108
1952	Charles White, THE PREACHER, 78
1953–1956	Richard Lippold, VARIATION WITHIN A SPHERE, NO. 10: THE SUN, 112
1953	Mark Tobey, EDGE OF AUGUST, 214
1954	Werner Bischof, LONE FLUTEPLAYER, 29
1954	Margaret Bourke-White, CONTOUR PLOWING, 95
1956	Elliott Erwitt, MOTHER AND CHILD, 21
1957	Yuichi Inoue, CALLIGRAPHY BUDDHA, 214
c. 1958	Man Ray, THE GIFT (replica), 201. See 1921.
1959	Charles Harbutt, SPECTATORS, 31
1959	Barnett Newman, DRAWING, 67
1960	Ansel Adams, MOON AND HALF DOME, YOSEMITE NATIONAL PARK, CALIFORNIA, 238
1960	Franz Kline, HORIZONTAL RUST, 215
1960	Saul Steinberg cartoon, 63
1960	Takis, ELECTROMAGNETIC SCULPTURE, 113
1960	Jean Tinguely, HOMAGE TO NEW YORK: A SELF-CONSTRUCTING, SELF-DESTROYING WORK OF ART, 228
1960	Andrew Wyeth, THAT GENTLEMAN, 216

1961 Hans Hofmann, THE GOLDEN WALL, 212, color plate 37

1961 Eliot Porter, TAMARISK AND GRASS, color plate 15

1962 Alexander Calder, THE GATES OF SPOLETO, 113

1962 Alberto Giacometti, SELF-PORTRAIT, 74

1962 Marisol, LOVE, 219

1962 Tony Smith, DIE, 230

1963–1964 Thomas Wilfred, LUMIA SUITE, OP. 158 (two stages), 227, color plate 39

1963 Richard Anuskiewicz, INJURED BY GREEN, 42, color plate 9

1963 William Kenzler, NICOLL RESIDENCE, interior, 124

1963 George Segal, THE GAS STATION, detail of, 223

1963 Tom Wesselmann, STILL LIFE NO. 33, 218

1964 Helen Frankenthaler, INTERIOR LANDSCAPE, 226, color plate 41

1964 Ivan Masser, THE PAUSE THAT REFRESHES, 219

1964 Robert Rauschenberg, TRACER, 217

1964 Bridget Riley, CREST, 225

1964 Kenzo Tange, OLYMPIC STADIUMS, exterior, Natatorium; aerial view; interior, Natatorium, 119

1965 Jasper Johns, FLAGS, 42, color plate 8

1965 Takis, ELECTROMAGNETIC SCULPTURE (modified), 113. See 1960

1965 Kazuaki Tanahashi, HEKI, 73

1965 Kenzo Tange, PLAN FOR RECONSTRUCTION OF SKOPJE, YUGOSLAVIA, 130

1966 Rober Breer, FLOATS, 58

1966 Victor Gruen and Associates, METROCORE AND ITS TEN CITIES, 131

1966 Al Held, GREEK GARDEN, 231

1966 Wes Wilson, THE SOUND, 227

1967 R. Buckminster Fuller, U.S. PAVILION, EXPO-67, 114

1967–1969 Luis Jiménez, THE AMERICAN DREAM, 223

1967 KALAPALO INDIANS HOUSE, 115

1967 Alice Parrott, RED FORM, 104, color plate 13

1967 Carol Summers, CHEOPS, color plate 14

1967 Victor Vasarely, UNTITLED, color plate 17

1967 Hale Woodruff, SHRINE, 85

1968 Elliott Erwitt, HIGHWAYS, 129

1968 Dennis Oppenheim, CANCELED CROP, 232

1968 Gordon Parks, BOY IN GRASS, color plate 16

1968 Frank Stella, HIRAQLA 1, 226

1968 Linda Wiig, ARTIFICIAL FORMULA, 311

1969 Bill D. Francis, PEACOCK FEATHER, 65, color plate 20

1969 Isamu Noguchi, CUBE, 224, color plate 18

1969 Kevin Roach and Associates, OAKLAND MUSEUM, 239

1969 Moshe Safdie, MODEL OF HABITAT ISRAEL, 132

1970 Max Bill, DOUBLEMENT, 231

1970 Marvin Lipofsky, LEERDAM GLASVORMCENTRUM COLOR SERIES 1970, 106

1971 Don Eddy, PRIVATE PARKING X,
 color plate, 40

1971 Claes Oldenburg, SCULPTURE IN
 THE FORM OF A TROWEL STUCK
 IN THE GROUND, 220

1971 Duane Preble, 101 NORTH, 2

1971 Toshiko Takaezu, CERAMIC POT,
 103, color plate 12

April 1971 ANTIAUTO POLLUTION DEMON-
 STRATION, 229

April 1971 APOLLO 16 ASTRONAUTS SALUTING
 FLAG ON THE MOON, 98

1972 Richard I Felver, PERCOLATOR
 DESIGN, 101

1972 Duane Preble, REFLECTIONS, 199

1973 Edward Brownlee, BRACELET, PEN-
 DANT AND RING, 107

1973 C. W. Felix, WALL, ESTEADA
 COURTS HOUSING PROJECT, 242

1973 The Shaver Partnership and Bob
 Campbell & Company, TENT
 STRUCTURE, 125

c. 1974 Dana Chandler, KNOWLEDGE IS
 POWER, STAY IN SCHOOL, 313

1975 Tom Hirai, CHAIR, 107

Date unknown CANOE PROW ORNAMENT, photo-
(collected graph by Axel Poignant, 136, color
1929) plate 22

Date unknown NAVAJO SAND PAINTING, 158

Credits

COLOR PLATES

1 Courtesy Christopher Kitson.
2 Kunsthistorisches Museum, Vienna.
3 Pushkin Museum of Fine Arts, Moscow.
4 Stedelijk Museum, Amsterdam.
5 The Minneapolis Institute of Arts. The John R. van Derlip Fund.
6 From THE VISUAL DIALOGUE: AN INTRODUCTION TO THE APPRECIATION OF ART by Nathan Knobler. 2nd ed., 1971. Reproduced by permission of Holt, Rinehart & Winston, Inc., New York City.
7 Uffizi Gallery, Florence. Photograph from Editorial Photocolor Archives, Inc., New York City.
8 Courtesy Leo Castelli Gallery, New York.
9 Collection Mrs. Janet S. Fleisher, Elkins Park, Pennsylvania.
10 Photograph by John Webb, London. The Tate Gallery, London.
11 The Museum of Fine Arts, Boston. Bequest of John T. Spaulding.
12 Courtesy of the artist, Honolulu.
13 Ceramics 70 Plus Woven Forms Exhibition, Everson Museum of Art, Syracuse, New York.
14 The Museum of Modern Art, New York City. John B. Turner Fund.
15 From THE PLACE NO ONE KNEW—GLEN CANYON ON THE COLORADO, published 1963 by Sierra Club Books, San Francisco.
16 Courtesy of the photographer, New York City.
17 Courtesy of the author.
18 Photograph by Jerome Feldman, New York City.
19 The Smithsonian Institution, Freer Gallery of Art, Washington, D.C.
20 Courtesy of W.S. Benson & Co., Austin, Texas.
21 Courtesy Mr. William M. Garland II. Los Angeles County Museum of Natural History.
22 Basel Museum, Switzerland.
23 Editions Arthaud, Paris.
24 Hans Hinz, Basel, Switzerland.
25 Musée Marmottan, Paris. Photo Routhier, Paris.
26 The Louvre Museum, Paris.
27 Collection Vincent van Gogh Foundation, Amsterdam.
28 Honolulu Academy of Arts. Gift of Mrs. Charles M. Cooke, 1933.
29 The Art Institute of Chicago. Helen Birch Bartlett Memorial Collection
30 Philadelphia Museum of Art. Purchased: The Geo. W. Elkins collection #E-36-1-1.
31 Galerie Welz Salzburg, Austria.
32 The Solomon R. Guggenheim Museum, New York City.
33 City Art Museum of Saint Louis.
34 Collection Alfred Roth, Zurich.
35 Los Angeles County Museum of Art.
36 Collection Frau T. Dürst-Haass, Muttenz, Switzerland. Color photograph from Hans Hinz, Basel, Switzerland.
37 The Art Institute of Chicago. Mr. and Mrs. Frank G. Logan Collection.
38 Whitney Museum of American Art, New York City.
39 Commissioned by The Museum of Modern Art, New York City.
40 Contemporary Gallery, New York City.
41 San Francisco Museum of Art.
42 National Aeronautics and Space Administration, Dallas.

BLACK AND WHITE ILLUSTRATIONS

1 © 1945 by Saul Steinberg.
2 The Art Institute of Chicago.
3 Courtesy of the author.
4 From LIFE Magazine, © Time, Inc., New York City.
5 From NATIONAL GEOGRAPHIC 136, No. 1 (July 1969): 156.
6 Student metaphor from magazine sources.
7 Royal Library, Windsor Castle. Reproduced by gracious permission of H. M. The Queen.

8 National Research Institute of Cultural Properties, Nara, Japan.

9 On extended loan to The Museum of Modern Art, New York City, from the artist. Permission S.P.A.D.E.M. 1972 by French Reproduction Rights, Inc., New York City.

10 Courtesy of the author.

11 Magnum Photos, Inc., New York City.

12 Reprinted with permission of The Macmillan Company from CREATIVE AND MENTAL GROWTH by Victor Lowenfeld and W. Lambert Brittain © 1970 by The Macmillan Company, New York City.

13 Drawn by author's daughter, Kristen, at age four.

14 Drawn by author's son, Jeffrey, at age four.

15 From THE PSYCHOLOGY OF CHILDREN'S ART by Rhoda Kellog with Scott O'Dell, published 1967 by CRM Books, Del Mar, California.

16 Courtesy Christopher Kitson.

17 Japanese National Commission for UNESCO.

18 Dumbarton Oaks, Washington, D.C. Research Library and Collection.

19 Estate of Eliot Elisafon, New York.

20 National Gallery of Art, Washington, D.C. Andrew Mellon Collection.

21 Museum Berlin, West Germany.

22 On extended loan to The Museum of Modern Art, New York City, from the artist. Permission S.P.A.D.E.M. 1972 by French Reproduction Rights, Inc., New York City.

23 Fogg Art Museum, Cambridge, Massachusetts.

24 Magnum Photos, Inc., New York City.

25 Florence Cathedral. Photograph from Alinari, Florence.

26 The Prado Museum, Madrid.

27 British Museum, London.

28 Graphische Sammlung Albertina, Vienna.

29 Kunsthistorisches Museum, Vienna.

30 Pushkin Museum of Fine Arts, Moscow.

31 The Baltimore Museum of Art. The Cone Collection.

32 Private collection, Paris. Permission S.P.A.-D.E.M. 1972 by French Reproduction Rights, Inc., New York City.

33 The Museum of Modern Art, New York City.

34 Philadelphia Museum of Art.

35 Magnum Photos, Inc., New York City.

36 Magnum Photos, Inc., New York City.

37 Magnum Photos, Inc., New York City.

38 Magnum Photos, Inc., New York City.

39 Courtesy of the photographer, Cole Weston, Carmel, California.

40 Photograph from Holle Verlag, Baden-Baden, Germany.

41 Archives photographiques de la caisse nationale des monuments historiques et des sites, Paris.

42 Photograph by Hisao Ohara. From KATSURA RIKYU, published 1972 by Toshobo.

43 French Government Tourist Office, New York City.

44 Courtesy of Mrs. Margaret French Cresson.

45 From ART TODAY, 5th ed., by Ray Faulkner and Edwin Ziegfeld, published 1969 by Holt, Rinehart & Winston, Inc., New York City. All rights reserved.

46 Courtesy of the author.

47 Henry P. McIlhenny Collection, Philadelphia.

48 Wadsworth Atheneum, Hartford, Connecticut. Ella Gallup Sumner and Mary Catlin Sumner Collection.

49 The Museum of Modern Art, New York City.

50 Courtesy TIME Magazine, New York City.

51 Collection Mrs. Janet S. Fleisher, Elkins Park, Pennsylvania.

52 Uffizi Gallery, Florence. Photograph from Editorial Photocolor Archives, Inc., New York City.

53 Private collection. Permission S.P.A.D.E.M. 1972 by French Reproduction Rights, Inc., New York City.

54 British Museum, London.

55 The Museum of Modern Art, New York City.

56 Photograph by John Webb, London. The Tate Gallery, London.

57 The Museum of Modern Art, New York City.

58 Photograph by Phokion Karas, Cambridge, Massachusetts.

59 Maris/Ezru Stroller Photographs.

60 Archives photographiques de la caisse nationale des monuments historiques et des sites, Paris.

61 From JAPANESE HOUSES: PATTERNS FOR LIVING by Kiyoyuki Nishihara, published 1968 by Japan Publications Trading Co., Inc., San Francisco.

62 Ryoko-in, Daitoku-ji, Kyoto.

63 Philbrook Art Center, Tulsa, Oklahoma. Samuel H. Kress Collection.

64 Stanze della Segnatura, Vatican, Rome.

65 Escher Foundation, Haags Gemeentemuseum, The Hague.

66 National Gallery of Art, Washington, D.C. Samuel H. Kress Collection.

67 The Museum of Fine Arts, Boston. Bequest of John T. Spaulding.

68 Bern Foundation, Photographie Giraudon, Paris. Permission A.D.A.G. 1972 by French Reproduction Rights, Inc., New York City.

69 The Smithsonian Institution, Freer Gallery of Art, Washington, D.C.

70 National Gallery of Art, Washington, D.C.

71 Galeria Bonino, New York City.

72 The Museum of Modern Art, New York City. Mrs. Simon Guggenheim Fund.

73 National Gallery of Art, Washington, D.C. Gift of the W. Averell Harriman Foundation in memory of Marie N. Harriman.

74 National Gallery of Art, Washington, D.C. Chester Dale Collection.
75 Graphische Sammlung Albertina, Vienna.
76 Graphische Sammlung Albertina, Vienna.
77 National Gallery of Art, Washington, D.C. Widener Collection.
78 The Frick Collection, New York City.
79 The Museum of Modern Art, New York City.
80 Fondation Le Corbusier. Photograph from G.E. Kidder Smith.
81 © 1960 by Saul Steinberg.
82 Idemitsu Art Gallery, Tokyo.
83 From SOME CONTEMPORARY ELEMENTS IN CLASSICAL ART by Tseng Yu-Ho, published in 1963 by University of Hawaii Press, Honolulu.
84 R. R. Donnelly & Sons Company, Chicago.
85 Courtesy Mrs. Cleve Gray, Cornwall Bridge, Connecticut.
86 The Louvre Museum, Paris.
87 The National Gallery, London.
88 Pitti Gallery, Florence.
89 The Museum of Modern Art, New York City.
90 The Fine Arts Gallery of San Diego, California.
91 From LAUTREC BY LAUTREC by Philippe Huisman and M. G. Dortu, published 1964 by Viking Press, New York City.
92 From LAUTREC BY LAUTREC by Philippe Huisman and M. G. Dortu, published 1964 by Viking Press, New York City.
93 East-West Center, Honolulu.
94 Private collection, New York.
95 From THE CHAPEL AT RONCHAMP by Le Corbusier, published 1957 by Praeger, Publishers, New York City. Courtesy Fondation Le Corbusier, Paris.
96 On extended loan to the Museum of Modern Art, New York City, from the artist. Permission S.P.A.D.E.M. 1972 by French Reproduction Rights, Inc., New York City.
97 The Metropolitan Museum of Art, New York City. Purchase, 1924, Joseph Pulitzer Bequest.
98 Kröller-Müller Foundation, Wassenaar, Otterlo, Holland.
99 The Smithsonian Institution, Freer Gallery of Art, Washington, D.C.
100 Whitney Museum of American Art, New York City.
101 Courtesy of the author.
102 From FRENCH DRAWING OF THE 20TH CENTURY, edited by Ed. Mermod-Lausanne, published 1955 by Vanguard Press, New York City.
103 British Museum, London.
104 National Palace Museum, Taipei, Taiwan, Republic of China.
105 Honolulu Academy of Arts.
106 From PORTRAIT OF AMERICA by Diego Rivera, published 1934 by Covici-Friede, Publishers. Photograph by Peter Juley.
107 Courtesy of Mrs. Edwina Ferguson, New York City.
108 Honolulu Academy of Arts.
109 Kunstmuseum der Stadt Dusseldorf, Germany.
110 The Metropolitan Museum of Art, New York City. Bequest of Mrs. H. O. Havemeyer, 1929.
111 The Brooklyn Museum. Gift of Mrs. H.O. Havemeyer.
112 The Cleveland Museum of Art. Gift of Ralph King.
113 Courtesy of the photographer, Massachusetts Institute of Technology, Cambridge.
114 From LIFE Magazine, © 1937 Time, Inc., New York City.
115 From LIFE Magazine, © 1954 Time, Inc., New York City.
116 George Eastman House, Rochester, New York.
117 Library of Congress, Washington, D.C.
118 CBS Television Network, New York City.
119 Collection of the Museum of Modern Art, New York. Gift of the manufacturer, Knoll Associates, Inc.
120 Photo by M. Sakai from HOW TO WRAP FIVE EGGS: JAPANESE DESIGN IN TRADITIONAL PACKAGING by Hideyuki Oka, published 1967 by Harper and Row, New York City.
121 American Cancer Society.
122 Permission granted by Liggett & Myers Incorporated to use the EVE advertisement. All rights reserved.
123 Sketch published with permission of Professor Richard I. Felver, Carnegie-Mellon University, and may not be reproduced without his written approval.
124 Courtesy of the photographers, M. & T. Bass, Berkeley, California.
125 From AFRICAN CRAFTS AND CRAFTSMEN by René Gardi, published 1970 by Van Nostrand Reinhold Co., New York City.
126 HONOLULU ADVERTISER, 1972.
127 Courtesy of the artist, Honolulu.
128 HONOLULU ADVERTISER, 1972.
129 Ceramics 70 Plus Woven Forms Exhibition, Everson Museum of Art, Syracuse, New York.
130 HONOLULU ADVERTISER, 1972.
131 HONOLULU ADVERTISER, 1972.
132 HONOLULU ADVERTISER, 1972.
133 Collection of Javier Garmendia, New York City.
134 Courtesy of the artist, Honolulu.
135 Courtesy of Mr. and Mrs. Charles Black, Honolulu.
136 The Museum of Modern Art, New York City. A. Conger Goodyear Fund.
137 Photograph from Alinari, Florence.
138 Courtey of The Museum of Primitive Art, New York City.
139 Hirmer Fotoarchiv, Munich.
140 Galerie Louise Leiris, Paris. Permission S.P.A.-

D.E.M. 1972 by French Reproduction Rights, Inc., New York City.

141 The Metropolitan Museum of Art, New York City. Fletcher Fund, 1956.

142 Gebriel Mann Verlag, photograph by Alexander Calder, appearing in FORM AND SPACE by Eduard Trier.

143 Photograph by John Palmer. Mr. Takis collection, Paris.

144 Courtesy R. Buckminster Fuller.

145 Photograph by Stan Wayman. From LIFE Magazine, © 1967 Time, Inc., New York City.

146 Hedrich-Blessing, Ltd., Chicago.

147 Skidmore, Owings, and Merrill, New York.

148 Photograph by M. Sakamoto. Reproduction rights Elsevier Nederland B.V.

149 From ISE: PROTOTYPE OF JAPANESE ARCHITECTURE by Kenzo Tange and Noboru Kawazoc, published 1965 by M.I.T. Press, Cambridge, Massachusetts.

150 Courtesy Kenzo Tange.

151 Agence Rapho, Paris.

152 From HOUSEBUILDING IN THE U.S.A. 1966, Ministry of Housing and Local Government, London.

153 Techbuilt Corporation, Cambridge, Massachusetts.

154 William Kenzler, INTERIOR, NICHOLL RESIDENCE, by Dun-Donnelley Publishing Corp., New York, 1963.

155 Cortez Corporation, Kent, Ohio.

156 From Construction Methods and Equipment, August, 1973, published by McGraw-Hill Inc., New York.

157 Pinacoteca Nazionale, Siena, Italy.

158 Courtesy of the photographer, San Jose, California.

159 From LE CORBUSIER: THE MACHINE AND THE GRAND DESIGN by Norma Evenson, published 1969 by George Braziller, New York City.

160 Photograph by Orlando Cababan. From WHO DESIGNS AMERICA? edited by Laurence B. Holland, published 1966 by Doubleday & Co., New York City.

161 Magnum Photos, Inc., New York City.

162 Photograph by Osamu Murai, Tokyo.

163 From EUROPE FROM THE AIR edited by Emil Egli and Hans Richard Muller, translated by E. Osers, published 1960 by Wilfred Funk, New York City.

164 Photograph by Irving W. Bailey (dec.), Professor of Botany, Harvard University. Courtesy of E. S. Barghoon, The Biological Laboratories, Harvard University, Cambridge, Massachusetts.

165 From WHO DESIGNS AMERICA? by Laurence B. Holland, published 1966 by Doubleday & Co., Garden City, New York.

166 From THE VISUAL DIALOGUE by Nathan

Knobler, 2nd ed., published 1971 by Holt, Rinehart & Winston, New York City.

167 Doxiadis Associates, Athens, Greece.

168 Editions Arthaud, Paris.

169 From MAN AND HIS SYMBOLS by C. G. Jung et al., published 1964 by Doubleday & Co., Garden City, New York.

170 British Museum, London.

171 Museum of the American Indian, New York City.

172 The Metropolitan Museum of Art, New York City.

173 Axel Poignant, New South Wales.

174 Musée Cernuschi, Paris.

175 From ROCK PAINTINGS OF THE CHUMASH by Campbell Grant, published 1965 by University of California Press, Berkeley.

176 Smeets Lithographers Weert, Netherlands.

177 Collection of Mr. and Mrs. Richard K. Weil.

178 National Museum, New Delhi.

179 From ART IN EAST AND WEST by Benjamin Rowland, published 1954 by Harvard University Press, Cambridge, Massachusetts.

180 The Cleveland Museum of Art. Purchase from the J.H. Wade Fund.

181 Bildarchiv Foto Marburg, Germany.

182 The Museum of Modern Art, New York City.

183 Photograph by Alison Frantz, Princeton, New Jersey.

184 Verlag M. Dumont Schauberg, Cologne, Germany.

185 Editorial Photocolor Archives, New York City.

186 Photograph from Alinari, Florence.

187 Government of India, Archaeological Survey of India, New Delhi.

188 Archives photographiques de la caisse nationale des monuments historiques et des sites, Paris.

189 Photograph from Alinari, Florence.

190 From NARRATIVE OF THE UNITED STATES EXPLORING EXPEDITION 5 by Charles Wilkes, published 1845 by Lea and Blanchard, Philadelphia, republished 1970 by Gregg Press, Upper Saddle River, New Jersey. Drawn by A. T. Agate, engraved by Rawdon Wright and Hatch. Courtesy British Museum, London.

191 French Government Tourist Office, New York City.

192 From SPACE, TIME AND ARCHITECTURE, vol. 5, by Siegfried Giedion, published 1967 by Harvard University Press. Etching, British Crown copyright. Photograph from Victoria and Albert Museum, London.

193 Acropolis Museum, Athens. Photograph from Ministry of Culture and Science, TAP Service, Athens.

194 Olympia Museum, Greece. Photograph from Alinari, Florence.

195 National Museum, Athens. Photograph from

Alinari-Art Reference Bureau, New York City.

196 Museo Profano Lateranense, Rome. Photograph from Phaidon Press London.

197 Academia, Florence. Photograph from Alinari, Florence.

198 Kofuku-hi, Nara, Japan.

199 The Museum of Fine Arts, Boston.

200 Detroit Institute.

201 Photograph by Alison Frantz, Princeton, New Jersey. National Museum, Athens.

202 Academia, Florence. Photograph from Alinari, Florence.

203 National Museum, Naples. Photograph from Alinari-Art Reference Bureau, New York City.

204 Koninklijk Museum, Antwerp.

205 Metropolitan Museum of Art, New York City. Bequest of Benjamin Altman.

206 Museum for Eastern Asiatic Art, Cologne, Germany.

207 Hans Hinz, Basel, Switzerland.

208 From MAN AND HIS SYMBOLS by C. G. Jung et al., published 1964 by Doubleday & Co., Garden City, New York.

209 Cappela degli Scrovegni, Padova, Italy. Photograph from Alinari, Florence.

210 Idemitsu Art Gallery, Tokyo.

211 Santa Maria delle Grazie, Milan. Photograph from Alinari, Florence.

212 Uffizi Gallery, Florence. Photograph from Alinari-Art Reference Bureau, New York City.

213 Kunsthistorisches Museum, Vienna.

214 The Louvre Museum, Paris.

215 The Prado Museum, Madrid.

216 The Louvre Museum, Paris.

217 Bayerische National Museum, Munich. Photograph from George Eastman House, Rochester, New York.

218 Photograph from the Bibliothèque Nationale, Paris.

219 Stavros S. Niarchos Collection.

220 Source unknown.

221 This painting was destroyed during World War II. Formerly in State Picture Gallery, Dresden. Verlag F. Bruckman KG, Munich.

222 National Gallery of Art, Washington, D.C. Gift of Horace Havemeyer in memory of his mother, Louisine W. Havemeyer.

223 Musée Marmottan, Paris. Photo Routhier, Paris.

224 Collection Jocelyn Walker, London. Permission S.P.A.D.E.M. 1972 by French Reproduction Rights, Inc., New York City.

225 Photograph by Durand-Ruel, Paris. Permission S.P.A.D.E.M. 1972 by French Reproduction Rights, Inc., New York City.

226 The Art Institute of Chicago. Helen Birch Bartlett Memorial Collection.

227 Collection Vincent van Gogh Foundation, Amsterdam.

228 Collection Vincent van Gogh Foundation, Amsterdam.

229 Honolulu Academy of Arts. Gift of Mrs. Charles M. Cooke, 1933.

230 Museum of the City of New York. Jacob A. Riis Collection.

231 The Art Institute of Chicago. Helen Birch Bartlett Memorial Collection.

232 The Art Institute of Chicago. A. A. Munger Collection.

233 Collection Mr. and Mrs. Louis C. Madeira, Gladwyne, Pennsylvania.

234 Courtesy of The Art Institute of Chicago.

235 Musée du Luxembourg, Paris. Photograph from Alinari, Florence. Permission S.P.A.D.E.M. 1972 by French Reproduction Rights, Inc., New York City.

236 Philadelphia Museum of Art. The Louise and Walter Arensberg Collection.

237 National Gallery, Bucharest.

238 Hirshorn Museum, Smithsonian Institution, Washington, D.C.

239 Philadelphia Museum of Art. The Louise and Walter Arensberg Collection.

240 Österreichische Galerie, Vienna.

241 Photo copyright 1976 by The Barnes Foundation.

242 Galerie Maeght, Paris.

243 The Solomon R. Guggenheim Museum, New York City.

244 Reproduced from CAMERA WORK. The Museum of Modern Art, New York City.

245 Hedrich-Blessing, Ltd., Chicago.

246 Musée de l'Homme, Paris. Collection Congrégation des Orphelines d'Auteuil.

247 Philadelphia Museum of Art. The A. E. Gallatin Collection.

248 The Museum of Modern Art, New York City.

249 Private collection. Photographie Giraudon, Paris. Permission S.P.A.D.E.M. 1972 by French Reproduction Rights, Inc., New York City.

250 The Metropolitan Museum of Art, New York City. Gift of Dr. and Mrs. Franz H. Hirschland.

251 Private collection. Permission S.P.A.D.E.M. 1972 by French Reproduction Rights, Inc., New York City.

252 Photograph by David Gahr. Permission S.P.A.-D.E.M. 1972 by French Reproduction Rights, Inc., New York City.

253 Collection Georges Salles, Paris. Photographie Giraudon, Paris. Permission S.P.A.D.E.M. 1972 by French Reproduction Rights, Inc., New York City.

254 Munson-Williams-Proctor Institute, Utica, New York.

255 Collection Alfred Roth, Zurich.

256 Fondation Le Corbusier, Paris.

257 Photograph by Lucia Moholy, Museum of

CREDITS

Modern Art, New York City.

258 Philadelphia Museum of Art. The Louise and Walter Arensberg Collection.
259 Courtesy of the photographer, Paris.
260 Philadelphia Museum of Art. The A. E. Gallatin Collection.
261 Courtesy of the author.
262 City Art Museum of Saint Louis.
263 The Museum of Modern Art, New York City.
264 The Museum of Modern Art, New York City.
265 The Museum of Modern Art, New York City.
266 Private collection, Paris.
267 The Museum of Modern Art, New York City.
268 Florian Kupferberg Verlag, Mainz/Berlin. From MALEREI FOTOGRAFIE FILM by Lazlo Moholy-Nagy.
269 Los Angeles County Museum of Art.
270 Source unknown.
271 Collection Frau T. Dürst-Haass, Muttenz, Switzerland. Color photograph from Hans Hinz, Basel, Switzerland.
272 Mr. and Mrs. Stanley Resor, New Canaan.
273 The Museum of Modern Art, New York City.
274 The Prado Museum, Madrid.
275 Collection Mr. and Mrs. Richard K. Weil, Saint Louis.
276 The Museum of Modern Art, New York City.
277 Dorothea Lange Collection, the Oakland Art Museum
278 Courtesy of the Art Institute of Chicago.
279 Collection of the Museum of Modern Art, New York City. Gift of M.M. Worburg.
280 On extended loan to The Museum of Modern Art, New York City, from the artist. Permission S.P.A.D.E.M. 1972 by French Reproduction Rights, Inc., New York City.
281 The Art Institute of Chicago. Mr. and Mrs. Frank G. Logan Collection.
282 Whitney Museum of American Art, New York City.
283 Collection Miss Katharine Ordway, Westport, Connecticut.
284 Museum of Modern Art, New York City.
285 Courtesy Paul Bijtebier, Brussels.
286 Courtesy Mrs. Albert D. Lasker, New York City.
287 Dallas Museum of Fine Arts. Dallas Art Association Purchase.

288 Collection Mr. and Mrs. Frank Titelman.
289 Sidney Janis Gallery, New York City.
290 Photograph by Jack Mitchell, New York City. Collection Mr. and Mrs. Tom Wesselmann.
291 Black Star Publishing Co., Inc., New York City.
292 Photograph by Hannah Wilke, Claes Oldenburg Collection, New York City.
293 Archives photographiques de la caisse nationale des monuments historiques et des sites, Paris.
294 Foundation Le Corbusier, Paris.
295 Anonymous collection.
296 The National Gallery of Canada, Ottawa.
297 Courtesy of the artist and David Anderson Roswell, New Mexico.
298 Photograph by Jerome Feldman, New York City.
299 Collection Mrs. Ben Cunningham, New York City.
300 Peter Stuyvesant Foundation.
301 Private collection, New York.
302 San Francisco Museum of Art.
303 Commissioned by The Museum of Modern Art, New York City.
304 Courtesy of the artist, Lagunitas, California.
305 Photograph by David Gahr, New York City.
306 Horst Schafer-Photo Trends, New York City.
307 Courtesy of Fourcade, Droll, Inc., New York.
308 Courtesy of the artist, Zurich.
309 Andre Emmerich Gallery Inc., New York City.
310 Photograph courtesy of the artist, Brooklyn, New York.
311 Courtesy of the photographer.
312 Courtesy of the photographer, New York City.
313 From STREET ART by Robert Sommer, published 1975 by Links Books, New York City.
314 Courtesy of the photographer, Carmel, California.
315 Photograph courtesy of The Oakland Museum
316 Photograph by D. A. Bermann, Oakland, California.
317 Zintgraff Photographers, San Antonio, Texas.
318 From STREET ART by Robert Sommer, published 1975 by Links Books, New York City.
319 M. Paul Friedberg and Associates, landscape architects, New York City.

We have made every attempt to obtain permission for reproduction of illustrations, but we were not able to locate a few of the owners. If the publishers have unknowingly infringed copyright on any of the illustrations reproduced here they will be glad to pay an appropriate fee upon being satisfied as to ownership.

Notes

FRONT MATTER AND INTRODUCTION

1 Ralph Graves, ed., *The Master of the Soft Touch*, LIFE 67, no. 21 (November 21, 1969): 64c.
2 Caroline Thomas Harnsberger, ed. TREASURY OF PRESIDENTIAL QUOTATIONS (Chicago: Follett Publishing Co., 1964), p. 22.

Chapter 1
WHY ART?

1 Reid Hastie and Christian Schmidt, ENCOUNTER WITH ART (New York: McGraw-Hill Book Co., 1969), p. 314.
2 C. L. Barnhart and Jess Stein, eds., THE AMERICAN COLLEGE DICTIONARY (New York: Random House, 1963), p. 70.
3 Henri Matisse, *The Nature of Creative Activity*, in EDUCATION AND ART, ed. Edwin Ziegfeld (New York: UNESCO, 1953), p. 21.
4 Douglas Davis, *New Architecture: Building for Man*, NEWSWEEK 77, no. 16 (April 19, 1971): 80.
5 Abraham H. Maslow, TOWARD A PSYCHOLOGY OF BEING (New York: Van Nostrand Reinhold Co., 1968), p. 136.
6 Bergen Evans, DICTIONARY OF QUOTATIONS (New York: Delacorte Press, 1968), p. 340.
7 Courtesy of Watts Towers.
8 John Holt, HOW CHILDREN FAIL (New York: Pitman Publishing Corp., 1964), p. 167. Reprinted with permission.
9 Henri Matisse, *Notes of a Painter*, trans. Alfred H. Barr, Jr., in PROBLEMS OF AESTHETICS, ed. Elised Vivas and Murray Krieger (New York: Holt, Rinehart & Winston, 1953), p. 256; originally printed as *Notes d'un peintre*, LA GRANDE REVUE (Paris, 1908).
10 Ibid., p. 260.
11 Ibid., pp. 259–260.

Chapter 2
WHAT DO WE RESPOND TO IN A WORK OF ART?

1 John Cage, A YEAR FROM MONDAY: NEW LECTURES AND WRITINGS (Middletown, Conn.: Wesleyan University Press, 1969).
2 Edward Weston, EDWARD WESTON, PHOTOGRAPHER: THE FLAME OF RECOGNITION, ed. Nancy Newhall (New York: Aperture Monograph, Grossman Publishers, 1965), p. 39.
3 Ibid., p. 34.
4 Kenneth Clark, CIVILISATION (New York: Harper & Row, Publishers, 1969), p. 50.
5 Faber Birren, COLOR PSYCHOLOGY AND COLOR THERAPY (New Hyde Park, N.Y.: University Books, 1961), p. 20.
6 Wassily Kandinsky, CONCERNING THE SPIRITUAL IN ART, original trans. Michael Sadleir, retrans. Francis Golffing, Michael Harrison, and Ferdinand Ostertag (New York: George Wittenborn, 1955), p. 58.
7 Albert E. Elsen, PURPOSES OF ART (New York: Holt, Rinehard & Winston, 1967), p. 437.
8 Leonardo da Vinci, *Perspective of Colour and Aerial Perspective: Of Aerial Perspective* (1488–1489), in A DOCUMENTARY HISTORY OF ART 1: THE MIDDLE AGES AND THE RENAISSANCE, ed. Elizabeth G. Holt (New York: Doubleday & Co., 1957–58), p. 282.
9 D. T. Suzuki, *Sengai, Zen and Art*, ART NEWS ANNUAL 27, pt. 2, no. 7 (November 1957), p. 118.

Chapter 3
WHAT ARE THE VISUAL ARTS?

1 Ichitaro Kondo and Elise Grilli, KATSUSHIKA HOKUSAI (Rutland, Vt.: Charles E. Tuttle Co., 1955), p. 13.

2 Louis H. Sullivan, THE AUTOBIOGRAPHY OF AN IDEA (New York: Dover Publications, 1956), frontispiece.

3 Kenzo Tange and Noborn Kawazoe, ISE: PROTO-TYPE OF JAPANESE ARCHITECTURE (Cambridge, Mass.: M.I.T. Press, 1965), p. 18.

4 UNESCO, ARTS AND MAN (Englewood Cliffs, N.J.: Prentiss-Hall, 1969), p. 65.

5 Constantinos A. Doxiadis, ARCHITECTURE IN TRANSITION (New York: Oxford University Press, 1968), p. 35.

Chapter 4
WHAT WAS ART LIKE
IN THE PAST?

1 Marius de Zayas, *Pablo Picasso, An Interview*, in ARTISTS ON ART, ed. Robert Goldwater and Marco Treves (New York: Pantheon Books, 1958), p. 418; originally printed in THE ARTS (New York, May 1923).

2 From the film THE EYE OF PICASSO, written and produced by Nelly Kaplan, Cythere Films, Paris, 1969.

3 Anada Coomaraswamy, DANCE OF SHIVA (New York: Noonday Press, 1965), p. 78.

4 Hellmut Wol, LEONARDO DA VINCI (New York: McGraw-Hill Book Co., 1967), p. 45.

5 Vincent van Gough in John Rewald, POST-IMPRESSIONISM — FROM VAN GOGH TO GAUGUIN (New York: Museum of Modern Art, 1958).

6 Vincent van Gogh, *To His Brother Theo*, in ARTISTS ON ART, ed. Goldwater and Treves, pp. 383–384.

7 Ronald Alley, GAUGUIN, The Colour Library of Art (Middlesex, Eng.: Hamlyn Publishing Group, 1968), p. 8.

8 Ibid., p. 19.

9 Ibid., pp. 19, 22.

10 CÉZANNE AND THE POST-IMPRESSIONISTS, McCall's Collection of Modern Art (New York: McCall Books, 1970), p. 5.

11 Ibid.

Chapter 5
WHAT IS THE ART OF OUR TIME?

1 Alfred H. Barr, Jr., ed., MASTERS OF MODERN ART (New York: Museum of Modern Art, 1955), p. 124.

2 William Fleming, ART, MUSIC AND IDEAS (New York: Holt, Rinehart & Winston, 1970), p. 342.

3 Ibid.

4 Helmut and Allison Gernsheim, CONCISE HISTORY OF PHOTOGRAPHY (New York: Grosset & Dunlap).

5 Beaumont Newhall, THE HISTORY OF PHOTOGRAPHY (New York: Museum of Modern Art, 1964), p. 111.

6 Wassily Kandinsky, *Reminiscences*, in MODERN ARTISTS ON ART, ed. Robert L. Herbert (Englewood Cliffs, N.J.: Prentice-Hall, 1964), p. 27.

7 Georges Braque in Roland Penrose, PICASSO: HIS LIFE AND WORK (New York: Schocken Books, 1966), p. 125.

8 Goldwater and Treves, eds., ARTISTS ON ART, p. 427.

9 Fleming, ART, MUSIC AND IDEAS, p. 351.

10 Cloven Tomkins, THE WORLD OF MARCEL DUCHAMP, eds. of Time-Life Books (New York: Time, Inc., 1966), p. 12.

11 Barr, ed., MASTERS OF MODERN ART, p. 86.

12 *Venerable Giant of Modern Sculpture Bares Views*, HONOLULU STAR-BULLETIN, August 24, 1971, p. F–2.

13 Hans Richter, DADA 1916–1966 (Munich: Goethe Institut, 1966), p. 22.

14 Barr, ed., MASTERS OF MODERN ART, p. 137.

15 Hans Arp in Paride Accetti, Raffaele De Grada, and Arturo Schwarz, CINQUANT'ANNIA DADA — DADA IN ITALIA 1916–1966 (Milano: Galleria Schwarz, 1966), p. 39.

16 Barr, ed., MASTERS OF MODERN ART, p. 137.

17 Kurt Schwitters in Accetti et al., CINQUANT'ANNIA DADA, p. 25.

18 Fleming, ART, MUSIC AND IDEAS, p. 346.

19 Paul Klee, *Notes from His Diary*, in ARTISTS ON ART, ed. Goldwater and Treves, p. 442.

20 Barr, ed., MASTERS OF MODERN ART, p. 131.

21 Lael Wertenbaker, THE WORLD OF PICASSO, eds. of Time-Life Books (New York: Time, Inc., 1967), p. 130

22 Herbert Read, A CONCISE HISTORY OF MODERN PAINTING (New York: Praeger, Publishers, 1959), p. 160.

23 Barr, ed., MASTERS OF MODERN ART, p. 174.

24 THREE HUNDRED YEARS OF AMERICAN PAINTING, art ed. of TIME (New York: Time, Inc., 1957), p. 289

25 Tomkins, WORLD OF DUCHAMP, p. 162.

26 Barr, ed., MASTERS OF MODERN ART, p. 121.

27 Tomkins, WORLD OF DUCHAMP, p. 171.

Chapter 6
HOW CAN ART HELP RENEW OUR
HOPE FOR THE FUTURE?

1 Sunset eds., NATIONAL PARKS OF THE WEST (Menlo Park, Calif.: Lane Magazine & Book Co., 1965), p. 11.

Bibliography

FOR GENERAL REFERENCE

A DICTIONARY OF ART AND ARTISTS by Peter Murray and Linda Murray. New York: Praeger, Publishers, 1966.

ART IN AMERICA. Published bimonthly, New York.

CRAFT HORIZONS. Published bimonthly, New York: Museum of Contemporary Crafts.

DOMUS: ARCHITECTTURA, ARREDAMENTO, ARTE. Published monthly, Milano.

ENCYCLOPEDIA OF WORLD ART. 12 vols. New York: McGraw-Hill Book Co., 1960–1969.

FROM ABACUS TO ZEUS: A HANDBOOK OF ART HISTORY by James S. Pierce. Englewood Cliffs, N.J.: Prentice-Hall, 1968.

GREAT MUSEUMS OF THE WORLD, editorial director, Carlo Ludovico Ragghianti, translated and edited by editors of ART NEWS. 15 vols. New York: Newsweek, Inc., 1968–1971.

HORIZON. Published bimonthly, New York.

MCCALL'S COLLECTION OF MODERN ART. 12 vols. New York: McCall Publishing Co., 1968–1970.

REALITES, editor-in-chief, Garith Windsor. Published monthly, New York.

THE COLOR LIBRARY OF ART. London: Paul Hamlyn, 1967.

THE MOTHER EARTH NEWS. Published bimonthly, North Madison, Ohio.

THE POCKET DICTIONARY OF ART TERMS edited by Mervyn Levy. Greenwich, Conn.: New York Graphic Society, 1961.

TIME-LIFE LIBRARY OF ART by editors of Time-Life Books. 28 vols. New York: Time, Inc., 1966–1970.

TIME-LIFE LIBRARY OF PHOTOGRAPHY by editors of Time-Life Books. 17 vols. New York: Time, Inc., 1970–1972.

Chapter 1
WHY ART?

ANALYZING CHILDREN'S ART by Rhoda Kellogg. Palo Alto, Calif.: National Press Books, 1969.

ART AND ILLUSION: A STUDY IN THE PSYCHOLOGY OF PICTORIAL REPRESENTATION by E.H. Gombrich. New York: Pantheon Books, 1960.

ART AND VISUAL PERCEPTION: A PSYCHOLOGY OF THE CREATIVE EYE by Rudolf Arnheim. Berkeley: University of California Press, 1954.

ARTS AND THE MAN by Irwin Edman. New York: W. W. Norton & Co., 1939.

ART: THE VISUAL EXPERIENCE by Irving Kriesberg. New York: Pitman Publishing Corp., 1964.

CREATIVITY AND PERSONAL FREEDOM by Frank Barron. Rev. ed. New York: Van Nostrand Reinhold Co., 1968.

CREATIVITY IN THE ARTS edited by Vincent Tomas. Englewood Cliffs, N.J.: Prentice-Hall, 1964.

EYE AND BRAIN by R. L. Gregory. New York: McGraw-Hill Book Co., 1966.

GROWING WITH CHILDREN THROUGH ART by Aida C. Snow. New York: Van Nostrand Reinhold Co., 1968.

INFLUENCE OF CULTURE ON VISUAL PERCEPTION by Marshall H. Segall, Donald T. Campbell, and Melville J. Herskovits. Indianapolis: Bobbs-Merrill Co., 1966.

KAETHE KOLLWITZ DRAWINGS by Herbert Bittner. Cranbury, N.J.: A. S. Barnes & Co., 1959.

MAN AND HIS IMAGES: A WAY OF SEEING by Georgine Oeri. New York: Viking Press, 1968.

MAN AND HIS SYMBOLS by Carl G. Jung et al. Garden City, N.Y.: Doubleday & Co., 1964.

MY WORLD OF ART by Blanche Jefferson and Clyde McGeary. 6 vols. Boston: Allyn & Bacon, 1964. Has teachers' manuals.

PURPOSES OF ART by Albert E. Elsen. New York: Holt, Rinehart & Winston, 1967.

SILENT LANGUAGE by Edward T. Hall. New York: Fawcett World Library, 1969.

THE ARTS AND MAN by UNESCO. Englewood Cliffs, N.J.: Prentice-Hall, 1969.

THE ARTS IN THE CLASSROOM by Natalie Robinson Cole. New York: John Day Co., 1940.

THE CREATIVE PROCESS edited by Brewster Ghiselin.

New York: New American Library, 1952.

THE FAMILY OF MAN by Edward Steichen. New York: Simon & Schuster, 1967.

THE NECESSITY OF ART: THE MARXIST APPROACH by Ernest Fischer. Baltimore: Penguin Books, 1964.

THE PSYCHOLOGY OF CHILDREN'S ART by Rhoda Kellogg with Scott O'Dell. Del Mar, Calif.: CRM Books, 1967

THE REVEALING EXPERIENCE by Kurt Kranz. New York: Shorewood Publishers, 1964.

THE SENSES by Wolfgang von Buddenbrock. Ann Arbor: University of Michigan Press, 1970.

THE VISUAL DIALOGUE by Nathan Knobler. New York: Holt, Rinehart & Winston, 1970.

Chapter 2
WHAT DO WE RESPOND TO
IN A WORK OF ART?

A COLOR NOTATION by Albert Henry Munsell. Baltimore: Munsell Color Co., 1946.

ART FUNDAMENTALS: THEORY AND PRACTICE by Otto G. Ocvirk et al. Dubuque, Iowa: William C. Brown Co., Publishers, 1968.

BASIC DESIGN: THE DYNAMICS OF VISUAL FORM by Maurice de Sausmarez. New York: Reinhold Publishing Corp., 1964.

COLOR: BASIC PRINCIPLES AND NEW DIRECTIONS by Patricia Sloane. New York: Reinhold Publishing Corp., 1968.

COLOR PSYCHOLOGY AND COLOR THERAPY by Faber Birren. New Hyde Park, N.Y.: University Books, 1961.

COMPOSITION IN PICTURES by Ray Bethers. New York: Pitman Publishing Corp., 1962.

DESIGN AS ART by Bruno Munari, translated by Patrick Creagh. Baltimore: Penguin Books, Inc., 1971.,

DESIGN THROUGH DISCOVERY by Marjorie Elliot Bevlin. New York: Holt, Rinehart & Winston, 1970.

INTERACTION OF COLOR by Josef Albers. New Haven: Yale University Press, 1963.

PERSPECTIVE: SPACE AND DESIGN by Louise Bowen Ballinger. New York: Reinhold Publishing Corp., 1969.

THE ART OF COLOR by Johannes Itten. New York: Reinhold Publishing Corp., 1961.

Chapter 3
WHAT ARE THE VISUAL ARTS?

A CONCISE HISTORY OF PHOTOGRAPHY by Helmut and Allison Gernsheim. New York: Grosset & Dunlap, 1965.

AFRICAN CRAFTS AND CRAFTSMEN by René Gardi. New York: Van Nostrand Reinhold Co., 1970.

A POET AND HIS CAMERA by Gordon Parks. New York: Viking Press, 1968.

ARCHITECTURE WITHOUT ARCHITECTS by Bernard Rudofsky. Garden City, N.Y.: Doubleday & Co., 1964.

ART CAREER GUIDE edited by Donald Holden. 2d ed. New York: Watson-Guptill Publications, 1967.

ART FROM FOUND MATERIALS: DISCARDED AND NATURAL: TECHNIQUES, DESIGN INSPIRATION by Mary L. Stribling. New York: Crown Publishers, 1966.

BEYOND HABITAT by Moshe Safdie. Cambridge, Mass.: M.I.T. Press, 1970.

CERAMICS: A POTTER'S HANDBOOK by Glenn C. Nelson. New York: Holt, Rinehart & Winston, 1966.

CITIES by Lawrence Halprin. New York: Reinhold Publishing Corp., 1963

DESIGN OF CITIES by Edmund N. Bacon. New York: Viking Press, 1967.

DRAWING by Daniel M. Mendelowitz. New York: Holt, Rinehart & Winston, 1967. Has companion study guide.

ELEMENTS OF THE ART OF ARCHITECTURE by William Muschenheim. New York: Viking Press, 1964.

EXPANDED CINEMA by Gene Youngblood. New York: E.P. Dutton & Co., 1970.

EXPERIENCING ARCHITECTURE by Steen E. Rasmussen. Cambridge, Mass.: M.I.T. Press, 1962.

FILM AS ART by Rudolf Arnheim. Berkeley: University of California Press, 1957.

FOCUS ON D.W. GRIFFITH by Harry M. Geduld. Englewood Cliffs, N.J.: Prentice-Hall, 1971.

HOKUSAI SKETCHES AND PAINTINGS by Muneshige Narazake. Palo Alto, Calif.: Kodansha International, 1969.

HOUSE FORM AND CULTURE by Amos Rapoport. Englewood Cliffs, N.J.: Prentice-Hall, 1969.

HOW TO TALK BACK TO YOUR TELEVISION SET by Nicholas Johnson. New York: Bantam Books, 1970.

HOW TO WRAP FIVE EGGS by Hideyuki Oka and Michikazu Saki. New York: Harper & Row, Publishers, 1967.

ISE: PROTOTYPE OF JAPANESE ARCHITECTURE by Kenzo Tange and Noboro Kawazoe. Cambridge, Mass.: M.I.T. Press, 1965.

IT'S ONLY A MOVIE by Clark McKowen and Mel Byars. Englewood Cliffs, N.J.: Prentice-Hall, 1970.

KINDERGARTEN CHATS by Louis H. Sullivan. Washington, D.C.: Scarab Fraternity Press, 1934.

KISS KISS BANG BANG by Pauline Kael. New York: Bantam Books, 1969.

MASTERS OF THE JAPANESE PRINT by Richard Lane. Garden City, N.Y.: Doubleday & Co., 1962.

MODERN PRINTS AND DRAWINGS by Paul J. Sachs. New York: Alfred A. Knopf, 1954.

NOTHING PERSONAL by Richard Avedon and James Baldwin. Toronto: McClelland & Stewart, 1964.

PAINTING: SOME BASIC PRINCIPLES by Frederick Gore. New York: Reinhold Publishing Corp., 1965.

PAINTING WITH SYNTHETIC MEDIA by Russell O. Woody, Jr. New York: Van Nostrand Reinhold Co., 1965.

PHOTOGRAPHERS ON PHOTOGRAPHY edited by Nathan Lyons. Englewood Cliffs, N.J.: Prentice-Hall, 1966.

PHOTOGRAPHS BY HENRI CARTIER-BRESSON by Henri Cartier-Bresson. New York: Grossman Publishers, 1963.

PIONEERS OF MODERN DESIGN by Nikolaus Pevsner. Baltimore: Penguin Books, 1964.

PRINTMAKING by Gabor Peterdi. New York: The Macmillan Co., 1961.

PRINTMAKING TODAY by Jules Heller. New York: Holt, Rinehart & Winston, 1958.

PRINTS AND VISUAL COMMUNICATION by William M. Ivins, Jr. New York: Plenum Publishing Corp., 1969.

PROBLEMS OF DESIGN by George Nelson. New York: Whitney Publications, 1965.

SCULPTURE (Appreciation of the Arts Series 2) by L. R. Rogers. New York: Oxford University Press, 1969.

SPACE, TIME AND ARCHITECTURE by Siegfried Giedion. 5th ed. Cambridge, Mass.: Harvard University Press, 1967.

SYNTHETIC PAINTING MEDIA by Lawrence N. Jensen. Englewood Cliffs, N.J.: Prentice-Hall, 1964.

THE ARTIST'S GUIDE TO HIS MARKET by Betty Chamberlain. New York: Watson-Guptill Publications, 1970.

THE ARTIST'S HANDBOOK OF MATERIALS AND TECHNIQUES by Ralph Mayer. New York: Viking Press, 1968.

THE ART OF DRAWING by Bernard Chaet. New York: Holt, Rinehart & Winston, 1970.

THE ARTS AND MAN by UNESCO. Englewood Cliffs, N.J.: Prentice-Hall, 1969.

THE BEHAVIORAL BASIS OF DESIGN by Robert Sommer. Englewood Cliffs, N.J.: Prentice-Hall, 1969.

THE CAMERA by editors of Time-Life Books. New York: Time, Inc., 1970.

THE CITY IN HISTORY by Lewis Mumford. New York: Harcourt Brace Jovanovich, 1972.

THE CONCERNED PHOTOGRAPHER by Robert Capa et al. New York: Grossman Publishers, 1969.

THE DECISIVE MOMENT by Henri Cartier-Bresson. New York: Simon & Schuster, 1952.

THE EMERGENCE OF FILM ART by Lewis Jacobs. New York: Hopkinson & Blake Publishing Co., 1969.

THE LANGUAGE OF ARCHITECTURE by Niels L. Prak. New York: Humanities Press, 1968.

THE LIVELIEST ART by Arthur Knight. New York: New American Library, 1957.

THE NATURAL WAY TO DRAW by Kimon Nicolaides. Boston: Houghton Mifflin Co., 1941.

THE WAY OF CHINESE PAINTING, ITS IDEAS AND TECHNIQUES by Mai-Mai Sze. New York: Random House, 1959.

WATERCOLOR: MATERIALS AND TECHNIQUES by George Dibble. New York: Holt, Rinehart & Winston, 1966.

WHO DESIGNS AMERICA edited by Lawrence B. Holland. Garden City, N.Y.: Doubleday & Co., 1966.

YOUNG DESGINS IN LIVING by Barbara Plumb. New York: Viking Press, 1969.

Chapters 4 and 5
WHAT WAS ART LIKE IN THE PAST?
AND WHAT IS THE ART OF OUR TIME?

A CONCISE HISTORY OF MODERN PAINTING by Herbert Read. New York: Praeger, Publishers, 1959.

A CONCISE HISTORY OF MODERN SCULPTURE by Herbert Read. New York: Praeger, Publishers, 1964.

A DOCUMENTARY HISTORY OF ART 1: THE MIDDLE AGES AND THE RENAISSANCE edited by Elizabeth Gilmore Holt. Garden City, N.Y.: Doubleday & Co., 1957–58.

A DOCUMENTARY HISTORY OF ART 2: MICHELANGELO AND THE MANNERISTS: THE BAROQUE, AND THE EIGHTEENTH CENTURY edited by Elizabeth Gilmore Holt. Garden City, N.Y.: Doubleday & Co., 1957–58.

AFRICAN ART by Frank Willett. New York: Praeger, Publishers, 1971.

A HISTORY OF FAR EASTERN ART by Sherman Lee. New York: Harry N. Abrams, 1964.

ANCIENT CHINESE BRONZES by William Watson. Rutland, Vt.,: Charles E. Tuttle Co., 1962.

ART: AN INTRODUCTION by Dale G. Cleaver. New York: Harcourt Brace Jovanovich, 1972.

ARTISTS ON ART edited by Robert Goldwater and Marco Treves. New York: Pantheon Books, 1958.

ART, MUSIC AND IDEAS by William Fleming. New York: Holt, Rinehart & Winston, 1970.

ART SINCE 1945 by Umbro Apollonio et al. New York: Washington Square Press. 1958.

ASSEMBLAGE, ENVIRONMENTS AND HAPPENINGS by Allan Kaprow. New York: Harry N. Abrams, 1966.

CHINESE PAINTING by James Cahill. Switzerland: Skira Art Books, 1960.

CONCERNING THE SPIRITUAL IN ART AND PAINTING IN PARTICULAR by Wassily Kandinsky. New York: George Wittenborn, 1966.

DADA: ART AND ANTI-ART by Hans Richter. New York: Harry N. Abrams, 1970.

FOUNDATIONS OF MODERN ART by Amédée Ozenfant, translated by John Rodker. New York: Dover Publications, 1952.

FOUR ESSAYS ON KINETIC ART by Stephen Bann, Reg Gadney, Frank Popper, and Philip Steadman. St. Albans, Eng.: Motion Books, 1966.

FROM THE CLASSICISTS TO THE IMPRESSIONISTS: A DOCUMENTARY HISTORY OF ART AND ARCHITECTURE IN THE NINETEENTH CENTURY edited by Elizabeth Gilmore Holt. Garden City, N.Y.: Doubleday & Co., 1966.

GARDNER'S ART THROUGH THE AGES by Horst de la Croix and Richard Tansey. 5th ed. New York: Harcourt Brace Jovanovich, 1972.

GAUGUIN by Ronald Alley. Middlesex, Eng.: Hamlyn Publishing Group, 1968.

GOYA, THE DISASTERS OF WAR by Xavier de Salas. Garden City, N.Y.: Doubleday & Co., 1956.

HISTORY OF ART by H. W. Janson, New York: Harry N. Abrams, 1969.

HISTORY OF MODERN ART: PAINTING, SCULPTURE AND ARCHITECTURE by H. H. Arnason. New York: Harry N. Abrams, 1968.

JAPANESE PRINTS FROM THE EARLY MASTERS TO THE MODERN by James A. Michener. Rutland, Vt.: Charles E. Tuttle Co., 1960.

KINETIC ART by Guy Brett. New York: Reinhold Publishing Corp., 1968.

MASTERS OF MODERN ART edited by Alfred H. Barr, Jr. New York: Museum of Modern Art, 1955.

MODERN ARTISTS ON ART edited by Robert L. Herbert. Englewood Cliffs, N.J.: Prentice-Hall, 1964.

MUSEUM WITHOUT WALLS by André Malraux, translated by Stuart Gilbert and Francis Price. Garden City, N.Y.: Doubleday & Co., 1967.

MYTHS AND SYMBOLS IN INDIAN ART AND CIVILIZATION by Heinrich Zimmer. New York: Harper & Row, Publishers, 1946.

PAINTING AND REALITY by Etienne Gilson. Princeton, N.J.: Princeton University Press, 1957.

PAINTING IN THE TWENTIETH CENTURY by Werner Haftmann. New York: Praeger, Publishers, 1965.

PICASSO'S GUERNICA by Anthony Blunt. New York: Oxford University Press, 1969.

PRIMITIVE ART by Paul S. Wingert. New York: World Publishing Co., 1965.

THE ART OF THE SOUTH SEA ISLANDS by Alfred Buehler, Terry Barrow, and Charles P. Mountford. New York: Crown Publishers, 1962.

THE DANCE OF SHIVA by Ananda Coomaraswamy. New York: Farrar, Straus & Co., 1937.

THE ETERNAL PRESENT: THE BEGINNINGS OF ARCHITECTURE by Siegfried Giedion. Princeton, N.J.: Princeton University Press, 1964.

THE HISTORY OF PHOTOGRAPHY by Beaumont Newhall. New York: Museum of Modern Art, 1964.

THE PAINTER AND THE PHOTOGRAPHER by Van Deren Coke. Albuquerque: University of New Mexico Press, 1964.

THE STORY OF ART by E. H. Gombrich, 12th ed. New York: Praeger, Publishers, 1972.

Chapter 6
HOW CAN ART HELP RENEW OUR HOPE FOR THE FUTURE?

AS WE LIVE AND BREATHE: THE CHALLENGE OF OUR ENVIRONMENT by Gilbert M. Grosvenor. Washington, D.C.: National Geographic Society, 1971.

CITY AND COUNTRY IN AMERICA edited by David R. Weimer. New York: Appleton-Century-Crofts, 1962.

DESIGN WITH NATURE by Ian L. McHarg. Garden City, N.Y.: Doubleday & Co., 1971.

GOD'S OWN JUNKYARD: THE PLANNED DETERIORATION OF AMERICA'S LANDSCAPE by P. Blake. New York: Holt, Rinehart & Winston, 1964.

IN WILDNESS IS THE PRESERVATION OF THE WORLD by Eliot Porter. San Francisco: Sierra Club Books, 1967.

MAN-MADE AMERICA: CHAOS OR CONTROL: AN INQUIRY INTO SELECTED PROBLEMS OF DESIGN IN THE URBANIZED LANDSCAPE by Christopher Tunnard and Boris Pushkarev. New Haven: Yale University Press, 1963.

MAN'S STRUGGLE FOR SHELTER IN AN URBANIZING WORLD by Charles Abrams. Cambridge, Mass.: M.I.T. Press, 1964.

MATRIX OF MAN: AN ILLUSTRATED HISTORY OF URBAN ENVIRONMENT by Sibyl Moholy-Nagy. New York: Praeger, Publishers, 1968.

MOMENT IN THE SUN by Robert Rienow and Leona Train. New York: Ballantine Books, 1967.

STREET ART by Robert Sommer. New York: Links Books, 1975.

SURVIVAL THROUGH DESIGN by Richard Neutra. New York: Oxford University Press, 1969.

THE AMERICAN AESTHETIC by Nathaniel A. Owings. New York: Harper & Row, Publishers, 1969.

THE AMERICAN ENVIRONMENT: READINGS IN THE HISTORY OF CONSERVATION edited by Roderick Nash. Reading, Mass.: Addison-Wesley Publishing Co., 1968.

THE AMERICAN LANDSCAPE by Ian Nairn. New York: Random House, 1968.

THE END OF AFFLUENCE by Paul R. Erlich and Anne H. Erlich. New York: Ballatine Books, 1974.

THE HIDDEN ORDER OF ART by Anton Ehrenzweig. Berkeley: University of California Press, 1971.

THE IMAGE OF THE CITY by Kevin Lynch. Cambridge, Mass.: M.I.T. Press, 1960.

THE LANGUAGE OF CITIES by Franziska P. Hosken. New York: The Macmillan Co., 1968.

THE LAST LANDSCAPE by William H. Whyte. New York: Doubleday & Co., 1968.

THE LAST WHOLE EARTH CATALOG. Menlo Park, Calif.: Portola Institute, 1971.

THE LIMITS OF GROWTH by Donella H. Meadows et al. New York: Universe Books, 1972.

THE WAY OF SILENCE: THE PROSE AND POETRY OF BASHO edited by Richard Lewis. New York: Dial Press, 1970.

THIS IS THE AMERICAN EARTH by Ansel Adams and Nancy Newhall. San Francisco: Sierra Club Books, 1970.

Index

A CHILD'S PAINTING OF A TREE, 17, color plate 1, near text page 26

A DEPRESSION BREADLINE, SAN FRANCISCO, Dorothea Lange, 208

A MOTHER HOLDING A CHILD AND FOUR STUDIES OF HER RIGHT HAND, Pablo Picasso, 20

A WAVE UNDER THE MOON, unknown Chinese artist, 65, 225

ABRAHAM LINCOLN, detail of, Daniel Chester French, 35

abstract art, 138

Abstract Expressionism, 170, 212–214, 220, 226

Abstract Surrealism, 207, 212

abstraction, 135, 153, 180, 181, 198

Academic Art., 165

ACROPOLIS, Ictinus and Callicrates, 144

acrylics, 85

action painting, 212–213

Adams, Ansel, MOON AND HALF DOME, Yosemite National Park, 238

advertising design, 99

aerial perspective, *see* perspective

AERIAL VIEW OF KATSURA, 34

AERIAL VIEW OF PALMANOVA, ITALY, 131

AERIAL VIEW OF VERSAILLES, France, 34

aesthetic, 8

African art, 18, 134–135
 influence of, 186–187

afterimage, 42, 96

Age of Reason, 163

Aitken, Donald W., DALY CITY, 127

AMERICAN GOTHIC, Grant Wood, 2, 208

analogous color, 41

Analytical Cubism, 189–190

ANNE OF CLEVES, Hans Holbein, 68

ANTIAUTO POLLUTION DEMONSTRATION, 229

Anuskiewicz, Richard, 42, 58, 85, quoted, 42
 INJURED BY GREEN, 42, color plate 9, near text page 59

APOLLO, 110

APOLLO 16 ASTRONAUTS SALUTING FLAG ON THE MOON, 98

ARCADES AND VAULTS OF NAVE AT REIMS CATHEDRAL, 49

architecture, 114–125
 Gothic, 49, 147
 Greek, 144

Roman, 147

sculptural, 221

social, 143–148

space in, 48–49

twentieth century, 125, 193, 221, 239

ARTIFICIAL FORMULA, Linda Wiig, 234

Ashanti sculpture, 18

assemblage, 111, 200, 201, 203, 219

AT THE MOULIN ROUGE, Henri de Toulouse-Lautrec, 175

AT THE TIME OF THE LOUISVILLE FLOOD, Margaret Bourke-White, 94

Athena, 144

auras, 39

awareness, 7, 235–237

Aztec Goddess, 18

BANDIT'S ROOST, Jacob Riis, 175

BARCELONA CHAIR, Ludwig Mies van der Rohe, 100

batik, 105

BATIKING, 105

BATTLE SCENE FROM THE COMIC OPERA "THE SEAFARER", Paul Klee, 204, color plate 36, near text page 218

Bauhaus, 118, 193

beauty, 8

BECHUANALAND, N. R. Farbman, 4

BENIN HEAD, 110

beyond the known world, 158–160

BICYCLE WHEEL, Marcel Duchamp, 200

BIG BOY, Isamu Noguchi, 108

bike path, 240

Bill, Max, DOUBLEMENT, 231

binder, 81

BIRD IN SPACE, Constantin Brancusi, 47

BIRTH OF VENUS, Sandro Botticelli, 161, detail of, 43, color plate 7, near text page 58

Bischof, Werner, 28–29, 94
 HUNGER IN INDIA, 28
 LONE FLUTE-PLAYER, 29
 SHINTO PRIESTS IN TEMPLE GARDEN, 29

BLACK CROSS, NEW MEXICO, Georgia O'Keeffe, 208

BLUE MOUNTAIN, Wassily Kandinsky, 183, color plate 32, near text page 186. *See also* 62

BLUE NUDE III and BLUE NUDE IV, Henri Matisse, 26
Bonnard, Pierre, DINING ROOM IN THE COUNTRY, color plate 5, near text page 27
Bosch, Hieronymus van Aeken, THE GARDEN OF WORLDLY DELIGHTS, detail of right panel, 206
Botticelli, Sandro, BIRTH OF VENUS, 161, detail of, 43, color plate 7, near text page 58
Bourke-White, Margaret, AT THE TIME OF THE LOUISVILLE FLOOD, 94
 CONTOUR PLOWING, 95
BOY IN GRASS, Gordon Parks, 92, color plate 16, near text page 91
BRACELET, PENDANT AND RING, Edward Brownlee, 107
Brancusi, Constantin, 46, quoted, 180
 BIRD IN SPACE, 47
 SLEEPING MUSE, (1906), 180
 SLEEPING MUSE, (1909–1911), 180
 THE NEWBORN, 180
Braque, Georges, 56, 187, 203, quoted, 187
 HOUSES AT L'ESTAQUE, 56
Breer, Robert, FLOATS, 58
Brownlee, Edward, BRACELET, PENDANT AND RING, 107
Brueghel, Pieter, THE PAINTER AND THE CONNOISSEUR, 24
Brunelleschi, Filippo, PAZZI CHAPEL, 147
Buddhist
 architecture, 34, 146
 art, 50, 140, 143
BULL FIGHT, Francisco Goya, 71
BULL'S HEAD, Pablo Picasso, 111
Bunshaft, Gordon, of Skidmore Owings and Merrill, LEVER HOUSE, 117. See also 62
Buonarroti, Michelangelo, see Michelangelo Buonarroti
Byzantine painting, ENTHRONED MADONNA AND CHILD, 19

Cage, John, quoted, 31
Calder, Alexander, 112, THE GATES OF SPOLETO, 113
Callicrates and Ictinus, PARTHENON, 144
calligraphy, 64, 159, 214–215
CALLIGRAPHY BUDDHA, Yuichi Inoue, 214
camera arts, 91–98, 232
CANCELLED CROP, Dennis Oppenheim, 232
CANOE PROW ORNAMENT, 136, color plate 22, near text page 122
CARICATURE, Leonardo da Vinci, 9
CARICATURE FROM CEILING OF HORYU-JI, NARA, JAPAN, 9
CARPENTER, Vincent van Gogh, 76
cartoons; cartooning, Steinberg, vi, 63–64
casting, 110
cave painting, 158
 Lascaux, 85
 Tassili, 133, color plate 23, near text page 123
Cayce, Edgar, 39
ceramics, 103
CERAMIC POT, Toshiko Takaezu, 103, color plate 12, near text page 90
Cézanne, Paul, 170, 172, 181–182, 188–189, quoted, 176
 MOUNT OFF SAINTE-VICTOIRE, 176, color plate 30, near text page 155
 THE GARDEN, 189
 THE GULF OF MARSEILLES, SEEN FROM L'ESTAQUE, 177
 THE TURNING ROAD, color plate 11, near text page 59
Chagall, Marc, 65, 206, I AND MY VILLAGE, 58
CHAIR, Tom Hirai, 107
Chandler, Dana, KNOWLEDGE IS POWER, STAY IN SCHOOL, 237

Chartres Cathedral, NOTRE DAME DE CHARTRES, 147
 Detail of sculpture on West Portal, SAINTS AND ROYAL PERSONAGES, 33
CHEOPS, Carol Summers, 87, color plate 14, near text page 90
chiaroscuro, 37, 38
CHIEF'S STOOL, 186
children's art, 12–17
Chinese painting, 157
CHINESE SACRAL VESSEL, 137
CHRIST, 142
CHRIST OF THE PENTACOST, detail of, 140
CHRIST PREACHING, Rembrandt van Rijn, 88
Christian architecture, 146–147
Christian art, 19, 22, 33, 140, 142, 143
cinematography, 96. See also 57
city planning, 126–132 See also environmental design.
Clavilux Lumia, 227
CLEMATIS VIRGINIANA, 131
color, 39–42
 and space, 226
 Cubist, 189
 Impressionist, 170
 Postimpressionist, 172, 174, 176
Color Music, 227
Color Wheel, 40–42, color plate 6, near text page 58
collage, 190, 203
collage experience, 196–197
combines, 127
commercial art, 99
communication, 5, 12, 30–31, 73, 98
complementary color, 40
composition, 14, 185. See also design
COMPOSITION WITH RED, YELLOW AND BLUE, Piet Mondrian, 192, color plate 34, near text page 187
Conceptual Art, 232
CONSTRUCTION FOR NOBLE LADIES, Kurt Schwitters, color plate 35, near text page 187. See also 203
content, and form, 31–34
CONTOUR PLOWING, Margaret Bourke-White, 95
Coolidge, Calvin, quoted, 2
Coomaraswamy, Ananda, quote from "The Dance of Shiva," 141
Corbusier, see Le Corbusier
Cortez Corporation, MOTORHOME, 125
COTTAGE IN THE BAHAMAS, Peter Jefferson, 48
Courbet, Gustave, THE STONE BREAKERS, 168, 169
Couture, Thomas, ROMANS OF THE DECADENCE, 165, 169
crafts, 102–107
creative imagination, 10–12
creativity, 10–17, 25
CREST, Bridget Riley, 225
CRYSTAL PALACE, Sir Joseph Paxton, 148
CUBE, Isamu Noguchi, 224, color plate 18, near text page 91
Cubism, 187–191. See also, 56, 177, 185, 195–199, 211, 226
Cunningham, Ben, PAINTING FOR A CORNER, 224
Curie, Marie and Pierre, 186

da Vinci, see Leonardo da Vinci
Dada, 200, 201, 203, 206
Daguerre, Louis Jacques Mandé, LE BOULEVARD DU TEMPLE, 166
Dali, Salvadore, PERSISTENCE OF MEMORY, 206
DALY CITY, Donald Aitken, 127
Daumier, Honore, TRANSNONAIN STREET, 90

DAVID, Michelangelo Buonarroti, 155, detail of, 151
DeCarava, Roy, UNTITLED, 236
de Chirico, Georgio, quoted, 205, THE MYSTERY AND MEL-
 ANCHOLY OF A STREET, 205, 206
de Hooch, Pieter, INTERIOR OF A DUTCH HOUSE, 69
de Kooning, Willem, WOMAN AND BICYCLE, 212, 213, color
 plate 38, near text page 218
De Stijl, 193
DEATH SEIZING A WOMAN, Käthe Kollwitz, 27
DEEP IN THE MOUNTAINS, Wang Hui, 157
DEER ISLE—MARINE FANTASY, John Marin, 83
Degas, Edgar, 170, PLACE DE LA CONCORDE, 170
Delacroix, Eugene, ODALISQUE, 167, PHOTOGRAPH FROM
 ALBUM, 167
DEPOSITION FROM THE CROSS, Michelangelo Buonarroti, 22
depression years, 208–209
design, 65–72
di Bondone, Giotto, see Giotto di Bondone
discovery and expression, 18–29
Dickson, W. K., FRED OTT'S SNEEZE, 97
DIE, Tony Smith, 230
DINING ROOM IN THE COUNTRY, Pierre Bonnard, color plate 5,
 near text page 27
DOLMEN OF MANÉ-KERIONED, 221
DOMINO CONSTRUCTIONAL SYSTEM, Le Corbusier, 193
DOUBLEMENT, Max Bill, 231
Doxiadis, Constantinos, quoted, 132
drawing, 74–80. See also 64
DRAWING, Barnett Newman, 67
DRAWING BY A TEN YEAR OLD, 17
DRAWING FOR A CITY OF THREE MILLION, Le Corbusier, 128
DRAWING FOR NOTRE-DAME-DU-HAUT, Le Corbusier, 75
drawing tools, 78
Duchamp, Marcel, 195, quoted 200, 232
 BICYCLE WHEEL, 200
 L.H.O.O.Q., 201
 NUDE DESCENDING A STAIRCASE, #2, 194
Durer, Albrecht, KNIGHT, DEATH AND DEVIL, 89

Eakins, Thomas, 170, NUDE ATHLETE IN MOTION, 167
ecological system, 235
environment; environmental, 233–242
environmental designers, 233–234
ECHO OF A SCREAM, David Alfaro Siqueiros, 209
Eddy, Don, PRIVATE PARKING X, color plate 40, near text page
 219
EDGE OF AUGUST, Mark Tobey, 214
Edgerton, Harold, MILK SPLASH RESULTING FROM DROPPING A
 BALL, 93
egg tempera, 216
Egyptian sculpture, 44, 152
Einstein, Albert, 186, quoted, 10
ELECTROMAGNETIC SCULPTURE, Takis, 113
electromagnetic spectrum, 40
engineering, and art, 49
engraving, 87–88
Enlightenment, 163
ENTHRONED MADONNA AND CHILD, 19
environmental design, 126–132. See also urban design,
 233–242
Erwitt, Elliott, HIGHWAYS, 129, MOTHER AND CHILD, 21
Escher, M.C., HAND WITH REFLECTING GLOBE, 54
esthetic, 8
etching, 87–88

expression, in art, 18–29
Expressionism, 139, 172
expressive art, 139–143

FACSIMILE OF CHUMASH INDIAN ROCK PAINTING, 138
FACSIMILE OF POLYCHROME CATTLE, 133, color plate 23, near
 text page 123
Fan K'uan, 83, TRAVELERS ON A MOUNTAIN PATH, 82
Farbman, N. R., BECHUANALAND, 4
Farm Security Administration, 208
FATATA TE MITI, Paul Gauguin, 59
Fauve, Les Fauves, 181, 189
Feininger, Lyonel, THE GLORIOUS VICTORY OF THE SLOOP
 "MARIA", 197, color plate 33, near text page 186
Felix, C. W., WALL, ESTRADA COURTS HOUSING PROJECT, 242
Felver, Richard I. PERCOLATOR DESIGN, 101
FEMALE PORTRAIT, 150
fiber arts, 103–105
Fields, Jack, NEW GUINEA TRIBESMAN, 6
FIGURE, Jacques Lipchitz, 199
filmmaking, see cinematography, 96
FIRST COMPOSITION STUDY FOR GUERNICA, Pablo Picasso, 75
FLAGS, Jasper Johns, color plate 8, near text page 58
FLOATS, Robert Breer, 58
form, 30–34
form and content, 31–34
FOREQUARTERS OF BULL, 158. See also LEFTHAND WALL,
 GREAT HALL OF BULLS, Lascaux Caves, color plate 24,
 near text page 123
FORTIFICATIONS AT SACSAHUAMAN, detail of, 121
Fragonard, Jean-Honoré, THE BATHERS, 163
Francis, Bill D., PEACOCK FEATHER, 65, color plate 20, near
 text page 122
Frankenthaler, Helen, INTERIOR LANDSCAPE, 226, color plate
 41, near text page 219. See also 85
FRED OTT'S SNEEZE, W. K. Dickson, 97
French Academic Art, 165
French, Daniel Chester, 35–36, ABRAHAM LINCOLN, detail of,
 35
French Revolution, 162–164
fresco, 83–84
Friedberg, M. Paul and Associates, VEST POCKET PLAYGROUND
 AND NATURE STUDY CENTER, 342
Fuller, R. Buckminster, 121, 127, U.S. PAVILION EXPO-67, 114
furniture, 107
Futurism, 195

GALLOPING HORSE, Eadweard Muybridge, 96
GARDENS AND TEAHOUSE AT KATSURA, 34
GARE SAINTE-LAZARE, Edouard Manet, 169
Gauguin, Paul, 59, 172, 173, 181, 186, quoted, 174
 FATATA TE MITI, 59
 TWO NUDES ON A TAHITIAN BEACH, 174, color plate 28, near
 text page 154
 WORDS OF THE DEVIL, 59
General Franco, 210
geometric abstraction, 153, 154, 160
gesture drawing, 74–75
Giacometti, Alberto, 44, 74, 109
 MAN POINTING, 45, detail of, 62
 SELF PORTRAIT, 74
Giotto di Bondone, 84
 THE DESCENT FROM THE CROSS, 159
glassblowing, 106

Gothic Cathedrals, 49, 147
Goya, Francisco, 163–165
 BULL FIGHT, 71
 THE THIRD OF MAY 1808, 164
GRAND PRIX OF THE AUTOMOBILE CLUB OF FRANCE, Jacques
 Henri Lartique, 195
graphic design, 99
Greek architecture, 143–144
GREEK GARDEN, Al Held, 231. *See also* 66
Greek sculpture, 149–150, 153–154
Gruen, Victor and Associates, METROCORE AND ITS TEN
 CITIES, 131
Gropius, Walter, quoted, 118, THE BAUHAUS, 193
GUERNICA, Pablo Picasso, 210–211, detail of, 20. *See also* 207,
 209
 FIRST COMPOSITION STUDY FOR GUERNICA, 75
 HEAD (study for Guernica), 9
GUITAR, Pablo Picasso, 190

HAND WITH REFLECTING GLOBE, M.C. Escher, 54
handmade furniture, 107
Happening, 228–229
Harbutt, Charles, SPECTATORS, 31
HEAD, (study for GUERNICA), Pablo Picasso, 9
HEAD OF SAINT MATTHEW, Rembrandt van Rijn, 61. *See also* 85
HEKI, Kazuaki Tanahashi, 73
Held, Al, GREEK GARDEN, 231. *See also* 66
Hellenistic period, 150
HERMES AND THE INFANT DIONYSIUS, Praxiteles, detail of, 149
HIGHWAYS, Elliott Erwitt, 129
Hindu art, 33, 141, 143
Hirai, Tom, CHAIR, 107
HIRAQLA 1, Frank Stella, 226
Hitler, Adolf, 210
Höch, Hannah, THE MULTI-MILLIONAIRE, 202
Hofmann, Hans, THE GOLDEN WALL, 212, color plate 37,
 near text page 218.
Hokusai, quoted, 77, TUNING THE SAMISEN, 77
Holbein, Hans, ANNE OF CLEVES, 68, SIR THOMAS MORE, 61
holography, 227
Holt, John, *How Children Fail*, quoted, 12
HOMAGE TO NEW YORK: A SELF-CONSTRUCTING, SELF-
 DESTROYING WORK OF ART, Jean Tinguely, 228
HOME IN WAYLAND, MASSACHUSETTS, Rommert W. Huygens,
 48
HORIZONTAL RUST, Franz Kline, 215
HORIZONTAL TREE, Piet Mondrian, 191
house construction, 122
HOUSES AT L'ESTAQUE, Georges Braque, 56
How Children Fail, John Holt, 12
hue, 40
Hui, Wang, *see* Wang Hui
human faces, 31, 149–151
human figures, 152–155
HUNGER IN INDIA, Werner Bischof, 28
Huygens, Rommert, W. HOME IN WAYLAND, MASSACHUSETTS,
 48
HYGIENIC APARTMENTS IN THE MAN-MADE DESERT, 128

I AND MY VILLAGE, Marc Chagall, 58. *See also* 65
Ictinus and Callicrates, PARTHENON, 144
imagination, 10–12
impasto, 62
IMPRESSION: SUNRISE, Claude Monet, 170

industrial design, 101
Impressionism, 169–172
industrial revolution, 166
INJURED BY GREEN, Richard Anuskiewicz 42, color plate 9,
 near text page 59. *See also* 85
Inoue, Yuichi, CALLIGRAPHY BUDDHA, 214
intaglio, 87–89
interior design, 124
INTERIOR LANDSCAPE, Helen Frankenthaler, 226, color plate
 41, near text page 219. *See also* 85
INTERIOR OF A DUTCH HOUSE, Pieter de Hooch, 69
INTERIOR OF A MANEABA, 148
International Style, 193, 221
IVORY MASK, 135

Japanese prints, influence of, 169, 173, 215
Janco, Marcel, quoted, 200
JANE AVRIL, Henri de Toulouse-Lautrec,
 oil on carboard, 72
 photograph, 72
Jefferson, Peter, COTTAGE IN THE BAHAMAS, 48
jewelry, 106–107
Jiménez, Luis, THE AMERICAN DREAM, 223
Johns, Jasper, FLAGS, color plate 8, near text page 58
JOY OF LIFE, Henri Matisse, 182

Kahn, Louis, quoted, 9
KALAPALO INDIAN HOUSE, 115
Kandinsky, Wassily, 62, 182, 183, 191, 212, 213
 quoted, 39, 182, 186
 BLUE MOUNTAIN, 183, color plate 32, near text page 186
 WITH BLACK ARCH NO. 154, 183
Kaprow, Allan, 228
Katsura, AERIAL VIEW OF KATSURA, 34, GARDENS AND TEAHOUSE
 AT KATSURA, 34
Kenzler, William, NICOLL RESIDENCE, interior, 124
kinetic art, 58, 113, 228
King Louis XIV, 34
KING MYCERINUS AND QUEEN, 152
Klee, Paul, 206, quoted 204,
 BATTLE SCENE FROM THE COMIC OPERA "THE SEAFARER",
 204, color plate 36, near text page 218
 SELF-PORTRAIT, 204
Kline, Franz, HORIZONTAL RUST, 215
Klimt, Gustav, THE KISS, 181, color plate 31, near text page 155
KNIGHT, DEATH AND DEVIL, Albrecht Dürer, 89
KNOWLEDGE IS POWER, STAY IN SCHOOL, Dana Chandler, 237
Kollwitz, Käthe, DEATH SEIZING A WOMAN, 27, SELF-PORTRAIT
 27
KORE, detail of, 149
K'uan, Fan, see Fan K'uan

landscape painting, 156–157
Lange, Dorothea, A DEPRESSION BREADLINE, SAN FRANCISCO,
 208
Lartique, Jacques Henri, GRAND PRIX OF THE AUTOMOBILE CLUB
 OF FRANCE, 195
Lascaux caves, 85
laser light, 227
Lautrec, Henri de Toulouse, *see* Toulouse-Lautrec, Henri de
LE BOULEVARD DU TEMPLE, Louis Jacques Mandé Daguerre,
 166
Le Corbusier, 74, 128
 DOMINO CONSTRUCTIONAL SYSTEM, 193

Drawing for a City of Three Million, 128
Drawing for Notre-Dame-du-Haut, 75
Notre-Dame-du-Haut, exterior, 221
Notre-Dame-du-Haut, interior, 62
Le Moulin de la Galette, Auguste Renoir, 170, color plate 26, near text page 123
Le Pont du Gard, 145
Leerdam Glasvorcentrum Color Series 1970, Marvin Lipofsky, 106
Lefthand Wall, Great Hall of Bulls, color plate 24, near text page 123
Léger, Fernand, The City, 196
Leonardo da Vinci, quoted, 39, 160
 Caricature, 9
 The Last Supper, 160
Les Fauves, 181
Lever House, Gordon Bunshaft of Skidmore Owings and Merrill, 117. See also 62
L.H.O.O.Q., Marcel Duchamp, 201
Lichtenstein, Roy, 219
Light, 35–36
 in painting, 24
 light primaries, 40
light shows, 227
Lincoln, Abraham, see perspective
line, 63–65. See also drawing, 74–80
linear perspective, see perspective
Lipchitz, Jacques, quoted, 199, Figure, 199
Lipofsky, Marvin, Leerdam Glasvorcentrum Color Series 1970, 106
Lippold, Richard, Variation Within a Sphere, No. 10: The Sun, 112
lithography, 86, 90
Lone Flute Player, Werner Bischof, 29
Lorenzetti, Ambrogio, View of a Town, 126
Lorrain, Claude, The Herdsman, 55
Love, Marisol, 219
lumia, 227
Lumia Suite, Op. 158 (two stages), Thomas Wilfred, 227, color plate 39, near text page 218

macramé, 105
Macrameing, 105
Madonna of the Chair, Raphael Sanzio, 69
magic, 134, 136, 158
Magritte, René, Portrait, 207
Malevich, Kasimir, quoted, 230
 Suprematist Composition: White on White, 38
 Yellow Quadrilateral, color plate 4, near text page 27
Man Playing a Syrinx, 153
Man Pointing, Alberto Giacometti, 45, detail of, 62
Man Wearing Lion Mask, 134
Maneaba, Interior of a Maneaba, 148
Manet, Edouard, 169, 188, Gare Saint-Lazare, 169
Manefesto of Futurism, Marinetti et al., quoted, 195
Mantegna, Andrea, The Madonna and Child, 19
Marin, John, Deer Isle—Marine Fantasy, 83
Marisol, Love, 219
Market Hall at Mereville, France, 148
mass, 43–46
Masser, Ivan, The Pause That Refreshes, 219
Maslow, Abraham, quoted, 10
Matisse, Henri, 25, 26, 79, 181, 182, quoted, 25
 Artist and Model Reflected in a Mirror, 26

Blue Nude III and Blue Nude IV, 26
Joy of Life, 182
Nasturtiums and the Dance, 25, color plate 3, near text page 27
Portrait of I.C., 79
medium, media, 73
Merchants' Exchange, 145. See also 116
Metrocore and Its Ten Cities, Victor Gruen and Associates, 131
Michelangelo Buonarroti, 22, 76, 94, 109, 151, 155
 David, 151
 Deposition from the Cross, 22
 Studies for the Libyan Sibyl in the Sistine Chapel, 76
 Unfinished Slave, 109
Mies van der Rohe, Ludwig, Barcelona Chair, 100
Milk Splash Resulting from Dropping a Ball, Harold Edgerton, 93
Miller, Wayne, Mother and Baby, 12
Minimal Art, 224, 225, 230–231
Miró, Joan, 139, 206, 207, 212–213
 Nursery Decoration, 139, 207
mobiles, 113, 200
Model of Habitat Israel, Moshe Safdie, 132
modern art, 134
Mondrian, Piet, 191, 208, 213, quoted, 192, 193
 Composition with Red, Yellow and Blue, 192, color plate 34, near text page 187
 Horizontal Tree, 191
Monet, Claude, 170, 177
 Impression: Sunrise, 170, color plate 25, near text page 123
 Water-Lilies, Giverny, 170
Mont Sainte-Victoire, Paul Cézanne, 176, color plate 30, near text page 155
Moon and Half Dome, Yosemite National Park, Ansel Adams, 238
Moore, Henry, Recumbent Figure, 46, color plate 10, near text page 59
Mother and Baby, Wayne Miller, 12
mother and child, 18–22
Mother and Child, Elliott Erwitt, 21
Mother and Child with Noisemaker, Kitagawa Utamaro, 86
motion, 58
 in cubism, 195
 in design; composition, 71
 in painting, 225
 in sculpture, 228
Motorhome, Cortex Corporation, 125
Mu Ch'i, Six Persimmons, 51
Muchaku, detail of, Unkei, 151
Muir, John, quoted, 239
Munch, Edvard, 60, 143, 181, 199,
 The Kiss
 dry point and aquatint, 60
 woodcut, 60
 The Shriek, 143
music, and visual art, 182, 227
Muybridge, Eadweard, Galloping Horse, 96

Napoleon, 164
Nasturtiums and the Dance, Henri Matisse, 25, color plate 3, near text page 27. See also page 181
Nasa, The World, color plate 42, near text page 219
nature,
 and art, 18

and man, 34, 235, 239
 design in, 65, 114
naturalism, in painting, 159
NAVAJO SAND PAINTING, 158
Nazis, 211
NEOLITHIC HOUSE, 118
Nervi, Pier, Luigi, quoted, 121
NEW GUINEA TRIBESMAN, Jack Fields, 6
new ways of seeing, 168–169
NEW WORKERS' SCHOOL MURALS, detail of, Diego Rivera, 84
Newman, Barnett, DRAWING, 67
Newton, Sir Isaac, 40, 227
NICOLL RESIDENCE, interior, William Kenzler, 124
Niepce, Joseph Nicephore, 166
NO. 14, Jackson Pollock, 213
Noguchi, Isamu, BIG BOY, 108
 CUBE, 224, color plate 18, near text page 91
Nolde, Emil, PROPHET, 87
nonrepresentational, 138–139, 180, 212
NOTRE DAME DE CHARTRES, 147
NOTRE-DAME-DU-HAUT, Le Corbusier, 221, drawing for, 75
NUDE ATHLETE IN MOTION, Thomas Eakins, 167
NUDE DESCENDING A STAIRCASE, #2, Marcel Duchamp. 194, 200
NURSERY DECORATION, Joan Miró, 139, 207

OAKLAND MUSEUM, Kevin Roach and Associates, 239
Oceanic sculpture, influence of, 186
ODALISQUE, Eugène Delacroix, 167
oil paint, 85
O'Keeffe, Georgia, BLACK CROSS, NEW MEXICO, 208
Oldenburg, Claes, quoted, i,
 SCULPTURE IN THE FORM OF A TROWEL STUCK IN THE GROUND, 220
OLYMPIC STADIUMS, Kenzo Tange, 119
101 NORTH, Duane Preble, 2
OP ART, 225
Oppenheim, Dennis, CANCELLED CROP, 232
oriental brush painting, 81
Orozco, Jose Clemento, 208, ZAPATISTAS, 70

PAINTED AND GLAZED EARTHENWARE VASE, 136
painting, 81–85
PAINTING FOR A CORNER, Ben Cunningham, 224
Palmer, Vincent, 36
PANTHEON, 146
Paris Exposition of 1937, 210
parks,
 city, 239–240
 national, 238–239
Parks, Gordon, BOY IN GRASS, 92 color plate 16, near text page 91
Parrott, Alice, RED FORM, 104, color plate 13, near text page 90
PARTHENON, Ictinus and Callicrates, 114
Patiner, Joachim, REST ON THE FLIGHT INTO EGYPT, 156
Paxton, Sir Joseph, CRYSTAL PALACE, 148
PAZZI CHAPEL, Filippo Brunelleschi, 147
PEACOCK FEATHER, Bill D. Francis, 65, color plate 20, near text page 122
PEPPER #30, Edward Weston, 32
perception, 7, 66
PERCOLATOR DESIGN, Richard I. Felver, 101
PERSISTENCE OF MEMORY, Salvadore Dali, 206
perspective, 52–55, 205

photomontage, 203
PHOTOGRAPH FROM ALBUM, Eugène Delacroix, 167
photography, 91–95, 166–167, 171, 232
 silk screen photography, 218
Photorealism, 232
Picasso, Pablo, 20, 43, 75, 111, 185–190, 203, 207, 209–211
 quoted, 133, 134, 211
 A MOTHER HOLDING HER CHILD AND FOUR STUDIES OF HER RIGHT HAND, 20
 BULL'S HEAD, 111
 FIRST COMPOSITION STUDY FOR GUERNICA, 75
 GUERNICA, 210–211
 Detail of, 20
 GUITAR, 190
 HEAD (study for GUERNICA), 9
 SELF-PORTRAIT, 186
 SHEET OF MUSIC AND GUITAR, 190
 THE CLARINET PLAYER, 189
 THE RESERVOIR AT HORTA DE EBRO, 188
 THE YOUNG LADIES OF AVIGNON, 187
 THREE MUSICIANS, 198
 YOUNG MAN'S HEAD, 43
pictorial space, 56
picture plane, 65
pigments, 40, 81
Pineda, Marianna, SLEEPWALKER, 222
PLACE DE LA CONCORDE, Edgar Degas, 71
PLAN FOR RECONSTRUCTION OF SKOPJE, YUGOSLAVIA, Kenzo Tange, 130
planographic, 90
PLUM TREES IN BLOSSOM, Vincent van Gogh, 173
Pointillism, 172
Pollock, Jackson, NO. 14, 213
POLYCHROME WALL PAINTING, detail of, 139
Polyclitus, SPEAR BEARER, 155
POMO FEATHERED BASKET, 136, color plate 21, near text page 122
POMO STORAGE BASKET, 135, 136
Pop Art, 217–220
Porter, Eliot, TAMARISK AND GRASS, color plate 15, near text page 90. See also 92.
PORTRAIT, René Magritte, 207
PORTRAIT HEAD, 150
PORTRAIT OF AN OLD MAN AND A BOY, Marietta Tintoretto, 162
PORTRAIT OF I.C., Henri Matisse, 79
Postimpressionism, 172–177
POTTING, 103
Poussin, Nicholas, SAINT JOHN ON PATMOS, 176
Praxiteles, HERMES AND THE INFANT DIONYSIUS, detail of, 149
PREACHER, Charles White, 78
prefabricated buildings; prefabrication, 122–123, 132, 148
PREFABRICATED THREE-BEDROOM HOUSE, Techbuilt Corporation, 123
prehistoric art, 133–135
Preble, Duane, 101 NORTH, 2
 REFLECTIONS, 197
primaries, 40
printmaking, 86–91
PRIVATE PARKING X, Don Eddy, color plate 40, near text page 219
PROPHET, Emil Nolde, 87
proportion, 66
Prud'hon, Pierre-Paul, STUDY OF A FEMALE NUDE, 37

Puccinelli, Angelo, TOBIT BLESSING HIS SON, 52
Pythagoras, 227

QENNEFER, STEWARD OF THE PALACE, 44

Raphael Sanzio, MADONNA OF THE CHAIR, 69, THE SCHOOL
 OF ATHENS, 53
Rauschenberg, Robert, TRACER, 217
Ray, Man, THE GIFT, 201
"ready-made", 200–201
Realism, 168
RECUMBENT FIGURE, Henry Moore, 46, color plate 10, near
 text page 59
RED FORM, Alice Parrott, 104, color plate 13, near text page 90
REFLECTIONS, Duane Preble, 197
Reims Cathedral, arcades and vaults of knave, 49
relationships, visual, 36
relief printmaking, 87
relief sculpture, 108
Rembrandt van Rijn, 61, 80, 81, 85, 110, 162
 CHRIST PREACHING, 110
 HEAD OF SAINT MATTHEW, 61
 SASKIA ASLEEP, 80
 SELF PORTRAIT IN A CAP, OPEN-MOUTHED AND STARING, 23
Renaissance, 147, 160–162
Renoir, Auguste, MOULIN DE LA GALETTE, 170, color plate 26,
 near text page 123
representation, 135
representational art, 138, 158, 160, 180–181, 193, 216
Representational Surrealism, 207
reproduction; reproductions, 35, 86, 230
REST ON THE FLIGHT INTO EGYPT, Joachim Patiner, 156
rhythm in art, 69–70, 140
RICE STRAW EGG CONTAINER, 100
Riis, Jacob, BANDIT'S ROOST, 175
Riley, Bridget, CREST, 225
RIVER WALK, 241
Rivera, Diego, 83, 208, Detail of NEW WORKERS' SCHOOL
 MURALS, 84
Roach, Kevin and Associates, OAKLAND MUSEUM, 239
ROBIE HOUSE, Frank Lloyd Wright, 185
Rococo, 162–163
Rodia, Simon, quoted, 11, WATTS TOWERS, 11
Rodin, Francois Auguste René, 62, 181, THE KISS, 178
Roman architecture, 145–147
ROMANS OF THE DECADENCE, Thomas Couture, 165, 169
Ronchamp, NOTRE-DAME-DU-HAUT, Le Corbusier, 221
Rosenquist, James, 219
RYŌAN-JI GARDEN, Japan, 50

Safdie, Moshe, MODEL OF HABITAT ISRAEL, 132
SAINT JOHN ON PATMOS, Nicholas Poussin, 176
SAINT SERAPION, Francisco de Zurbarán, 38
SAINTS AND ROYAL PERSONAGES, facade of west portal, Notre
 Dame de Chartres, 33
San Antonio, Texas, river in, 240
Sanzio, Raphael, see Raphael Sanzio
Sartre, Jean Paul, 44
SASKIA ASLEEP, Rembrandt van Rijn, 80
Sasetta and assistant, THE MEETING OF SAINT ANTHONY, 57
scale, 66
SCENE FROM KANDARYA TEMPLE, India, 33
Schwitters, Kurt, 217, quoted, 203, CONSTRUCTION FOR NOBLE
 LADIES, 203 color plate 35, near text page 187
sculpture, 108–113

SCULPTURE IN THE FORM OF A TROWEL STUCK IN THE GROUND,
 Claes Oldenburg, 220
secular art, 161–162
Segal, George, THE GAS STATION, detail of, 223
self-portrait, 14, 22–24, 26–27, 234
SELF-PORTRAIT, Alberto Giacometti, 74
SELF-PORTRAIT, Paul Klee, 204
SELF-PORTRAIT, Käthe Kollwitz, 27
SELF-PORTRAIT, Pablo Picasso, 186
SELF-PORTRAIT IN A CAP, OPEN-MOUTHED AND STARING,
 Rembrandt van Rijn, 23
Sengai, Gibon, quoted, 64, THE CRAB, 64,
 THE FIST THAT STRIKES THE MASTER, 159
serigraphy, 91
Seurat, Georges, 172, 176, SUNDAY AFTERNOON ON THE IS-
 LAND OF LA GRANDE JATTE, 172, color plate 29,
 near text page 155
shape, 43, 58–60
 Cubist, 188–198
SHEET OF MUSIC AND GUITAR, Pablo Picasso, 190
SHINTO PRIESTS IN TEMPLE GARDEN, Werner Bischof, 29
SHIVA NĀTARĀJA, 141
SHRINE, Hale Woodruff, 85
SHRINES AT ISE, Main Sanctuary from northwest, 118
Sierra Club, 239
silk screen printing, 91, 99, 105
 photographic, 218–219
Siqueiros, David Alfaro, ECHO OF A SCREAM, 209
SIR THOMAS MORE, Hans Holbein, 61
SIX PERSIMMONS, Mu Ch'i, 51
SLEEPING MUSE, Constantin Brancusi,
 1906, 180
 1906–1911, 183
SLEEPWALKER, Marianna Pineda, 222
SMITH FROM NORTHERN DAHOMEY, 102
Smith, Tony, DIE, 230
social architecture, 143–148
social realism, 209
SOLOMAN AND THE QUEEN OF SHEBA, 57, color plate 19, near
 text page 122
space, 48–56
 architectural, 48–49, 185
 Cubist, 188, 196–197
 implied or illusionary, 53, 59, 224, 226
 Postimpressionist, 177
 Surrealist, 205–206
Spanish Civil War, 139
Spanish Revolution, 210
SPEAR BEARER, Polyclitus, 155
SPECTATORS, Charles Harbutt, 31
spectrum, 40
sphere illustrating light and dark system, 37
stabile, 113
STANDARDIZED CONSTRUCTION UNITS, 122
STANDING BUDDA, 140
STANDING YOUTH, 154
Stanford, Leland, 96
Steinberg, Saul, 64, cartoon, vi, 63
Stella, Frank, HIRAQLA 1, 226
stencil, 91
Stieglitz, Alfred, quoted, 185,
 THE STEERAGE, 184
STILL LIFE NO. 33, Tom Wesselmann, 218
structural systems, 120–121

STUDIES FOR THE LIBYAN SIBYL IN THE SISTINE CHAPEL CEILING, Michelangelo Buonarroti, 76
STUDY OF A FEMALE NUDE, Pierre-Paul Prud'hon, 37
styles, in art, 220
subject matter, 30
Sullivan, Louis, 117, 128, WAINWRIGHT BUILDING, 116
Summers, Carol, CHEOPS, 87, color plate 14, near text page 90
SUNDAY AFTERNOON ON THE ISLAND OF LA GRANDE JATTE, 172, color plate 29, near text page 155
Surrealism, 204–207
Synthetic Cubism, 190

Takaezu, Toshiko, CERAMIC POT, 103, color plate 12, near text page 90
Takis, ELECTROMAGNETIC SCULPTURE, 113
TAMARISK AND GRASS, Eliot Porter, 92, color plate 15, near text page 90
Tanahashi, Kazuaki, HEKI, 73
Tange, Kenzo, quoted, 118
 OLYMPIC STADIUMS, 119
 PLAN FOR RECONSTRUCTION OF SKOPJE, YUGOSLAVIA, 130
Tassili, rock painting at, FACSIMILE OF POLYCHROME CATTLE, 133, color plate 23, near text page 123
Techbuilt Corporation, PREFABRICATED THREE-BEDROOM HOUSE, 123
television, 97–98
tempera, 84–85
TENT STRUCTURE, The Shaver Partnership and Bob Campbell and Company, 125
textile design, 105
texture, 61–62
THAT GENTLEMAN, Andrew Wyeth, 216. See also 85
THE AMERICAN DREAM, Luis Jiménez, 223
THE ARTIST IN HIS STUDIO, Jan Vermeer, 24, color plate 2, near text page 26
THE BATHERS, Jean-Honoré Fragonard, 163
THE BAUHAUS, Walter Gropius, 193
THE CITY, Fernand Leger, 196
THE CLARINET PLAYER, Pablo Picasso, 189
THE CRAB, Gibon Sengai, 64
The Dance of Shiva, Ananda Coomaraswamy, quoted, 141
THE DESCENT FROM THE CROSS, Giotto di Bondone, 159. See also 83
THE FIST THAT STRIKES THE MASTER, Gibon Sengai, 159
THE GARDEN, Paul Cézanne, 189
THE GARDEN OF WORLDLY DELIGHTS, Hieronymus van Aeken Bosch, detail of right panel, 206
THE GAS STATION, detail of, George Segal, 223
THE GATES OF SPOLETO, Alexander Calder, 113
THE GIFT, Man Ray, 201
THE GLORIOUS VICTORY OF THE SLOOP "MARIA," Lyonel Feininger, 197, color plate 33, near text page 186
THE GOLDEN WALL, Hans Hofmann, 212, color plate 37, near text page 218
THE GREAT STUPA, 146
THE GULF OF MARSEILLES, SEEN FROM L'ESTAQUE, Paul Cézanne, 177
THE HERDSMAN, Claude Lorrain, 55
THE KISS, Constantin Brancusi, 178–179
THE KISS, Gustav Klimt, 181, color plate 31, near text page 155
THE KISS, Edvard Munch,
 drypoint and aquatint, 60
 woodcut, 60
THE KISS, Francois Auguste René Rodin, 178. See also 62

THE LAST SUPPER, Leonardo da Vinci, 160
THE MADONNA AND CHILD, Andre Mantegna, 19
THE MAIDS OF HONOR, Diego Rodrigues de Silva Velázquez, 23
THE MEETING OF SAINT ANTHONY AND SAINT PAUL, Sassetta and assistant, 57
THE MULTI-MILLIONAIRE, Hannah Höch, 202–203
THE MYSTERY AND MELANCHOLY OF A STREET, Giorgio de Chirico, 205
THE NEWBORN, Constantin Brancusi, 180
THE PAINTER AND THE CONNOISSEUR, Pieter Brueghel, 24
THE PAUSE THAT REFRESHES, Ivan Masser, 219
THE RESERVOIR AT HORTA DE EBRO, Pablo Picasso, 188
THE SCHOOL OF ATHENS, Raphael Sanzio, 53
The Shaver Partnership and Bob Campbell and Company, TENT STRUCTURE, 125
THE SHRIEK, Edvard Munch, 143, 199
THE SOUND, Wes Wilson, 227
THE SOWER, Vincent van Gogh, 173, color plate 27, near text page 154
THE STEERAGE, Alfred Stieglitz, 184–185
THE STONE BREAKERS, Gustave Courbet, 168–169
THE THIRD OF MAY 1808, Francisco Goya, 164
THE TURNING ROAD, Paul Cézanne, 56, color plate 11, near text page 59
THE WORLD, NASA, color plate 42, near text page 219
THE YOUNG LADIES OF AVIGNON, Pablo Picasso, 187
THREE MUSICIANS, Pablo Picasso, 198–199
tie dye, 105
time, in art, 57
Tinguely, HOMAGE TO NEW YORK: A SELF-CONSTRUCTING, SELF-DESTROYING WORK OF ART, 228
Tintoretto, Marietta, PORTRAIT OF AN OLD MAN AND A BOY, 162
TLAZOLTÉOTL, 18
Tobey, Mark, quoted, 214, EDGE OF AUGUST, 214
TOBIT BLESSING HIS SON, Angelo Puccinelli, 52
Tolstoy, Leo, quoted, 5
tools, 135
Toulouse-Lautrec, Henri de, 72, 175, 186
 AT THE MOULIN ROUGE, 175
 JANE AVRIL
 Oil on carboard, 72
 Photograph, 72
TRACER, Robert Rauschenberg, 127
TRANSNONAIN STREET, Honoré Daumier, 90
TRAVELERS ON A MOUNTAIN PATH, Fan K'uan, 82
TUNING THE SAMISEN, Hokusai, 77
twentieth century art, 178–232
TWO NUDES ON A TAHITIAN BEACH, Paul Gauguin, 174, color plate 28, near text page 154

UNFINISHED SLAVE, Michelangelo Buonarroti, 109
Unkei, MUCHAKU, detail of, 151
Unknown Chinese artist, A WAVE UNDER THE MOON, 65
UNTITLED, Roy DeCarava, 236
UNTITLED, Victor Vasarely, color plate 17, near text page 91
urban planning; urban design, 233–242
 See also environmental design, 126–132
U.S. PAVILION, Expo-67, R. Buckminster Fuller, 114
Utamaro, Kitagawa, MOTHER AND CHILD WITH NOISEMAKER, 86

value, 36–38, 41
 value scale, 36

van Gogh, Vincent, 76, 172, 173, 181, 186, 199, 212,
 quoted, 173
 CARPENTER, 76
 after Hiroshige, PLUM TREES IN BLOSSOM, 173
 THE SOWER, 173, color plate 27, near text page 154
van Rijn, *see* Rembrandt van Rijn
van Ruisdael, Jacob Isaac, WHEATFIELDS, 156
VARIATION WITHIN A SPHERE, NO. 10: THE SUN, Richard
 Lippold, 112
Vasarely, Victor, 225, UNTITLED, color plate 17, near text page
 91
Velásquez, Diego Rodrigues de Silva, 23, 162
 THE MAIDS OF HONOR, 23
Vermeer, Jan, 24, 162, THE ARTIST IN HIS STUDIO, 24, color
 plate 2, near text page 26
Versailles, 34
VEST POCKET PLAYGROUND AND NATURE STUDY CENTER,
 M. Paul Friedberg and Associates, 342
Victorian art, 165
VIEW OF A TOWN, Ambrogio Lorenzetti, 126
visual communication, 30–31. *See also* communication
visual elements, 35
volume, 36, 49

WAINWRIGHT BUILDING, Louis Sullivan, 116
WALL, ESTRADA COURTS HOUSING PROJECT, C. W. Felix, 242
Wang Hui, DEEP IN THE MOUNTAINS, 157
Warhol, Andy, 219
WATER-LILIES, GIVERNY, Claude Monet, 170, 177
watercolor, 83

WATTS TOWERS, Simon Rodia, 11
weaving, 103–104
Wesselmann, Tom, STILL LIFE NO. 33, 218–219
Weston, Edward, quoted, 32, PEPPER #30, 32
WHEATFIELDS, Jacob Isaac van Ruisdael, 156
White, Charles, PREACHER, 78
Wiig, Linda, ARTIFICIAL FORMULA, 234
Wilfred, Thomas, LUMIA SUITE, OP. 158, (two stages), 227,
 color plate 39, near text page 218
Wilson, Wes, THE SOUND, 227
WITH THE BLACK ARCH, NO. 154, Wassily Kandinsky, 183
WOMAN AND BICYCLE, Willem de Kooning, 212, color plate 38,
 near text page 218
WOMAN SPINNING, 102
Wood, Grant, AMERICAN GOTHIC, 2, 208
Woodruff, Hale, SHRINE, 85
WORDS OF THE DEVIL, Paul Gauguin, 59
Works Progress Administration, 208
Wright, Frank Lloyd, 117, 185
 ROBIE HOUSE, 185
writing, 64
Wyeth, Andrew, quoted, 216, THAT GENTLEMAN, 216

YELLOW QUADRILATERAL ON WHITE, Kasimir Malevich, color
 plate 4, near text page 27
YOUNG MAN'S HEAD, Pablo Picasso, 43

Zen Buddhism, 214
ZAPATISTAS, Jose Clemento Orozco, 70
Zurbarán, Francisco de, SAINT SERAPION, 38